LANDSCAPING WITH NATURE

LANDSCAPING
WITH
NATURE

USING NATURE'S DESIGNS
TO PLAN YOUR YARD

Jeff Cox

Rodale Press, Emmaus, Pennsylvania

Copyright © 1991 by Jeff Cox

Printed in the United States of America on acid-free ∞, recycled paper

Copy Editor: Lisa D. Andruscavage
Book Designer: Acey Lee
Book Layout: Lisa Carpenter
Illustrator: Frank Fretz
Front Cover:
 Inlaid Photograph by Susan A. Roth
 Garden Design by Mitsuko and Andrew Collver
 Background Photograph by Steve Terrill
Back Cover:
 Photographs by Marilyn Cox
"Best Native Plants for Your Garden" on pages 205-53 by C. Colston Burrell

If you have any questions or comments concerning this book, please write:

 Rodale Press
 Book Reader Service
 33 East Minor Street
 Emmaus, PA 18098

Library of Congress Cataloging-in-Publication Data

Cox, Jeff.
 Landscaping with nature : using nature's design to plan your yard / by Jeff Cox.
 p. cm.
 ISBN 0–87857–911–7 hardcover
 ISBN 0–87596–742–6 paperback
 1. Landscape gardening. 2. Gardening to attract wildlife. I. Title.
SB473.C69 1990
712'.6—dc20 90–45938
 CIP

Distributed in the book trade by St. Martin's Press

12 14 16 18 20 19 17 15 13 hardcover
 2 4 6 8 10 9 7 5 3 1 paperback

For my dad.

CONTENTS

INTRODUCTION:
PARTNERS WITH NATURE

WHAT IS LANDSCAPING
WITH NATURE?

Most of us leave home to enjoy nature. And usually, when we're vacationing in the mountains or picnicking by a waterfall, we enjoy the scenery just for itself. But there's no need to leave those wonderful wilderness feelings behind when we get back in the car. The unspoiled beauty of natural places can be a rich source of inspiration for our home gardens. When we walk through the woods or wild meadow and stop, and become as still inside as the world is quiet outside, then the details of this beauty become focused for us. We may be struck by the way the upright, bare branches of a small tree add life to a dense mass of evergreen shrubs. We may like the way water plays over rocks or enjoy the color harmonies of a group of spring flowers.

We can find ways to recreate these details at home in our gardens. We can reproduce them literally (say, by building a pond in a low part of the yard) or suggest them with parallel effects (instead of building the pond, by putting a half barrel with a water lily on the patio). When we do this, we construct a new kind of very personal garden, a "natural landscape." The natural landscape is based on our own responses to wild beauty. When we landscape with nature, we evoke favorite natural places through our use of wood, water, plants, and stone. Although based on actual landscape features, the garden will also become a map of the gardener's own likes and dislikes—a landscape that begins in the mind.

If we look at a garden as the physical realization of a mental landscape, then we can see the wild world as the mind of Nature expressed.

(Throughout this book, you'll find that I personify Nature with the feminine pronoun. That's because I think of the Earth as our mother and Nature as the spirit of the Earth.) We garden best when we are partners with Nature. In a garden, our physical work, mental reasoning, and spiritual appreciation are synthesized into a whole. This synthesis forms the groundwork for our partnership with Nature.

LEARNING FROM NATURE

We are beginning to understand that the quality of our relationship to the Earth will determine the quality of our future. Landscaping with nature gives us a reason to go to Nature and learn from her and to recreate some of her beautiful features in our gardens. Nature is our great teacher. She contains within her cycles and expressions all that we need to know to be truly and fully human. Only our ignorance prevents our full flowering. "It's not nature-as-chaos that threatens us," says the poet Gary Snyder, "but ignorance of the real natural world."

The "real natural world" can teach us who we are and how to live. "I went to the woods because I wished to live deliberately, to front only the essential facts of life, and see if I could not learn what it had to teach, and not, when I came to die, discover that I had not lived," Henry David Thoreau wrote about his experience at Walden Pond. Thoreau's journey back to wilderness will continue to cast its light through the ages, even though he merely spent a year cultivating beans by a rustic pond outside a small Massachusetts town. There was nothing remarkable about the woods around Walden Pond. Thoreau "entered what was essentially an inner forest," as author and naturalist Loren Eiseley said. His woods had meanings, and correspondences to places in himself.

Nature's lessons will remain opaque as long as we are full of our own ideas and preconceptions. An empty cup can receive, a full one can't. We need to be open-minded and respectful when we walk in Nature's wild places. Gary Snyder compares the wilderness trekker to the archetypal pilgrim, experiencing a profound sense of ecstasy. "Not just backpackers, of course. The same happens to those who sail in the ocean, kayak in the rivers, tend a garden. The point is in making intimate contact with wild world, wild self. 'Sacred' refers to that which helps take us out of our little selves into the larger self of the whole universe," Snyder says.

Learning from Nature means establishing a relationship with her. And learning is most thorough when you have a lifelong relationship with Nature as she expresses herself in a certain place, as the naturalist and writer John Muir did with Yosemite. John Muir found God's presence in the beauty of Yosemite and the High Sierra. He had trouble understanding the tourists who came to Yosemite, for they didn't seem to be concerned about God's natural sermons.

"It seems strange that visitors to Yosemite should be so little influenced by its novel grandeur, as if their eyes were bandaged and their ears stopped. Most of those I saw yesterday were looking down as if wholly unconscious of anything going on about them, while

the sublime rocks were trembling with the tones of the mighty chanting congregation of waters gathered from all the mountains roundabout, making music that might draw angels out of heaven. Yet respectable-looking, even wise-looking people were fixing bits of worms on bent pieces of wire to catch trout," Muir wrote in *My First Summer in the Sierra.*

While Muir called the voices of water on stone sermons, I might call them songs, for they seem more akin to music than preaching. The sound of water splashing on rocks may be perceived as a small voice singing nature's rhythmic song. You don't need a stream on your property to achieve this effect. A trickle of water falling from rock to rock will evoke it.

THE HEALING POWER OF WILDERNESS

Such communion with Nature—joining in her harmonies—has a positive, healing effect on human beings. Although we think of ourselves as modern, only our intentions have evolved so fast. Our bodies are essentially the same as they were in Paleolithic times. A diet of wild roots, berries, nuts, and greens is as healthy for the urbane Manhattanite as it was for a Cro-Magnon nomad.

In our inner, psychological world, our Paleolithic programming may also be intact. Paul Shephard, Avery Professor of Human Ecology at Pitzer College in Claremont, California, underscores the necessity for preserving wilderness and natural habitat by describing its benefits for our mental development. He points out

that our need for natural places is bound up in our basic biological and psychological roots. We have an innate need to clamber on rocks and see a valley without a building. Then, when the hawk sails by, we can soar up with it.

Shephard says that Paleolithic people used the natural, wild landscape, with its ecological relationships intact, as the prime metaphor for working out abstract ideas. An early hunter saw, for instance, that the wolf, which cannot run as fast as a deer, can run farther than a deer. The wolf uses persistence to overcome fleetness of foot. The hunter can then find persistence in himself, which he uses to accomplish tasks as seemingly impossible as a wolf catching a deer. Aesop's fables, providing animal analogies for human problems, give similar natural contexts for problem solving. Wild places are therefore necessary for the proper development of the human intellect.

As the untrammeled wilderness breaks apart and disappears before advancing civilization, we lose the ability to use it as a context for problem solving. Perhaps in a totally urban context we lose it entirely. "The loss is subtle," says nature writer Barry Lopez, "and largely visible just to the eye. But some believe it is a loss that registers on the human spirit as profoundly as the loss of a trace amount of zinc in the blood will affect the health of the human body." Thus, wilderness fills another basic human need: It gives people a place to go for deep healing. Threats to wilderness jeopardize our personal health: That's how closely we are connected to the Earth.

Our health and the health of our environment are to some extent also dependent on the

FIT FOR A DOG

"I'd like to have a dog," the man said sadly, "but I live in an apartment. An apartment is no place for a dog."

Think about that.

Would you want your family to live in a place that wasn't fit for a dog?

—Dale Timmons
Countryside magazine
Vol. 68, No. 8, August 1984

quality of our biological and environmental sciences, which measure effects and discover problems. Wilderness has a central place in such biological research. It provides scientists with baseline data from which human interference (for good *or* ill) can be measured. Wilderness is a biological research park where a new science, called biogeochemistry, is tracking the movements of elements like calcium, sodium, and potassium as they make their way from living creature to soil to rock and perhaps back to living creature. By understanding how such elements circulate in the wild, scientists can better understand how we interrupt these natural cycles by our human activities and avoid problems before they start.

Not only does wilderness enhance human physical and mental health, it directly influences human spiritual health. It is in the untrammeled regions of desert, mountain, and forest that we find, as Wallace Stegner put it, "the geography of hope." There our spirit is released to join with the spirit of the place in a concern beyond human necessity. There the imagination soars. Extraordinary conditions usually exist in a wilderness or natural place that crack the ordinary boundaries of our lives to set us—if only for a moment—free. One such condition is the great silence of natural places, a sensory vastness in which human thoughts may expand without hindrance. Along with the silence go, in desert and mountain regions especially, the vast vistas that give us grand perspectives.

"The Lakota make a point concerning Wakan Tanka, the Great Spirit, which is helpful in understanding the importance of any landscape," Lopez writes. "The Great Spirit, they say, is inherent in the land. In nature, one sees various forces at work: A bolt of lightning shatters a yellow pine, a mule deer chews leaves of mountain mahogany, creek water splashes in a sandstone basin. These relationships, between lightning and trees, the deer and the plant, water and stone, are what is called Wakan Tanka. They reveal a spiritual realm within the physical landscape. A person aligned properly in this invisible realm is thought to be in a state of health. All relationships are in good order . . . immersed in the relationships of a natural place, we regain our spiritual senses."

Preservation of wilderness is also the preservation of spiritual values that are based in nature. These spiritual values are timeless in their importance.

BACK IN OUR OWN BACKYARDS

Unfortunately, the American approach to the wilderness has devolved into one of two choices: Pave it or preserve it. But there is a third choice, and that is to welcome nature back into our living areas, starting with our own backyards. Fifty square feet of backyard ground is subject to the same wild energies and urges as 50 square miles of wilderness: The ground is subject to the same effects from freezes and thaws; hard rains will erode backyard and wilderness soil; plants respond to sunlight in our yards just as they do in the wild; wild birds act the same in our bushes as in wild bushes; low, wet spots in our yards will be colonized by the same mosses and wild bog plants as live in local bogs. To watch wild nature operate on that 50 square feet, we have to create a natural landscape, then leave it alone. Small though it may be, the plot is then reclaimed for wild nature.

Landscaping with nature not only heals and refreshes us, it heals Nature, too. Most Americans realize that our forebears plundered and squandered the riches of the natural wilderness. Now it is important that we turn to wild places for guidance in how we should care for our land. In the wild, we find Nature caring for the land as she deems best. She gives us the mark to shoot for.

In our gardens, we will reforge a close relationship with Nature and learn how to work with her again. Think what our country might have been like if we had aimed to go into partnership with wild Nature, rather than subjugate her will to ours. Although she is broken, she can be healed. That partnership is still possible if we recognize that Nature is the great gardener, and we are her students.

Wilderness breaks down boundaries: If we gardeners are able to add art to nature, then Nature gave us that ability to begin with. Landscaping with nature allows us to identify ourselves in nature and nature in us.

In this book, you'll find out how *you* can learn from Nature and design your own customized natural garden. The gorgeous color photo section will inspire you with a hundred successful ideas for natural landscaping. Then, you'll find out how to turn your plan into reality by choosing the right plants and building materials (such as stones, materials for a path or mulching, water fountains, fencing, and pool liners) for your climate, area, and needs. Once you've learned how to plant your landscape and added natural enhancements such as wood, stone, and water, you'll discover the ultimate pleasure of the natural garden—how to encourage wildlife to feel at home. Next time you feel the urge to see some beautiful natural scenery, you can just step outside!

The most sublime state a human being can aspire to is being in the wilderness alone with God.

—Malcolm Muggeridge

LEARNING FROM NATURE

GLADE, GLEN, AND GROTTO

On Valentine's Day, I pulled on my hiking boots and drove to Sonoma County's Sugarloaf State Park, several thousand wild acres in northern California, acres perched on the Mayacamas Mountains between the Napa Valley to the east and the Valley of the Moon to the west. It's spectacular country, where the bones of the mountains stick out of the stony soil and deep canyons plummet nearly straight down.

The parking lot is in a vale surrounded by the tops of mountains, and all the trails lead off to one or another of the peaks. It was midafternoon, and the slopes of the peaks to the southeast were in shadow, while a huge round hill to the northeast was bathed in sun. The day was refreshing—a cool 65°F in the shade with a friendly warmth wherever my skin was touched by the late winter sunshine.

I had come to this wild area for garden inspiration—to find ideas for my property, especially the front yard. The previous owner had planted a crescent-shaped berm (a low earth wall or mound 1 to 3 feet tall) with eye-jarring ice plant, then abandoned it. Coyote brush and weeds had invaded. It was an ugly sight. But how to redo it? The challenge of creating a natural landscape was irresistible, and so here I was in Sugarloaf looking for ideas, surveying the land and wondering which direction to explore. I chose to go toward the sunny hilltop.

A narrow gravel road led up the round mountain, but soon veered off to the left and out of sight. As I walked up the road, my eye was caught by groups of large rocks sitting in abandoned heaps in a field of annual grasses. I'd been working with naturalistic rock compositions in our front garden and marveled at how

effortlessly Nature composed these stones into pleasing piles and shapes. They embodied the effects I was striving for.

High above the left flank of the round hill, five turkey vultures spun in a wide circle as they peered down at something far below. The hill itself was crowned with scrubby oak, madrone, manzanita, and acacia. Just below the top, grassland mixed with patches of trees and scrub brush—a good example of the natural oak-and-grass composition of wilderness Sonoma County. It was particularly beautiful at this time of year, for the grasses were young and brilliantly green. From July to November, they are toasted a golden tan.

I was high enough now to see across the entire valley and could make out rock cliffs on the steep wooded faces of the jagged peaks where eagles must have lived in less civilized times. Now a red-tailed hawk was flying in large loops along the cliff face.

GLADE

I continued up the road until I came to a small grove of trees on my left. From the corner of my eye, I saw a bird flit in the glade of soft green grass under the trees. I stood still to see if I could catch another sight of the bird, then turned and looked down the road behind me. There, 50 yards away and heading straight up the road toward me, was a mule deer doe. She loped along with her big mule ears sticking out and a serious expression on her face, as if she were running a race. She kept coming right at me. She was out in the bright sunlight; I was in the shade. I realized that she didn't see me.

What would I do if she kept coming at me? But she veered to her left 30 feet from me, through the trees into the green glade where I was going to spy out the bird.

The doe gave me a remarkable image to remember: In this glade that had caught my fancy, so prettily ringed with madrone, oak, acacia, and the moss-covered trunks of fallen trees, through a shaft of sunlight that was spotlighting the emerald grass, moved the deer. My impression was less of her body than of a brown spirit moving quickly through. I'd found a glade to stop in and listen for a bird and instead had caught the spirit of a deer.

From My Nature Notebook:

Plant a ring of favorite trees in an area that leads up to our front garden, with shade-loving grass in the middle.

GLEN

I moved on, intending to follow the road upward and around a bend, but my attention was caught by a stream flowing toward me from a grove of trees on my right. The water in this seasonal creek never made it to the road. It seemed to diminish, then disappeared entirely about 10 feet from me, its flow absorbed into the sandy soil forming the creekbed. At the road, the bed was dry.

I left the road and walked along this intriguing little creek toward the grove of trees. Just inside the woods, leaf litter gave way to a sunny bank covered with tiny three-leaf clovers

that edged the creek. The spot was sheltered by an acacia just bursting into soft, dusty yellow bloom. Where the clover faded into leaf litter under the acacia, a jumble of wild sweet-pea vines glowed with magenta flowers. I lay down there and listened to the water splash, looking without success for a four-leaf clover.

From My Nature Notebook:

Plant the softly rounded bank of the berm with small-leaved plants like baby's-tears, moss, clover, or wild pink wood-sorrel. Put in a pool of water below the berm to suggest the flowing stream. Make it a place to sprawl and watch the water.

The sound of the water was insistent: It called from farther upstream. I followed a barely noticeable deer trail along a steep bank into the woods and sat down above the creek where the water's voice was loud and clear. Here was a cool, natural glen. The water was pure and fresh from the top of a wild mountain. It ran heavily, too, with a flow that made its absorption into the streambed 150 feet downstream even more remarkable.

With a growing appreciation, I noticed the placement of rocks, large and small, in this glen. Below me, in the creekbed, was a huge boulder and upstream 20 feet, on the other side of the creek, was another. Both were of reddish mauve sandstone sprinkled with patches of emerald green moss. Upstream on my side of the creek, two rocks lay on top of one another at a rakish angle, one reddish, the other gray.

These rocks and others formed the stream's boundaries in exactly the natural way I wanted a rock wall to make a boundary between the lawn and the raised berm where my wife, Marilyn, and I intended to plant our garden. I wasn't trying to build a wall as much as find natural-looking ways in which rocks can define a boundary. The rocks in the creek did that job perfectly. Every problem of placement and arrangement I'd been wrestling with at home was solved with an easy grace and with added details of beauty only Nature could have imagined.

For example, the water pooled just between these rocks, and the canopy of forest trees overhead allowed one slanting sunbeam to sneak in. It hit the pool of water at a 45-degree angle and threw ripples of reflected light on the angled stones. It also sank into the stream, illuminating a small pool of water that flashed with color. Multicolored pebbles glowed in the sunbeam's spotlight—a pool of jewels. Their red, yellow, blue, and green colors were crisscrossed by glowing lines of undulating white light as the ripples gathered and concentrated the sunlight.

From My Nature Notebook:

When siting a pool of water below the berm, make sure a sunbeam can get through. Use stones with interesting colors under the water to make a pool of jewels.

I also noticed that as the creek had worn away the soil from the sides of the gully, it had

exposed the roots of forest trees. These roots formed sinuous lines like railings along the descending creek, easing the sharp angles of the rocks.

> ## From My Nature Notebook:
>
> When digging out the berm to create different levels in the garden, don't chop out tree roots. Just expose their lengths as they emerge and then reenter the soil. Work them into the garden design. Maybe over time, Nature will provide them with interesting patinas and moss.

All along the stream, the water was singing. The loudest water song came from behind the next group of large rocks upstream, and I climbed up to reach it. A dead grapevine hung lifeless from a tree overhead, and where it had once touched the water, the vine was strangely flattened out and formed swirling arabesques in the grain of its wood. The arabesques turned around a focal point, which, appropriately for Valentine's Day, was the shape of a heart.

GROTTO

Climbing became harder now as the hillside got steeper, and I reached a relatively flat place in the creekbed to rest. Across from me was a huge white rock with a cavern about a foot high that ran back into it. The water line curved back into the cavern—and I realized that I was looking at a grotto. If there are water sprites and grotto spirits, they surely dwell in that

place. The mouth of the grotto faced across the stream to a large, water-licked rock worn smooth by millennia of winter torrents.

> ## From My Nature Notebook:
>
> Edge the pool below the berm with rocks that form holes and hollows to produce little grottoes for ferns, mosses, and cresses, as well as for featured shade-loving wildflowers such as twinflower (*Linnaea borealis*), gentians (*Gentiana* spp.), or tall wands of black cohosh (*Cimicifuga racemosa*). Plant Kenilworth ivy (*Cymbalaria muralis*) on the bank above the grotto stones to trail down into the water.

Everything upstream from the grotto was so steep that passage was blocked by rocks and roots. Now the climbing got serious, and I had to scale an almost vertical bank. By the time I reached the road above, I could hear my heart pounding in my ears.

Glade, glen, and grotto: three related ideas to use in the natural garden. In a few hours' walk in wild nature, I had discovered three valuable garden concepts and a number of ideas for recreating them at home.

THE CAMPSITE GARDEN

Just as I drew inspiration for my natural garden from my hike through Sugarloaf State Park, other gardeners have been enriching their yards with memories of their favorite natural places.

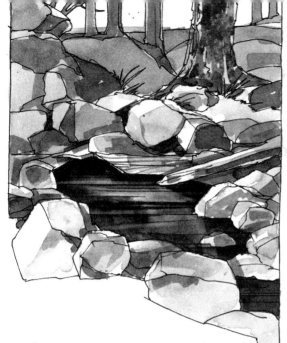

I discovered this beautiful wild grotto on a nature hike. It inspired me to create a landscaped grotto in my own yard.

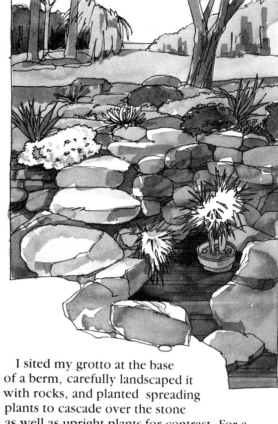

I sited my grotto at the base of a berm, carefully landscaped it with rocks, and planted spreading plants to cascade over the stone as well as upright plants for contrast. For a finishing touch, I placed a potted umbrella palm (*Cyperus alternifolius*), a water-loving bog plant, in the little pool.

I first heard about Rob Thayer's campsite garden at a conference where Thayer—chairman of the Department of Environmental Design at the University of California, Davis—described a month-long, 250-mile canoe trip down the Big Salmon and Yukon rivers in Alaska.

The trip deeply affected him. He and his wife, Lacey, paddled among spawning salmon, saw bald eagles, and caught Arctic grayling on the first few casts. They saw moose, howled with wolves, startled bears, found old log cabins, watched Dall mountain sheep play, observed Indians fishing, picked giant blueberries, and caught and roasted fresh salmon.

Thayer brought his wilderness inspiration back to Davis with him. From the very start, he tried to capture some of the spiritual intensity he'd found on the trip and during other camping and wilderness experiences. Davis topog-

raphy, flora, and climate are far removed from those of the Alaskan wetlands, so he made no attempt to replicate the Yukon landscape or use native Alaskan plants. His yard is on one small lot among many that make up the neat, quiet properties of Village Homes in Davis. No site would seem more tame. Yet Thayer wanted the garden to make him feel like he felt during those high moments on the Big Salmon River.

He came up with the idea of a campsite: a fire pit and surrounding seating made of rock and wood. He designed a small, rounded, sunken patio paved with Mexican brick and bordered by a curving wooden bench. The paving and semicircular bench face a round hole filled

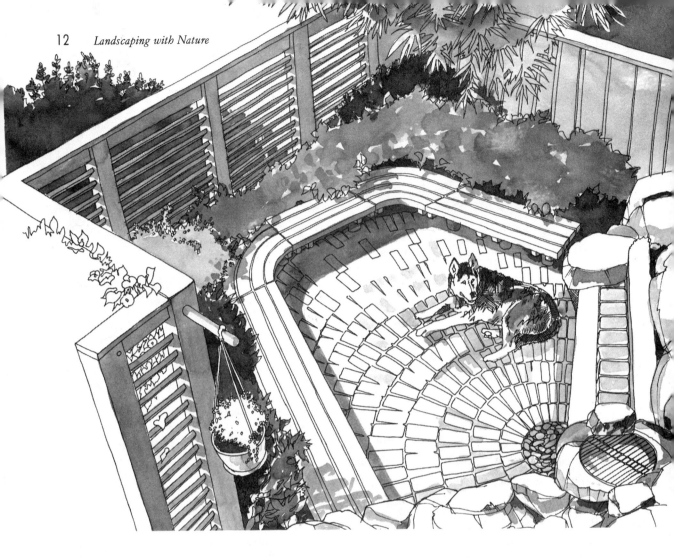

Rob Thayer recreated the feeling of a wilderness campsite in his small suburban California yard. Benches and a patio direct the eye to the central "campfire." The area is landscaped with rocks and drought-tolerant plants.

with stones. Above this, framed by large rocks, is a fireplace, which takes a grill for barbecuing or can be used without the grill like a campfire. Behind the semicircular bench is a fringe of shrubbery from which a tree emerges and arches overhead, giving shade.

For Thayer, the campsite echoes the kivas of the cliff dwellers, the primitive stone circles (like Stonehenge) of the Britannic druid socie-

ties, the sunken lodges of the California Indians, and his own experiences camping in the western wildernesses.

Reserving a place for fire in his garden was crucial. "It's when I'm staring into a fire that I feel most connected to nature," he says. "Objectively, my behavior might not appear far removed from that of any apron-wrapped suburbanite tending the Weber. For me, however,

it is a far more serious and essential ritual. Just below the fireplace is a small hole 6 feet deep into the earth—a reference to the *sipapu,* or entrance to the spirit world among the ancient Anasazi cliff dwellers and later pueblo societies. The hole is filled with smooth black rocks and also serves as a dry well, returning runoff water back into the ground."

The campsite garden was constructed with practical principles in mind, too. Drought-tolerant, low-maintenance, native plants such as verbena, ceanothus, manzanita, mahonia, and rosemary were used behind the semicircular seating. A tree was essential for the garden, but this tree had to be drought-tolerant and low growing, so it wouldn't block the solar greenhouse, yet spread wide enough to provide shade for the campsite. Thayer chose a South African sumac and keeps it pruned low and wide. On the surface, it's a typical suburban California garden, but for Thayer, it's loaded with essential meanings.

Rob Thayer's campsite garden is a natural landscape that brings the mystery and beauty of wild nature back home. And he did it without resorting to gimcrackery. It's simple. The paving is ordinary brick. The seating is conventional, as are the plants that surround the campsite. At night, when firelight flickers on the shrubs and sparks fly up toward the sky, and the big round window in the second story of the house is glowing like an Alaskan full moon, it is possible to feel the ancient connection in that place. Thayer has created a metaphor for the wilderness in his backyard. The same exciting and pleasant task awaits us.

CREATING HABITAT

A walk in any wild place shows us varied habitats: Here is a pool of dry shade where the deer lie and the pipsissewa blooms; there is a dark, wet place where the mosses and ferns and turtles live; over there is a sunny knoll covered with annual grasses and scrub oak; and there is a forest of maples and pines where the wild turkey nests.

When you landscape with nature, you recreate something of the habitats that inspire you, though on a small scale. A brown thrasher needs only one small bush to hide in. You can invite nature to return with even a modest planting.

As the natural landscape takes shape, the mysterious processes of nature will begin to change and augment your work in the garden: cycles of the seasons, the movement of water, growth and decay, and the weathering of surfaces. Elemental forces are at work in the world, applied equally to wilderness and to suburban lot. The natural landscape gives these forces an arena to operate in, and wonders result. For the first time, a hummingbird visits the garden; a toad appears on the path and a frog chirps in the water; a gopher snake sets up residence (maybe those pesky rodents won't annihilate the vegetables this year); spectacular spiders hang webs in the shrubbery.

We built a small pool of water beneath our berm, and within three months, there was a water strider on its surface! There are no bodies of water near our house. How did it get to our little pond? I have no answer except to say that when we provide the habitat, nature

(continued on page 17)

NATURAL LANDSCAPING
FOR A BACKYARD FIRE PIT

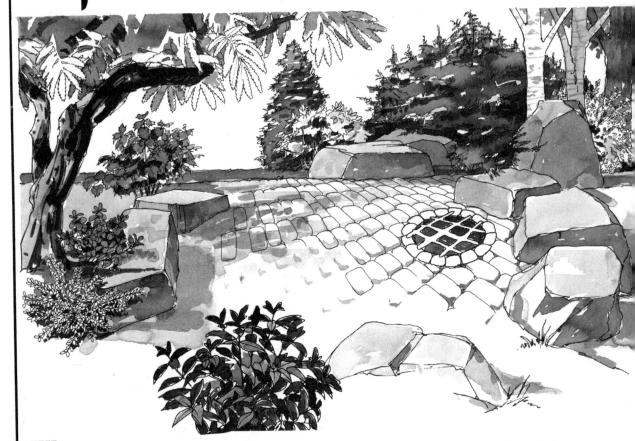

When you design a natural fire pit, you want it to look like an open clearing, a natural, circular campsite. Look at your yard and pretend for a moment that it is still pristine wilderness with fallen logs and dense shrubbery. Where in this wilderness would you find a good campsite? Good sites are usually somewhat protected, perhaps in a slight depression sheltered by plants, and certainly near water if you have it on your property.

Place large rocks directly behind your fire pit, on the side of the pit opposite prevailing winds. The rocks will reflect heat and prevent sparks from blowing into the surrounding shrubbery. It's important that stones placed behind the pit and for sitting on are large enough to look like permanent landscape features. This is no place for dinky little rocks. The space above the pit should be open and clear so that smoke can rise without interruption from tree limbs and leaves.

Site the pit itself inside a large circle of cobblestone set in mortar. Fit the pit with bottom drainage and a screen that allows light ashes—but not coals and chunks of wood—to pass through.

Flush the drainage pipe from time to time with a hose. Set a large stone on the edge of the cobblestoned area opposite the pit for sitting or leaning against. Make sure that the cobblestoned area either slopes away from the fire pit or the pit has a slight lip to prevent rainwater from draining into it from the surrounding paving.

Landscape the fire pit site with trees, shrubs, and herbaceous plants that are hardy, not particularly showy, and provide good masses of foliage to balance all the rock. Using plants with these traits will ensure that the area looks like a natural clearing in the woods. Use native plants, or select plants that suggest a particular place, such as a mountain scene or a riverbank.

Keep the area simple. If you follow these landscape suggestions, it will be perfect for several people to enjoy. If you have a larger gathering, you can always bring out chairs and tables, but for most occasions, it should look naturally inviting.

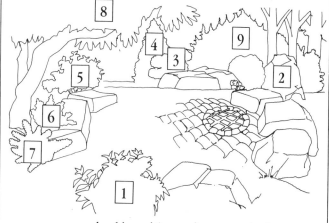

Best Plants for Your Fire Pit

1. Koreanspice viburnum (*Viburnum carlesii*)
2. Barberries (*Berberis* spp.)
3. Highbush blueberry (*Vaccinium corymbosum*) or privets (*Ligustrum* spp.)
4. Clumping bamboo (*Sinarundinaria nitida*) or lawson cypress (*Chamaecyparis lawsoniana*)
5. Rugosa or Japanese rose (*Rosa rugosa*) or European cranberrybush viburnum (*Viburnum opulus*)
6. Winter creeper (*Euonymus fortunei*) or shrubby cultivars of common juniper (*Juniperus communis*)
7. Hedge-type cotoneasters (*Cotoneaster* spp., especially *C. divaricatus*, spreading cotoneaster, or *C. multiflorus*, many-flowered cotoneaster)
8. Mimosa (*Albizia julibrissin*) or flowering cherries (*Prunus* spp., especially *P. serrulata* 'Kwanzan', 'Kwanzan' flowering cherry, *P. subhirtella* 'Pendula', weeping Higan cherry, or *P. yedoensis*, Yoshino cherry) or strawberry tree (*Arbutus unedo*)
9. Eastern hemlock (*Tsuga canadensis*)

Background Screens for Dancing Lights

If you're like us, you'll find that you enjoy your fire pit most at night. When it's dark, the fire will send light upward and outward from the pit. In a position behind the rocks flanking the pit, far enough away so there's no danger of scorching from large fires, plant a dense hedge or screen of foliage that can catch this flickering light and reflect it back to the people watching the fire. This screen of foliage will act like a movie screen, and the patterns of light dancing on the hedge will be another attraction of the fire pit area.

Shrubs with small, dense leaves like privets are excellent, as are evergreen hedging plants like eastern hemlock kept pruned back to hedge size with a yearly shearing. Shear the hemlock into an irregular rounded shape to preserve the natural appearance of the site. Bamboos, barberries, and even fruiting shrubs like blueberries are good choices for screening the fire pit.

If the fire pit is near a fence, you can make the fence a part of your fire pit scene by using it as a second screen to catch the flickering firelight. You may want to cover it with climbing vines to conceal its man-made origins and help it blend in with the natural look of the site. Woodbine (*Lonicera periclymenum*), a fragrant honeysuckle with yellowish white flowers that are often tinged with red, is a good choice for this purpose, as are clematis, wisteria, and the hardy winter jasmine (*Jasminum nudiflorum*).

Digging and Draining the Fire Pit

1. Install 4-inch drainage pipe.
2. Install 1/2-inch hardware cloth screen.
3. Excavate rest of pit and backfill.
4. Line pit with fire brick.
5. Install standard fireplace or barbecue grate.

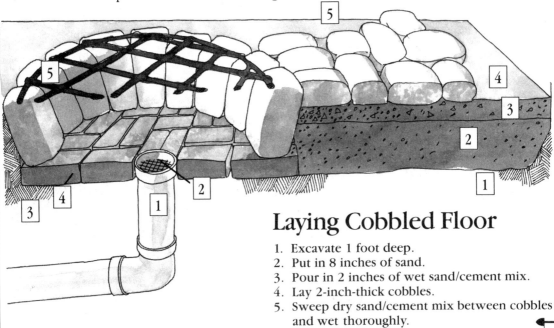

Laying Cobbled Floor

1. Excavate 1 foot deep.
2. Put in 8 inches of sand.
3. Pour in 2 inches of wet sand/cement mix.
4. Lay 2-inch-thick cobbles.
5. Sweep dry sand/cement mix between cobbles and wet thoroughly.

somehow provides the creatures to take advantage of it. These are signs of burgeoning life, of a regenerative building of life upon life in a widening spiral.

A central part of providing habitat is protecting it. Carefully constructing a tiny woodland habitat, then indiscriminately dousing it with chemical pesticides and herbicides defeats the new garden's chances before you see the first wake-robin open, much less before a box turtle, with its delightful geometric orange-and-black shell, could pay a visit. Even the invisible life of the soil needs protection—concentrated fertilizers could kill it, creating a sterile, chemical-dependent environment for the plants that grow there.

A natural garden is not a wilderness untouched by man. The gardener who created it is responsible for soil building, weeding, pest control (if it's needed), and maintenance, just as he or she would be in a conventional garden. But when you landscape with nature, you have the added responsibility of taking care of your garden in a way that benefits the habitat you've made. The natural way to meet that responsibility is to garden organically.

BONUSES IN THE ORGANIC GARDEN

Consider what happens when we incorporate compost made from the leavings of previous generations of plants into the soil. Our intent is to make the soil more crumbly—easier to work —and to improve its fertility. Compost will do that. But it has these further benefits as well: The dead leaves, stalks, and other organic wastes are food for the beneficial microscopic crea-

tures in the soil. Given dead plant matter and manure, they bloom in the soil, reproducing wildly until there are trillions of them in each handful of soil—several tons in the top few inches of soil of each composted acre. They live and die fast, and when they die, the microorganisms decompose in turn and release nutrients in the perfect form for use by plants, promoting optimal, but thrifty, growth.

Nature designed the system to operate in this cyclical way: Plants drop leaves to the soil, where microorganisms dismantle them, then die and feed the plants. When we add compost to the soil, we are not working at cross-purposes with nature, but simply augmenting and speeding up the process.

As a result, the plants benefit. They live up to their potential. Healthy ornamental plants flower abundantly. Healthy food plants provide optimal levels of nutrients for the human beings who eat them. We humans benefit. We then gather up the leavings and make more compost. Then the earth benefits because compost in the soil prevents soil erosion, aids water percolation, holds water, and promotes larger-scale soil life such as insects, earthworms, and moles. Earthworms greatly increase the soil's fertility, which again benefits the plants. The insects fight their own ecological tugs-of-war among the crops, and if all is in balance and the garden kept for the benefit of all, the insects will usually keep themselves in balance, too. Gardening organically benefits all of nature. And that benefits us.

Through the falling of leaves and other plant detritus, Nature creates a mulch on the floor of her wild gardens. And so mulches of

shredded leaves make a perfectly natural-looking dark brown base for plants and stones. Mulches will help keep down weeds and hold water in the soil and will add fertility to the soil as they decay. You'll find that the dark contrasting color of a shredded leaf mulch will make your plants much more attractive than light, dun-colored bare soil. By following Nature's own practices, like mulching, we can make our gardens more beautiful as well as more fertile.

Creating beautiful gardens involves us as well as nature. We are free to exercise our artistic impulses all we like in a natural garden as long as our decisions are based on care for the Earth and its creatures and a respectful use of its energies and resources. What this really means is that we need to be the kind of people who carry a love for the Earth in our hearts, which then influences our every thought and action. That's really what organic gardening is all about.

This alignment with natural forces creates enormous bonuses for us gardeners. We come to anticipate the unexpected. The whole of spring arrives with the opening of the first flower.

LANDSCAPE PREFERENCES

As we create habitats in our natural gardens for our fellow creatures, we shouldn't overlook our own preferred habitat. Scientists have found

KEYS TO NATURALLY FERTILE SOIL

It takes three years for soil to thoroughly digest additions of actively decaying plant matter, but the benefits start coming right away. For plantings of trees, shrubs, and flowers (both perennials and annuals), first turn up the soil to a shovel's depth and remove any roots of weeds and scrub plants. Do this when the soil is moist, but not drenched as it is right after a rain. Break up any chunks or blocks of soil. With the soil turned up, spread compost or manure about 6 inches thick on the soil surface, then spade it into the soil to a shovel's depth. You can use fresh manure, but only if you allow the soil to mellow for eight weeks after you add it, keeping it moist at all times, before planting anything. Well-rotted or composted manure can be added anytime before planting—it won't burn plants' roots like fresh manure.

Add manure the first year to get fertility up, but you may never need to add it again to an ornamental planting, because you won't need all the powerful nutrients that manure contains. Yearly additions of finished compost will usually be enough for flowering and shade plants. Even if a soil test shows you need them, there's no reason to add soil amendments such as limestone, wood ashes, or bonemeal to the entire soil surface. Incorporate these into the planting holes when you plant out your stock. Know the soil preferences of your plants—bog plants will like the acid soil conditions typically found in a bog; ornamental grasses will like a sweet soil amended with limestone. Most other plants like a neutral to slightly acid soil—the kind you'll get naturally by adding compost and manure.

that human beings prefer certain kinds of landscape over others, and that these preferences are hard-wired into our biological circuitry—an artifact of our species' development on the savannas and grasslands of East Africa. The most pleasing gardens result when we understand and use these preferred landscape forms.

PREFERENCE FOR GRASS AND WATER
Ecologist John H. Falk of the Smithsonian Institution worked with people from all over the world who were born and reared in varying environments, showing them pictures of landscapes and asking them which ones they liked best. As reported by Tony Hiss in the *New Yorker* magazine, "Falk found a deep, innate preference for a grass landscape, even among people who'd never been in a grass landscape in their lives. . . . It's Falk's conclusion that people may have a genetically transmitted predisposition for the surroundings of the species' birth and early development."

LANDSCAPE ROOTS: OR WHY WE LIKE LAWNS

Stephen and Rachel Kaplan, research psychologists at the University of Michigan, relate landscape preferences to the human species' development on the grassy plains of Africa. In their book *Human Scape,* the Kaplans explain the lawn phenomenon this way: They claim that open spaces provide landscapes with "legibility." They say, "Just as one can imagine oneself somewhere in a scene acquiring new information, one can imagine oneself in a scene getting lost. Legibility . . . is characteristic of an environment that looks as if one could explore extensively without getting lost. Environments high in legibility are those that look as if they would be easy to make sense of as one wandered farther and farther into them . . . enough openness to see where one is going, as well as distinctive elements to serve as landmarks."

However, the Kaplans also make the case for our preference for winding paths that seem to beckon us toward the unknown. Landscapes with such paths and mysterious places waiting to be discovered "give the impression that one could acquire new information if one were to travel deeper into the scene."

The Kaplans tie mystery to the origin of mankind, when humans walked over thousands of square miles in search of food, water, and shelter and acquired the ability to snoop around and sum up a new area's usefulness. Our ancestors knew when to search farther and when to turn back. Their curiosity was aroused by winding paths that promised to reveal the mystery beyond: perhaps a glade or a glen with fresh water, a startled deer, a tree dripping with ripe fruit.

Thus, the most satisfying landscapes, from our human viewpoint, provide both open spaces and a few surprises—both legibility *and* mystery. In addition, the Kaplans believe that lack of human beings' preferred surroundings leads to stress, aggression, and antisocial behaviors. Thus inner-city violence may be a result of the "concrete jungle" as much as of poverty and drugs, and our crankiness after another long day at the office may be genetically programmed outrage at confinement in an artificial environment.

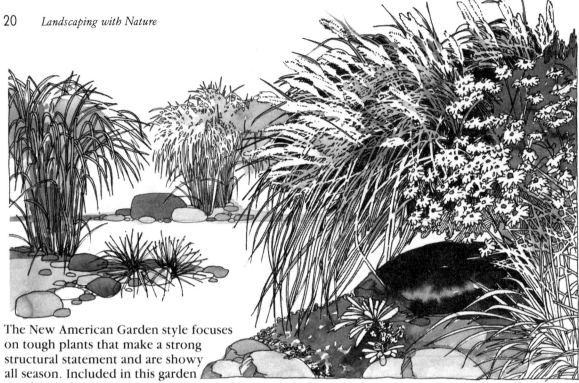

The New American Garden style focuses on tough plants that make a strong structural statement and are showy all season. Included in this garden are fountain grass (*Pennisetum alopecuroides*), blue fescue (*Festuca caesia*), giant miscanthus (*Miscanthus floridulus*), 'Goldsturm' black-eyed Susan (*Rudbeckia fulgida* var. *sullivantii* 'Goldsturm'), and 'Ruby Glow' sedum (*Sedum* × 'Ruby Glow').

PROSPECT AND REFUGE

One of the first researchers into landscape responses and preferences in humans was Jay Appleton of the University of Hull in England. Appleton found that people have an innate preference for what he calls prospect, a vista from which we can take a long view of the big picture, and refuge, a hiding place, or somewhere we can see without being seen. As children, we all felt the awesome thrill of taking in a grand view and the delicious secret thrill of spying on the world from our secret hiding place. These concepts can be scaled down to small spaces if they are carefully designed. The preference for a view across a sweep of open space may be another reason for the way grass is used around American homes.

We evidently carry a preference for those habitats that support human life: We need a view of the surrounding countryside, of course, to make sure no one is sneaking up on us and to see what's happening with the environment. We do need water to live and so we can't stray too far from it, giving us our preference for water in the landscape. We like grassy places where we can see for long distances. But we also like some woodlands, or caves and rocky hollows, where we can take shelter and hide and where we can climb to see out. We share the landscape preferences of ancient, hunting-gathering humankind, and garden designs that incorporate those preferences in some way will be perceived with a feeling of well-being that says we are at home.

Perhaps this innate preference explains the phenomenon of lawns—about 30 million acres of them in the United States now, requiring billions of dollars in equipment and chemicals and upkeep. And yet these yards could be planted with beautiful trees, shrubs, and groundcovers at far less eventual expense and labor. If a drive down any suburban street is an indication, we do indeed seem to have a thing for grass.

LEAVING THE LAWN BEHIND

The landscape architecture firm of Oehme, Van Sweden, and Associates in Washington, D.C., has been creating grass-dominated landscapes, but not by using lawn grasses. Instead, they are using ornamental grass in creatively different ways—large, variegated, and plumed grasses in drifts. A recent permanent installation at the National Arboretum in Washington features what Oehme and Van Sweden call the New American Garden. It brings ornamental grasses and native plants right up to the living areas that surround a house there. The idea is to recall the sweep of the prairie and the heave of the earth at the Rockies.

Public response to the firm's designs has been enthusiastic. In tight spaces, small ornamental grasses like blue fescue (*Festuca caesia,* sold as *F. glauca*) and golden variegated hakonechloa (*Hakonechloa macra* 'Aureola') add an easy-to-care-for look of excitement; in larger spaces, grasses such as giant miscanthus, also called giant Japanese silver grass (*Miscanthus sinensis* 'Giganteus'), which reaches 15 feet, can become an exotic focal point with all-season interest.

Tall grasses act as screens and gently interrupt extended views, creating outdoor rooms and planting areas. The shorter grasses, from chest-high down, can be used as soft green accents for broad-leaved shrubs and perennials. Grasses can even be used as specimen plants—Japanese sedge grass (*Carex morrowii* var. *expallida*) is good looking enough to take a featured spot in a small garden.

Grasses and their close relatives, the sedges, are often found in nature where there is flowing water. The presence of water can be suggested by a long, sinuous patch of ornamental grasses—even where there is no water at all. This can be important in putting together a really satisfying natural landscape, because water is the most highly preferred element in the landscape, according to Dr. Falk. "We've learned to avoid having water in any of the pictures we show subjects [to determine their landscape preferences]. It's so highly preferred that its very presence will raise preference by an order of magnitude."

THE LESSON OF THE UNICORN

As we try to design a natural garden that makes us and our wild friends feel at home, we often overlook an important point. I call it The Lesson of the Unicorn. Once, when I was living in New York City, I took the subway far uptown, north of the George Washington Bridge, to Fort Tryon Park and The Cloisters—a museum of medieval architecture, paintings, gardens, sculpture, and tapestries. A central room in The Cloisters is hung with a series of six exquisite tapestries woven in France in the late fifteenth century.

These tapestries tell the ancient story of the seeker after beauty who used a maiden to lure a unicorn, and then tried to catch the fabulous animal. But the unicorn was a wild creature and refused to be subdued and fought until it died in the bonds and snares of its captor. Its beauty died with it and the would-be captor was left with a horrid, bloody corpse. The moral, of course, is that our attempts to possess beautiful things often result in their ruin. It's an important moral to keep in mind when scouting through wild and natural areas for garden ideas.

WHAT THE UNICORN TEACHES US

For the most part, we want to bring ideas, not physical things, back to our gardens. The orchid that blooms in the woods will die if brought to our gardens, because it depends on microscopic root fungi, found only in the soil of its native woodland, for sustenance. If too many people dig these beautiful plants, thinking to enrich their own gardens, there will be no more orchids in the woods and none in "captivity," either. A particularly nice bit of stone in a creekbed should be left in place no matter how strong the temptation to bring the stones home for paving or to use in one's own "dry creekbed."

"Wild" means undisturbed by humans, and if we use our excursions there to dig and transport, then we are roping the unicorn. Even if our plants root, they surely won't give the same natural feeling they did in their wild setting. The stone that glimmers with such mysterious messages in the wild glen turns dull and silent beside the path in the garden. Our purpose is much higher than merely hauling beautiful wild things willy-nilly to our home gardens. We are really out to recreate the spirit of a place. If we notice an attractive detail in nature, we need to plumb the reasons why it's attractive. A jewel looks most brilliant in a good setting, and so does a feature of a natural landscape. It is the relationship of the elements in the scene that provides the setting that enhances each of the elements in turn.

SUBSTITUTING FOR WILD PLANTS

Wandering in the wild, for instance, one might be struck by the beauty of a wild blueberry shrub with its hanging white flowers and finely twisted stems. It seems most pleasing by itself, but then we notice that it grows over a large rock, and it is this rock that ties the upright, springy bush to the earth. We notice, too, that the blueberry is flanked by a shady, wet area overgrown with the large quilted leaves of skunk cabbage (*Symplocarpus foetidus*) setting off the blueberry's small leaves.

This same blueberry, planted without regard to its setting, would be the most ordinary plant in the world. If a gardener tried to recreate the scene, however, substituting hostas for skunk cabbage, finding a rock to associate with the blueberry, then success is at least possible. Perhaps the gardener will find that what she really responded to was the ghostly white blossoms of the blueberry against the dark boggy shade. It may be that the similar but more profuse flowers of Japanese pieris (*Pieris japon-*

ica, often sold as *Andromeda japonica*) would suit the spirit of the scene even better than a blueberry and fit in better with the shade requirements of the hostas (*Hosta* spp.). The pieris has other features, such as gorgeous reddish foliage in the spring and more attractive leaves, that make it a good choice. We must not be too literal about our wild inspirations—they give us sparks from which our imaginations can strike fire.

A LESSON NOT LEARNED

The story of the unicorn as told in the tapestries is all the more poignant given what our civilization has done to the land in North America in recent centuries. Our forebears had a near-infinite wilderness to deal with, and the industrial revolution gave them the tools to deal with it summarily and brutally. With tractors and power shovels, they obliterated millions of places that might have been saved in some way, if only in spirit.

Our ancestors looked at wilderness and saw future scenes of productive farmland. They didn't see past the farmland to the suburban malls and urban sprawls. And they didn't see the wilderness the way the Indians did, as the sum of all the sacred places they were connected with, where the drama of life is enhanced as it's played out.

The natural garden is a place for us to be connected to the spirit of Nature. It should not be merely a collection of artifacts from our travels in the wild. Let the unicorn remain free, but create a garden where he'd be at home.

LEARNING FROM MIXED LANDSCAPES

Although wild places are a great source of ideas for the natural garden, they aren't the only source. Some of my best ideas have come from observing mixed landscapes. In a mixed landscape, human intervention and wild nature are both evident: a country scene of fields and woods; a long-established park. There's evidence that the most pleasing landscapes are the ones where human intervention has been softened by time and worked by nature—improving on our improvements, so to speak.

If we can't get to the wilderness regularly, we can always get to mixed landscapes where people and Nature are working together. Sometimes they work in harmony, as when a property owner manages his woods for peak biological diversity rather than peak income per acre. Sometimes they may work at cross-purposes, as when farmers regularly uncover the raw earth for planting, and Nature just as regularly tries to cover it again with her green weeds.

Mixed landscapes have great potential as a source of garden ideas. I found many on a drive along Westside Road, which parallels northern California's Russian River from Guerneville to Healdsburg. The valley floor is a mixture of vineyards, wild patches of cottonwoods along the river, orchards, and the digs of sand and gravel companies. The hills hold more vineyards and orchards, but also have grasslands where horses, cattle, and sheep graze and large swaths of the natural oak and redwood mixed forest remain on the tops and steep parts of the hills. I drove the route on a bright spring morning,

taking my notebook, jotting down a few things that I liked, all of them from mixed landscapes.

COLORS OF SPRING

Someone had planted an orchard of small cherry trees on a ¼-acre piece of land between two properties overgrown with shrubs and trees. The overgrowth funneled the sunlight to the orchard, and the blossoms hung in the air like a hot pink cloud. Annual turning of the orchard soil favored wild mustards, whose blossoms cast a bright yellow haze over the soil below. The effect was two hazy horizontal bands of brightest pink and yellow—the pink contributed by the person who planted the orchard, the coordinated yellow provided by nature's response to tillage.

Pink tulips above a planting of basket-of-gold (*Aurinia saxatilis,* often sold as *Alyssum saxatile*) would give the same effect in miniature. Or if you had space, you could reproduce it full size with a grove of 'Kwanzan' flowering cherry trees (*Prunus serrulata* 'Kwanzan') underplanted with the dwarf greenstem forsythia (*Forsythia viridissima*). A third color—the clear, pale blue flowers of 'Ray Hartman' ceanothus—would complete the Easter-egg appearance of this spring-blooming combination.

Farther up Westside Road, a large western redbud (*Cercis occidentalis*) was covered with blinding magenta flowers above a swath of electric deep blue created by four blooming 6-foot shrubs of 'Dark Star' ceanothus. The association had been planted by a gardener, but time and Nature brought the redbud into a perfectly harmonious composition with the smaller shrubs. She contributed shape and form to the gardener's bold color scheme.

A WILDERNESS SWIMMING HOLE

A mixed landscape can be functional as well as natural. Usually, we think of a swimming pool as a rectangle of turquoise-painted concrete slapped down helter-skelter in the backyard—an eyesore that can't be coordinated into the landscape because it looks so unnatural. But it doesn't *have* to look that way. The way John Woods of Sciota, Pennsylvania, handled his swimming pool still sets my personal standard of excellence in pool design, even after 30 years. One-half mile above John's property was a small dam that created a weedy lake full of sunfish, perch, and pickerel. I learned to fish there as a boy. The lake spilled over the dam and made a creek that wound down through the woods to John's property. It had originally cut a gulley about 8 feet deep into the soft soil there and joined a larger creek about 30 yards farther downstream. John excavated the narrow stream to form a generous pool shape, then laid down concrete reinforcing wire and covered it in concrete. This was faced with glacier-smoothed native rocks, large and small, carefully worked to look natural and provide comfort to the swimmers.

Where the stream entered the pool it fanned out widely, making a shallow place with a solid concrete bottom, great for small kids. The pool sloped to about 10 feet deep at the outfall end. John fit both corners with large smooth rocks protruding from the sides of the pool about 4 feet under the surface, allowing one or two

people to stand. Two vertical metal tracks held boards that dammed the stream.

After the winter rains had covered the bottom of the pool with mud, he'd slide out the boards and scrub down the bottom—the stream itself providing clean, flowing water—then put them back in. The pool filled in a few days.

He landscaped this pool with native plants, especially hemlocks and rhododendrons, the dominant plants in the surrounding forest. He screened the area from the house with mixed plantings of white pine and hickories. Along the stream, and along the backside of the pool, he used native woodland plants like Solomon's-seal (*Polygonatum biflorum*) and black cohosh (*Cimicifuga racemosa*).

The effect was completely natural. Visitors left the house and wandered across the road to a sunny field by the horse barn, where they found a path designed to pique their curiosity and lead them to the white pines. The pines and hickories formed a grove with the path leading through it to a grassy bank bordering what at first appeared to be a rocky stream. As guests walked up to the stream, the rocks descended into dark, deep water, which invited visitors to doff those hot clothes and slip into the pool. This visitor did—many times. It was like finding the perfect natural pool in an unspoiled setting, yet without the difficulties of getting to the wilderness.

John Woods respected the beauty of the natural setting—no turquoise paint for him—and Nature responded by lovingly enclosing the pool and its surroundings in a shady, mossy forest, bejeweled with woodland plants.

Not everyone has enough land or money to construct a swimming pool, but most of us can scale down the idea to an ornamental pool the size of a spring source. Site it in your shadiest spot, coming out from under a tree root or a rock. If you've ever noticed the way real springs arise, they generally have sandy bottoms, rocks, roots, mosses, and ferns around them.

Dig out a shallow watercourse. Line this shallow trench with soft earth (fine clay is especially good) so that rocks and sticks don't poke into and puncture the water-retaining plastic liner that goes down next. Make sure you use extra thick, pool liner-grade black plastic, available from landscape supply houses and swimming pool supply stores. Use cement, sand, and rocks to cover the bottom of the plastic for a natural look. The water flows into a shallow pool where a small recirculating pump returns it underground to the source. Take a cue from John Woods and screen this place from the house so that visitors discover it themselves by following the intriguing paths you've created.

COLOR COORDINATION

Modest effects in mixed landscapes can be spectacularly effective, especially when they reveal the quality of thought that went into them. Not far from New Hope in Bucks County, Pennsylvania, is a stately house nestled in the trees on a wooded knoll. Just in front of the house is a large, rough-surfaced rock, pitted with holes, whose colors alternate between patches of tan and reddish brown. The rock is a feature in the lawn, about 10 feet wide and irregularly shaped to about 7 feet tall.

The gardener, in a brilliant stroke of understatement, selected about a hundred 'Apricot Beauty' tulips and placed them in a natural-looking drift in front of the rock. The effect occurs only during May when the tulips are blooming. The composition is one of quiet repose. But the colors are so subtly and delightfully matched that one recognizes the gardener's intent right away. The rock was nature's contribution; the tulips were the gardener's. Together, they make an idea worth swiping for ourselves.

IMPATIENS ON THE ROCKS

Pretty mixed landscapes may be found anywhere, and they can always give us ideas for taking home. Once on the wild north shore of Maui, Hawaii, I came to a steep canyon where water poured down over huge, gray, squarish chunks of rock covered with patterns of gray, black, and white lichens. A large, smooth-barked tree grew from between two chunks, its bark dappled with black-and-gray patches, a variation of the patina on the stones. The tree's canopy threw a dense shade upward and inward into the tangled jungle. From deep in the shadows, a river of impatiens (*Impatiens wallerana*) in pinks and whites flowed down with the water, filling in the crevices and niches between the stones with color, and finally tumbling over the edge of the precipice to hang in the air above the valley floor far below.

This was a remarkable scene and would be possible to translate to a garden at home, at least during the warm months. I'd first select stones and trees with matching colors: perhaps white-and-black birches with gray granite chunks. The gardener will choose depending on the colors of the stones available and the plants that are climatically suited to his or her area. Because of the intense flower color, it's wise to keep the stones and bark colors muted, especially to whites, blacks, and grays. Impatiens are easy to start from seed or stem cuttings and are also widely available as bedding plants. They look wonderful softening the edges of rocks in the shade beneath a stand of trees, flowing like a river of color.

WILD WALLFLOWERS

Just as exotic, although closer to home, was my trek to Chimney Rock Vista, on the headlands at Point Reyes National Seashore on the coast of northern Marin and southern Sonoma counties here in California.

It was April—wildflower time—and I found my way to a bluff overlooking the Pacific Ocean, where the green grasses sparkled with color. Two major color themes were stated by the bright yellow coastal buttercup (*Ranunculus acris*) and the red-violet wild musk mallow (*Malva moschata*). These were accented with the liquid sapphire blue of wild Douglas irises (*Iris douglasiana*) glinting in the morning sun. Here and there the final color accents were given by rising mounds of salmon and red-orange Indian paintbrushes (*Castilleja* spp.). Small mounds of pale yellow wallflowers (*Erysimum menziesii*) perfumed the air of this wind-swept coast with the smell of orange blossoms. Far out to sea, a group of eight gray whales rolled and tumbled in the swells, blowing spouts

of mist skyward as they moved north. From Drakes Bay miles away on my left all the way around to the headlands facing the ocean on my right, not a single boat was in sight.

There was no single scene or detail to bring home. But I saw again how artistic Nature is in her use of color. She does the underpainting in subtle greens (grasses and leaves), then brings out major areas with soft pastel or muted colors (musk mallow and buttercups), accents these with a stronger, related color (irises), and finally gives a small accent with the complementary color (Indian paintbrushes). This knowledge of natural color schemes is invaluable when designing with colorful plants.

We've been looking at how both wilderness (untouched wild areas) and mixed landscapes (where wild nature and human beings have had a relatively equal impact) are a source of inspiration for the garden. In chapter 2, we'll find out how to turn those inspirations into landscape reality in our backyards.

CHAPTER
TWO

FEATURES OF THE LANDSCAPE

COLOR IN NATURE

Color—even if it's only green or brown—is more important in the landscape than you might guess. As we walk through our gardens, we think we see a thousand things: leaves, twigs, petals, grass blades, birds. But, surprising as it is, all we *really* see are colors—and the grays that stretch between black and white. All the rest is interpretation.

Our senses of distance, mass, and form are all given by color cues. The softer and mistier the color of a mountain, the farther away from us it seems. The shadows that give roundness and mass to large objects are variations on the color of the objects. Although we tend to outline the shape of objects when we draw them, there are few true outlines in nature, only boundaries between one color and another.

Color, then, is our visual perception of the objective world. Color tells us the meanings of things. As you can see, color plays a major role in the natural landscape. To create the most satisfying gardens, we have to know how to work with color, to get it to do what we want. As we'll see in the following pages, we can use color to add levels of meaning to our landscapes, and we can also use it to recreate our favorite wilderness scenes—even if our favorite is the Grand Canyon at sunset and we live in New Jersey—by cleverly layering colors to evoke the scene.

SEEING COLOR IN THE LANDSCAPE

Most of the colors we see in nature are the colors of camouflage—black, white, gray, brown, ocher, and green. If we mix these earthy colors using paints on a palette, we find that all of them are produced from mixtures of the three

primary colors (red, yellow, and blue) plus black and white.

When we look across hills and valleys and see a wide expanse of uniform green covering a distant hill, we are seeing a summation of all the colors in that scene. That uniform green becomes, as we come closer to the hill, many different greens and grays and browns, varying from tree to tree and from base to peak. When we come still closer, we see that each tree is really a busy tapestry of many shades of green leaves, plus bursts of other colors of flowers, fruit, or seedpods, and dying leaves. Upon very close inspection, down in the leaves we find a small world of many colors in the insects, spider webs, dew, leaves, bark, red twigs, yellow and white lichens, and all the rest. The closer we get to the scene, the more fragmented and primary the color becomes.

As you study color in nature, note whether the colors occur as light areas in a dark background or vice versa. When recreating the effect at home, try to follow the same light-dark patterns. Group dark-colored plants together into drifts and dark "pools," and light colors together into bright areas. You might intersperse dark areas of lilyturf (*Liriope muscari*) and pachysandra (*Pachysandra terminalis*) with the light leaves of spotted dead nettle (*Lamium maculatum* 'Beacon Silver' or 'White Nancy') or a variegated ivy (like *Hedera helix* 'Hahn's Self-Branching').

MEANING IN COLOR

What do the natural colors mean? Pure colors can send and reinforce warnings—as in the case of bright yellow-and-black caterpillars. One bite is enough to make a bird stay away from yellow-and-black caterpillars for the rest of its days. This protective coloration benefits *all* yellow-and-black caterpillars, including species that survive by mimicking the bad-tasting caterpillars, even though birds would normally find them quite tasty.

Perhaps some of Nature's decorative touches are a form of play, but most often, nature's colors have a purpose. The white-tailed deer, for example, is a camouflaged brown color when peacefully nibbling at the tips of an apple tree, but when alarmed, its tail rises to reveal a patch of pure, very visible, white.

On plants that are bee-pollinated, flower petals are vividly marked with colorful "guides" to help bees find their way to the nectar and pollen source. These markings are even more visible to bees in ultraviolet light than in the light visible to humans. Plants that are moth-pollinated often bear the same intricate markings as their pollinators, to trick lovesick moths into alighting. Many of the interesting shapes and colorful markings of orchids evolved this way. And plants that are fly-pollinated, like the stapelias, often have flowers that are the color of carrion.

Nature often uses color in pursuit of procreation: the baboon's florid behind; the colors of flowers; the peacock's brilliant fan; but also the red apple and the yellow banana. "Here I am. Come and get me!" they all seem to say.

In using color in our natural gardens, we should also strive to give it meaning where possible. This is a personal matter, really. There can be no hard-and-fast rules for expressing

meaning with color, as there are for expressing harmonies and dissonances. It's not desirable to invest every color combination with some secret meaning, but expressing an idea with the overall planting organizes our thinking and lends subtle structure to the landscape. The ideas are seeds that blossom into full-scale designs.

An idea that gives meaning to the garden's colorations doesn't have to be elaborate. A garden made entirely of white flowers was designed by Vita Sackville-West to showcase the subtlety of these then-neglected flowers at the end of the Victorian era. Her purpose was simple—give the whites new importance by featuring them at her home, Sissinghurst. People are still talking about that garden.

In landscaping with nature, we look at nature's color combinations and try to find associations in them that are meaningful to us. We can sometimes also determine Nature's meanings, and if we do, we should coordinate our personal meanings with them. Take the case of gray-green foliage and golden flowers, a

COLOR ASSOCIATIONS

Try this: Pick two colors you like, but make them subtle ones, like muted, mossy jade green and the subdued pale gold of a Lady Banks rose. Make a list of associations sparked by these colors. For example, here are my lists.

MUTED JADE	PALE GOLD
mosses	eggnog
copper patina	French vanilla ice cream
old silk	pollen
seawater	butterflies
luna moths	shampoo
lichen-covered wood	ginger ale

I can see from my entries that the jade color has an old-fashioned, nostalgic quality for me, while the gold has a contemporary, even edible, quality. How can I use these associations in the garden? Jadelike, gray-green foliage is often associated with gold and russet in nature. A West Coast gardener might place a dwarf Asian pear with its russet and gold applelike fruit in a bower of gray-green Japanese pittosporum (*Pittosporum tobira*). An Eastern gardener might use a dwarf 'Golden Delicious' apple and underplant it with the feathery gray-green foliage of 'Lambrook Silver' wormwood (*Artemisia absinthium* 'Lambrook Silver') to create the same effect.

Or I could substitute other gold-fruited plants. For example, flowering quinces (*Chaenomeles speciosa*) with their beautiful flowers and aromatic rich gold fruit or yellow-fruited crabapples, such as 'Bob White', 'Gibbs Golden Gage', 'Ormiston Roy', and 'Winter Gold' (*Malus* spp.). This kind of planting adds a personal meaning to one of nature's favorite color combinations.

common combination in the Mediterranean region. We see this scheme repeated often in dry, sunny situations where drought-tolerant plants grow: in the downy, gray-green leaves and yellow flowers of yarrows like *Achillea* 'Maynard's Gold' and the silvery green leaves and yellow flower buttons of lavender cotton (*Santolina chamaecyparissus*).

We may want to relieve the gloom that hangs under mature trees by bordering them with gray-green foliage plants like sage and santolina, and cheery yellow-flowering annuals or perennials like heliopsis and coreopsis. A planting like this uses nature's color cues for a dry, sunny place to emphasize the contrast between the dark, moist grove and the light, dry flower border. It contrasts brightness with shade and relieves the darkness.

APPLE BLOSSOM MEMORIES

One of my earliest and most pleasant memories is the smell of apple blossoms that drifted inside from the big tree in our side yard on misty spring mornings. I loved the delicate sweet scent and the blush pink buds that opened white. When I was 12, I'd roam the deep woods of eastern Pennsylvania in June and discover wild rhododendrons covered with pale pinkish white, sweetly fragrant blossoms. After getting to know many fragrant plants, I've come to see that Nature often uses white with a certain shade of rosy pink to color beautifully perfumed flowers.

Now, in the front yard where Marilyn and I walk most frequently, we've planted several fragrant plants with this color scheme. On the left of the brick path is a variegated cultivar of fragrant or winter daphne (*Daphne odora* 'Aureo-Marginata'), which we think is the most gorgeous plant on our property. In January and February, it puts on a display of rose pink-and-white flowers in small clusters that have a surpassingly beautiful fragrance. If I were still living in Pennsylvania, or anywhere in the East that's warmer than USDA Plant Hardiness Zone 4, I'd plant koreanspice viburnum (*Viburnum carlesii*) in place of the tender daphne. The viburnum's pink buds open to white flowers that scent the early spring air with a rich, delicious, spicy fragrance.

A large old 'Gravenstein' apple tree overarches our path from the right. This tree was here when we moved in and makes a reliable display of lightly fragrant pink-and-white apple blossoms each March. The scent of its flowers is the purest and cleanest fragrance I know. A climbing Chilean jasmine (*Mandevilla laxa*) grows up into the tree and spills bushels of clustered, white, gardenia-scented flowers from the branches. The scents don't compete because the jasmine blooms after the apple and continues through most of the summer.

The kitchen window overlooks this little garden, and below it, we've put up a trellis and grown a specimen of pink jasmine (*Jasminum polyanthum*). On April mornings, the rose-and-white flowers of the jasmine open in the warming sun. When I pull up the shade and open the window, sunlight and the scent of jasmine fill the kitchen. This garden brings childhood memories as close as my front door. It's a satisfying little garden, full of evocative color and fragrance.

A COLORADO COLOR SCHEME

I've also used nature's color schemes to design a garden of bold colors. On a trip through Colorado several years ago, I stood on a green bank by a swift river that was milky with mountain sediment. Across the river a steep bluff rose 1/4 mile into the air, layered with horizontal bands of red and yellow sandstone. Above the bluff, an azure high-country sky completed the picture. I looked at the scene simply as color. It dissolved into horizontal layers from bottom to top: green, white, red, yellow, and blue.

I didn't have to divine any color meanings to find this combination attractive, and I designed a perennial border to follow the Colorado color scheme. Grasslike common thrift or sea pink (*Armeria maritima*) covers the ground in front. Behind it is a band of pretty white 'Fuller's White' wild sweet William (*Phlox divaricata* 'Fuller's White'). I provided midheight reds and yellows with a mixture of red and gold gaillardia (*Gaillardia* × *grandiflora*), common globeflower (*Trollius europaeus* 'Superbus') with its 2-inch buttercup-like yellow flowers, yarrows (*Achillea* spp.) in both sulfur and red, and red carnations (*Dianthus caryophyllus*). I suggested the overarching blue of the Colorado sky by magnificent 5-foot spires of a sky blue Pacific Hybrid delphinium, 'Summer Skies' (*Delphinium elatum* hybrids). The wild scenery sparked an idea for a traditional perennial border that puts on quite a show in June.

LANDFORMS

Landforms add structure and interest to the landscape. If your property slopes gently down to a stream, juts up into rugged cliffs, or features hills or hollows, it has built-in interest that no amount of planting can give it (though of course, planting can enhance it!). But if your property has no wonderful rock forms or water features, don't despair. You can add them—*and* give them a timeless, natural look—without too much trouble. Following are some ideas and projects for spicing up your landscape.

ROCK-AND-BERM DESIGNS

There's a soothing, nursery-rhyme quality about softly rounded hills. But let stones emerge from these hills and the picture changes radically. The stones add mystery, energy, solidity, and rigidity. They suggest a subterranean world of rock buried somewhere below. I find the combination of softly rounded earth and protruding masses of hard rock both evocative and beautiful. I react positively to this sight in wild nature and in the garden.

In the home landscape, you can achieve this effect with selected stones and a softly rounded berm or mound of earth. Design this by placing the stones to suggest more and deeper stones below, waiting to emerge. Then bring in a few truckloads of soil and berm it up to wash around the rocks, contrasting curving soil with craggy rock.

When a lot of soil is needed, it can be cheaper and easier to hire a backhoe operator to reshape the land. Reshaping land can be a key to creating a natural landscape, although a lot of home gardeners don't think of doing it. Berms can give the yard as much visual privacy as a

fence without interrupting the natural look of the plantings.

The rock-and-berm arrangement especially benefits small yards that are on flat, level ground. Plants can add mounds and tiers of leaves, but the sense is always of a flat place. There's no substitute in a landscape for a shaped portion of earth itself—a high place, a low place, and transitions in between. It gives the scene a new order of interest and gives the gardener new staging areas for realistic, natural-looking plantings. When we look at our yards, we need to think of the space as extending farther than the two dimensions of a bed or border. We need to think in three-dimensional terms—height above ground, space below ground—in addition to width and length.

A friend, Carl Doney of Nazareth, Pennsylvania, did a masterful job of thinking about his front yard in three dimensions when he tore out a perfectly uninteresting front slope, excavated the soil, then heaped in huge boulders. He bermed the boulders with the excavated soil, covered that with topsoil, and planted it with permanent plantings and flowers. The design left a space between two monoliths to reach the basement level of the house, so that his family emerged from the house as from an underground tunnel of rock.

Carl's front yard was particularly impressive to me because the forest not far from my house contains a hillside with massive, house-sized boulders tumbled on one another, creating tunnels and chambers between them.

Groups of very large rocks or boulders, partially covered by trees and shaded for the greatest part of the day, can develop beautiful patinas of mosses, ferns, and lichens on their surfaces, especially if the gardener brings home a little moss for starters. To establish moss, pack rock surfaces with compost or forest floor duff, then crumble pads of moss in a quart of water and pour this slurry over the prepared rock surfaces.

Variation in soil levels, especially in combination with large stones, is the key to unlocking the landscaping potential of many flat properties. If your yard is flat, try to imagine different parts of it with hills, berms, cliffs, or caves. See if it doesn't bring a delightful sense of natural wilderness back to your land.

TERRACING NATURALLY

Some properties, on the other hand, are all disconcerting slopes, so that when you try to get your horizon line straight, all the trees look like they're growing from the ground at an odd angle. In such places, establishing a level area gives context to the rest of the slope and makes it much easier to live with. The level place may have to be excavated or built up with fill. It could also be formed into a slope with stone. But without a level area, everything's a little cockeyed. One of the nicest things about pools of water in the garden is that they provide perfectly level places where our restless sense of balance can rest at last, at least for a moment. A level place on a sloping contour is refreshing and welcome.

Some people might think that terraces are an unnatural solution to a problem slope, but that's not the case. Rivers and watercourses cut their way through the land as horizontally

(continued on page 38)

MAKE A TERRACE

If you're like me, when you think back, you'll realize that a lot of your favorite natural places are on slopes. Slopes are interesting because they lead the eye up, they have three dimensions instead of two, and they provide a natural staging area where choice plants can be tiered for maximum effect.

Unfortunately, natural slopes can have drawbacks. Any bank with a grade steeper than about 20 percent is subject to erosion, especially when it's made up of loose, sandy soil. Steep banks are naturally well drained. If they're in full sun, they will be very dry during the summer months over much of the country, requiring either drought-tolerant plants or frequent waterings.

The way to have your slope and enjoy it, too, is to terrace. Terracing stops erosion and maximizes the landscaping potential of the site. Each natural-looking terrace you make can contain a different group of plants that form striking combinations of flower colors, foliage types, and shapes.

Another good reason to terrace your yard is if it slopes too steeply for children to play easily. A terrace can be a large, flat area for family sports and picnics outside, as well as a site for an interesting garden.

Terrace the bank by making it a natural-looking rock garden. Think about the way nature places rocks at the base of an eroding bank: Large rocks fall and roll out a little away from the bank. Sand and silt wash out around the rocks. Other rocks are staggered back into the bank, creating flat spaces between rocks that make small planting areas. A few rocks at the top of the bank jut above the soil surface. This natural bank is the perfect setting for rock-garden plants, with their jewel-like beauty.

Siting Steps in a Terrace

You may need to make steps between the top of your terrace and the ground below. Think of how paths form in isolated areas: Sometimes the footing is provided by a rock, at other times, by flat spaces of forest duff or by a protruding root. All steps, naturalistic or not, should make for safe walking first of all. For safety and comfort in walking steps, keep the rise of each step to 6 to 8 inches and the distance from the front of one step to the back of the next at least 18 inches. The steeper the slope, the more steps you'll need. If you don't want them to run straight up the bank, you can design the path to meander up the slope, going back and forth past groups of featured plants.

First, walk easily and naturally up the bank. How big are your steps in each place? Cut the rough shape of the path into the soil with a shovel. If you find a big root or rock, excavate to expose it. Don't remove these natural features unless it's absolutely necessary: They're what give your path its distinctively natural look. Protect exposed roots from injury until their bark has had a chance to toughen up on exposure to air.

Next, set in your steps. These can be made from railroad ties, flat rocks, or flagstone. Provide outdoor lighting along the steps if they are near the house and family or visitors are likely to use them at night. Low fixtures will throw a soft, inviting light on the steps.

Use large rocks to edge the steps, and intersperse them with planting areas. Ornamental grasses look good in planting areas along steps and paths, and so do low-growing plants and those with spectacular flowers. Fragrant plants add a delightful touch to a path, releasing scent when someone brushes past. One of my all-time favorite plants with rocks is common thrift, also called sea pink (*Armeria maritima*). Out of bloom, it looks like neat, dark grass. In bloom, it sends up dainty pink or white flower balls on 3- to 4-inch stems.

Easy Terracing

If terracing with rock and steps is more work than you want to do, or more than your site needs, you can make a simpler terrace. To terrace a bank in a staggered descent without any retaining walls, start at the top of the bank. Make temporary barricades from scraps of wood just in front of each place where you plan to put a plant.

Using a cut-and-fill technique, fill the area behind each barricade with soil cut from the bank above. Work on down the bank, so you end toward the bottom. Improve the soil with compost as you fill in behind the barricades. Put in plants that will hold the bank firmly, such as those that spread by suckers or take root where their stems touch the ground.

When the plants are established and firmly rooted, remove the scrap barricades. By then, the bank will be stabilized and the plants will keep it from washing out.

Easy Terraces for Slopes

To make an easy terrace, put a temporary wooden barricade in front of each place you want a plant, starting at the top of the slope and working your way down.

Plants for Terraces

These plants will provide erosion control on steep banks.

Perennials

Big periwinkle (*Vinca major*)
Crown vetch (*Coronilla varia*)
Ivies (*Hedera* spp.)
Marjoram (*Origanum majorana*)
Oregano (*Origanum* spp.)
Periwinkle, creeping myrtle (*Vinca minor*)
Rosemary (*Rosmarinus officinalis*)
Sage (*Salvia officinalis*)
Thyme (*Thymus* spp.)

Shrubs

Bearberry cotoneaster (*Cotoneaster dammeri*)
Blackberry (*Rubus macropetalus*)

Fill in behind each barricade with soil from the bank above, enriching the soil with compost, then plant spreading plants that will hold the slope. Remove the barricades when the plants are well established.

'Blue Rug' juniper (*Juniperus horizontalis* 'Wiltonii'/'Blue Rug')

Creeping cotoneaster (*Cotoneaster adpressus*)

Creeping junipers (*Juniperus horizontalis*), especially 'Blue Chip' creeping juniper, 'Blue Mat' creeping juniper, and 'Emerald Spreader' creeping juniper

Lilacs (*Syringa* spp.)

Littleleaf cotoneaster (*Cotoneaster microphyllus*)

Memorial rose (*Rosa wichuraiana*)

Raspberry (*Rubus idaeus, R. occidentalis*)

Rockspray cotoneaster (*Cotoneaster horizontalis*)

Willowleaf cotoneaster (*Cotoneaster salicifolius* 'Repens')

Build a Footer for a Dry Stone Wall

A dry stone wall is built without mortar, and unless the base stones have a footer, frosts can heave the wall and bring it down.

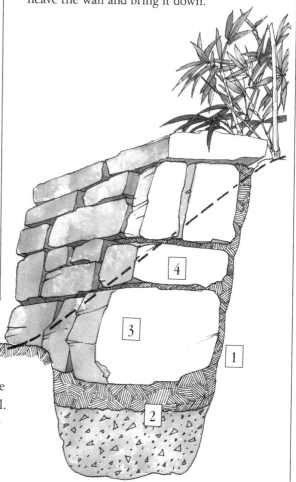

1. Dig a 2-foot trench along the base of the bank that you plan to terrace with a wall. As you dig, angle the bank back slightly from the vertical so you can build the wall into it.

2. Place 1 foot of sand in the hole and top it with 2 or 3 inches of concrete. Set in the large base stones along the trench, then fill the trench to within an inch or two of soil level with more concrete.

3. When the concrete is dry, pull soil back over it and snug it around the base stones.

4. Build the dry wall using the two-over-one, one-over-two technique—two stones come together over the middle of the one below; one stone goes over the joint where two stones meet—angling it back slightly into the bank. Cap the wall with a smooth top stone.

as they can manage, and they often leave a series of natural terraces behind. Terracing is a wonderful way to arrange tiers of garden spaces. One way to handle terraces is to think of them as the banks of a river and create a sinuous flow of stones or groundcovers on the garden's floor.

When the land slopes gently, terraced walls are very visible from below, but can be perfectly invisible when seen looking downslope from higher ground. These walls are highly effective in separating levels without fences or other visible structures.

USING WATER WITH LANDFORMS

A shallow depression or boggy place can be the site for a lake, waterfall, and stream. Springwater or groundwater will fill the lake, rush over the fall, and be carried away by the stream. Digging out the lake (or perhaps more realistically, the pond) also helps drain the surrounding land, which will be available to a much wider range of plants than it was when wet. Its accessibility will improve. And its mosquito-breeding potential will decrease.

I think the most choice natural feature a site can have is a spring, with its cold, clear, sweet water bubbling up in a sandy patch in the woods. As a boy, I knew several springs that had been enclosed many years before, judging by the old, mossy look of their stone and concrete. Typically, they'd be fitted with a small 2-by-3-foot screened door. A gray enameled dipper with rusty chipped spots always hung by the door. If they were close to a good place to picnic, they'd be filled with beer and soda at picnic time.

Watercress grew around them, spilling out and over the watery runoff area. Big floppy mayflies would hover lazily, their bodies glinting metallic blue in an occasional shaft of sunlight.

Our experiences in nature may give us clues for handling natural features like springs. Instead of a concrete house over the water, we may want to construct an arrangement of boulders and gravel where the water issues, or create a deep pool overlooked by a large, flat rock. In any case, shade is imperative. Direct sun turns spring sites rank and weedy—the opposite of the cold, pure water you're aiming for.

We'll look at water in more detail in chapter 7, Wildlife and Water in the Natural Garden. Used the right way—the soothing, tranquil water garden, not the screaming blue concrete rectangle—it's one of the nicest things you can do for your natural garden, and for yourself.

TEXTURES AND BROCADES

Most of what we see when we look at wild nature is leaves, whether they are blades of grass, the dense blue-green darkness of evergreen needles, or quaking, shimmering masses of deciduous leaves in the noon sun. One of the principles of landscape design is to try to create beauty without bloom—that is, design the garden to be beautiful with no flowers. It will then be doubly beautiful in bloom. You can create beauty without bloom by artfully using the shapes, sizes, colors, and densities of foliage in striking combinations.

From a distance, the texture of leaves isn't as visible as the form of the trees and shrubbery.

TEXTURAL QUALITIES OF LEAVES

Let's look at three qualities of leaves and class them as either fine- or coarse-textured. Fine-leaved plants and plants with glossy foliage give the landscape a fine texture. Plants with dark or dull foliage—and plants with large, unkempt foliage—give landscapes a heavy, coarse texture. Many, if not most, plants fall between these extremes and have medium-size, low-gloss green leaves. These look good with either fine- or coarse-textured plants. For maximum landscape interest, use dramatic textural contrast, such as a shiny-leaved glossy privet with a large-leaved hydrangea.

FINE	COARSE
Color	**Color**
Silvery	Dark green
Gray-green	Blue-green
Yellow-green	Greenish black
Size	**Size**
Small	Large
Narrow	Wide
Short	Long
Shape	**Shape**
Finely cut (mimosa)	Broad lobed (rhubarb)
Narrowly palmate (cutleaf Japanese maple)	Widely palmate (Japanese fatsia)
Lancelike (weeping willow)	Large oval (southern magnolia)

Most leaves are dull or nonreflective, but others are shiny. Shiny, reflective leaves like those of southern magnolia and rhododendron are heavier in texture, because they call attention to themselves with glints of light. Plants with a loose, open habit like butterfly bush have a lighter texture than dense, closely packed plants like boxwood or spirea.

Notice that Nature masses lots of similar forms together and accents them with contrasting forms. A hillside of conifers will be accented with the huge, rounded head of a deciduous tree. An array of deciduous trees with round and oval shapes will be accented with the pointed cone of a conifer. With large plants like trees, Nature tends to use contrast sparingly. In emulating her, we can place trees of contrasting form at points we want to emphasize, heightening their impact.

Up close, where we get to see the leaves in detail, texture is more important than form. To give movement to the landscape and make it seem smaller, choose trees and shrubs of increasingly larger, bolder textures running back into the distance. But to give an illusion of depth and space, use large, bold-leaved plants close to

(continued on page 44)

TREE AND SHRUB SHAPES

Plant Name	Height × Width (ft.)
Columnar	
American mountain ash (*Sorbus americana*)	30 × 11
Blue lawson false cypress (*Chamaecyparis lawsoniana* 'Allumii')	35 × 15
'Columnaris' lawson false cypress (*Chamaecyparis lawsoniana* 'Columnaris')	40 × 15
Irish yew (*Taxus baccata* 'Stricta')	18 × 7
Japanese stewartia (*Stewartia pseudocamellia*)	26 × 6
Korean stewartia (*Stewartia koreana*)	16 × 7
'Pyramidalis' smooth Arizona cypress (*Cupressus glabra* 'Pyramidalis')	50 × 16
'Scanlon' red maple (*Acer rubrum* 'Scanlon')	33 × 4
Sentry maple (*Acer saccharum* 'Monumentale' ['Temple's Upright'])	23 × 8
'Skyrocket' Rocky Mountain juniper (*Juniperus scopulorum* 'Skyrocket' [formerly listed as *J. virginiana* 'Skyrocket'])	13 × 1
Conical	
Blue atlas cedar (*Cedrus atlantica* 'Glauca')	65 × 45

Columnar

Plant Name	Height × Width (ft.)
Colorado blue spruce (*Picea pungens* fa. *glauca*)	80 × 33
'Elegantissima' English yew (*Taxus baccata* 'Elegantissima')	20 × 20
Fragrant snowbell (*Styrax obassia*)	28 × 15
Gold Monterey cypress (*Cupressus macrocarpa* 'Goldcrest')	50 × 15
Hinoki false cypress (*Chamaecyparis obtusa*)	10 × 6
Sourwood (*Oxydendrum arboreum*)	23 × 11
Sweet gum (*Liquidambar styraciflua*)	65 × 26
Western red cedar (*Thuja plicata*)	80 × 40

Conical

Domed

Carolina silverbell (*Halesia carolina*)	13 × 13
Common lilac (*Syringa vulgaris*)	16 × 10
English hawthorn (*Crataegus laevigata*)	20 × 20
Loebner magnolia (*Magnolia* × *loebneri*)	15 × 10
Purple smoke tree (*Cotinus coggygria* 'Royal Purple')	15 × 15

Domed

(continued)

TREE AND SHRUB SHAPES – *Continued*

Plant Name	Height × Width (ft.)
Domed – *continued*	
Red horse chestnut (*Aesculus × carnea*)	50 × 40
White willow (*Salix alba* var. *sericea*)	23 × 26
Fan-shaped	
Birchbark cherry (*Prunus serrula*)	10 × 10
Cornelian cherry (*Cornus mas*)	23 × 30
Fringe tree (*Chionanthus virginicus*)	10 × 11
Japanese kerria (*Kerria japonica*)	6 × 6
'Kwanzan' flowering cherry (*Prunus serrulata* 'Kwanzan')	15 × 15
Saucer magnolia (*Magnolia × soulangiana*)	25 × 33
Star magnolia (*Magnolia stellata*)	11 × 17
Tea crabapple (*Malus hupehensis*)	18 × 20
'Vossii' golden-chain tree (*Laburnum × watereri* 'Vossii')	20 × 20
Weigelas (*Weigela* spp.)	6 × 6
Round	
Cherry plum (*Prunus cerasifera*)	15 × 15

Fan-Shaped

Round

Plant Name	Height × Width (ft.)
Japanese maple (*Acer japonicum*)	10 × 13
'Thundercloud' cherry plum (*Prunus cerasifera* 'Thundercloud')	13 × 15

Spreading

Doublefile viburnum (*Viburnum plicatum* var. *tomentosum*)	13 × 20
Flowering dogwood (*Cornus florida*)	20 × 26
Kousa dogwood (*Cornus kousa*)	15 × 15
Mimosa (*Albizia julibrissin*)	20 × 30
'Shirotae' flowering cherry (*Prunus serrulata* 'Shirotae')	13 × 20
Small-flowered tamarisk (*Tamarix parviflora*)	10 × 10

Spreading

Weeping

Elaeagnus (*Elaeagnus × ebbingei*)	16 × 20
Fountain buddleia (*Buddleia alternifolia*)	10 × 10
Japanese flowering crabapple (*Malus floribunda*)	26 × 33
'Red Jade' crabapple (*Malus* 'Red Jade')	10 × 23

(continued)

TREE AND SHRUB SHAPES – *Continued*

Plant Name	Height × Width (ft.)
Weeping – *continued*	
Threadleaf Japanese maple (*Acer palmatum* 'Dissectum Atropurpureum')	12 × 16
Toringo crabapple (*Malus sieboldii*)	10 × 15
Weeping atlas cedar (*Cedrus atlantica* 'Glauca Pendula')	20 × 30
Weeping Higan cherry (*Prunus subhirtella* 'Pendula')	12 × 18
Weeping purple beech (*Fagus sylvatica* 'Purpurea Pendula')	25 × 25
Yoshino cherry (*Prunus yedoensis*)	15 × 25

Weeping

the viewer and progressively smaller and finer-leaved plants farther back in the landscape.

You will create tension in the landscape if you put a large, heavy-textured tree or shrub next to a small, fine-leaved one. As with contrasting forms, you can use tension at points in the landscape that need emphasis. Be careful, as plants of medium to coarse texture can appear very heavy and overpowering when contrasted with fine-leaved plants.

With smaller plants, such as herbaceous perennials, texture contrasts can be used much more frequently, because these plants are small and *need* to call attention to themselves.

Trees and shrubs are dominant in the visual field. When using them to provide a backdrop for featured small shrubs and perennials, gradually change their colors and textures rather than making abrupt contrasts.

When you're seeking ideas and inspirations in nature, take notes on the foliage textures around you. How do the leaves of the plants look together? What shapes, sizes, colors, and habits are they displaying, and what are the effects achieved? Good notes here can greatly help when recreating an effect at home.

CREATING A LIVING BROCADE

Foliage has more to offer than texture, however, and never more so than in fall. Fall gives the landscape the look of a rich brocade. To me, this beautiful cloth is most apparent in an autumn field.

When tramping around the eastern United States, I particularly enjoy seeking out abandoned old fields. These fields were last turned perhaps 20 to 40 years ago. Nature throws a tremendous diversity of plants into these spaces, and their areas of open grasses and perennial and annual weeds intermix beautifully with shrubs, trees, and vines. They're rich in bird species—a birder's paradise. They're usually also good places to hunt for wild bramble berries and wild grapes, as well as rabbit and pheasant.

Any recently turned plot of land will begin to revert to its climax vegetation—the group of plants that would ultimately colonize the site if it were left undisturbed—but it takes many years to get there. First, Nature tries to cover her bare soil with broad-leaved annual weeds like lamb's-quarters, pigweed, and chickweed. In subsequent years, she adds the brambles and other perennial weeds, then sassafras and sumac, and finally the pines and deciduous hardwoods that will eventually reclaim the field as forest.

We can enjoy the feeling of a fall field in our own yard by recreating an old field association from scratch. The "field" doesn't have to be the size of a farmer's field—even a space 40 by 50 feet will do, if you plant most of the trees and shrubs around the perimeter. We're landscaping it for the special nostalgia that an old

field evokes, especially in the fall when the leaves turn to fire and the cold weather sets in.

Here's how I would design the finished "field": At the edge toward the prevailing wind, there will be a stand of intermixed loblolly and shortleaf pines (*Pinus taeda* and *P. echinata*). This stand borders an area of perennial grasses, especially orchard grass (*Dactylis glomerata*) and fountain grasses (*Pennisetum* spp.). In front of the background pines, planted in the grasses, are the tall cones of eastern red cedar (*Juniperus virginiana*) and low, shrubby cultivars of common juniper (*Juniperus communis*).

At the opposite edge, facing the prevailing wind, stands a background group of quaking aspen (*Populus tremuloides*). You'll see the shimmering leaves every time the summer winds blow—and they turn a lovely, toasty, golden yellow in the fall. The aspens are augmented by sassafras (*Sassafras albidum*) and staghorn sumac (*Rhus typhina*) in front of the trees. Sassafras turns a myriad of rich colors from purple through red, orange, and yellow. Staghorn sumac develops the most intensely deep red leaves of any plant. A Virginia creeper (*Parthenocissus quinquefolia*) trailing up into the sassafras or sumac and spilling out of their crowns adds even more intense fall color to the scene.

In the field's featured area, what could be nicer or more dramatic than a trio of chokecherries (*Prunus virginiana*)? These develop long white flower racemes in spring that twist and turn this way and that, giving them a life of their own. Meadow perennials like butterfly weed (*Asclepias tuberosa*) and mullein (*Verbascum thapsus*) will add spots of color to your

FOLIAGE TEXTURES OF COMMON TREES AND SHRUBS

FINE-TEXTURED PLANTS

The following fine-textured shrubs and trees are good for shearing and making dense screens and hedges to block views. From a distance, they give a solid, neutral appearance, but up close, they reveal a density of texture that contrasts well with the coarse-leaved plants that follow.

Alpine currant (*Ribes alpinum*)
American arborvitae (*Thuja occidentalis*)
Athel tamarisk (*Tamarix aphylla*)
Boxwoods (*Buxus* spp.)
Brush cherry eugenia (*Syzygium paniculatum*)
California lilacs (*Ceanothus* spp.)
Cape plumbago (*Plumbago auriculata*)
'Cecile Brunner' rose (*Rosa* 'Cecile Brunner')
Columnar Italian cypress (*Cupressus sempervirens* 'Stricta')
Darwin barberry (*Berberis darwinii*)
Dwarf coyote brush (*Baccharis pilularis*)
Dwarf myrtle (*Myrtus communis* 'Microphylla')
Dwarf white pine (*Pinus strobus* cultivars)
Eastern hemlock (*Tsuga canadensis*)
Fern pine (*Podocarpus gracilior*)
Glossy abelia (*Abelia* × *grandiflora*)
Heaths (*Erica* spp.)
Heavenly bamboo (*Nandina domestica*)
Hedge cotoneaster (*Cotoneaster lucidus*)
Hiryu azalea (*Rhododendron obtusum*)
Hollyleaf cherry (*Prunus ilicifolia*)
Italian buckthorn (*Rhamnus alaternus*)
Japanese euonymus (*Euonymus japonica* cultivars)
Lavender cotton (*Santolina chamaecyparissus*)
Magellan barberry (*Berberis buxifolia*)
Mugho pine (*Pinus mugo* var. *mugo*)
New Zealand tea tree (*Leptospermum scoparium*)
Pomegranate (*Punica granatum*)
Purple osier (*Salix purpurea*)

field. Mow it only once a year when the initial crop of orchard grass reaches 2 to 3 feet high in early June.

If you'd like an old field "brocade," but don't have a 40-by-50-foot plot for it, you can still get something of the effect by making a

Rosemary (*Rosmarinus officinalis*)
Shrubby cinquefoil (*Potentilla fruticosa*)
Smooth Arizona cypress (*Cupressus glabra*)
Snowmound spirea (*Spiraea nipponica* 'Snowmound')
Sonoma manzanita (*Arctostaphylos densiflora*)
Southernwood (*Artemisia abrotanum*)
Wall germander (*Teucrium chamaedrys*)
Yaupon (*Ilex vomitoria*)
Yews (*Taxus* spp.)

COARSE-TEXTURED PLANTS

The following coarse-textured and large-leaved shrubs and trees make good contrast plants with the fine-textured plants above. Plant these behind fine-leaved plants in groups, or bring one forward as a specimen. Despite the glossiness of the leaves of some of these plants, which makes them less heavy, they are coarse enough to belong in this list.

Bigleaf hydrangea (*Hydrangea macrophylla*)
Cherry laurel (*Prunus laurocerasus*)
Chinese-lantern (*Abutilon hybridum*)
Common horse chestnut (*Aesculus hippocastanum*)
Devil's-walking stick (*Aralia spinosa*)
Giant reed (*Arundo donax*)
Japanese fatsia (*Fatsia japonica*)
Leatherleaf viburnum (*Viburnum rhytidophyllum*)
Loquat (*Eriobotrya japonica*)
Mahonias (*Mahonia* spp.)
Mock orange (*Philadelphus* × *virginalis*)
Orange-eye butterfly bush (*Buddleia davidii*)
Panicled golden-rain tree (*Koelreuteria paniculata*)
Rose-of-Sharon (*Hibiscus syriacus*)
Saucer magnolia (*Magnolia* × *soulangiana*)
Southern catalpa, Indian bean (*Catalpa bignonioides*)
Southern magnolia (*Magnolia grandiflora*)
Staghorn sumac (*Rhus typhina*)
Yucca (*Yucca flaccida*)

small display against a wall. A brick wall is especially pretty with a Virginia creeper trained up on it. A well-pruned sassafras can be a focal point in front of the wall, with a small grape-vine trained to grow in its branches. Plant grass and perennials like butterfly weed beneath the

sassafras tree. Be sure to confine the roots of the sassafras or be conscientious about removing suckers—sassafras tends to be invasive where it's happy.

You could also domesticate the old field effect and change its color peak from fall to spring by replacing the Virginia creeper with a hybrid clematis, the sassafras with lilacs, and the perennial wildflowers with blue-flowered campanulas (bellflowers).

MATERIALS AND PATINAS

Age improves some man-made garden materials even as it disintegrates others. Consider this when designing your natural garden and selecting materials to use in building it.

One reason why terra-cotta is such a good material for planters, for instance, is that it acquires a wonderful patina over time: It gets crusty with whitish salt deposits, the red-orange to tawny new clay darkens into a richer tone, and tiny mosses often grow on it when it's in a shady, moist spot. Terra-cotta tiles make a good garden patio in frost-free areas for the same reason.

Bronze and copper acquire beautiful, dusty bluish green patinas from the oxidation of the copper and other elements in the metals. Old walls that have been stuccoed and restuccoed gain a rich, ancient look. Redwood doesn't rot—it just looks better as it silvers with age.

Then there are the materials that wear out: Untreated wood only lasts a few years in the moist portions of the country before it rots away. Paint eventually flakes and peels and needs redoing. Cloth doesn't stand up to sun, rain,

wind, and cold. Even a natural material like sand "wears out" over time as organic matter gets into it and allows weeds and other plants to take root.

In the natural garden, we keep the use of man-made materials to a minimum, but that doesn't mean we don't use them at all. We can't get so wrapped up in remaining true to the strictly "natural" that we destroy the garden's sensual appeal. We are still in a garden and entitled to some of the comforts of a garden: a space for entertaining, sitting out, building a fire, socializing and enjoying ourselves, sunning, swimming, and so forth. We're not creating an arboretum, but a functioning garden that represents us as well as nature.

Marilyn and I saw a marvelous example of created patinas in a garden not far from the Tedeschi Winery in up-country Maui, Hawaii. The owner is artist Reems Mitchell, a sculptor who has turned the ruins of a 120-year-old sugar mill into a house and grounds that look like they've been there since the sugar mill was built. Most of what's there was built by Mitchell over the past couple of decades using cement and dyes to match the colors of the old walls and their patinas that developed over the past 120 years. By fiddling around with color and patching materials, he's produced beautiful patinas on wood, cement, iron, metal, stone, and brick. Mitchell's triumph has been to take the ruins, build new walls and buildings that incorporate them, and make all the parts look ancient.

Garden stones that have existing patinas of lichens and mosses should certainly be preserved, along with old logs embroidered with moss and other surfaces worked by nature.

GLOSSY-LEAVED PLANTS

The following plants have glossy to shiny leaves that glisten and reflect sunlight. Plant them with needle-leaved evergreens and dull-leaved plants for an interesting contrast. Try not to plant two glossy-leaved plants together, or the glittery reflections will look busy.

Arrowwood (*Viburnum dentatum*)
Buckthorn (*Rhamnus cathartica*)
Camellias (*Camellia* spp.)
Cherry laurel (*Prunus laurocerasus*)
Common gardenia (*Gardenia jasminoides*)
Common pear (*Pyrus communis*)
Cornelian cherry (*Cornus mas*)
Dwarf myrtle (*Myrtus communis* 'Microphylla')
False holly (*Osmanthus heterophyllus*)
Flowering quince (*Chaenomeles speciosa*)
Fortune fontanesia (*Fontanesia fortunei*)
Fraser photinia (*Photinia* × *fraseri*)
Glossy abelia (*Abelia* × *grandiflora*)
Glossy privet (*Ligustrum lucidum*)
Hedge cotoneaster (*Cotoneaster lucidus*)
Hollies (*Ilex* spp.)
Japanese euonymus (*Euonymus japonica*)
Myrtle (*Myrtus communis*)
Oregon grape holly (*Mahonia aquifolium*)
Rhododendrons (*Rhododendron* spp.)
Roses (*Rosa* spp.)
Scarlet firethorn (*Pyracantha coccinea*)
Sonoma manzanita (*Arctostaphylos densiflora*)
Southern magnolia (*Magnolia grandiflora*)
Washington hawthorn (*Crataegus phaenopyrum*)
Winter creeper (*Euonymus fortunei*)

There's a graciousness and comfort to old, many-layered objects that new materials can't match. Rubbing down new materials with natural stains and residues, or even antiquing products, may seem a bit like Hollywood to a natural gardener, but new materials sometimes need help while we wait for time and the forces of nature to weather their surfaces.

When making pathways and paved areas in the garden, continue the natural theme by using stone surfacing on cement. Native stone usually blends with the surrounding countryside,

(continued on page 54)

MAKE NATURAL-LOOKING CONCRETE

Cement, with its artificial gray look, stands out in the environment as man-made. Concrete looks more natural because it is salted with stones, pebbles, or gravel, but the telltale gray cement still appears between the stones.

Fortunately, you can soften the cement color and make it look more earthy by adding powdered pigments that are used to color household paints. The same pigments are used for coloring both oil and latex and both indoor and outdoor paints. In the right combinations and amounts, it will give cement the same color range as the stones, sand, and earth around it, so your cement work will blend right into the natural background.

You can usually buy the inexpensive pigments by the ounce from the paint store. Remember that these powders are the concentrated essence of color, so wear gloves and don't work where a pigment can damage something if it spills.

To make your cement match the colors around it, first evaluate the dominant colors of the rocks in your landscape. Gray slate, yellow sandstone, silver-gray granites flecked with black and white, rocks that are reddish, bluish, charcoal, or beige, rocks with neutral warm tones or neutral cool tones — what do you have out there? If your rocks vary widely in color from one to another, you probably live in an area that is or was the outwash of a river or sea, where rocks have been carried out and tumbled together. The more diverse the rocks are in color and composition, the more likely they are to be cobbles, rounded by tumbling in moving water. In this case, you'll probably want to vary the colors in your cement to match the dominant colors in your rocks. Take a quick inventory of your rocks and note the color range: gray to yellow, brown to red, blue to gray. When you're coloring cement for the landscape, stay within the same color range you find in your yard.

Mix cement as usual in a wheelbarrow or cement mixing pan where you can clearly see the color. When it liquefies, add the powdered coloring agent. It takes very little of this concentrated pigment to color a 75-pound bag of Sakrete or portland cement. You don't want the cement to be too brightly colored, or it will stand out from the muted natural colors of the landscape. At first, add just a teaspoon of the powdered color and mix it, then add more little by little until you match the color of the native stone in your landscape.

If you are making concrete by adding pebbles or gravel to the cement, move the color of the cement away from dead gray toward the color of the gravel by using powdered color sparingly as you mix. If you need to match two or three colors, make them in separate batches. Mix the powdered color thoroughly into the cement *before* adding pebbles or gravel. It's much easier to mix pigment into liquefied cement than into concrete, with its heavy load of stones.

The cement is originally flat gray, so your pigments won't make it lighter than that unless you use titanium oxide, which is white. If you're matching a very light stone, first add titanium oxide powder — available at the paint store — then a bit of powdered color to match the stone.

You can also color cement that will be used in drain culverts, pathways, or steps. In places like culverts that may be surrounded by greenery, a muted dull green-gray-dun combination may look better than stone colors. Just keep the colors muted—in the wintertime, any obvious green cement will tend to make the garden look like a miniature golf course. The color of cement in pathways can be darker than in other places, even dull grayish brown, suggesting bare soil or shredded bark. But again, keep the color muted—chocolate brown pathways don't look appropriate.

You might occasionally need to use highly colored cement in the landscape, such as when you're mimicking very dark stone or forest duff. You can save a few bucks on powdered pigment by mixing the cement or concrete as usual, without added color, but reserving a bucket or two for a highly colored top layer. Pour the uncolored cement to within $1/2$ inch of the surface, then spread the highly colored cement on top and smooth it with a trowel. Pour and smooth the colored cement immediately after pouring the regular cement—while it's still wet—so the two layers will mix at their interface and bond.

Matching Mottled Stone

Matching a stone like granite with flecks in it is somewhat more challenging. In this case, pour the cement or concrete that you've colored to match the base color of the stone, but reserve a quarter bucket of cement to make the color of the flecks. Dip the bristles of a large, coarse whitewashing or paperhanging brush in the flecking mixture, then flick the brush at a cardboard box or other practice surface until the drops coming off your brush match the natural flecks in the stone.

Another way to do this that makes finer flecks is to wear a rubber glove and pull your hand back across the bristles, ruffling them so they spray bits of fleck-colored cement onto the surface of the wet base cement. Don't trowel this, or you'll end up with strange-looking streaks. Let it bond, set up, and dry, then scuff off loose flecks with your foot or a dry towel.

Color Choices for Natural Effects

White: titanium oxide
Black: Mars black
Red: alizarin crimson or red oxide
Yellow: yellow ochre
Blue: cobalt blue
Brown: raw umber, burnt umber

Experimenting with these colors will bring you close to almost any natural color. Try blending a small amount of cement and powdered color.

Most earth tones, whether of rocks or bark or green foliage, are a mixture of all the colors in greater or lesser amounts. The pure colors in nature seem reserved for flowers and plumage. To create a soft, muted, natural color, use some of each pigment in the batch of cement, varying the components to get the right hue.

Mute a color by adding its complement, rather than trying to darken it with black. If, for example, you're matching a light yellow-orange stone and you have about the right color in the cement but it's a little too bright, mute it with a tiny bit of blue-violet, its complement. To find any color's complement, look directly across the color wheel from that color.

BUILD YOUR OWN PATH

Paths of dark, rounded stones look like rivers as they meander naturally through a garden. You can create a very informal, natural look by constructing a path of varying widths with places to put plants.

First, establish the left edge of the path with a garden hose or length of heavy twine. Make the edge meander. Now create another meandering edge on the right side, but don't have it follow the left edge exactly. Make it irregular, so that the width of the path will vary.

Now dig out the soil from the path down about 6 inches, and put in a series of support stakes 18 to 24 inches apart to follow the contours of both the left and right edges. Place several stakes outside the path and tie level lines to them. Wet down ¼-inch benderboard or hardboard and lay it on the inside of the stakes, tacking it to the stakes as you go. Brace the form from the outside with a brace every 4 or 5 feet. Drive support stakes into the ground to level the form. Check it by the level grading lines.

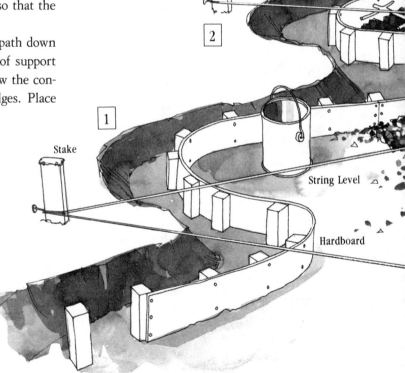

Stake

String Level

Hardboard

1. When you've outlined your path, excavate it to a depth of 6″. Make forms of 8″-high benderboard or hardboard shaped with stakes and braces.
2. Pour 3–4″ of gravel onto the path. Place gallon-size paint cans where you want to add plants.
3. Cut concrete reinforcing mesh to fit the path, adding holes for the paint cans. When the mesh and cans are in place, pour in concrete to the top of the form.
4. Top the path with cobbles, tapping them in place with a float. When the concrete is too hard to poke with a finger, brush the surface and remove the paint cans. Fill the holes with soil and plant.

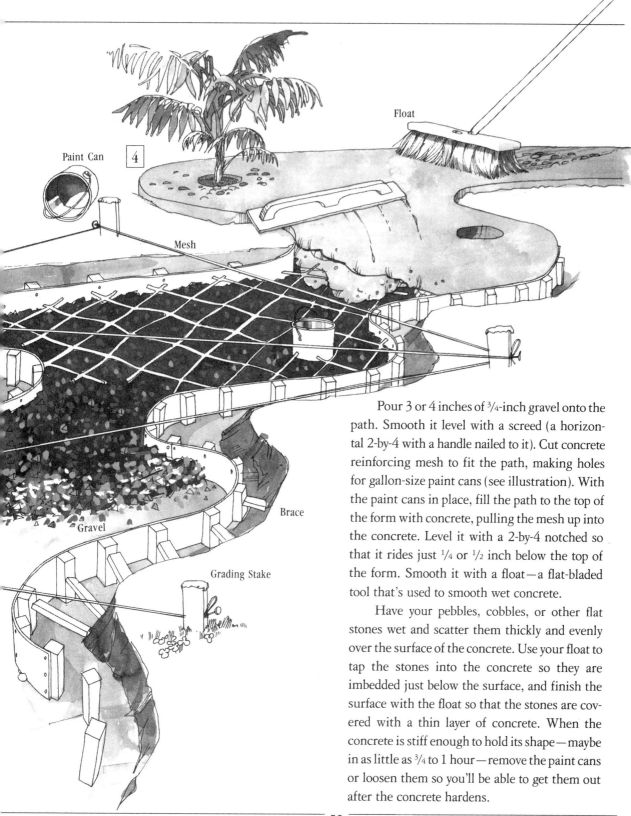

Paint Can

4

Float

Mesh

Gravel

Brace

Grading Stake

Pour 3 or 4 inches of ¾-inch gravel onto the path. Smooth it level with a screed (a horizontal 2-by-4 with a handle nailed to it). Cut concrete reinforcing mesh to fit the path, making holes for gallon-size paint cans (see illustration). With the paint cans in place, fill the path to the top of the form with concrete, pulling the mesh up into the concrete. Level it with a 2-by-4 notched so that it rides just ¼ or ½ inch below the top of the form. Smooth it with a float—a flat-bladed tool that's used to smooth wet concrete.

Have your pebbles, cobbles, or other flat stones wet and scatter them thickly and evenly over the surface of the concrete. Use your float to tap the stones into the concrete so they are imbedded just below the surface, and finish the surface with the float so that the stones are covered with a thin layer of concrete. When the concrete is stiff enough to hold its shape—maybe in as little as ¾ to 1 hour—remove the paint cans or loosen them so you'll be able to get them out after the concrete hardens.

After the water on the surface has evaporated and the concrete is hard enough so you can't poke a hole in it with your finger, brush the surface with a stiff workbrush or nylon-bristle brush to expose about half of the surface of each cobble. If cobbles come loose, wait until the concrete is firmer. If you have trouble scrubbing the concrete from the surface of the cobbles, finish the job quickly, as the concrete is getting hard and will only get harder. Commandeer someone to hose the surface while you scrub it again, keeping the water moving off the stones. Go back and scrub the path one last time about 4 hours after the first scrubbing to remove any residue from the stones' surfaces.

Take out the loosened paint cans and remove most of the gravel from the bottom of the holes.

Fill the holes with good compost or soil, and put in the plants of your choice. You might choose hostas (*Hosta* spp.) for a shady pathway, or ornamental grasses like sedges (*Carex* spp.) in the sun.

A bag of cement mixed with stones will cover approximately 10 square feet of walkway, so if you're mixing the cement by hand in a wheelbarrow, plan on doing just a 10-foot section or two at a time.

If you're planning to make an extensive walkway or to do the whole walkway at once, it will be worth your while to rent either a hand-turned or motorized cement mixer from an equipment rental store and call in some friends to help out. In the case of very large jobs, it may pay you to have a load of ready-mixed cement delivered and poured.

which is good for gardens that reflect the look of the natural world around them. For gardens that evoke more exotic beauty, choose the kind of stone that fits in with your scheme. Small, dark, rounded Japanese cobbles and beach stones make a sleek, shimmering surface when pressed into wet concrete. Paths, risers for steps, and whole patio areas for outdoor living can be created using a variety of cobbles and pebbles to give a natural look to the surface.

When using wood in the garden to recreate natural effects, you'll most often be trying to get a weathered, timeworn look as the wood turns silvery gray. Wood allowed to stand unprotected outdoors will, of course, eventually turn silver on its own—usually in a couple of years.

It's possible to hasten this process using bleaching agents found at any hardware store. This gives an all-over bleached look to wood, which can seem artificial. Naturally weathered wood will bleach and darken in patterns determined by how much moisture and sun the various areas of the wood get.

Stones fresh from the earth look raw and new, and stick out in the landscape. Soften their raw colors by scrubbing them with a stiff brush and water, or even tone them down with an exterior latex paint thinned to a very pale wash of dark, earthy colors that you slap on loosely. By the time the paint washes off, the rocks will have achieved a weathered patina of their own.

BARKS AND BERRIES

There was a spot in the deep woods near my home when I was young that had a fine mixture of birches. The boys I knew would shave off strips of the dark, aromatic, wintergreen-flavored bark of the black birch (*Betula lenta*) to make tea so good even we kids liked to drink it. The soft, chalky white and pinkish patches of the paper birch (*B. papyrifera*) were great fun to play with, and though the technology for turning the bark into canoes was beyond us, we knew how to sew squares together using dried vines to make furnishings for our cabin. Curled bits of bark from yellow birch (*B. alleghaniensis*) gave us tinder for fires. And on the way home from our forages into nature, we'd swing on the long branches of the European white birch (*B. pendula*) planted in our neighbors' yards.

I've found that children especially appreciate bark. What country child hasn't spent a few magic moments wondering about how the patches of color got on an ancient sycamore (*Platanus occidentalis*), prying loose long strips of bark from a shagbark hickory (*Carya ovata*), or even staging mock battles with the long, smooth thorns of a honey locust (*Gleditsia triacanthos*)?

To this day, I still appreciate beautiful bark in nature and try to find places for plants with outstanding bark in the garden. Such plants don't need to be placed as specimens—they are just as effective hidden in a grove with other trees where their bark can be casually discovered by visitors. Interesting bark is a subtle feature that may not even be noticed by most people, but it will be there to delight those with an eye for detail.

Berries are another matter. Trees and shrubs with conspicuous berries do best when they are given a featured place in the landscape and allowed to grow naturally without pruning. Positioning these plants where they can soak up sunshine stimulates fruit production. And when you site a berry-bearing plant so it stands alone in the landscape, you and your visitors gain a clear view of it. Berried plants also attract birds, especially in the winter when the berries and birds are at their showiest, displayed against the drab colors and white snow.

Many cultivated berry-bearing plants from other places are planted around the country these days. In the East, the European mountain ash or rowan (*Sorbus aucuparia*), a native of northern Europe, features showy berries of orange, red, yellow, or white, depending on the cultivar. In the West, especially, scarlet firethorn (*Pyracantha coccinea*) bushes (originally from Europe and Asia) are spectacularly laden with bright red to orange berries in midwinter.

Native berry-bearing plants in the East include the beautiful red chokeberry (*Aronia arbutifolia*). It's one of the plants I used to find growing along the edges of old fields that were reverting to woodlands. Where it gets full sun, it develops red foliage to accompany the brilliant red berries that last well into the winter. Another native that thrills me when I run across its rampant vines growing in the messy fencerows and waste places of the Northeast is American bittersweet (*Celastrus scandens*). Its yellow seedpods contain orange-red berries: a stunning combination, but because of its invasiveness, one that's better enjoyed in the wild than brought to most home landscapes. Also in

(continued on page 59)

HOW TO GIVE WOOD AN AGED LOOK

Because of their earthy good looks, wood and stone are the materials to use for benches, steps, tables, and planters in the natural landscape.

Use rot-resistant woods like black locust, redwood, cedar, and oak when you can find them. Black locust in anything but fence posts is hard to find, and rough, ugly-looking stuff when you do find it. It is best for understructures, fences, and other uses where people won't touch it. Red oak is beautiful for decking, but because oak is so hard, if you plan to use it, you should predrill it. When wood weathers naturally, it changes color through a process called photodegradation. The sun's ultraviolet rays striking the exposed surface of the wood turns the surface a beautiful silvery gray.

To speed up this aging process, you can apply an alkaline solution that will penetrate the surface of the wood. The solution will react chemically with the tannic acid in the wood to form soluble compounds that wash out of the cells. Some people use a solution of baking soda as the alkaline agent, but wood finisher Don Ray of Reed Brothers (a Sebastopol, California, firm that specializes in fine garden furniture) cautions that baking soda can give unpredictable results—including possibly turning the wood black. If you want to try baking soda, test a 25 percent solution on scrap pieces of the same wood you plan to weather.

But Ray has a technique that's better than baking soda—he uses a solution of 8 or 9 parts water to 1 or 2 parts ordinary cement. Like baking soda, the cement is alkaline and will react with the wood's tannic acid. Cement is gray, and it leaves some residual gray color in the grain of the wood.

Ray's technique is simple: Wash the cement solution onto the wood with a big, wet brush and allow it to dry. Then, using a dry brush or a leather glove, wipe or rub the surface down to scuff off any loose bits of cement. Finish the piece with a product like Cabot's Wax Stain in a driftwood color or, if the wood is nicely grayed, rub clear paste wax into the surface.

With this method, the surface of the wood will take on a weathered look long before it ordinarily would. You can integrate new pieces into your garden without the distracting bright appearance of new wood. The cement-and-wax-treated wood will be able to age normally—its pores will still be open to the natural checking and cracking that accompany true aging and are part of the weathered look. As long as the cracks aren't in structural pieces of wood, they're an asset, helping to blend the wood into the landscape.

If you're using wood other than redwood or oak, such as pressure-treated fir or pine, don't try to bleach the wood with the muriatic (hydrochloric) acid solution sometimes sold for that purpose.

The results are too variable—pine especially is subject to unpredictable color changes, becoming red, yellow, green, or even black.

Ray suggests using gray stains, but warns that pine has areas of pitch-filled hard grain that resists stain, so you'll end up with part of the wood stained gray and part still yellow or yellow-green. If you put on enough stain to swamp the hard grain, the wood will look painted. For these reasons, Ray says that if the appearance of the wood is important to you, go with redwood, cedar, or oak, a cement wash, and a hand-rubbed wax finish.

Make a Pathside Planter

all wood 2″ wide

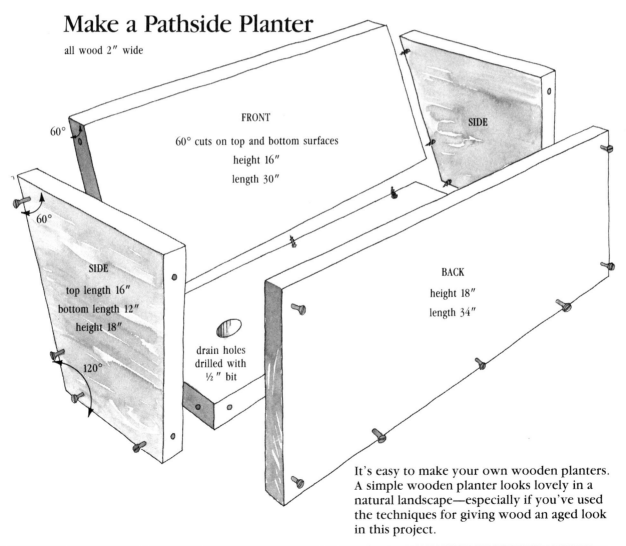

60°

FRONT

60° cuts on top and bottom surfaces

height 16″

length 30″

SIDE

60°

SIDE

top length 16″

bottom length 12″

height 18″

120°

drain holes
drilled with
½″ bit

BACK

height 18″

length 34″

It's easy to make your own wooden planters. A simple wooden planter looks lovely in a natural landscape—especially if you've used the techniques for giving wood an aged look in this project.

Plants for Pathside Planters

Wooden planters are a simple and natural way to feature a mix of spring bulbs, cheerful annuals along a sunny path, or perennials and specimen ferns along a shaded pathway. Here are some suitable plants for pathside planters.

Annuals

Begonia (*Begonia semperflorens*)
Browallia (*Browallia speciosa*)
Impatiens (*Impatiens wallerana*)
Wishbone flower (*Torenia fournieri*)

Perennials

Carpathian harebell (*Campanula carpatica*)
Coralbells (*Heuchera sanguinea*)
Creeping polemonium (*Polemonium reptans*)

Ferns
Hens-and-chicks (*Sempervivum* spp.)
Hostas (*Hosta* spp.)
Japanese sedge (*Carex morrowii*)
Lithodora (*Lithodora diffusa*)
Primroses (*Primula* spp.)
Speedwells (*Veronica* spp.)
Stonecrops (*Sedum* spp.)
Wild sweet William (*Phlox divaricata*)

Bulbs

Anemones (*Anemone* spp.)
Crocuses (*Crocus* spp.)
Daffodils (*Narcissus* spp.)
Hyacinth (*Hyacinthus orientalis*)

An Old-Log Planter

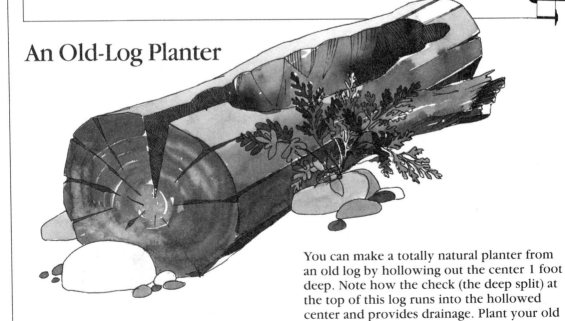

You can make a totally natural planter from an old log by hollowing out the center 1 foot deep. Note how the check (the deep split) at the top of this log runs into the hollowed center and provides drainage. Plant your old log planter with ferns, begonias, impatiens, or hens-and-chicks.

the East, it's not uncommon to run across huge specimens of wild holly (*Ilex* spp.) with its scarlet winter berries defining the Christmas season. I especially remember one particularly enormous holly tree growing on the north bank of the Navesink River in northern New Jersey.

The American cranberry bush or high-bush cranberry (*Viburnum trilobum*) does produce edible fruits, but they're not the bog cranberries we eat over the fall and winter holidays. Highbush cranberries are best left for the birds. This handsome shrub also features masses of beautiful flowers in the spring. It's an underused landscape plant in the North, where it enjoys the cool summers.

Many other ornamental plants have berries of nearly every color (see "Trees, Shrubs, and Vines with Attractive Berries" on page 72) that brighten winter landscapes. Although profusions of berries may not often be found in nature, we can add them to otherwise undramatic landscapes to heighten and brighten the overall effects.

TREES AND SHRUBS WITH INTERESTING BARK

Plant Name	Description	Height (ft.)
American hophornbeam (*Ostrya virginiana*)	Deciduous tree with grayish brown, scaly bark and numerous reddish brown zigzagging branches that form an oval to round habit at maturity. Dark green, $1\frac{1}{2}$- to 5-in.-long, toothed, alternate leaves turn yellowish in fall. Flowers are yellow-green catkins; $1\frac{1}{2}$- to 3-in.-long, greenish white fruit resembles hops.	25–40
American hornbeam (*Carpinus caroliniana*)	Deciduous, crooked-stemmed tree with umbrella-shaped crown; wide-branching form with 20- to 25-ft. spread. Leaves are doubly toothed, 2 to $3\frac{1}{2}$ inches long, oval to egg-shaped, and dark green; pale yellow-orange color in fall. Flowers are green catkins. Fruit is a nutlet.	25–35
American persimmon (*Diospyros virginiana*)	Deciduous tree with round crown, spreading 20–35 ft. Dark gray or brown bark arranged in thick blocks. Alternate, $2\frac{1}{4}$- to $5\frac{1}{2}$-in.-long, dark green leaves turn yellow to purple in fall. Small white flowers. Orange-yellow, 1- to $1\frac{1}{2}$-in.-long fruit is edible when thoroughly ripe.	35–60
Amur chokecherry (*Prunus maackii*)	Deciduous, densely branched, round-headed tree. Golden to cinnamon brown bark is smooth and glistens with a metallic sheen. Will peel like birch as it matures. Medium to brilliant green leaves form early in spring and drop early in fall. Slender, fragrant, 2- to 3-in.-long, white flower spikes from May through July. Tiny black fruit.	35–45
Beeches (*Fagus* spp.)	Large, densely leaved, deciduous trees with smooth, silvery bark. Round habit; spread can be as much as height. Alternate, toothed leaves usually turn coppery in fall. Flowers form in late spring. Fruit consists of 1 or 2 triangular nuts surrounded by a spiny shell.	50–100

USDA Plant Hardiness Zone	Light and Soil Requirements	Comments
3	Does best in partial shade; cool, moist, fertile, well-drained, slightly acid soil.	Found naturally in wooded upland areas. Slow growth rate. Difficult to transplant. Not salt-tolerant.
3	Full sun to partial shade; moist, cool, fertile, slightly acid soil.	Steel gray bark with musclelike ridges offers winter interest. Slow growth rate. Use in naturalized landscape. Difficult to transplant. Can be used along street.
4	Full sun; prefers moist, well-drained, sandy soil, but tolerates a variety; pH 6.0–7.0.	Slow to moderate growth rate. Transplanting is difficult due to large taproot. Some fruit may persist through midwinter. Drought-tolerant. Most American cultivars require both male and female trees for proper fruiting. Grows well in urban areas. Do not plant near sidewalks, as fallen fruit may be messy.
2	Full sun; moist, well-drained, loamy soil.	Flowers make nice summer show. More subject to disease and insects when used in southern Zones (6–7). Forms flowers on previous year's growth.
3	Full sun to partial shade (purple-leaved beeches prefer sun; yellow-leaved cultivars prefer light shade); moist but well-drained, loamy, acid soil.	Excellent specimen tree for landscape, but requires a lot of room. Branches usually touch the ground. Good for shade and winter interest. Most popular species and related cultivars are American beech (*Fagus grandifolia*) and European beech (*F. sylvatica*). Because of their shallow root systems and the deep shade they cast, little will grow beneath them.

(continued)

TREES AND SHRUBS WITH INTERESTING BARK – *Continued*

Plant Name	Description	Height (ft.)
Birchbark cherry (*Prunus serrula*)	Deciduous tree with round habit. Has shiny, reddish brown, peeling bark. Small, white, 5-petaled flowers appear in May along with 2-in.-long, ovate to lanceolate, dark green, toothed leaves. Yellow color in fall. Fruit is $\frac{1}{2}$ in. long and reddish brown.	25-30
Chinese elm, lace-bark elm (*Ulmus parvifolia*)	Small deciduous or semi-evergreen, round-headed tree with spread about $\frac{1}{3}$ of height. Tends to fork. Mottled, exfoliating bark. Alternate, leathery, narrowly oval, $\frac{3}{4}$- to $2\frac{1}{2}$-in.-long, toothed, dark green leaves are shiny above, but hairy below when young. Leaves turn yellow or reddish purple in fall in northern climates, but essentially remain green and persist in the South. Small, greenish flower clusters bloom in late summer. Fruit is a bright green, small, winged nutlet grouped in clusters.	30-60
Chinese paper birch, Chinese brown-bark birch (*Betula albo-sinensis*)	Deciduous tree with round, open habit. Peeling, reddish orange bark has whitish bloom. Yellowish green, $2\frac{3}{4}$-in.-long, oblong-oval, toothed leaves turn yellow in fall. Flowers are catkins. Fruit is a small nutlet.	40-90
Crape myrtle (*Lagerstroemia indica*)	Deciduous, multitrunked tree with upright, rounded habit. Attractive smooth, silvery to tan bark peels to reveal lighter layers underneath. Opposite, 1- to 2-in., medium green, oval leaves turn red or yellow in fall; newly emerged leaves are bronze. Showy, 6- to 8-in. clusters of crinkly, $1\frac{1}{4}$-in.-wide flowers in pink, white, red, or purple bloom in summer. Fruit is a capsule.	20-25
Eucalyptus (*Eucalyptus* spp.)	Large genus of evergreen trees and shrubs, mainly native to Australia. Many are grown as ornamentals for their attractive flowers, leaves, and bark. Mainly alternate, blue-green, usually fragrant leaves may change from round to lance-shaped as they mature. Small, fuzzy clusters of red, yellow, or white flowers usually bloom among leaf axils. Fruit is a capsule.	20-100

USDA Plant Hardiness Zone	Light and Soil Requirements	Comments
5	Full sun to partial shade; any soil.	Hard to find. Excellent for winter interest. May be susceptible to borers. Won't get full effect of bark until 7-10 yr. old.
5	Full sun; prefers moist, deep, well-drained soil, but adaptable to poor, alkaline, compacted soil.	Fast growing. Resistant to Dutch elm disease. Less bothered by insects than other elms. Shallow rooted. Use as specimen tree or shade tree. Drought- and heat-tolerant.
5	Full sun; prefers moist, cool soil, but tolerates wide range.	Good winter interest. Won't get full effect of bark until 7-10 yr. old.
7	Full sun; moist, well-drained soil rich in organic matter. pH 5.0-6.5.	Good as hedge or specimen tree. Winter interest. May be grown in containers. Moderate to fast growth rate. Difficult to transplant. Some cultivars prone to mildew in moist conditions. Tolerates drought once established.
8-10, depending on species	Full sun; prefers fertile, well-drained soil, but tolerates wide range of soil conditions.	Fast growth rate. Shallow-rooted. Shelter from cold winds. Good for street or specimen trees and screens. Don't water or fertilize in fall to discourage late growth and consequent freezing. Lemon-scented gum (*Eucalyptus citriodora*) grows in Zones 8-10. It has white, fall-blooming flowers, lemon-scented leaves, and attractive tan peeling bark. Red gum

(continued)

TREES AND SHRUBS WITH INTERESTING BARK – *Continued*

Plant Name	Description	Height (ft.)
Eucalyptus—*continued*		
European white birch (*Betula pendula*)	Deciduous tree with oval habit at maturity. Bark is white when young, does not peel like paper birch, and develops black patches with age. Triangular, alternate leaves are 1–3 in. long and 3/4–1 1/2 in. wide, toothed, and shiny dark green; foliage turns yellow-green or yellow in fall. Fruit is a tiny nutlet.	30-50
Golden-twig dogwood (*Cornus sericea* 'Flaviramea')	Deciduous shrub. Yellow bark; develops many stems. Stems are upright with few branches. Leaves are oblong or lance-shaped, 2–5 in. long and 1–2 1/2 in. wide, medium green. White flowers are in flat clusters. Spherical white fruit appears in late summer.	7-9
Golden weeping willow (*Salix alba* var. *vitellina*)	Broad, round-topped, open tree with long, drooping branches. Bark is yellow-green. Leaves are 1 1/2–4 in. long, 1/4–5/8 in. wide, bright green above, silvery beneath; may have golden color in fall. Flowers are yellow catkins. Fruit is a small capsule.	50-75
Japanese stewartia (*Stewartia pseudocamellia*)	Deciduous tree with pyramidal to oval habit. Gray-brown to light red-orange bark peels off in large flakes. The 1 1/2- to 3 1/2-in.-long foliage is bright green in spring, changing to dark green in summer and yellow, crimson, and purple in fall. Two- to 2 1/2-in.-wide white flowers with crepe paper-like texture appearing in midsummer. Fruit is a woody capsule.	30-60
Kousa dogwood (*Cornus kousa*)	Deciduous, vase-shaped tree, becoming layered at maturity with horizontal branches. Attractive bark with patches of gray and tan on older wood. Leaves are smooth, oval, dark green turning red in fall. Blooms for up to 4 weeks in May and June with 1- to 2-in. white bracts. In late August, inch-wide pinkish, raspberry-like fruit appears on mature trees, remaining until October.	15-30

USDA Plant Hardiness Zone	Light and Soil Requirements	Comments
		(*E. camaldulensis*), Zones 9-10, grows rapidly to 75-125 ft. with smooth mottled peeling bark and drooping branches.
2	Full sun; moist, well-drained, sandy or gravelly soil.	A commonly used specimen tree in eastern America. Moderate to fast growth rate. Declines in about 30 yr. Prone to borers in the Mississippi Valley and Midwest. For a borer-free, light-barked birch, try the river birch cultivar 'Heritage', which has salmon-white bark.
2	Full sun or partial shade; moist to wet soil. Tolerates poor soil.	Good massed with Siberian dogwood for vivid winter color. Grows fast. May be subject to canker.
2	Full sun; moist soil.	Fast growing. Good along streams. Spreading root system; plant away from pipes. Tends to be messy. Susceptible to wind and storm damage.
5	Full sun to partial shade; moist, well-drained, acid loam.	This species has interest in all seasons, but its bark is unsurpassed for beauty in winter. Won't tolerate winds and drought, so plant in a well-watered, protected spot.
4	Full sun; sandy, humus-rich, moist, well-drained, acid soil.	Protect from wind. Good for specimen or shrub border. Attracts birds.

(continued)

TREES AND SHRUBS WITH INTERESTING BARK – *Continued*

Plant Name	Description	Height (ft.)
Lace-bark pine (*Pinus bungeana*)	Evergreen tree with pyramidal to round open habit; 20- to 35-ft. spread. Often multitrunked, becoming broad and flat-topped with age. Bark is smooth, gray, and shiny. It separates into scales that flake off to reveal cream, red, and green mottling underneath. Stiff, sharp, shiny, medium to dark green needles are 2-4 in. long and borne in groups of 3. Golden brown cones are 2-3 in. long, 2 in. across.	40-60
London planetree (*Platanus × acerifolia*)	Deciduous tree with wide, open habit at maturity. Tan to gray patches of thin bark peel away to reveal beautifully marbled mottlings of light olive to creamy yellow beneath. 6- to 7-in.-long, 5- to 10-in.-wide, medium green, 3- to 5-lobed leaves turn an ugly brown in fall, but bark looks good through winter. Insignificant flowers appear in spring. Fruit is encased in prickly balls that are grouped in clusters of 2 or 3.	40-100
Paperbark maple (*Acer griseum*)	Deciduous, low-branching tree with open, oval habit. Curling, papery strips of cinnamon brown outer bark reveal glistening red-orange new bark underneath. Olive green, 2- to 3-in.-long, trifoliate leaves may develop vibrant red and orange color in fall. Greenish flowers occur in drooping clusters. Fruit is a samara.	20-40
Paper birch (*Betula papyrifera*)	Deciduous tree with broad, round crown and 25- to 56-ft. spread. Bark is chalky white in patches with tan to pink undertones and flakes in paperlike layers. Branches are usually retained close to the ground. Oval, coarsely serrated, 2- to 4-in.-long leaves are a dull dark green, turning yellow in fall. Catkins are 2-4 in. long. Fruit is a small nutlet.	50-70

USDA Plant Hardiness Zone	Light and Soil Requirements	Comments
5	Full sun; average, well-drained soil.	Exceptional bark. Grows slowly and is a beautiful specimen. May sustain damage in heavy snow or ice.
5	Full sun or light shade; deep, rich, moist, well-drained soil. Tolerates alkaline soil.	Good for large open areas. Moderate growth rate. Easily transplanted. Tolerates pollution. May be subject to cankerstain, a lethal disease.
5	Full sun; moist, average, well-drained soil. Will grow in clay soil.	Plant where it will be seen in winter, especially against an evergreen background. Grows slowly. Not messy, so it can be used close to the patio or house.
2	Full sun; moist, well-drained, acid, sandy or silty loam soil.	Bark traditionally used for Native American canoes and basketwork. Tree occurs naturally from Labrador to Pennsylvania and west to Nebraska. When grown farther south or in drought conditions, it's prone to borers. For a light-barked birch in the South, try the borer-resistant 'Heritage' birch, a cultivar of river birch with salmon-white bark. Best for cold climates in clumps or as a specimen.

(continued)

TREES AND SHRUBS WITH INTERESTING BARK – *Continued*

Plant Name	Description	Height (ft.)
Poplars (*Populus* spp.)	Group of around 40 species of deciduous trees. Usually fissured gray or reddish bark at maturity. Leaves alternate, usually broad and coarsely toothed with long stems. Catkins appear before leaves in late winter or spring. Fruit is a small capsule. Female trees may produce many cottonlike seeds.	40-100
River birch (*Betula nigra* [also found as *B. rubra*])	Deciduous, single- or multitrunked tree with oval habit at maturity. Smooth, red-brown bark develops into flaking, peeling, brown-and-black sheets. Becomes a large, irregular tree with slender, weeping branch tips. Alternate, $1^{1}/_{2}$- to $3^{1}/_{2}$-in.-long, $^{3}/_{4}$- to $2^{1}/_{2}$-in.-wide, egg-shaped, doubly toothed, medium green leaves turn yellow in fall. Flowers are catkins that open in the spring. The fruit is a small nutlet.	50-90
Shagbark hickory (*Carya ovata*)	Deciduous, upright tree with oblong crown. Gray to brown shaggy bark peels in large, thin plates. Alternate leaves consist of usually 5 leaflets that are 4-6 in. long, elliptical, hairy, and toothed. The yellow-green leaves turn golden in fall. Male flowers occur in drooping catkins; female flowers are in terminal racemes. Nuts are edible.	60-100
Siberian dogwood (*Cornus alba* 'Sibirica')	Deciduous, arching shrub with a 5- to 10-ft. spread. Sparsely branched. Richly colored, deep coral red stems that turn greenish with red patches in summer. Leaves are oval, 2-$4^{1}/_{2}$ in. long. Flowers are in $1^{1}/_{2}$- to 2-in., flat-topped cymes. Bluish fruit is $^{3}/_{8}$ in. across.	6-10

USDA Plant Hardiness Zone	Light and Soil Requirements	Comments
2	Full sun; prefer deep, moist, well-drained soil, but tolerate a wide range of conditions including drought, pollution, and salt.	Fast-growing. Do not plant near pipes, as roots will invade. Weak-wooded, messy, susceptible to disease, and short-lived. Useful to fill out landscape while other trees are becoming established. Some good as windbreaks, screens, or for erosion control. White poplar (*Populus alba*) has leaves that are white and fuzzy underneath and is not as prone to disease. Japanese poplar (*P. maximowiczii*) is also not as disease-prone and has pale gray-green bark with dark green leaves. Quaking aspen (*P. tremuloides*) has leaves that wave in the lightest breeze and turn yellow in fall.
5	Full sun to partial shade; moist, well-drained, acid soil.	Common in wetlands and along river banks from Massachusetts to Florida and west to Kansas. Moderate to fast growth rate.
4	Full sun; fertile, deep, moist, well-drained soil.	Excellent specimen for larger landscapes. Long taproot.
2	Full sun or partial shade; moist, average, well-drained soil.	Stems make a vivid display against winter snow or an evergreen background. Best massed in a corner of the garden that can be seen from the house in winter. To keep the red winter feature, prune out older stems, which lose color.

(continued)

TREES AND SHRUBS WITH INTERESTING BARK – *Continued*

Plant Name	Description	Height (ft.)
Striped maple, moosewood (*Acer pensylvanicum*)	Deciduous, open, upright tree with arching branches. Bark is striped with green and white on young growth. Coarse 5- to 7-in.-long, opposite, 3-lobed, toothed, bright green leaves turn yellow in fall. Yellow, $1/3$-in.-wide flowers grouped in hanging 4- to 6-in.-long clusters bloom in late spring. Fruit is a samara.	15-30
Sweet gum (*Liquidambar styraciflua*)	Deciduous tree with rounded crown at maturity. Gray-brown bark, deeply furrowed into narrow, somewhat rounded ridges. Alternate, 5- to 7-lobed, 4- to $7^1/2$-in.- wide, dark green, glossy leaves are paler underneath; may turn a deep yellow to purple in fall. Male flowers occur in terminal racemes or panicles; female flowers appear in a rounded head. Fruit is encased in bristly brown balls that persist into winter.	60-80
Yellowwood (*Cladrastis lutea*)	Deciduous tree with rounded crown at maturity; 20- to 25-ft. spread. Gray to tan, smooth, beechlike bark. Twigs make an interesting zigzag pattern. Alternate, 8- to 12-in.-long, bright green leaves composed of 7-9 leaflets that turn yellow in fall. 1- to $1^1/4$-in.-long, fragrant white flowers borne in late spring to early summer hang in clusters like wisteria. Brown pods form in fall.	30-50

USDA Plant Hardiness Zone	Light and Soil Requirements	Comments
3	Partial shade; cool, moist, well-drained soil.	Good for woodland borders. Slow growth rate.
5	Full sun to partial shade; deep, moist, well-drained, acid soil.	Roots need lots of room for development. Moderate to fast growth rate. Good as specimen.
4	Full sun; average, well-drained soil. Tolerates acid or alkaline pH, drought, wet conditions, and extreme temperatures, once established.	Moderate growth rate. Specimen tree. Flowers bloom profusely every other year or so. A favorite of bees.

TREES, SHRUBS, AND VINES WITH ATTRACTIVE BERRIES

Plant Name	Description	Height (ft.)
American bittersweet (*Celastrus scandens*)	Deciduous vine. Alternate, oval, 2- to 4-in.-long, shiny, dark green leaves turn yellow-green in fall. Small, yellowish white flowers appear in June. Females produce bunches of showy yellow seedpods with ⅓-in. scarlet to crimson berries in fall and early winter.	20-30
American cranberry bush, highbush cranberry (*Viburnum trilobum*)	Deciduous, round-topped, dense, handsome shrubs with maplelike, 3- to 5-in., dark green leaves that turn yellow to red-purple in fall. Bark is gray-brown. In late spring, plants bear 4-in.-wide, flat flower heads that look like doilies with larger white flowers around the margins. Clusters of scarlet fruit ripen in midsummer and remain on the shrubs until late winter.	8-12
American holly (*Ilex opaca*)	Evergreen tree with 15- to 30-ft. spread and branches to the ground. The tree is dense, prickly, and pyramidal when young, broadening to a large, round-headed tree in maturity. Mature bark is smooth, light gray. Leaves are usually spiny-toothed, 2-4 in. long, dull to glossy, depending on the cultivar, and medium to dark green with yellowish green undersides. Flowers are dull white; not showy. ⅖-in.-wide red berries dot the branches in November and December.	40-50
Autumn olive (*Elaeagnus umbellata*)	Deciduous, spreading shrub up to 30 ft. wide. Alternate, smooth leaves are 2-4 in. long, slender ovals, bright green above with silvery undersides. Funnel-shaped, fragrant, creamy white flowers, ½-in. long, bloom in May and June. Profusion of red scaly berries, ¼- to ⅓-in. long, ripen in September and October.	12-18
Chinese photinia (*Photinia serrulata*)	Evergreen shrub or tree. Lance-shaped to oblong, toothed, leathery dark green leaves are 4-8 in. long. New leaf growth appears deep coppery red, and old leaves turn rich crimson a few at a time in winter. The white, ⅓-in.-wide, malodorous flowers bloom in 6-in.-wide panicles in spring, followed by clusters of red, ⅓-in. berries that persist all winter.	10-15 as shrub; to 40 as tree

USDA Plant Hardiness Zone	Light and Soil Requirements	Comments
4	Full sun; any well-drained soil.	A strong-growing vine that quickly reaches 20 or more feet. Plant both sexes for fruit production. A rampant grower that can girdle the trunks of shrubs and small trees and kill them; very invasive. Plant these vines on a wall or fence out of reach of other plants; harvest the beautiful berries to dry for wreaths and arrangements; and prune the vines to control them.
2	Full sun to partial shade; moist, well-drained, slightly acid soil.	Good for screens. Moderate growth rate. The fruit is edible and is used for jellies. Slightly susceptible to scab and powdery mildew, moderately susceptible to fire blight.
5	Full sun to partial shade; moist, well-drained loam or sandy soil with a pH of 6.5 or lower.	Over 1,000 cultivars of American holly. Male and female flowers are borne on separate plants, so plant cultivars that flower at the same time to make sure you have berries. Tolerates air pollution.
3	Full sun to partial shade; light, sandy loam; tolerates poor soil and coastal conditions.	Because it is attractive to birds, seeds can be widely distributed so that it becomes a weed. Best for naturalizing. Moderate to fast growth rate.
7	Full sun to partial shade; rich, well-drained soil. Tolerates alkaline conditions.	A rather coarse-looking shrub or tree. Use as specimen, screen. Moderate to fast growth rate. Drought-tolerant.

(continued)

TREES, SHRUBS, AND VINES WITH ATTRACTIVE BERRIES – *Continued*

Plant Name	Description	Height (ft.)
'Compact' European cranberrybush (*Viburnum opulus* 'Compactum')	Deciduous shrub. Leaves are glossy dark green in summer and may turn red in fall. Many delicate white flowers appear in spring and early summer. The bright red berries turn transparent as they hang on the shrub over winter.	4-5
Cornelian cherry (*Cornus mas*)	Deciduous, multistemmed shrub or small oval tree with brown exfoliating bark. Dark green, 2- to 4-in.-long, elliptical foliage is dense and attractive in summer. Small yellow flowers grouped in 3/4-in.-wide umbels appear in March and are followed in August by 5/8-in.-long, cherry red, acidic but edible berries.	15-25
Cranberry cotoneaster (*Cotoneaster apiculatus*)	Deciduous shrub that is evergreen in mild climates. Nearly oval, pointed leaves are a handsome, glossy dark green in summer and turn bronze-purple in the fall. Pink, mostly solitary flowers appear in May and June. Masses of bright crimson, 3/8-in. berries cover the stems in fall.	2-4
English holly, Christmas holly (*Ilex aquifolium*)	Evergreen tree. Forms a stiff pyramid of prickly, glossy, dark green, wavy foliage. Small, white, fragrant flowers in spring. Produces lots of large red berries in winter.	20-50
European mountain ash, rowan (*Sorbus aucuparia*)	Deciduous tree with pale gray-brown bark. Becomes a round tree that develops loads of 1/16-in., bright orange-red fruit in August and September. Various cultivars have yellow, apricot, and pink fruit. Alternate, compound leaves made of 9-15 toothed, dark green leaflets. Tiny, white, malodorous flowers grouped in 3- to 5-in.-wide clusters appear in May.	30-60

USDA Plant Hardiness Zone	Light and Soil Requirements	Comments
4	Full sun; rich, moist, well-drained soil.	Needs no pruning and grows into a dense, small shrub that looks good massed. Both flowers and fruit are showy in their seasons. May have trouble with stem borers.
5	Full sun or partial shade; prefers rich, well-drained soil.	Moderate growth rate. The fruit makes an excellent tart jelly—also attracts birds.
4	Full sun to partial shade; average, well-drained soil.	Makes a low mound that beautifully covers banks and rocks and follows the contours of the ground. Cultivars of this genus have showy red berries, usually 1/4-in. or more across, range in height from prostrate to over 15 ft. tall, and can be very useful in the landscape. However, most species are susceptible to fireblight and are attacked by a variety of insects. Before committing to a large planting, test a few to see how they fare.
7	Full sun to partial shade; rich, moist, well-drained, acid soil.	Takes pruning well. Male and female flowers are borne on separate plants, so buy male and female cultivars that flower at the same time to make sure you have berries.
2	Full sun; rich, moist, well-drained, acid soil.	Very showy, but the display soon ends because the birds quickly gobble up the berries. Moderate growth rate.

(continued)

TREES, SHRUBS, AND VINES WITH ATTRACTIVE BERRIES – *Continued*

Plant Name	Description	Height (ft.)
Evergreen bittersweet (*Euonymus fortunei* var. *vegeta*)	Semi-evergreen vine or sub-shrub. Thick, rounded, 1- to 2-in.-long, medium green leaves persist throughout most of the winter. White to pink fruit capsules split open to show orange berries in fall.	12-15 as vine; to 5 as shrub
Flowering dogwood (*Cornus florida*)	Deciduous, low-branching, wide-spreading tree. Branches have layered effect. Grayish brown bark forms rectangular plates. Dark green, smooth, narrowly oval leaves are 3-6 in. long and turn red to reddish purple in fall. White, pink, or rose flowers, 2 in. wide, appear before foliage. Glossy red, $2/5$-in.-long fruit, grouped in clusters of 3 or 4, ripens in September and lasts into December.	15-30
Heavenly bamboo, sacred bamboo (*Nandina domestica*)	Evergreen to semi-deciduous upright shrub. Compound, leathery, bluish green leaves are blushed with purple, bronze, and red when new and again in winter. White, $1/4$- to $1/2$-in.-long flowers appear in long clusters in May. Pretty, red, $1/4$-in. berries borne in large, loose sprays in winter.	6-8
Japanese barberry (*Berberis thunbergii*)	Deciduous, round, dense shrub. Alternate, $1/2$- to $1 1/5$-in.-long, spoon-shaped, bright green leaves turn orange to purple in fall. Some cultivars have red foliage. Yellow, $1/3$- to $1/2$-in.-long flowers appear in spring. $1/3$-in.-long berries that follow in the fall are strung along the stems like droplets of red enamel, lasting long into the winter.	4-6
Japanese skimmia (*Skimmia japonica*)	Evergreen shrub. Whorled, $2 1/2$- to 5-in.-long, oblong, bright green leaves. Fragrant, 2- to 3-in.-long clusters of yellowish white flowers produce bright red, $5/16$-in. berries. The berries are showy against the evergreen leaves and stay on the shrub well into winter.	2-5
Korean mountain ash (*Sorbus alnifolia*)	Deciduous tree with 20-30 ft. spread. Bark is rich gray. Lustrous, dark green, oval leaves are toothed, 2-4 in. long, and turn shades of scarlet and crimson in the fall. Flat, 2- to 3-in. clusters of $3/4$-in. white flowers in May. The fruit is a $1/2$-in. oval of yellow to deep red-orange, appearing in September and October and remaining on the tree for months.	40-60

USDA Plant Hardiness Zone	Light and Soil Requirements	Comments
5	Full sun to full shade; average, well-drained soil.	A very ornamental plant that will climb like a clinging vine if trained on supports up a brick wall or into a dead tree, or will form a mounded shrub if left to sprawl. Susceptible to scale.
5	Full sun to partial shade; well-drained, humus-rich, acidic soil.	Good for specimen, shrub border. Fruit attracts birds. Does not tolerate pollution.
6	Full sun to partial shade; prefers moist, rich soil. Tolerates other conditions.	A superior plant for filling in and massing. Resembles bamboo, but is actually a member of the barberry family. Loses leaves at 10°F; killed to ground at 5°F. Moderate to fast growth rate.
4	Full sun to shade; average, moist to dry soil.	Thorny barrier and hedge plant. Bees love the flowers. Best in full sun, but it's extremely adaptable.
7	Full sun to partial shade; deep, rich, moist, acid soil.	Makes a low, evergreen mound. Male and female plants are required for fruit production. Slow-growing.
6	Full sun; average, well-drained soil.	Grows rapidly to 20-30 ft., then slower to a mature oval, densely twigged, symmetrical form. Susceptible to fireblight and borers. Won't tolerate pollution.

(continued)

TREES, SHRUBS, AND VINES WITH ATTRACTIVE BERRIES – *Continued*

Plant Name	Description	Height (ft.)
Kousa dogwood (*Cornus kousa*)	Deciduous, vase-shaped tree, becoming layered at maturity with horizontal branches. Attractive bark with patches of gray and tan on older wood. Leaves are smooth, oval, dark green turning red in fall. Flowers for up to 4 weeks in May and June with 1- to 2-in. white bracts. In late August, pinkish, raspberry-like, inch-wide fruit appears on mature trees, remaining until October.	15-30
Laurustinus (*Viburnum tinus*)	Evergreen, upright shrub. Densely branched bush with beautiful, dark, glossy, 1½- to 4-in.-long evergreen leaves. Spring flowers are 2-4 in. wide, pink in bud, turning white as they open. These are followed by berries that turn a striking bright metallic blue, then mature to black.	6-12
Lilly-pilly (*Acmena smithii*)	Evergreen shrub or small tree. Oval, 2- to 3-in.-long, shiny green to pinkish green leaves. Small white flowers bloom in clusters at the tips of the branches in summer. Clusters of ¼- to ½-in. edible berries appear in shades of white, lavender, and lavender-pink.	10-25
Linden viburnum (*Viburnum dilatatum*)	Deciduous shrub. Opposite, round, 2- to 5-in.-long, toothed, hairy leaves. Malodorous, white flowers appear in spring in 3- to 5-in.-wide, flat-topped clusters. In September, the gray-green foliage and showy, ⅓-in.-long, red berries produce a very satisfying effect together. The berries remain on the bush into winter, when they turn a purple-red.	8-10
'Paul's Scarlet' English hawthorn (*Crataegus laevigata* 'Paul's Scarlet' ['Paulii'])	Deciduous tree. Toothed leaves are lustrous dark green and daintily shaped. Branches are laden with brilliant scarlet double flowers in May followed by ¼- to ½-in. scarlet fruit in September and October.	15-25
Porcelain vine (*Ampelopsis brevipedunculata*)	Deciduous vine. Broad, 2½- to 5-in.-long, 3-lobed, dark green leaves. Small, greenish flowers appear in summer. ¼-in. berries are borne in medium-size clusters in the fall. They are prized for their subtle colors: green, yellow, whitish, pale lilac, and porcelain blue berries occur at the same time, because they ripen at different rates.	10-20

USDA Plant Hardiness Zone	Light and Soil Requirements	Comments
4	Full sun; moist, well-drained, humus-rich, acid soil.	Protect from wind. Attracts birds. Good for specimen, shrub border.
7	Full sun to partial shade; sandy, moist, well-drained soil.	Makes a good screen. Likes coastal sites.
9	Full sun; deep, rich, moist, well-drained soil.	Fruit of this Australian native makes a dramatic winter display. Can be trained as a single-trunked tree or allowed to sucker. Good for screen.
5	Full sun to partial shade; rich, moist, well-drained soil.	Plant away from paths and patios, because the flowers have a disagreeable odor. Good for specimen or shrub borders. Slow to moderate growth rate.
5	Full sun; average, well-drained soil.	A pretty, well-proportioned, slow-growing tree. Very susceptible to hawthorn leaf spot or blight.
5	Full sun or partial shade; average, well-drained soil.	A vigorous climber that needs strong support. More fruit if vines are planted in full sun.

(continued)

TREES, SHRUBS, AND VINES WITH ATTRACTIVE BERRIES – *Continued*

Plant Name	Description	Height (ft.)
Possum haw (*Ilex decidua*)	Deciduous tree with many branches and pale gray stems. Small, spoon-shaped, dark green foliage turns yellow in fall. The flowers are insignificant. Produces $\frac{1}{8}$- to $\frac{1}{4}$-in. yellow to scarlet berries.	10-30
'Profusion' beautyberry, 'Profusion' bodinier beautyberry (*Callicarpa bodinieri* var. *giraldii* 'Profusion')	Deciduous shrub. Pale green leaves. Covered with small lilac flowers in August followed by masses of striking, $\frac{1}{8}$-in. violet-purple berries in the fall.	8-10
Pyracantha, scarlet firethorn (*Pyracantha coccinea*)	Semi-evergreen to evergreen shrub. Long, sprawling limbs are drenched in gorgeous, $\frac{1}{4}$-in., orange-red berries that ripen in September and persist through the winter. 1- to $2\frac{1}{2}$-in.-long, dark green, narrowly oval leaves. Flowers are $\frac{1}{3}$-in. wide, white, malodorous, in clusters.	6-10
Red chokeberry (*Aronia arbutifolia*)	Deciduous shrub. An upright, open plant. $1\frac{1}{2}$- to $3\frac{1}{2}$-in.-long, oblong, dark green leaves margined with black-tipped teeth and gray hairs underneath. Small white flowers in spring in 1- to $1\frac{1}{2}$-in.-wide clusters. Sets clusters of bright red, berrylike fruit that lasts well into winter. Red fall foliage complements fruit.	6-10
'Red Jade' crabapple (*Malus* 'Red Jade')	Deciduous tree. Tips of long, slender, weeping branches are laden with clusters of $\frac{1}{2}$-in., bright red fruit that hangs on the tree well into the fall. Masses of white flowers in spring.	To 15
Rugosa rose (*Rosa rugosa*)	Deciduous, upright shrub. Lustrous, deep green, compound leaves have 5-9 toothed leaflets. Canes are densely bristled. A beautiful plant with 3- to 4-in., fragrant flowers that range from white through deep purple-red, depending on the cultivar. Blooms from June through August. Bears 1-in., edible, orange-red fruit called hips.	5-8
Sargent crabapple (*Malus sargentii*)	Deciduous tree or large shrub. Small, round, spreading tree with interesting zigzag branching. White, 1-in. spring flowers are nicely fragrant. Bears heavy annual crops of small, $\frac{3}{8}$-in., dark red fruit.	6-10

USDA Plant Hardiness Zone	Light and Soil Requirements	Comments
6	Full sun to partial shade; moist to wet soil.	Colorful fruits give a festive, decorative look late in the season. Self-pollinating. Stays compact and maintains itself nicely.
5	Full sun to partial shade; average, well-drained soil.	European selection chosen for its heavy flowering and fruiting, but all types need heavy pruning in spring—to within 4-6 in. of the ground—as fruit forms on new wood. Vigorous.
7	Full sun to partial shade in a protected spot; well-drained soil.	Showiest of all the berry-bearing plants. Vigorous, healthy look. Drape over a wall or doorway, or espalier on a fence. Drought-tolerant. May be very susceptible to fireblight.
5	Full sun to shade; grows in any soil.	'Brilliantissima' has best fruit and foliage color of any cultivar. Fruits best if shrubs are planted in full sun. Commonly found over a wide area of the eastern United States. Tolerant of adverse conditions; will even grow in swamps.
5	Full sun; fertile, well-drained, deep soil.	Flowers make a showy display in the spring. Fruits heavily every other year. May be susceptible to scab and powdery mildew.
2	Full sun; rich, well-drained, acid soil. Salt-tolerant.	Hips make a magnificent show in fall and are used in tea, preserves, and vitamins. A trouble-free rose with many advantages. Good for hedges.
4	Full sun; fertile, well-drained, deep soil.	Grows slowly. Makes a good specimen. Flowers are showy.

(continued)

TREES, SHRUBS, AND VINES WITH ATTRACTIVE BERRIES – *Continued*

Plant Name	Description	Height (ft.)
Sea buckthorn, sallow thorn (*Hippophae rhamnoides*)	Deciduous shrub. Makes a big spreading mound with silvery green, willowlike leaves. Yellow flowers emerge before leaves in early spring. Bright, $1/3$-in.-long, orange-yellow berries from September to April.	10-15
Serviceberries (*Amelanchier* spp.)	Genus of around 25 deciduous trees and shrubs. Smooth gray bark with red grooves. Alternate toothed leaves turn yellow to red in fall. Showy white flowers emerge before or along with foliage in spring. Red to black berries, some of which are edible.	3-40
Siebold viburnum (*Viburnum sieboldii*)	Deciduous tree with stiff, open habit. 2- to 5-in.-long, oblong, lustrous, dark green leaves are malodorous if crushed. Creamy white flowers cover this small, compact tree in spring, and large clusters of oval fruit follow. The berries are first pink, then turn deeper and deeper red, and finally turn blue-black.	10-20
Snowberry (*Symphoricarpos albus*)	Deciduous shrub. Dark green, $3/4$- to 2-in.-long leaves are hairy underneath. Tiny pink flowers in spikes borne in June. Produces large, $5/8$-in., white berries. Berry-laden stems bend to ground.	3-6
Strawberry tree (*Arbutus unedo*)	Evergreen tree with reddish bark. Dark green leaves have red stems. Strings of small, white, urn-shaped flowers and showy scarlet and yellow strawberry-like fruit hang on tree in fall and winter.	15-30
Tea viburnum (*Viburnum setigerum*)	Deciduous shrub. The 3- to 6-in.-long foliage is a soft blue-green to dark green. White, 1- to 2-in.-wide flowers in flat clusters appear in May. Lovely, $1/3$-in., bright red berries decorate this plant from October to December.	8-12
Trifoliate orange (*Poncirus trifoliata*)	Deciduous, round shrub. Dark green, 3-part leaves are 1 to $2\frac{1}{2}$ in. long and turn yellow in fall. The 2-in. white flowers borne in May may be citrus-scented, and the yellow, down-covered, fragrant, golfball-size fruit makes an attractive display in September and October.	10-20

USDA Plant Hardiness Zone	Light and Soil Requirements	Comments
3	Full sun; sandy, infertile soil.	A seaside resident that can take salty air and strong winds. Does a good job stabilizing dunes. Also grows in dry, sandy soil away from the ocean. Because male and female flowers are on separate plants, plant a few males to have berries on the females.
3	Full sun to partial shade; moist, well-drained, nonalkaline soil.	Good for naturalizing, specimen. Fireblight is sometimes a problem.
5	Full sun to partial shade; rich, moist, well-drained soil.	Berries of all shades are borne simultaneously. The effect is very striking and much appreciated in the landscape. Moderate growth rate.
3	Full sun to partial shade; average, well-drained soil.	Pretty, delicate shrub with many stems. Berries create quiet drama when displayed against a dark evergreen like a yew. The fruit attracts many species of bird. Fast growing. Spreads rapidly.
7	Full sun to partial shade; average—but not alkaline—soil.	When pruned to a single-trunked tree, its twisting shape becomes more beautiful as the tree matures. The fruit is edible but flavorless. Slow to moderate growth rate.
6	Full sun; rich, moist, well-drained soil.	Fruit is unsurpassed for beauty among the viburnums. Because it can grow spindly with sparse foliage at its base, it's best to underplant it with evergreen shrubs.
6	Full sun to partial shade; well-drained, acid soil.	Makes a dense shrub with sharp green thorns and is an impenetrable barrier when planted as a hedge. Slow to moderate growth rate.

(continued)

TREES, SHRUBS, AND VINES WITH ATTRACTIVE BERRIES – *Continued*

Plant Name	Description	Height (ft.)
Washington thorn, Washington hawthorn (*Crataegus phaenopyrum*)	Deciduous, oval tree. Sharply toothed, 3- to 5-lobed leaves are 1–3 in. long. The glossy green foliage turns a spectacular orange-red in fall. Covered with white flowers in May. Profuse, ¼-in., shiny, scarlet berries appear in September and remain on tree all winter.	20-30
Winterberry (*Ilex verticillata*)	Deciduous, dense, oval to rounded shrub with fine-twigged branches. Narrowly oval, 1½- to 3-in.-long, toothed, rich green leaves. Intense red, ¼-in. berries ripen in September.	6-15

USDA Plant Hardiness Zone	Light and Soil Requirements	Comments
4	Full sun; moist, average, well-drained soil.	Fruit makes a beautiful winter show. The tree is narrow when young but broadens into a graceful mature specimen.
3	Full sun to partial shade; rich, moist—even wet—acid soil.	Few sights can surpass these berries decorating the frozen wastes of January when planted with an evergreen holly behind, echoing the red berries. A favorite of birds. Slow-growing. Requires male and female for berry formation.

CREATING A NATURAL GARDEN

NATURAL DESIGN PRINCIPLES

Much of the "design" we find in nature is simply the result of environmentally suitable plants fighting it out for their place in the sun. Things usually end in a trade-off, with all the plants that survive fitted to a certain scale with one another. This sense of proportion and scale, found everywhere in the wild, is one of the most pleasant aspects of a natural landscape. In this chapter, we'll discuss how to work with design principles like proportion and scale, using techniques as sophisticated as the golden section and as simple as squinting, and how to apply these principles to natural garden designs.

THE GOLDEN SECTION

If you look at any natural scene, you'll see what artists call the golden section. The golden sec-tion breaks a line into two unequal parts. Expressed as a ratio, the small part of the line is to the big part as the big part is to the whole line. (In mathematical terms, if the whole line is 1, the point of the break falls at .618, or about $8/13$ of the whole.) The golden section applies to both vertical and horizontal lines.

Using the golden section in garden de-sign is the best way to ensure pleasing scale and proportion in the garden between natural features such as rocks and gullies, rocks and trees, trees and shrubs, and shrubs and groundcovers.

Historically, the golden section was used by the ancients to create harmony in their buildings. It's still part of our architecture, and it occurs in nature with infinite repetition. It's a harmony to which humans respond, because it is a ratio found repeatedly in the human form

(see the illustration below). And it's easy to put to use in the garden.

To use the golden section, take a strip of wood 13 inches long and paint it black with ¼-inch white tips at either end. Put a white diamond at the 8-inch mark (or, for even more accuracy, use a 1-meter stick and place the mark at 61.8 centimeters). Stand or sit in your favorite spots on your property and move the stick closer to you or farther away to find the golden section between two points.

For instance, let's say you have a mature tree growing 50 feet from the edge of an outbuilding. Hold your stick up horizontally with the edge of the outbuilding at one end and the tree trunk at the other. You can see immediately where the golden section falls—at about 30 feet from either tree or building, depending on whether the diamond is on the left or right side of the stick.

The tree's branches and leaves form a canopy about 35 feet across—a radius of 18 feet from the trunk. This *dripline* is an awkward place to plant other trees or shrubs—they would clutter the appearance of the tree. If we count the 30 feet from the building, we get too close to the dripline. If we count 30 feet from the tree, we mark a spot 12 feet beyond the dripline—a good place for a plant to go. Placed here, the plant's shape won't interfere with the appearance of the tree.

Let's say the mature tree is 50 feet tall. The golden section for this height will be found at either 30 feet tall or 20 feet tall, depending on whether we're measuring the height using the long or short portion of the section. We must decide whether the new planting should grow to a mature height of 30 feet or 20 feet. Either way, it will be a harmonious arrangement.

If we choose the 30-foot height, I'd use a

The Golden Section

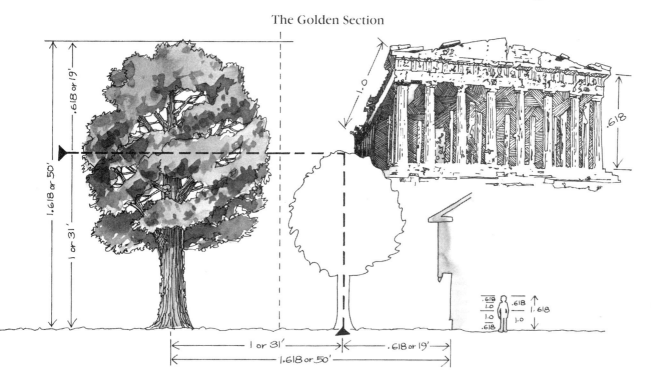

plant that develops an upright, round head to repeat the shape of the mature tree, such as yellowwood (*Cladrastis lutea*), and use plants of contrasting shapes as accents. On the other hand, if we choose the 20-foot height, I'd contrast shape as well as size—short and squat, like saucer magnolia (*Magnolia* × *soulangiana*), to go with the mature tree's tall and stately look.

These choices are purely personal. But the golden section gives us an easy-to-use measure for making relatively foolproof decisions. I say relatively because if nothing but golden sections are used in a design, it can be a bit dull. Contrast and variety are the designer's spices. It's the unexpected variation that sets off the fundamental design: Suddenly crowd ten tall plants together. Deliberately clash colors. But use these unexpected variations sparingly.

PLANT PROPORTIONS

Once we choose our plants, how do we distribute them in our garden landscape? For inspiration, we turn to nature once more. We find that the higher the plant (or creature) in the evolutionary order, the fewer there are of it. In the plant kingdom, for instance, there are more yeast cells, mold spores, and other simple microorganisms in a handful of soil than there are apple trees in North America. The larger the creature, the fewer there are of it. More mice than elephants. More fleas than dogs. The higher up the food chain the creature, the fewer there are of it. A thousand krill are eaten by one little fish; ten little fish are eaten by one big fish.

These axioms are usually followed in natural landscapes. Lots and lots of grass, lots of small shrubby plants, a few big trees. Lots of herbaceous perennials, fewer shrubs, still fewer trees. This rule is general, however. You can always find exceptions: a dense forest dominated by big trees or a shady bog with rare water plants growing abundantly.

A lot of the beauty in nature arises because of the relative abundance of different plants jockeying for position, striving to stay alive and prosper. It's this progression of change, this perpetual freshness, that we find so stimulating: In nature, we really *can't* ever look at the same scene twice. Freshness and change are what we want to convey in our natural gardens— the abundance and continuity of life.

SQUINTING: A NEW WAY TO LOOK AT YOUR LANDSCAPE

Good artists and designers squint at their work and at the things that inspire their work. They do this because it simplifies things. As garden designers, and when looking to nature for cues, it's important for us to do the same thing.

Hold your open hand about 14 inches from your eyes and about the same distance above a background, such as the table with books and papers on it. Focus on your hand. When you are purposefully focused on your hand, the table and books are indistinct and illegible. When you shift focus from the hand to the table and books, the hand becomes transparent and indistinct. It's hard to get a relative sense of the light and dark areas in the composition when half the scene is visually evaporating. So, designers squint.

With your hand in the same position, squint

hard until two-thirds to three-quarters of the light is excluded from your eye. Meanings drain away with the light, and now you can see the scene as areas of light and dark; their spatial proximity to the eye is not as important. The scene becomes flatter and more two-dimensional as the visual cues for depth perception disappear, and immediately the relative intensities of hues and values are apparent. Squinting reduces whatever we're looking at to compositional elements that we can deal with.

When you find a natural detail you like, squint at it and note the relative abundance of lights and darks. This is a good aspect to note in your nature notebook. When recreating it at home, squint frequently at your garden as you construct it and as it appears over time. Strive to balance the areas of light and dark much as you originally saw them, even though the individual plants, rocks, and soil in your garden will have different values from those of the natural inspiration.

Weighing Color

Different colors have different "weights"—blues and greens are inherently darker and visually heavier than reds and yellows. Pastels are by definition lighter than pure colors, although a pastel purple may be darker in weight than a saturated yellow. The way to test the relative weights of colors is to squint until the literal meaning of what you're seeing is squeezed out. As you close your eyes ever more narrowly, more and more information emerges. The relative weights of the composition's light and dark areas are among the very last bits of information to go.

Colors Ranged by Weight. Some colors are darker and visually heavier than others. Blues and greens, for example, weigh more than reds and yellows, while pastels weigh less than pure tones. By squinting at colors, you can perceive their relative weights. In this graph, the colors are ranged with the heaviest at the right and the lightest at the left. You can see from the number of squares for each color how to "balance the scales": It might take twice as much green to have the same visual weight as purple, but six times as much yellow.

| Yellow | Orange | Red | Blue | Green | Purple |

As you squint, you peel off layers of meaning: You can identify less of what you're seeing, but you see more of the formal elements that artists worry about—line, mass, form, value, and so forth.

When composing a scene with two or three dominant colors, try balancing them equally in light intensity and in the weight they receive in the scene. Accent colors should not only contrast in color, but in light intensity and in area of the scene occupied. For instance, let's say we're creating a bed of perennials using a pastel lavender, pale sulfur yellow, and shell pink. All three are of about the same light intensity when you squint. Accent colors, such as a strong blue or red, should occupy just a small portion

of the scene. A little bit of bright red or blue would harmonize with the colors above and be of a contrasting, darker value than the pastels.

For another example, let's say we're creating a scene with green leaves, water, and a path. The water is usually very dark. So the leaves of the plants may be very dark, and the path also, perhaps made from a dark mulch or asphalt. Then flowers—of light color and texture—or light-leaved plants and whitish rocks can be used as accents.

Meanings in a scene direct our thinking. The statue of the mounted cavalry officer in the park is meant to inspire us with a sense of his brave deeds. A glimpse of brightly colored tiles through the dark leaves of patio plants can mean there's more to see if we continue on. When we squint, and we shut down intellectual meanings in favor of composition and structure, we are moving from the rational side of our minds to the intuitive.

In the intuitive side of the mind, we respond to inspiration. Here's where new, transforming ideas are born. Squinting—simple though the technique may be—is the perfect garden designer's tool for seeing clearly.

ENGAGING THE SENSES

What is it about a hike that's so totally refreshing? And how can we get some of that quality into our gardens?

You reach the moment of exhilaration, after some effort, when the trail climbs up to a high vantage. The sun warms and the breeze cools sweat-shiny skin. The forest air is clean and sweet. Distances are defined by the dim

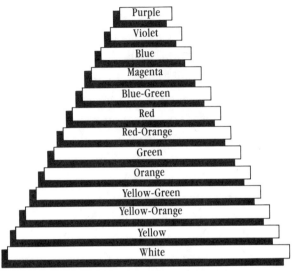

Colors Ranged by Intensity. Colors have different light intensities as well as different visual weights. Some, like clear yellow, are naturally brighter than others, such as blue-green. Again, you can easily see the light intensity of colors by squinting at them. In this graph, the higher the intensity, the higher the bar.

rush of a faraway waterfall plunging down a gorge, and the air is alive with birds' song. Ripe huckleberries beckon from the side of the trail.

The experience is exhilarating because all of our senses are engaged at once. We are viewing a vista of more or less grand proportions compared with the confines of everyday life. We feel the sun and breeze, smell the forest air, hear the waterfall and birds' song, and taste the berry.

Of course, all our senses are always engaged when we're awake: We feel the armchair, see the TV, smell the meatloaf, and so forth. But routine dulls the awareness. We don't think about the fact that we feel the soft covering of the upholstery or that the soles of our feet feel the insides of our shoes.

Our awareness, then, is usually focused on input from one sense at a time—the TV, for instance, or the feel of silk between our fingers. We're gathering information through one sense, and we're usually unaware of routine inputs from the others.

On a nature hike, however, we're not gathering information. We are working at walking and climbing, and our awareness becomes centered on all the physical senses acting in sync—rhythmic breathing, repetitive muscle flexing, purposeful movements of the eye to see where the next step will go. When we reach a promontory and rest, our senses are all open and ready to drink in the totality of the scene, which, because it is extraordinary, fills us with a deep enjoyment and sense of well-being.

Gardens for All the Senses

It's possible to construct a natural garden that lures our awareness out to cover all our senses. Two techniques will help capture that magic.

First, we can provide for each sense. We may decide to include lamb's-ears just for their downy feel or choose a flower for its scent rather than its looks. This idea lends a romantic, Victorian feel to our garden.

Second, and much more to the point, is the idea of appealing to more than one sense at a time. Garden designer Vince Healy, who creates gardens for children and hospices for the dying, says, "A way to make a small garden unusually satisfying is to focus on the stimuli reaching two or more of the senses simultaneously—and with equal intensity." He gives the example of a stand of aspens in a breeze. The leaves shimmer, and they rustle in the breeze.

Another example is the damask rose—equally appealing to the sight and smell.

Appealing to more than one sense with stimuli of equal intensity "has the effect of mesmerizing the viewer," Healy says in his monograph *The Hospice Garden.* A waterfall mesmerizes our sight and hearing equally—and our touch as well, if we happen to be standing underneath it.

In these examples, the sensual stimulation comes from a single source. But it is possible to mix sources and still retain a strong appeal to a viewer. For instance, we visited a small garden with a central court faced with fired enamel tiles. A tiled basin of water stood at the center. Around the edges of the tiled court were palms, bamboos, and other exotic plants. A few sparks of color from trailing flowers mingled with the green of the broad leaves, and from behind the scene came the sound of falling water. The sound was subtle, the use of flower color was subtle, but they were of equal intensity and made an equal appeal to the senses. They compelled a viewer to stop for a moment—as though the scene contained a message and it was important to figure out what was being communicated.

Appealing to Each Sense

There is no question that gardens appeal most strongly to our visual sense. One reason why people plant large beds of violently colored annual flowers is to make a strong visual statement. In their earnestness, they overdo it and make a visual assault. Nature rarely makes a visual assault, and neither does the natural gardener.

(continued on page 96)

DESIGN A GARDEN FOR THE SENSES

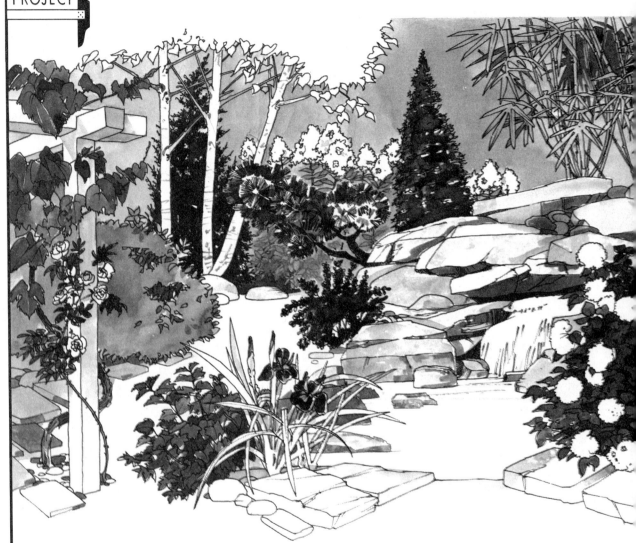

When we're outdoors, we often encounter only one sensory appeal at a time: a fragrant honeysuckle, the sound of running water, an eye-catching trumpet vine, the silken surface of a water-worn rock, or the delightful succulence of ripe wineberries. In this garden design, we want to bring all these appeals into our own yards, so we can enjoy them every time we step outside.

We'll appeal to our sense of hearing with a small waterfall softly babbling as it spills over rocks—a soothing sound that will interact with all the other sense appeals to hold the viewer spellbound. The water runs to a pool that can feature hardy water lilies (*Nymphaea* spp.) and other water plants and be stocked with goldfish or koi to add visual interest and eat mosquito

larvae. (For specifics on waterfall and pool construction, see chapter 7.) The pool can be bordered with spring cinquefoil (*Potentilla tabernaemontani*) in the sunny spots, European wild ginger (*Asarum europaeum*) in the shade, and ajuga (*Ajuga reptans*), also called bugleweed, holding the middle ground and linking the two.

Fragrant plants make a strong appeal to the sense of smell. On the right of the path around the pool, you can plant a fragrant snowball (*Viburnum × carlcephalum*) shrub, which will fill the air with a delicious cinnamon-freesia scent in late April and May and treat viewers again in fall with a rich red and burgundy foliar display.

On the left side of the path is a pergola leading to the patio and house. You can plant deep red, floriferous 'Climbing Chrysler Imperial' roses to ramble over it. 'Chrysler Imperial' will scent the warm, moist June air with a heady rose fragrance. Besides the visual and aromatic appeal, the pergola will appeal to the taste buds if you add a 'Canadice' grapevine, which bears very sweet, seedless grapes that ripen in September.

On the right, near the water, plant a clump of purple and pink Japanese iris (*Iris ensata*, formerly *I. kaempferi*), with its stunning, handkerchief-like blooms, to add color. Make another appeal to the taste buds by planting a shrubby 'Red Lake' red currant between the iris and the path. Its berries are ripe but still tart in late June and continue to ripen, becoming milder and sweeter, until September.

Farther on and across the path, you can add fragrance with a common mock orange (*Philadelphus coronarius*), with June flowers that have a delicate, citrusy scent. Add subtle sound by planting a stand of quaking aspen (*Populus tremuloides*) behind the mock orange. The aspen has fine, light, gray-green bark, shimmering leaves

Plants and Features

1. Fragrant snowball (*Viburnum × carlcephalum*)
2. Boulders, stepped waterfall, pond with recirculating pump
3. Clumping golden bamboo (*Phyllostachys aureosulcata*)
4. 'Emerald Green' arborvitae (*Thuja occidentalis* 'Emerald Green')
5. Red-leaf barberry (*Berberis thunbergii* 'Atropurpurea')
6. Japanese iris (*Iris ensata*)
7. 'Red Lake' currant (*Ribes* 'Red Lake')
8. Pergola with 'Climbing Chrysler Imperial' and 'Canadice' seedless grape
9. Common mock orange (*Philadelphus coronarius*)
10. Quaking aspen (*Populus tremuloides*)
11. East of Rockies: dwarf white pine (*Pinus strobus* 'Nana') West of Rockies: Japanese black pine (*Pinus thunbergiana*)
12. 'Thundercloud' phlox (*Phlox paniculata* 'Thundercloud')

in summer breezes, and bright yellow fall color. Farther in the background, add color and textural contrast with a conical arborvitae, 'Emerald Green', also called 'Smaragd' (*Thuja occidentalis* 'Emerald Green').

At the back of the garden, plant a clump of 'Thundercloud' phlox (*Phlox paniculata* 'Thundercloud') with red flowers in August that will echo the roses and provide a spot of color in the focal point of the garden. Pick up the red of the phlox with a red-leaf barberry (*Berberis thunbergii* var. *atropurpurea*). Plant it on the bank of the pool beside a "sitting stone" at the edge of the water. Behind it, add the cooling tones of a carefully pruned and maintained dwarf white pine (*Pinus strobus* 'Nana') if the garden is east of the Rockies or a Japanese black pine (*Pinus thunbergiana*) if west.

Flank these plants with another 'Emerald Green' arborvitae behind the rocks. Behind the arborvitae and pines, add a clump of clumping golden bamboo, also called yellow groove bamboo (*Phyllostachys aureosulcata*). The clump-forming bamboo will add more soft, rustling sounds to the garden and provide an appealing visual contrast to the evergreens. It's hardy to −20°F, but if you live in Zone 5, use giant miscanthus (*Miscanthus floridulus*) instead.

In a short walk through our garden for the senses, you'll be able to see wonderful color combinations, smell delightful fragrances, taste delicious fruit, hear soothing sounds, and touch the differing textures of leaves, flowers, bark, thorns, rocks, and water.

Trees for Best Bark Features

Lace-bark pine (*Pinus bungeana*) has trunks with a wonderful mottled appearance; the bark flakes off to reveal patches of green, cream, and red. Other trees with multicolored mottling are eastern sycamore (*Platanus occidentalis*), Japanese stewartia (*Stewartia pseudocamellia*), and Chinese or lace-bark elm (*Ulmus parvifolia*).

The yellow birch (*Betula alleghaniensis*) has a silvery yellow-white bark that peels away from the trunk in small, shaggy strips. Beeches (*Fagus* spp.) are known for their smooth, gray, or shiny copper bark.

Rough bark can also have interesting patterns, as is often the case with pines, including Scotch pine (*Pinus sylvestris*), which has cinnamon brown bark, and ponderosa pine (*P. ponderosa*), with yellowish brown bark in large, flat plates. A deciduous tree with interesting rough bark is the shagbark hickory (*Carya ovata*), with gray to brown bark that forms shaggy flakes.

Other trees with noteworthy bark include paperbark maple (*Acer griseum*), which has curling, papery strips of cinnamon brown bark; European white birch (*Betula pendula*), with white bark that develops black patches with age (due to problems with leafminers and birch bark borers, gardeners from the Midwest to the Atlantic should substitute the handsome river birch [*B. nigra*]); yellowwood (*Cladrastis lutea*), with smooth, beechlike, gray bark; flowering dogwood (*Cornus florida*), which has an amazing rectangular

pattern on its trunk that looks reptilian; kousa dogwood (*Cornus kousa*), which has gray- and tan-patched bark; ginkgo (*Ginkgo biloba*), with gray-brown, deeply ridged and furrowed bark; amur maackia (*Maackia amurensis*), with smooth, dark gray-brown to black bark; dawn redwood (*Metasequoia glyptostroboides*), which has shredded, fissured bark; London planetree (*Platanus* × *acerifolia*), with peeling bark that has light olive to creamy yellow mottling; Sargent cherry (*Prunus sargentii*), with smooth, red-brown bark; white oak (*Quercus alba*), with light, ash gray bark that is deeply ridged and fissured; and golden weeping willow (*Salix alba* var. *tristis*), which has bright yellow bark on immature branches.

Ten Favorite Fragrant Shrubs

1. 'Alphonse Lavallee' lilac (*Syringa vulgaris* 'Alphonse Lavallee'): strong lilac fragrance; deep purple flowers; blooms late spring; Zone 4
2. 'August Beauty' gardenia (*Gardenia jasminoides* 'August Beauty'): highly perfumed; creamy white flowers; blooms spring to summer; Zone 8
3. Clove currant (*Ribes odoratum*): very spicy fragrance; yellow-and-red tubular flowers; blooms early spring; Zone 5
4. Common mock orange (*Philadelphus coronarius*): light, citrusy fragrance; white flowers; blooms late spring to early summer; Zone 5
5. Garland daphne (*Daphne cneorum*): delicate perfume; pink flowers; blooms in spring and again in fall; Zone 5
6. Japanese wisteria (*Wisteria floribunda*): heady sweet scent; lilac-blue flowers; blooms summer; vine must be trained into a standard to form a shrub; Zone 4
7. Koreanspice viburnum (*Viburnum carlesii*): koreanspice viburnum, burkwood viburnum (*V.* × *burkwoodii*), and fragrant snowball (*V.* × *carlcephalum*) are all strongly clove-scented; white flowers; bloom midspring; Zone 5
8. Shrub roses (*Rosa* spp.): rose scented; 'Fragrant Cloud' has particularly intense perfume; shades of red, white, pink, rose, and yellow flowers; bloom summer; Zones 3-6, depending on species
9. Sweet pepperbush (*Clethra alnifolia*): highly fragrant; white or pink flowers; blooms summer; Zone 4
10. Winter honeysuckle (*Lonicera fragrantissima*): richly fragrant; creamy white flowers; blooms early spring; Zone 5

Because the visual sense is so dominant in our species and in our customs—our children are taught to look at picture books or TV before they know how to speak—the task of the natural gardener is to bring the visual appeal into some semblance of balance with the appeals of the other senses. At the same time, we need to think of ways to increase the appeal of the other senses in our gardens.

Taste can be given its place by using the concept of edible landscaping; that is, planting food-producing plants as part of the landscape design. Nature does this, of course. Piñon pines cover the Sangre de Cristo mountains with harvests of sweet, piny nuts. Wild apples litter the eastern landscape. The whole world is an edible landscape: Imagine what a hillside of sweet green grass looks like to a cow. So remember the human taste buds—let the sweetest blackberries represent the briar patch, and hide plump strawberries among the sun-loving groundcovers.

The sense of touch is stimulated not only by what we feel, but by the feeling of what we see. We don't have to touch a spiny cactus to imagine its feel. Similarly, textures, whether we can touch them or not, are an important part of the tactile experience of the garden. Other ways to stimulate the sense of touch are to make paths of very soft shredded bark interspersed with areas of rock and gravel to add variety to the walking experience. If you're willing to walk a path like this in bare feet, you'll experience the changing textures directly, but even thin-soled shoes will let you feel the path's changing composition. Tell visitors who will walk on your garden paths a story by the way you vary the materials.

The story of a life can be told in fragrance: honeysuckle evoking the overgrown summer woods of a childhood home, apple blossoms recalling a spring vacation in the country, roses bringing back a vivid picture of your grandmother in her garden. Scent is the most powerful stimulus to memory—you may not remember that your grandma even *had* a garden until the smell of roses throws you back in time. Make your garden meaningful with fragrance.

Sound in the natural garden is made by essentially one of three things: the wind sighing in the boughs or rustling the leaves; the sound of water gurgling, falling, splashing, tinkling, and bubbling; and the sound of animals, such as birds, which we invite in through our attention to natural details.

Natural Details

When gathering inspiration in nature, take note of how each of your senses is affected by natural details. Note the relative strength of the appeals to the senses. Rank them from one to five in order of strength. Later, at home, when you're trying to recreate the emotion of the scene, you'll find that these relative appeals are the backbone of your approach.

Gardens have an enchanting quality when they're designed with all the senses taken into account. An exercise to develop your sensitivity to sensory appeal is to design a garden for a blind person. The four senses of touch, taste, hearing, and smell are all that count. Tactile elements should be closest to the visitor. Scent can be emphasized or de-emphasized by proximity to the visitor. Sound sources, such as water, can similarly be designed for near or far. When the exercise is over, you may find that

because these four senses are in place, the visual sense will be too, and all you'll have to do—if anything—is adjust the flower colors for a delightfully stimulating garden.

As in nature, the natural garden will provide narrow and wide focuses for the attention. At times, scenes will stimulate several senses at once for heightened awareness, and at other times, they will focus on one aspect. These variations are what create interest.

RANDOMNESS IN NATURAL GARDEN DESIGN

When we want to make a drift of spring-flowering bulbs appear natural, we scatter them randomly across a garden bed, planting them where they come to rest. At first glance, you might conclude that trees and plants, water, outcroppings, and pathways in nature are similarly placed at random. But pure randomness is pure chaos, and that's not what we see in nature.

The natural landscape is full of organization, from the simple crystal lattice of a grain of quartz to a whole highly interdependent ecological system like a tropical rain forest. It is the combination of randomness with the order imposed by natural forces that makes wild landscapes so appealing.

We need to understand and cooperate with these forces when siting the elements in a natural garden. The more we think about how forces operate in nature, the more natural our own garden designs will look. The effect of each force can be duplicated in our gardens. But first, we need to recognize these forces in action. They include gravity, mountain making, sunlight, wind, freezing and thawing, biology, and weather.

Gravity

Decaying rock outcroppings drop pieces of stone down slopes. Earth, sand, and gravel slide downhill. Rainwater runs downhill, carrying earth and stone with it. Fallen trees tumble into ravines. Trees that grow at the tops of crumbling banks often cling precariously there with their trunks arched gracefully out and over the land below.

In the home landscape, trees can be trained to arch over a path below a bank, giving a beautiful effect of gravity's pull on their trunks. Beeches (*Fagus* spp.) especially can develop a natural curve in their trunks that appeals to me, but any tree will do. The simplest way to make a leaning tree is to choose a young sapling, cut the roots on the side away from the direction of the tilt, and tilt the tree to a 30-degree angle, packing soil and rocks under the cut roots so they re-root. Make sure you cut no more than a third of the sapling's roots. Since most of the roots remain uncut, the tree simply regrows in the new position. It's best to do this with a tree that is 5 to 8 years old and not too big. And it's best to do it in the early spring, before the tree leafs out. Cut only enough roots on one side to allow you to push the tree over to the desired angle. Another option is to tie down a young sapling, anchoring the guywire to a stake and running the wire through a section of hose where it contacts the trunk. If you don't have a suitable sapling, you can simply plant a young tree at a slant.

I once saw a beautiful specimen of goldenchain tree (*Laburnum* × *watereri* 'Vossii') arched over a path with its long panicles of yellow flowers hanging over the heads of passersby. It was quite spectacular, especially because the

tree swung out and over the path to display its flowers.

Mountain Making

Rock and earth move upward over geologic time in periods of mountain building. Rocks appear in folded, layered bands. The altitude of a place affects the kinds of plant life that can grow there. Think of the soil as being constantly eroded away from the underlying rocks and the internal forces constantly pushing rock to the surface. One of the prettiest stone walls I ever saw was made with flat stones laid at 45-degree angles, suggesting an upthrusting sheet of folded rock emerging from the ground. The property overlooked the Potomac River in Virginia, and the water behind the wall set off the stones and increased their dramatic impact.

Sunlight

Availability of light is the greatest determining factor in the density and kinds of plants in a given spot. When gathering inspiration for a natural garden, notice how the elements are arranged in relation to the path of the sun across the sky. More than almost anything else, the availability of sunlight determines the display of leaves and nature's choice of plants for a given spot.

When planning your home garden, learn where the sunlight falls and for how long, which places get morning sun and which get afternoon sun, and which areas get dappled sun, bright shade, and deep shade. Choose plants that fit each of these conditions. While some plants tolerate the range of solar input from full sun to shade, others must have deep shade or full sun.

When you think of the different kinds of plants that grow in sunny meadows and in mature woods, you'll see that the availability of sunlight determines the kinds and densities of plants in nature. When designing your own yard, track the path of the sun across the yard during the day. Find which areas are in full sun, partial shade, and full shade, and for how long. Then choose plants to match your conditions.

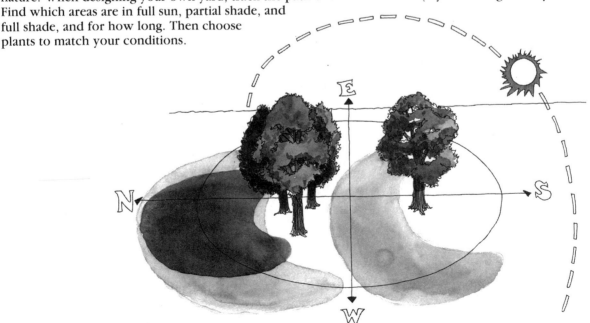

Wind

Winds move sand and earth, and they sculpt living plants. Where they blow strongly and constantly, they limit the plants that will grow in a given spot. If your property has an exposed, windy area, choose plants carefully for that place. A windy spot might be the place for a stand of quaking aspens, which show off in the breeze. But vines like clematis and any broad-leaved plant can take a real beating in the stiff gusts of thunderstorms. Make sure vines are on sturdy supports, and plant them on the side toward the prevailing winds. That way, they'll be blown toward their supports, rather than off of them.

Freezing and Thawing

The freezing and thawing of water cracks open rocks, heaves the land, diverts winter runoffs, and affects the landscape in many other ways. Where the ground freezes deeply, low spots may form what are called vernal pools, that is, small ponds that persist until the soil thaws through and the low spot drains. These spots provide habitat for spring peepers (the singing tree frogs) and homes for wild plants like skunk cabbage and cultivated plants like hellebores.

Biology

Evolution is a major force, for all the native plants in a natural scene have evolved or co-evolved there to fit the area's physical and environmental forces. Another biological force is allelopathy: Some plants produce substances that prohibit other plants from growing near them. There are countless other biological forces: Roots split rocks; vines strangle trees. Man-kind is a mighty biological force that affects the landscape. A given type of soil favors some plants and not others. The reproductive strategies of plants, including the way they scatter seed or send out creeping stems or rhizomes, have a lot to do with how plants are arranged in nature. The presence of grazing or browsing animals has great impact on the features of the landscape, creating meadows and allowing the proliferation of plants that cattle avoid, like the multiflora rose.

Another example of biological forces acting on the landscape is the impact that a beaver has on the North woods. In your home garden, you may want to reproduce that impact by building a small dam on a watercourse, or suggest it by making a dam of flowering shrubs for a pool of stones behind.

Weather

Temperature extremes, rainfall patterns, heat accumulations, and the like, all contribute to the final look of a natural place. These forces limit the plants that will grow well and naturalize in a given area to those that are native or convergent, that is, from climates much like your own. Exotic plants may grow in your garden, but they probably won't naturalize unless they are convergent plants. For gardens that don't require lots of maintenance, use plants that are suited to your climatic conditions, such as stonecrop (*Sedum* spp.) and hens-and-chicks (*Sempervivum* spp.) in hot, dry areas.

One of the wilderness's chief attractions is that mankind hasn't interfered with the placement of the elements in the scene. They represent the forces of nature at work—every natural

scene displays the result of the interaction of all the forces.

HARMONY AND BALANCE

The job of the natural gardener is to place elements in the garden scene as nature does. The site of every object in the garden should answer the question: "Why is that there?" We may choose to place a boulder where it might have ended up had it rolled down a hill to our garden. Or where it may have emerged from a glacial till as the surrounding soil was washed away by ten thousand seasons.

Can you feel the presence of large boulders somewhere down under the earth? Can you feel them slowly rising toward the surface—or rather, the surface slowly descending toward them? Look at your site. Where would one of these boulders emerge? Get a feel for it. Then bury the bottom two-thirds of the boulder to make it look like it's coming out of, rather than going into, the ground.

When judging the suitability of a site for a particular plant, the more physical or biological reasons for its suitability, the more perfect the site. For instance, who hasn't been struck by the beauty of white birches against dark conifers in winter? Let's say we want to reproduce this effect in our natural garden. The effect is given by the relationship between birches and conifers, so we must first select our viewing site, then the site for the background conifers, and finally, the placement of the birches.

I've noticed that conifers like to mass on the north sides of hills, and therefore would choose a viewpoint that looks south toward a

When you're siting rocks in the landscape, try to achieve a natural-looking, satisfying arrangement. When you've sited the rocks, bury the lower part of each rock so they look as if they're rising from the earth—don't just plop them down on the surface. (1) Three rocks of varying sizes and textures. (2) The three rocks placed in a harmonious grouping, looking as if they might have ended up there naturally. The two smaller rocks balance the large rock. (3) The three rocks lined up in a stiff row like wooden soldiers. There's nothing natural or interesting about this arrangement.

northern slope, or simply the north side of a fence. I'd adjust the spot to give the conifers maximum sunlight. I'd plant them where the soil is deep and not over a subsoil outcropping of solid rock. To the north of the conifers, I'd plant the clump of white birches so that their white trunks could be seen against the dark green mass in the background. The conifers would throw a partial shade, which the birches tolerate.

When actually planting the conifers and birches, we need to give them balance. The word "balance" here refers to an innate sense of harmony that human beings seem to have. Balance is very simple—it is an arrangement of objects that satisfies our sense of harmonious composition. Take any three objects, such as three different rocks, and arrange them any way that seems balanced. An evenly spaced straight line seems very static and unsubtle. A much more satisfying arrangement is for the two smallest rocks to be relatively close together and the third larger rock at some distance, their masses balancing on an unseen focal point somewhere between them.

In a natural garden, try to use plants as Nature might. The goal is not to border our beds with bright colors, but to pay homage to natural beauty with artistic interpretations of it.

ASSESSING YOUR GARDEN SITE

Now that you're familiar with the various principles and techniques of natural garden design —including the golden section, squinting, engaging the senses, randomness, and harmony and balance—it's time to start sizing up your own property. One of two possibilities faces every homeowner who wants to create a natural garden: Either the site is occupied by existing plants and buildings or the site is pretty much a vacant lot and any design will be from scratch. If the property is a new house on an unimproved vacant lot, your design choices are nearly infinite. You have a blank slate and can install whatever landscaping appeals to you. If, on the other hand, your property already has plants on it, you'll need to assess what's there before you can start designing. The best way to start is by making a home site survey.

MAKING A SITE SURVEY

Before you begin to plan your natural landscape, make a site survey of the entire area. Draw a large map and note where the soil is rich, which will usually be in the valleys and swales, and where it's poor and dry, usually on top of rock outcroppings and under thirsty trees like maples.

Map the conditions of the four elements: where is it sunny all day, in the morning only, in the afternoon only, not at all? Where do the shadows fall? Are there wind alleys formed by trees that funnel winds to a certain spot? Where are the prevailing winter and summer winds? Are there wet spots, bogs, or poorly drained low spots with thick, gooey clay soil? Where does the soil change from a rich loam to a sandier composition?

When you complete the site map, you'll find that you have delineated a group of natural habitats. You can then begin fitting in plants that like those habitats. Choose these plants to

reproduce effects in nature that you are bringing home. Once you know the habitats available on your property, you may be able to seek out nearby wild places with the same environmental conditions. See what's growing there and how it's growing. (But remember—you're just looking for *ideas,* not plants to bring home!) This will greatly simplify your job of recreating those effects at home and increase your chances of success.

Before you can create a natural landscape design, you need to know what's in your yard right now. The best way to find out is to make a rough "map" or home site survey. Sketch in your yard's major features—house, garage, outbuildings, driveway, paths, fences, hedges, trees, shrubs, garden areas, play area, slopes, banks, valleys, rock outcroppings, water, or whatever. Indicate dips and rises with arrows. Mark in soil conditions, sunny and shady areas, windy or exposed sites, and any other features which could help you. Add compass points and dimensions and you're ready to plan!

HOW TO *REALLY* LOOK AT YOUR YARD

Once you've completed your basic site survey, the way to begin assessing any site for a potential garden is to simply be there long enough for your attention to be narrowed and focused solely on the details of that spot. Once you're totally focused on the garden site, inventory what's already there—rocks, grades, streams, flat areas, trees, shrubs, lawn, and so on. Ask yourself if you can subtract anything from the scene to improve it. Remember Michelangelo's comment —the job of the sculptor is to find the sculpture inside the stone and release it. It may be that your job as gardener is to first find the garden that's already on the site by removing what's unessential, ugly, diseased, awkward, or disruptive.

But let me give you a caution. Be very sure that the plants and trees you plan to take out are wrong where they are. My personal rule of thumb when I assess existing plantings is to keep a plant unless there's a good reason to remove it. I know a man who moved to a place that had a beautiful collection of old wisteria vines on a rotting trellis. He pulled down the trellis and vines to "clean the place up." If he had had an ounce of sense, he would have propped up the vines and rebuilt the trellis under them. Why pull out years of existing plantings to put in baby plants that will take years to get back to where you started?

Become familiar with the trees and plants you're removing. Keep the trees that contribute most to the quality of the overhead canopy with strong limbs that touch those of nearby trees. Remove noxious weeds like poison ivy or poison oak, but make sure you know what grows

in a place for a full year before disturbing the site—you don't want to unknowingly kill the wild orchids and stands of creeping phlox that may lurk beneath the woodland duff. When planning landscape changes, the natural gardener's motto is: Look first, think second, act last.

Once you've inventoried what's on the site and decided what you'd like to remove, make an inventory of what you will keep—existing trees, large shrubs that can be used as backdrops or partitions between discrete garden areas and any perennials that may be in beds or borders. These will form the skeleton of the new landscape and determine what else is planted.

COMPOSING YOUR GARDEN

When you've decided what's worth keeping and what's not, you can begin fantasizing—imagining how ideas for a natural garden will fit onto your improved property. See how each part of the landscape appeals to your imagination. If there's a steep bank that falls to a dry creek on the north slope of a hill, that might be where the elusive grouse would hide if you lived deeper in the country. That could be just the place to recreate the woodland dell you remember from childhood. It carries a certain emotional flavor. If the flavor is consistent with the flavor of the wild area that inspired you to try a natural garden, you've probably found a good site.

If your wild inspiration was mountainous, open, and sunny, find the highest, sunniest spot you have and start there. If the wild inspiration was private, sheltered, and shady, you may already have an area that fits that description. In any case, application of a wild inspira-

tion to a site will probably be most successful when the flavor of wild place and site are naturally similar.

However, if you're wild about mountains and you're starting with a bare, flat piece of ground, you can add interest with the structural features you're recreating from the wild—banks, stones, water, terraces, gravel, and so forth. To relieve a site's flatness, you can use boulders to create raised areas of soil that can be planted with ornamental grasses and shrubs. They can be any size, but a mound that reaches 12 feet tall with a diameter of 24 feet will have the effect of a small mountain.

Build these "rock piles" with large, naturally weathered boulders raised up in a jumble, then dump topsoil into the crevices between the rocks. The topsoil will form a variety of large and small flat areas of soil. Tamp these down, add more soil, and tamp again until the soil fills the crevices and spaces to the top. Now rearrange or add stones so that a pathway is formed among the areas of soil. You can make the path wind back and forth up the slope. Plant a tree that will grow large at maturity to arch over the raised area, and add shrubbery at appropriate places on the mound. (An appropriate place for shrubbery is wherever you decide it looks good.)

Soften hard rock edges with shrubs. Mass several together, rather than dotting them evenly over the mound. When the shrubs are in, plant ornamental grasses like the sedges, blue fescue, and hakonechloa to spill over the rocks like a waterfall of green foliage. (For recommended ornamental grasses, see "Ornamental Grasses for the Natural Garden," on page 106.) This

(continued on page 110)

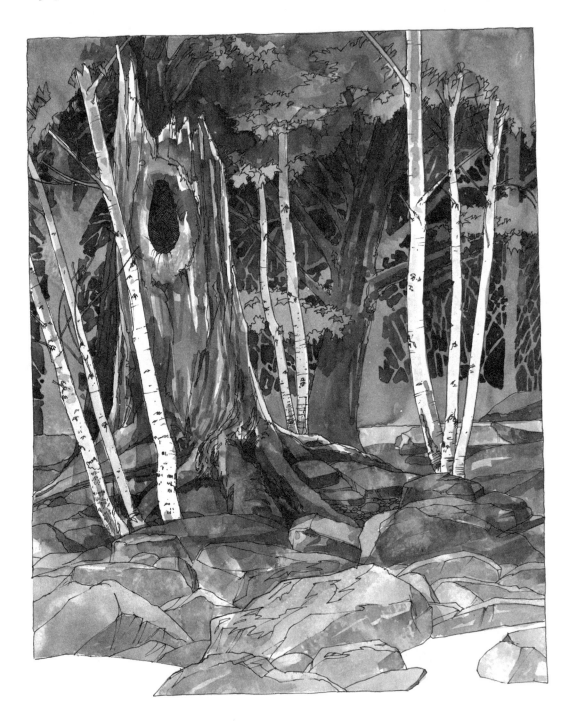

Before: This rocky, overgrown area is an eyesore. The deep shade cast by the woody tangle adds to the cluttered, uninviting feeling, and the jumble of rocks makes walking and planting difficult.

After: Creating a path and opening up the woods makes the area more accessible and inviting. The rhododendrons add a deep green backdrop, and the beautiful clematis vine provides a touch of color. Note that the old stump has been left to provide atmosphere, as well as food and shelter for birds.

ORNAMENTAL GRASSES FOR THE NATURAL GARDEN

Ornamental grasses are low-maintenance plants that give a natural look to the landscape. They add grace and movement to plantings of trees and shrubs, and their shapes and textures contrast nicely with herbaceous plants in the flower border. They're good in masses and can add four-season interest to any planting. The following are some of the most useful and widely available ornamental grasses.

Plant Name	Description	Height
Big bluestem (*Andropogon gerardii*)	Makes large clumps of upright foliage with a blue-green tint, turning orange-red in fall. Three-part flower heads appear in August.	4-6 ft.
Bird's-foot sedge (*Carex ornithopoda* var. *variegata*)	Leaves have creamy white centers with green edges. Insignificant flowers may occur in spikes or panicles.	4-6 in.
Blue fescue (*Festuca caesia*)	Forms pretty tufts of silvery blue-gray foliage. Bears panicles of small flowers in summer.	6-12 in.
Blue oat grass (*Helictotrichon sempervirens*)	Forms clumps of well-behaved, blue-green foliage. Straw-colored flower spikes occur in summer.	2-3 ft.
Crimson fountain grass (*Pennisetum setaceum* 'Rubrum')	Rich burgundy leaves form upright clumps. Purple, arching flower heads persist through the summer.	2-3 ft.
Eulalia grass (*Miscanthus sacchariflorus*)	Strong, tall, vigorous, clump-forming green grass with plumes that persist into winter. Has silvery plumes and orange fall color.	6-8 ft.
European feather grass (*Stipa pennata*)	Many slim, arching, brownish green stems form neat clumps. The showy flower heads are long, fluffy, and white.	3 ft.
Feather reed grass (*Calamagrostis arundinacea* 'Karl Foerster')	Habit is a graceful, upright clump of deep green leaves. Produces long-lasting pink flower plumes in June and July.	5-6 ft.

USDA Plant Hardiness Zone	Culture	Comments
4	Full sun. Well-drained, sandy soil. Propagate by division or seed.	Native to the tallgrass prairie.
7	Partial shade. Moist, fertile soil. Propagate by division.	Lovely planted beside a water garden.
4	Full sun to partial shade. Well-drained soil. Propagate by division.	Popular grass well suited to rock gardens and low edges. Often sold as *Festuca ovina* var. *glauca*.
5	Full sun. Well-drained soil. Propagate by division or seed.	Mixes effectively in flower borders or in naturalistic rock gardens. Formerly *Avena sempervirens*.
8	Full sun. Fertile, well-drained soil. Propagate by division or seed.	Can be grown as an annual in northern zones.
5	Full sun to partial shade. Rich, moist, well-drained soil. Propagate by division or seed.	*Miscanthus sinensis* 'Gracillimus', maiden grass, is a shorter, graceful, fine-textured miscanthus; *M. sinensis* 'Zebrinus', zebra grass, has horizontal yellow striping on its leaves; *M. floridulus,* giant miscanthus, often sold as *M. sinensis* 'Giganteus', grows to 12 ft. tall.
5	Full sun. Prefers warm, dry places. Propagate by division or seed.	Slow-growing. Difficult to germinate.
5	Full sun. Likes moist, fertile soils, but tolerates a variety. Propagate by division.	Good specimen in a mixed group of ornamentals.

(continued)

ORNAMENTAL GRASSES FOR THE NATURAL GARDEN – *Continued*

Plant Name	Description	Height
Fountain grass (*Pennisetum alopecuroides*)	Graceful tufts of green foliage and white flower spikes tinged pink in late summer and fall. Habit is fountainlike.	2-4 ft.
Golden variegated hakonechloa (*Hakonechloa macra* 'Aureola')	Graceful, compact habit with arching yellow and green striped foliage that turns a gorgeous tawny pink in fall. Panicles of reddish brown flower spikes are produced in fall.	1-1½ ft.
'Hime Kansuga' sedge (*Carex conica* 'Hime Kansuga')	A low-growing sedge with white-variegated foliage. Brown spikelets appear in summer.	4 in.
Japanese blood grass (*Imperata cylindrica* var. *rubra*)	Upright clumps of thin, light green grass blades are colored blood red on their upper portions.	1-2 ft.
Little bluestem (*Schizachyrium scoparium*)	A smaller version of *Andropogon gerardii* with reddish fall foliage. White seedheads appear in fall.	2-4 ft.
Northern sea oats (*Chasmanthium latifolium*)	Large, attractive plant with narrow, light green leaves and showy, drooping seed heads that are green when new, then ripen to brown in fall.	3-5 ft.
Orange sedge (*Carex flagellifera*)	Forms clumps of orange-bronze foliage in all seasons. Insignificant flower spikelets appear in summer.	1½-2½ ft.
Palm branch sedge (*Carex muskingumensis*)	Wide, straplike, light green leaves and buff fall color. In summer, brown flower spikelets are produced.	2-3 ft.
Plume grass, ravenna grass (*Erianthus ravennae*)	Striking, 3-ft.-long, purplish plumes form in late August and September above very tall clumps of silvery green foliage that turns brown to purplish brown in fall.	8-12 ft.
Quaking grass (*Briza media*)	Thick spikelets of purplish flowers dangle on arching stems above narrow foliage.	10-24 in.

USDA Plant Hardiness Zone	Culture	Comments
5	Full sun. Rich, moist soil. Propagate by division or seed.	Very ornamental. Good for mass plantings.
4	Partial shade. Rich, well-drained soil. Propagate by division.	Contrasts beautifully with hostas, ferns, and other shade-loving plants. Color fades in full sun.
6	Partial shade. Moist, fertile garden soil. Propagate by division.	Makes a good groundcover.
5	Full sun to partial shade. Rich, moist, well-drained soil. Propagate by division.	Leaves look especially striking with the afternoon sun behind them. Also sold as *Imperata cylindrica* 'Red Baron'. Variety spreads more slowly than the species.
4	Full sun to partial shade. Light, sandy, well-drained soil. Propagate by division or seed.	Good for mass plantings. Formerly *Andropogon scoparius.* Native.
4	Partial shade. Rich, moist soil. Propagate by division or seed; also self-sows.	Makes a nice flower display that persists for months. Native. Formerly *Uniola latifolia.* Spreads slowly from rhizomes.
7	Partial shade. Moist, fertile soil. Propagate by division.	Good for adding a spot of unusual color; striking with reddish rocks.
5	Partial shade to full shade. Moist, fertile soil. Propagate by division or seed.	A native American sedge.
5	Full sun. Moist, well-drained soil. Propagate by division or seed.	Makes a showy specimen plant.
4	Full sun. Poor soil. Propagate by division or seed.	Spikelets tremble or "quake" in the breeze. Good in dried arrangements.

(continued)

ORNAMENTAL GRASSES FOR THE NATURAL GARDEN – *Continued*

Plant Name	Description	Height
Switch grass (*Panicum virgatum*)	Narrow green leaves with an upright habit turn yellow in fall. Large, open, airy panicles of beige flowers in midsummer.	3-6 ft.
Tufted hair grass (*Deschampsia caespitosa*)	Mounding, compact tufts of green foliage that persist into winter. Bronze or yellow flowers in large, airy panicles bloom late June through August.	3 ft.
Variegated Japanese sedge (*Carex morrowii* 'Aureo-Variegata')	Yellow central stripes on mounding clumps of fine-textured leaves. Insignificant flowers appear in summer.	6-12 in.
Yellow meadow foxtail (*Alopecurus pratensis* 'Aureo-Variegatus')	Broad, yellow leaf margins and dense 3-in.-long flower heads in spring.	2 ft.

small mountain will also have spaces for alpines and miniature shrubs. Place the mound toward the back of the yard and mass tall, dark evergreens behind and to the sides of it. Hide its complete shape from view, and you'll suggest a larger land mass than is actually there.

If you have slopes, you may want to consider a watercourse with falls. When looking up a slope, you need dark background shrubs at the top to set off the tiers of plants ascending the slope. Some shrubs' flowers look best when viewed from below; shrubby abutilons are examples. Some flowers look best when viewed from above. It's a nice garden experience to look down a slope into the open cups of magnolias and franklinia or onto the billows of flowers covering any tree that blooms over its entire crown, such as mimosa, crabapple, and flowering cherries, peaches, and plums.

DON'T FORGET THE HOUSE

Think about how close you can bring the natural garden to the house. Ideally, you'd merge the house and garden so that the buildings become gazebos and indoor and outdoor spaces merge almost imperceptibly into one another. Outdoor rooms and patios with trees growing in them right outside the house's main windows are effective in carrying us from the house to the garden with as little transition shock as possible.

Don't forget practical considerations when

USDA Plant Hardiness Zone	Culture	Comments
5	Full sun. Well-drained soil. Propagate by division or seed.	Native. Can become weedy.
5	Full sun or shade. Any soil. Propagate by division or seed.	Good for naturalizing.
5	Partial shade. Moist, fertile soil. Propagate by division or seed.	An outstandingly beautiful groundcover.
5	Full sun. Fertile, moist, well-drained soil. Propagate by division.	Makes good groundcover.

you're siting garden features. Every place on your land has a certain proximity to the house, and that will generally determine how much you'll do to it. The areas right around the house have better access to tools, and because they're close, it's easier to keep an eye on them. They are also the places that visitors are most likely to see and explore. The farther from the house the place on the property, the less you want to have to do to it.

Think about watering the garden. Unless you're designing a xeriscape, or dryland garden, with drought-resistant plants that almost never need supplemental water, watering will be a fact of life for much of each growing season. Are you going to run a water line to a spigot in the garden or to an installed irrigation system?

Or are you just going to drag the hose out there? Whatever your plans, the ease of watering should be a paramount consideration. You don't want to have to drag 150 feet of garden hose to the back of the yard each week, then haul it back to the shed.

OPENING NEW VISTAS

Look at your site with Darrel Apps's concept of "progressive realization" in mind. Dr. Apps is a landscape designer and horticulturist who believes that approaches to a house are best when they progressively open new vistas before the viewer as he or she walks up the path. Twists in the path take the visitor behind shrubs

(continued on page 116)

DESIGN A JAPANESE GARDEN
FOR YOUR BACKYARD

For centuries, the Japanese have reproduced nature in small garden settings, and they are the world's masters of this garden style. We can use their techniques to enrich our own natural landscapes, especially in small gardens close to the house.

The garden pictured here works with landforms, water, plants, and stone. To create it, build a river of cobbles or gravel that winds from the patio back into the landscape. Make it swirl around the base of our focal point—three large rocks set in a harmonic group. Behind the rocks, plant a berm with groundcovers to form a peninsula of low green growth. (You can learn more about berms in chapter 1.) Crown the berm with a group of three trees, two of which will flower consecutively in spring. Underplant with azaleas. In the right foreground, add a low-growing mugho pine.

At the left corner of the yard, plant another berm with groundcovers and top it with a dense, pretty Russian hawthorn (*Crataegus ambigua*). In the shade thrown by the hawthorn, set up a *tsukubai* arrangement: a bamboo flume that drips water invitingly into a simple stone basin. The arrangement of stones around the flume and basin should be very traditional, as shown: The basin sits on a rock that the Japanese call the setting-down stone. Water flowing from the basin drips into a river of cobbles called the sea, which

is designed to slope slightly, carrying water away. In front of the basin is what is called the front stepping stone, inviting the passerby to stop there and contemplate the simplicity and peace of the garden. A larger rock called the protection stone flanks the arrangement. You can plant yellow flag iris and ferns in back of the *tsukubai* arrangement, or substitute bamboo and grasses.

As the left berm continues back toward the house, add another mugho pine (*Pinus mugo* var. *mugo*) to echo the one on the right. Finish the picture with a Hinoki false cypress (*Chamaecyparis obtusa*) and a tall clump of giant miscanthus (*Miscanthus floridulus*).

Japanese gardens can be made much more distinctly American by eliminating the pagodas and celadon dragons and substituting a simple group of pleasing plants. The ideas behind a garden like this include:

• Simplicity with no clutter and an informal grace.

• A restrained and subtle use of plants, with the emphasis on foliage, mass, and shape rather than on flowers and color (although our garden features plenty of flowers).

• A willingness to work with the site, including existing plantings and the view of the surrounding landscapes.

This kind of garden is like a miniaturized glimpse of the wide world brought home. And as you can see, it fits very nicely into our concept of landscaping with nature.

Tsukubai:
TRADITIONAL JAPANESE FLUME AND BASIN ARRANGEMENT

Making the Flume

Before assembling the bamboo flume, cut the spout piece on a slant to make a lip at the bottom. When the flume and tsukubai are set up, let the water run at a slow drip.

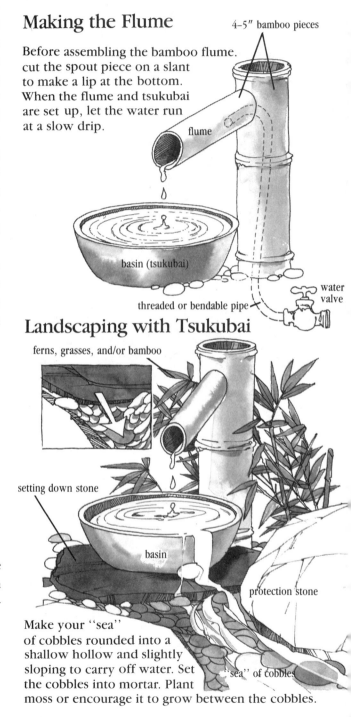

4–5″ bamboo pieces

flume

basin (tsukubai)

threaded or bendable pipe

water valve

Landscaping with Tsukubai

ferns, grasses, and/or bamboo

setting down stone

basin

protection stone

"sea" of cobbles

Make your "sea" of cobbles rounded into a shallow hollow and slightly sloping to carry off water. Set the cobbles into mortar. Plant moss or encourage it to grow between the cobbles.

Favorite Plants
for Your Japanese Garden

1. Groundcovers: liriope (*Liriope muscari*), with areas of ferns, such as the exquisite hedge fern (*Polystichum setiferum*) or Japanese silver-painted fern (*Athyrium goeringianum* 'Pictum', also sold as *Athyrium nipponicum* 'Pictum'), and hostas (*Hosta* spp.) in shade; common thrift or sea pink (*Armeria maritima*), woolly yarrow (*Achillea tomentosa*), stonecrop (*Sedum* spp.), and hens-and-chicks (*Sempervivum* spp.) in sunny spots

2. Japanese maple (*Acer palmatum* 'Dissectum')

3. Sargent crabapple (*Malus sargentii*)

4. 'Shogetsu' oriental cherry (*Prunus serrulata* 'Shogetsu')

5. Russian hawthorn (*Crataegus ambigua*)

6. Yellow flag iris (*Iris pseudacorus*)

7. Ferns such as lady fern (*Athyrium filix-femina*) or hay-scented fern (*Dennstaedtia punctilobula*)

8. Mugho pine (*Pinus mugo* var. *mugo*)

9. Hinoki false cypress (*Chamaecyparis obtusa* 'Gracilis')

10. Giant miscanthus (*Miscanthus floridulus*)

11. Azaleas (*Rhododendron* spp.)

and in back of berms in order to reach the front door—which is often invisible from the street.

Remember that people enjoy twisting paths that reveal information as they walk. People just plain like to discover what's around the next bend. Always encourage exploration of the garden, but discourage any sense of entrapment. Create several ways out of a glade. Avoid the cul-de-sac. Even the gopher has a back door.

One way to open new vistas and add excitement to your property is by adding a Japanese stroll garden. A stroll garden has a clearly designed path that leads the visitor through a series of experiences making a maximum use of space. Such a stroll recalls our trips to the wilderness, where our hikes revealed surprises beyond every turn—a deer beside the path, a wildcat track, a hawk overhead, a breathtaking view. If we were alert to the experience, each new discovery suggested something deep and meaningful. Can we recreate a particularly uplifting hike we have taken in the setting of a stroll garden at home? Why not? Find the emotional key to each experience on the hike and recreate it around the little bends of the stroll.

USING PLANTS IN THE LANDSCAPE

Once you've assessed your site and planned basic features like slopes and paths, it's time to think about plants. Siting plants in a natural setting is a mixture of science and art. The science is in knowing the various environments of the property and the needs of the plants, then fitting them compatibly together. The art is to site them cleverly with flashes of insight as to what the plants might like. (See "Thinking Like a Plant" on the opposite page.)

"Plants are used to form foreground, background, or frames for activities or views," Dr. Apps says. "Whether we like it or not, the lines, forms, textures, and colors of plants are seldom consciously seen or noticed by most people. This is because the average viewer's eye is in constant motion, envisioning changing views as he moves. Generally, a person views whole scenes and pays little attention to detail unless that person has been specially trained. Be aware of this "total vista versus individual plant principle, and be careful not to use too many different plants or your home could become a focal point in a botanical zoo."

In other words, casual garden visitors don't usually look at individual plants, even if we gardeners do. To the garden visitor, our rare pink deutzia is just another low shrub filling a portion of a border. Visitors look at overall effects, just as we do when we hike into the wild country and find our way to a shaded promontory, then take satisfaction from a tree-framed view out into a sunny distance. We have not yet focused on the pretty little fleabane at our feet, although if we spend some time in that place, we will begin to notice the details.

The idea is to be aware that most of your garden plantings will be seen as unremarkable herbage by most visitors, and that if you want to draw attention to a plant, you must put it in a

spot to which the eye is drawn by virtue of composition or color. For instance, placing a pale pink shrubby rose like 'Gruss an Aachen' within a group of dark-leaved foliage plants obviously pulls the eye to the pale pink of the flowers. Less obvious, and even more beautiful, is to stand at the vantage place where the garden will be most often seen, look at the existing composition of terrain and plants, and find the spot where the eye naturally alights. That's the place for a specimen or featured plant, such as a glorious double-file viburnum, or a standard wisteria (one that's trained to grow into a tree form).

THINKING LIKE A PLANT

When siting plants in the natural garden, it helps to think like a plant. If we have a shrub to place—let's say it's a rhododendron—we have to find the site in which the plant will be happiest. This calls all our knowledge into play: We know it likes some shade, moisture, acid soil, and protection from strong winds. Once we find a place with those conditions, we have to identify the exact spot where it will be happiest. To do this, ask yourself a silly but important question: "If I were a rhododendron, where would I like to grow?" This kind of technique forces us to use our intuition and helps train our instincts, because we eventually get to see whether the plant is indeed happy with its spot.

For example, in siting a lenten rose (*Helleborus orientalis*) in our garden, Marilyn and I knew it liked moist, woodsy shade. We have a large stretch of just that condition under our photinias. But where within that stretch to put it? Here's where the art comes in. The lenten rose has very shy flowers that nod and avoid your gaze. So we tucked it back behind and between several prominent features in an area that doesn't draw attention. The lenten rose is not a particularly conspicuous plant to begin with, and so the spot seemed fit to the plant's shy habit.

Well, our lenten rose has thrived in that spot and in February, when the plant blooms here in coastal California (it blooms March to May in the East), it takes center stage, as the other prominent features are deciduous and out of bloom at that time of the year. There are several weeks, then, when the lenten rose is the most spectacular plant in the whole shady area.

I would not have predicted such success for our lenten rose, but in retrospect, the siting process was right. We gave it the environmental conditions it likes, with a graceful placement that took the plant's nature into account. Human understanding seems made for this game. Fitting the plant to the site and then watching to see if your instincts are right is one of the chief joys of gardening.

This can also be a useful technique for finding plants that will be happy in a challenging site—a hot, sunny, rock-strewn spot with soil on the dry side, for example. Try creating a miniature mountaintop by arranging rocks. Then, look for low-growing plants that will look good when tucked between them and will also thrive in full sun and dry soil. Sedums and hens-and-chickens (*Sempervivum* spp.) fit the bill perfectly. They're low growing and will flourish in

the conditions the site naturally has to offer. In addition to requiring virtually no maintenance, they are available in a delightful variety of colors and textures, so you can use them to create a rich alpine patchwork.

Each of us is making a journey of self-discovery when we landscape with nature. Discover yourself in your likes and dislikes in nature, then display your discoveries in the form of a garden design.

LANDSCAPING WITH NATURE

Landscaping with nature means forming a partnership: Nature provides the inspiration; we provide the landscaping. It's a creative partnership, not a monkey-see, monkey-do business. If we're thrilled by a meadow of beautiful wildflowers, we don't just grab a shovel and start digging them up. We respect our landscaping partner—what we "grab" is the *idea:* a wildflower meadow.

The wildflower meadow that inspires us may be a miles-wide sea of orange California poppies washing against the base of the Rockies, or a midwestern prairie with brilliant flowers like jewels sewn on a backdrop of native grasses, or even a roadside display of "weeds" like Queen Anne's lace, cornflowers, mullein, and yarrow, with their lovely soft tapestry of complementary colors and textures. But the meadow we imagine in our yard may be a few hundred feet along a split-rail fence, planted with a cheerful combination of the most colorful wildflowers and some natural-looking garden flowers.

We may be thinking of planting black-eyed Susans, bachelor's buttons, blue lupine, Indian blanket, coreopsis, California and Shirley poppies, gloriosa daisies, purple coneflowers, bee balm, crimson clover, and evening primroses in our meadow garden. But after a little reading, we discover that most wildflower meadows rely on grasses for year-round texture and structure, with the wildflowers providing seasonal color. So we modify our original idea, adding switchgrass for structure, tall clumps of maiden grass as accents, and fountain grass for its graceful

beauty. We decide to tailor our meadow to plants that grow well in our area and focus on perennials, so we drop the poppies, lupine, bachelor's buttons, Indian blanket, and clover, and add butterfly weed, yarrow, goldenrod, and New England asters. Our wildflower meadow won't look exactly like anything we've seen in nature, but every time we look at the beautiful, naturalistic fencerow, it will speak to us of the loveliness of wild meadows.

Gaining inspiration from nature begins when we're moved by its beauty. Our garden re-creations remind us of these memorable occasions, taking us back to those wonderful places—at least in our minds—each time we see them. When we landscape with nature, we surround ourselves with a personal vision of natural beauty. Our home landscape becomes not only beautiful but meaningful.

Meaning adds layers of interest to the landscape. Suppose we want to create a little bird sanctuary at the back of our property. While a visitor looking at the sanctuary area might see a naturalistic shrub border, we would see autumn olives, Cornelian cherries, European cranberrybush viburnums, winterberries, rugosa roses, and other fruiting shrubs preferred by birds. We'd enjoy the trumpet vine, morning glories, and honeysuckle climbing adjacent tree trunks, and the colorful planting of bee balm, phlox, salvia, nicotiana, cardinal flowers, and cleome—all favorites of hummingbirds. When we refilled the birdbath, we'd be thrilled again at how natural it looked, just like a large stone with a dip in the middle, when we'd really made it from concrete.

Our bird sanctuary would be lovely, but it would also be interesting, because of the diversity of plants and wildlife, from the bees and butterflies drawn there by the flowers to the myriad birds that would feed, bathe, and nest there. There would always be plenty to see and think about. We'd often take along a field guide in case something new showed up, and might even keep a nature journal to follow the seasons in our backyard.

No matter where a beautiful natural place occurs—East, Midwest, or West, North or South—it is relevant to gardeners everywhere. We can reproduce what we see as beautiful in the wild with a fair degree of accuracy at home, using elements that are similar or sometimes quite different from those we found in nature. There are vivid examples of this in the pages that follow. Throughout, the emphasis is on helping you choose commonly available plants to recreate the beauty of nature in your own backyard.

We'll start with the elements that make up natural landscapes—stones, water, wildflower meadows, woodswalks. Then we'll inspect some wild landscapes for what they can teach us about the way nature puts together color, form, materials, and plants. Finally, we'll look at wildlife in the landscape. And throughout, we'll see how some of the most creative gardeners in America have used these natural lessons to produce gardens and yards of incredible beauty.

To show how wild inspiration helps to create colorful backyard reality, let's begin with wild beach grasses and then glimpse the garden they inspired.

On visits to Mount Desert Island on the coast of Maine, Jacqueline and Eric Gratz were struck by the beauty of the native beach grasses, as shown at left. Back home in Baltimore, Maryland, they were inspired to incorporate the beauty of grasses into their home landscape. They called on Wolfgang Oehme (of Oehme, Van Sweden and Associates, Washington, D.C., landscape architects known for their use of ornamental grasses) to design the garden shown below. Here, a golden pool of black-eyed Susans (*Rudbeckia fulgida* 'Goldsturm') in the Gratz garden shows to advantage against a backdrop of two grasses, feather reed grass (*Calamagrostis acutiflora* var. *stricta*) on the left and tall eulalia grass (*Miscanthus sinensis* 'Gracillimus') at right.

Stone in the Garden

Stones are the "bones" of the earth. Their place-
ment creates planting areas within the garden.
Their beauty and functions are often overlooked.

They relieve the repetitious green colors,
fine textures, and regular shapes of plants with
earthy colors, bold textures, and variable shapes.
When we look closely at most natural scenes,
we see how dramatically stones influence the
picture. To appreciate and work with stone is to
set a good foundation for any natural landscape.

Water-worn cobbles once lined an Ice Age beach
on the shore of Lake Superior. When the glacial
ice melted, the land rose, lifting the beach a few
hundred feet above the present-day lake shore. In
time, mosses and strands of grass colonized the
soil accumulating between the stones. My wife,
Marilyn, and I liked the contrast between hard
stone and soft moss, and we liked the way the
cobbles appear to be islands in a soft, green
sea. We wanted to try to use this effect at home.

We drove to the beach at Russian Gulch on the
Sonoma Coast and selected a bag full of interest-
ing cobbles in the outwash of a seasonal creek
that empties into the ocean there. At a local
nursery, we bought a flat of Irish moss (*Sagina
subulata*) and laid it around a small pool of water
under an old apple tree outside our living-room
door. We inserted the stones in areas cut out of
the moss carpet. This scene captures the spirit of
that far-off beach and adds an unusually beautiful
touch to a frequently visited place in the yard.

Naturally occurring stones nestled into beds of
moss can also inspire a more formal treatment.
Here, old Boston street pavers planted with
low-growing white clover were used to create a
place that can support the occasional automobile
as well as heavy foot traffic, yet still look pretty
and unforced. How much nicer this is than an
area of white gravel that needs constant weeding.

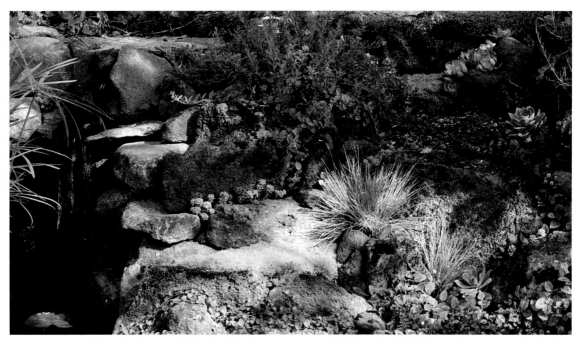

This naturalistic stone wall in our own garden was inspired by the rocky bank bordering a rushing mountain creek. Instead of a sheer wall with a flat face, the natural bank we admired ascended in steps, with flat areas of soil where plants were growing. We created this wall to reproduce that effect. A blue-flowered morning-glory (*Convolvulus mauritanicus*) cascades from top center. The flat spaces between rocks are planted with pools of lime green Irish moss (*Sagina subulata*), tufted sprays of blue fescue grass (*Festuca ovina* var. *glauca*), sedums, and echeverias for a rich, tapestry-like effect.

Just one stone like this pretty white and gray rock can create a spot of dramatic landscape interest. An evergreen 'Matsayu' azalea brushes the hard stone with its soft apple-blossom pink blooms, and blue star creeper (*Laurentia fluviatilis*) washes it with a sea of tiny bluish white flowers. In the colder zones, you can reproduce the effect with a yako rhododendron (*Rhododendron yakusimanum*). This azalea-like plant stays low (to 3 feet), carries pink buds that open to white flowers, and is hardy to −20F°. Similarly, you can plant perennial candytuft (*Iberis sempervirens*) rather than the tender blue star creeper.

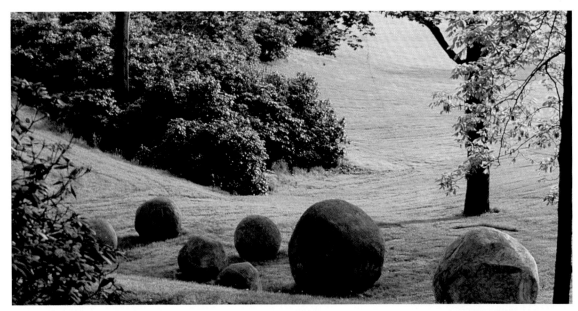

Round stones can also add drama in groups. At a first glance, sculptor Grace Knowlton's arrangement of rocks entitled *Spheres* seems to be moving across a green lawn at Storm King Art Center in Mountainville, New York. At a second glance, they might also have rolled there like marbles tossed down a slope by Nature's hand. This playful use of natural rocks adds humor, movement, and interest to an otherwise static, if serene, spring landscape. The stones-in-a-field motif is useful in many landscape situations, but seldom is it used so well. The point for your own yard is that here, a simple group of stones have transformed a lawn into a landscape.

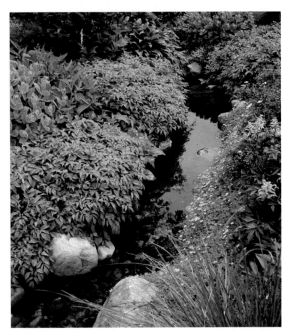

Stone forms a natural landscape partnership with foliage and with water, as this stream in the Alexander garden in East Hampton, New York, demonstrates. Low-growing, fine-leaved peonies grow along the left side of the stream, with sedum behind the stream in the center, and yellow creeping Jenny (*Lysimachia nummularia*) on the right bank. The whitish rocks are used sparingly, but to great effect, in a very natural placement.

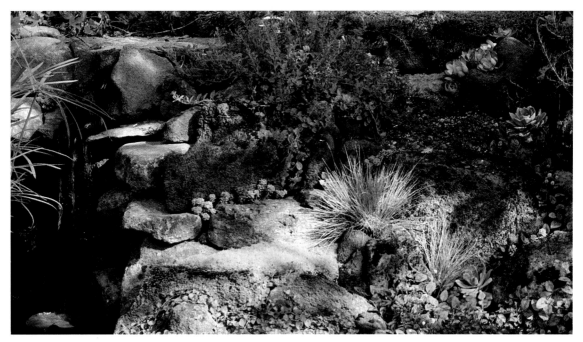

This naturalistic stone wall in our own garden was inspired by the rocky bank bordering a rushing mountain creek. Instead of a sheer wall with a flat face, the natural bank we admired ascended in steps, with flat areas of soil where plants were growing. We created this wall to reproduce that effect. A blue-flowered morning-glory (*Convolvulus mauritanicus*) cascades from top center. The flat spaces between rocks are planted with pools of lime green Irish moss (*Sagina subulata*), tufted sprays of blue fescue grass (*Festuca ovina* var. *glauca*), sedums, and echeverias for a rich, tapestry-like effect.

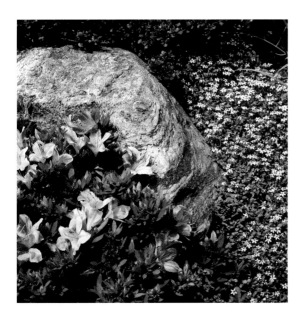

Just one stone like this pretty white and gray rock can create a spot of dramatic landscape interest. An evergreen 'Matsayu' azalea brushes the hard stone with its soft apple-blossom pink blooms, and blue star creeper (*Laurentia fluviatilis*) washes it with a sea of tiny bluish white flowers. In the colder zones, you can reproduce the effect with a yako rhododendron (*Rhododendron yakusimanum*). This azalea-like plant stays low (to 3 feet), carries pink buds that open to white flowers, and is hardy to −20F°. Similarly, you can plant perennial candytuft (*Iberis sempervirens*) rather than the tender blue star creeper.

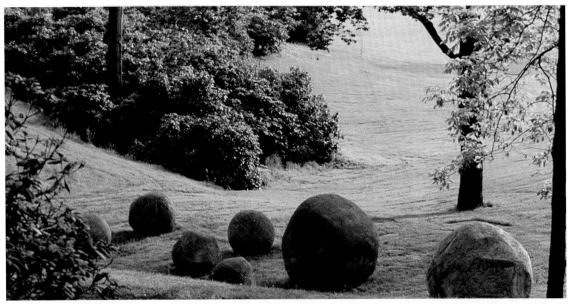

Round stones can also add drama in groups. At a first glance, sculptor Grace Knowlton's arrangement of rocks entitled *Spheres* seems to be moving across a green lawn at Storm King Art Center in Mountainville, New York. At a second glance, they might also have rolled there like marbles tossed down a slope by Nature's hand. This playful use of natural rocks adds humor, movement, and interest to an otherwise static, if serene, spring landscape. The stones-in-a-field motif is useful in many landscape situations, but seldom is it used so well. The point for your own yard is that here, a simple group of stones have transformed a lawn into a landscape.

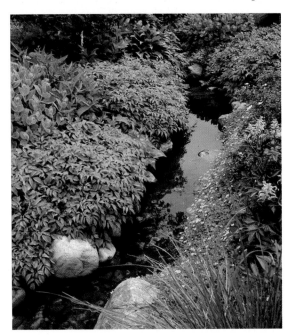

Stone forms a natural landscape partnership with foliage and with water, as this stream in the Alexander garden in East Hampton, New York, demonstrates. Low-growing, fine-leaved peonies grow along the left side of the stream, with sedum behind the stream in the center, and yellow creeping Jenny (*Lysimachia nummularia*) on the right bank. The whitish rocks are used sparingly, but to great effect, in a very natural placement.

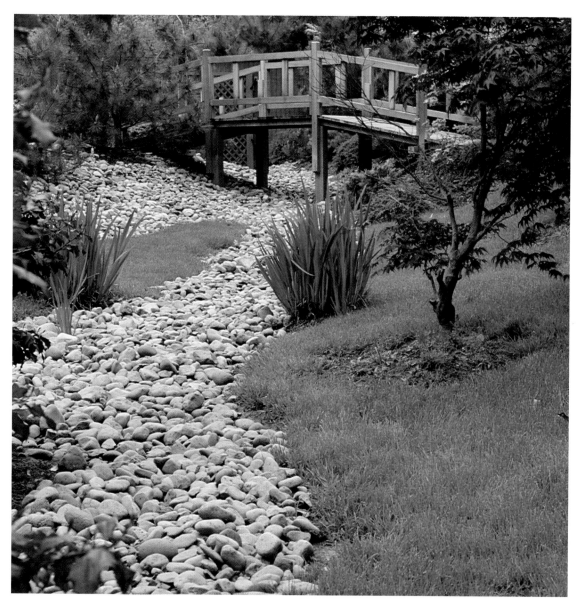

Stones can stand not only for themselves in the landscape but also for other elements, such as water.
Here, a "river" of stones dramatically suggests a streambed. The stones – cobbles from the shores of the
Delaware River – line a low trough where surface water runoff from strong rains naturally flows,
turning necessity into a landscape virtue. Stoney Bank Nurseries of Gladwyne, Pennsylvania, who
created the design, wisely installed an island of grass and iris in midstream to relieve the expanse of
stones and broke the edge where grass meets stone with another clump of tall iris. The 'Bloodgood'
Japanese maple (*Acer palmatum* 'Bloodgood') on the right directs the eye upward toward the bridge,
which adds conviction to the water theme. These simple and subtle – but very important – touches add
focal points for the eye and interest to the scene. If you can't have "real" water in your landscape but
enjoy its effect, design a river of rock for your yard.

Landscaping with Water

Water is the most attractive landscape element
of all, but few of us have grand sweeps of it. We
may have a modest length of stream, however,
or a backyard pool for water lilies and goldfish.
Water has much to teach us about the landscape.
If we're willing to look and learn, we can restate
those teachings using grasses, wood, or stone.

Tufted islands of wild hatpins (*Syngonanthus flavidulus*) are anchored in a
shallow stream in western New Jersey. What a wonderful idea to borrow for
the home landscape. Two hatpin look-alikes are the 'Spring Beauty' grass
pink (*Dianthus plumarius* 'Spring Beauty'), which has red flowers and
makes a nice tuft of blue-green foliage when out of bloom, and 'Dusseldorf
Pride' sea pink or common thrift (*Armeria maritima* 'Dusseldorf Pride'),
which also forms dense tufts of fine foliage. Plant them in shallow pots set
on a base above the water line: Sea pink won't tolerate wet feet.

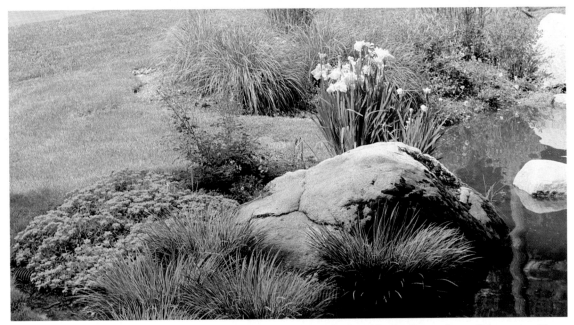

Bog plants in nature are often tufted and spiky, contrasting nicely with the flat surface of the water. You
can create the same effect around your backyard pond with readily available plants. In this backyard
re-creation, clumps of grasslike liriope (*Liriope muscari*) in the foreground echo the shape of the
hatpins above, while the clump of yellow-flowered goldmoss sedum (*Sedum acre*) at the left echoes
the shape of the large pondside rock. A Japanese iris (*Iris ensata*) makes another vertical statement
behind the rock.

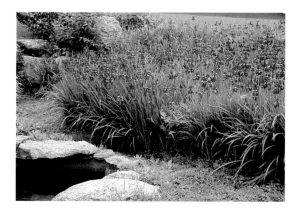

A well-established clump of Siberian iris (*Iris sibirica*) provides stunning bloom color as well as spiky foliage. The lively iris makes a strong contrast with the placid stones and water.

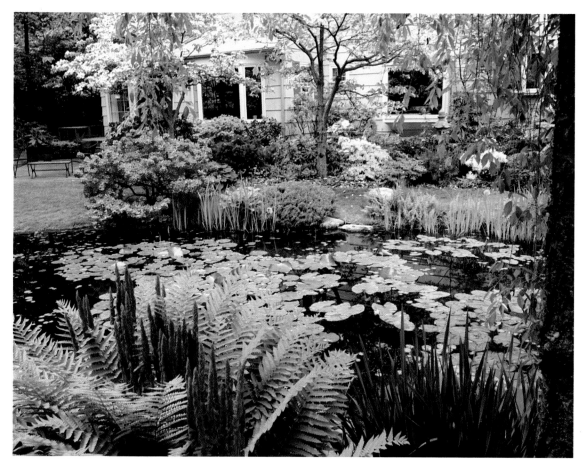

The brilliant colors of azaleas enliven the gorgeous lily pond designed and built by Mitsuko and Andrew Collver at their Long Island home. Strong verticals of yellow flag iris (*Iris pseudacorus*) line the pond's edge by the azaleas, reminding us of the wild hatpin, while cinnamon fern (*Osmunda cinnamomea*) focuses the attention with a dramatic spray in the foreground.

The long, slender foliage of bur reed (*Sparganium minimum*) and little rounded leaves of water-shield (*Brasenia schreberi*) subtly decorate a beaver pond in northern Minnesota. The leaves float in the two-dimensional plane of the water's surface, giving a restful effect, as opposed to the active look of the tufted plants on the previous pages. You can recreate this restful look in your backyard pond with the flat leaves of water lilies.

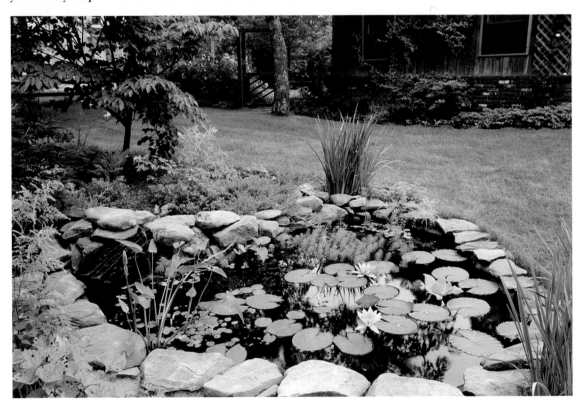

Round water lily leaves floating on a small pond give a calm and restful look to the backyard landscape. When these plants bloom, they produce the most spectacular and exotic flowers in the whole garden. This water garden would be easy to install in any landscape.

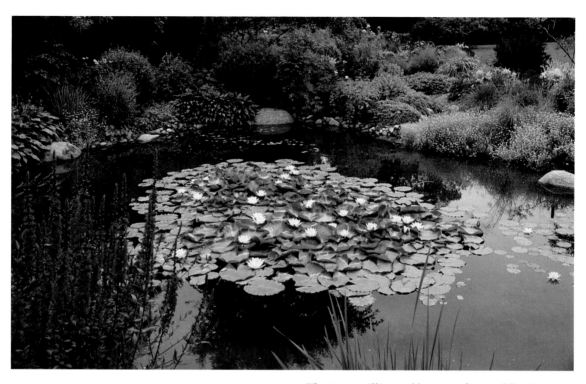

The tranquillity and beauty of water lilies is even more pronounced in a larger setting, as in this well-designed pond. The water lily flowers are cups of pale yellow light in the dark water. The cherry red flower spikes of loosestrife (*Lythrum salicaria*) in the foreground and background plantings add a major color accent, and the large stone at the far end of the pond echoes the shape of the mass of water lilies, the focal point for the whole composition. If you'd like a loosestrife accent for your own pond, buy only named cultivars, which are usually sterile; the species itself is a beautiful but noxious weed that spreads rapidly and overwhelms native species.

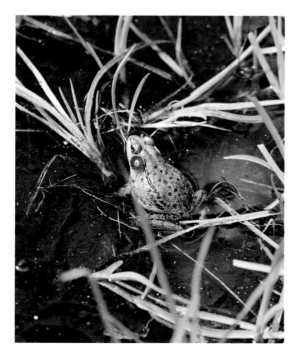

Not all the benefits of a backyard pond are horticultural. You might find that green frogs will come to live in a man-made wetland. Frogs, tadpoles, and fish keep backyard ponds free of mosquito larvae and other pests, in addition to providing entertaining antics.

Nature's Details: Bark

Nature's beauty can be so overwhelming that we sometimes get lost in a grand scene. When we're landscaping with nature, it's important to focus our attention on the small details as well as the big picture because it's often these details that matter in the backyard. In the sequence that follows, bark takes center stage.

If you're hiking in the New Hampshire mountains, you might stop for a moment to drink in the sight of nature's glorious fall colors blazing from the trees. You might be struck by the lovely white bark of the native birches and think, "I want white bark in my landscape."

If you live in the East, consider planting a stand of white birches like this where you can see them from a window. These birches emerge from a luminous bed of variegated bishop's weed (*Aegopodium podagraria* 'Variegatum'). Bishop's weed (also called goutweed) is invasive, but here the gardener has tamed it with a barrier in the soil. On the left is a mature clump of fine-leaved fringed bleeding-heart (*Dicentra eximia*).

If you live on the West Coast and want white bark in your landscape, consider planting one of the white-barked eucalyptuses. Here, candle-bark eucalyptus (*Eucalyptus rubida*) contrasts well with an underplanting of evergreen and decidu-ous shrubs in a natural-looking landscape artfully designed by Marshall Olbrich in Occidental, California. The conical juniper's color, texture, and shape create sharp visual opposition to the eucalyptus's open airiness.

Wildflower Meadows

For many of us, Nature's beauty is best expressed in her wildflower meadows, and a natural garden is a garden of wildflowers. From the stunning sweeps of alpine tundra with their spring coats of brilliant color, to the exuberant bloom of the prairies, to a riot of aster and goldenrod in an abandoned field, Nature goes all-out with her wildflowers. The photos that follow show us how to do the same, even if we only have a foot or two for flowers.

Lavender lupines (*Lupinus latifolius*) dominate a wildflower meadow near the timberline on Mount Rainier in Washington. White tufts of beargrass (*Xerophyllum tenax*) and red tufts of Indian paintbrush (*Castilleja miniata*) have supporting roles. How to bring home such a grand scene? Imagine that Mount Rainier is the house and the meadow is an 8-foot-wide border along the sunny east wall. Plant the border with blue lupines (*Lupinus* 'Russell Hybrids'), white madonna lilies (*Lilium candidum*), and red maltese cross (*Lychnis chalcedonica*) for a close color match.

The wild lupines that thrilled us on the slopes of Mount Rainier are ancestors of the grand hybrids used to recreate a mountain meadow in this small yard. They still make quite a show, even without the breathtaking backdrop.

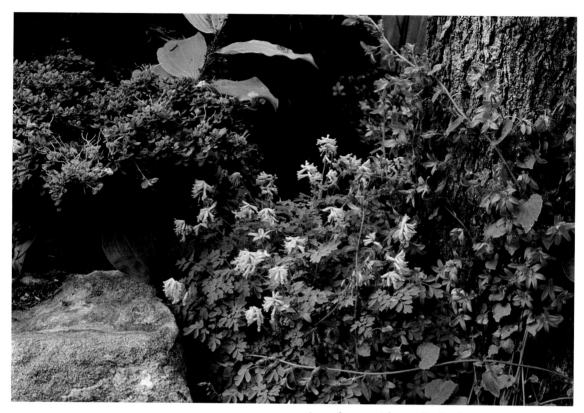

A gardener with very limited space can bring home just the color scheme of a meadow of blue lupines dotted with yellow wildflowers. In this eastern garden, the lavender-blue stars of serbian bellflower (*Campanula poscharskyana*) and pretty yellow clusters of yellow corydalis (*Cory-dalis lutea*) enhance a tiny space between a rock and tree trunk.

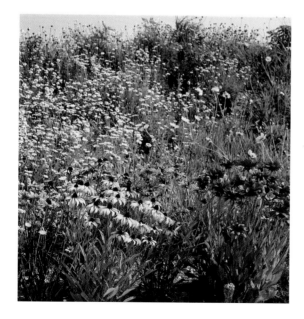

A gorgeous lupine meadow may inspire us to create a meadow scene at home, but what if we have only a difficult spot like a dry bank to work with? A fine solution is to keep the idea of the meadow, but use drought-tolerant plants in another color scheme. These golden marguerites (*Anthemis tinctoria* 'Beauty of Grallagh') and the burnished golds and oranges of hybrid black-eyed Susan (*Rudbeckia* spp.) create a dryland meadow that's really spectacular.

The hollow shell of a fallen log, rose-pink blossoms of wild rhododendron, and the ghostly white plumes of beargrass (*Xerophyllum tenax*) turn a misty Mount Hood meadow in Oregon into a magical scene of unspoiled nature. In the eastern part of the country, gardeners can suggest the exquisite sight of the wild Cascade meadow by using *Rhododendron maximum,* the great laurel or rosebay of the Appalachians, and the eastern cousin of beargrass, called turkeybeard (*Xerophyllum asphodeloides*), native to mountain woods and pine barrens, sometimes in association with great laurel. If you can't find turkeybeard at your nursery, substitute black cohosh (*Cimicifuga racemosa*), goatsbeard (*Aruncus dioicus*), astilbes (*Astilbe* spp.), or false Solomon's-seal (*Smilacina racemosa*). All of these are available from nurseries and have white plumes.

The pink and white wild meadow may inspire you to work with pink rhododendrons and azaleas at home. Even the smallest yard has room enough for a rich pink azalea and sprays of white and blue Spanish bluebells (*Hyacinthoides hispanica*), growing beautifully together here. I'd look for a fallen log to provide a backdrop for these plants, as it does in the photo on the opposite page, and complete the evocation of the Mount Hood wilderness.

Creative Natural Plantings under Trees

The areas under backyard trees present two major difficulties to the gardener: Tree roots compete intensely with other plants for soil moisture and nutrients, and it's usually very shady. Most of us try to extend the lawn under the trees, but lawn grasses need lots of water, food, and light to grow well. So we end up with sparse grass—and usually plenty of bare, muddy patches—under our trees. And when we try to mow, we damage tree trunks with the lawn mower and damage our lawn mower with the tree roots. However, it doesn't have to be that way. There are plenty of plants that grow beautifully under trees and don't need mowing. And there are more decorative mulches than you might guess, as we'll see in the following photos. What does nature do under trees and around their trunks? The answers suggest wonderful ideas for the home landscape.

A stand of aspen trees in the Clackamas Range in Oregon grows with a natural groundcover of small Solomon's-seal (*Polygonatum biflorum*) mingled with western bleeding-heart (*Dicentra formosa*). Since both are available in nurseries and grow well in understory shade throughout the United States, it is easy to recreate this combination in your yard. In the East, gardeners will be delighted to find that *D. formosa* blooms through much of the summer, unlike common bleeding-heart (*D. spectabilis*), its more well-known and showy, but shorter-lived, cousin.

A soft and pretty carpet of pine needles makes walking a pleasure under these ponderosa pines. Pine needles make an excellent mulch under other trees as well, especially maples, which tend to stick their knobby roots above the soil level. I've gathered two or three full lawn bags of needles by hand in less than 15 minutes, and that's enough to cover 100 square feet.

A stand of saucer magnolias (*Magnolia* × *soulangiana*) drops its petals to make its own extraordinary groundcover. To achieve an effect like this, keep vegetation low around the trees. Very floriferous trees, like magnolias and crab apples, and shrubby plants, like peonies, stage once-a-year displays of ground-carpeting petal drops. If you'd like to have the effect of a beautiful pale mulch year-round, try large white pebbles under the trees.

Using nature's tactic of surrounding trees with shade-loving plants, gardener Grace Rose of Berwyn, Pennsylvania, skillfully solved the problem of trying to grow lawn grass under her trees. She replaced the grass with rings of grasslike liriope (*Liriope muscari*) in the center foreground and an assortment of hostas around the three background trees. A practical benefit is that the rings prevent a lawn mower from banging into the trees and knocking off chunks of bark.

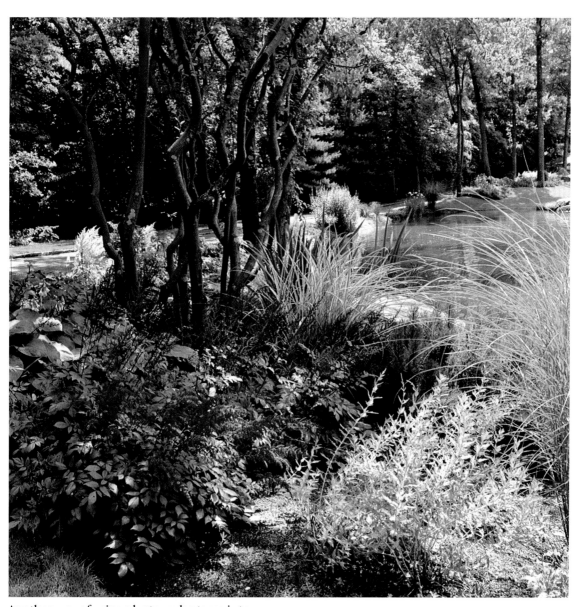

Another way of using plants under trees is to
mass several types in an island bed with the
trunks as the central focal point. This sophisti-
cated bed includes broad-leaved hostas (*Hosta
sieboldiana*), fine-textured and red-plumed 'Fanal'
astilbe (*Astilbe × arendsii* 'Fanal'), and ornamen-
tal grass. The astilbes and hostas have rich,
blue-green foliage, with the grass providing a
lighter contrast. The trunks are pruned to reveal
their interesting zigzag growth.

Nature's Details: Flowers

Simple yellow flowers, all by themselves, can be highly dramatic and beautiful in natural settings.

A field of the golden umbels and foamy green foliage of bladder parsnip (*Lomatium utriculatum,* also called spring gold) grows along the Hood River in Oregon. Lengths of downed tree limbs snake through the wildflowers. In the home garden, euphorbias would nicely imitate the appearance of bladder parsnip. And why not have an anguished limb struggling up and out of the soft bed of plants?

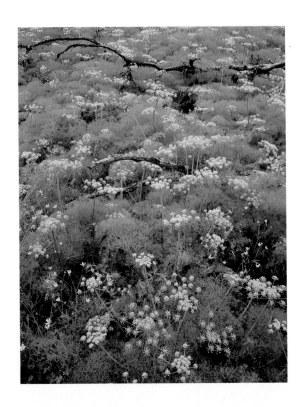

This beautiful association of plants and rocks includes the sunflower-like heads of arrowleaf balsamroot (*Balsamorhiza serrata*) interspersed with gray-green mounds of bladder parsnip and lichen-mottled chunks of reddish basalt. To reproduce this lovely effect in the home rock garden, substitute heliopsis or gaillardia for the balsamroot and silver mound artemisia (*Artemisia schmidtiana* 'Silver Mound') for the bladder parsnip.

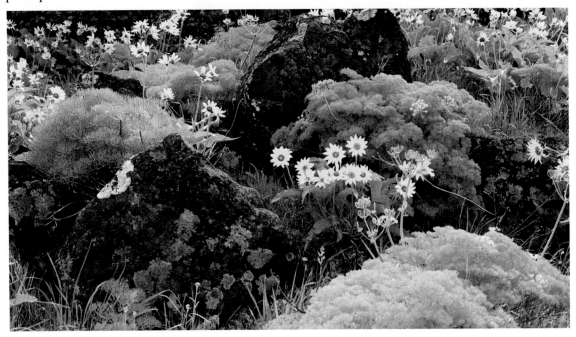

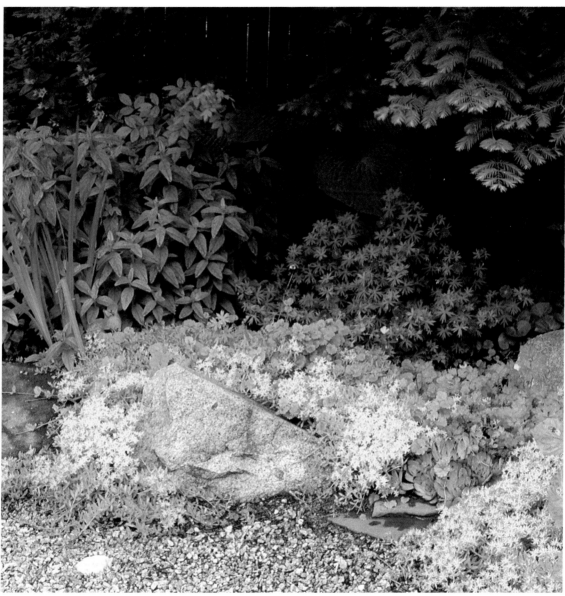

This East Coast garden displays a well-designed transition from full shade to full sun, using the combination of yellow flowers and rocks found in the Cascades. The carpet of yellow is succulent goldmoss sedum (*Sedum acre*), punctuated by hens-and-chicks (*Sempervivum* spp.). European wild ginger (*Asarum europaeum*) nestles under a hardy geranium (*Geranium sanguineum*) with its bright magenta flowers. The broad, blue-green leaves of hosta (*Hosta sieboldiana*) create a mysterious feeling in the deep background shade and contrast beautifully with the ferny branches of dawn redwood (*Metasequoia glyptostroboides*) overhead.

A Walk in the Woods

Walking down a woodland path is one of our favorite ways to enjoy nature. The path is usually shady, and we enjoy the cool, protective shade thrown by a canopy of trees, especially on a hot summer day. Interesting and beautiful plants on either side of us provide plenty to look at as we walk the path. Following the path is an adventure; we never know what's around the bend. It feels good to get some exercise. And as we walk, we have time to think, dream, or just listen to birds' songs.

A walk in the woods can be built into even small backyards. These photographs show several excellent examples.

A corner of the Collver property on Long Island was once an ordinary backyard. The all-too-typical grass and clothesline are gone. Now it is a wonderful woodland walk: a path of natural bark chips, flanked by azaleas and a Japanese maple on the right, and azaleas, cinnamon ferns, and a weeping flowering cherry on the left bordering the lily pond.

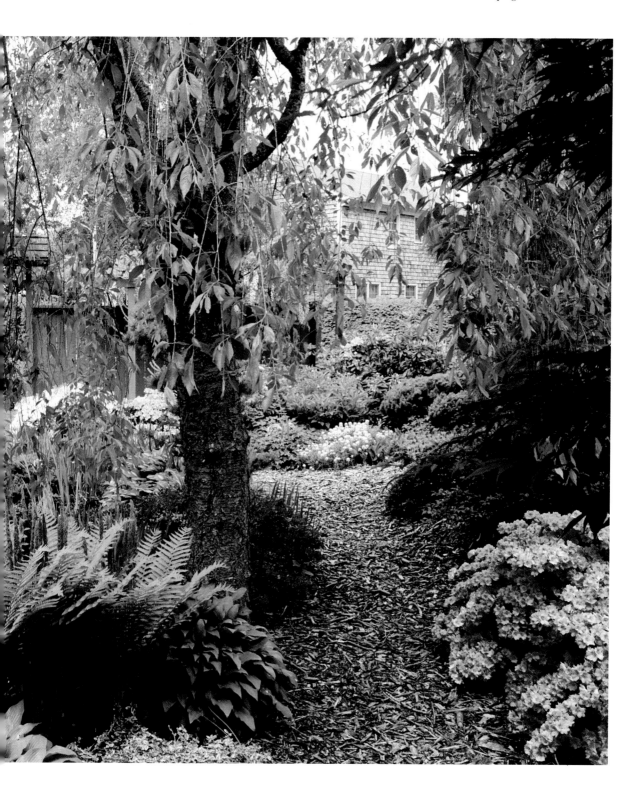

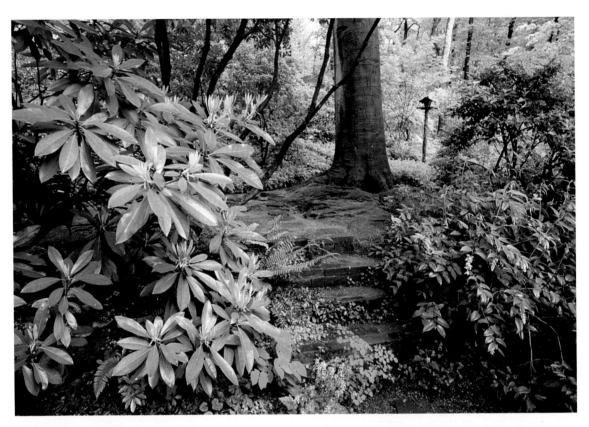

Where the shade deepens, even a short stretch of path suggests the mystery and timelessness of the forest. The rich green leaves of rosebay rhododendron (*Rhododendron maximum*) on the left and drooping leucothoe (*Leucothoe fontanesiana*) on the right flank a well-placed path in David Benner's Bucks County, Pennsylvania, garden. Accumulated mosses set with tiarella (*Tiarella cordifolia*), Christmas fern (*Polystichum acrostichoides*), and dwarf English ivy (*Hedera helix*) soften the brick steps. Moss covers the ground under the American beech tree (*Fagus grandifolia*). The leucothoe's leaves turn bronzy red in winter – a striking combination with the evergreen rhododendron.

A careful mixture of foliage colors and shapes gives this woodsy walk a formal appearance, while retaining a natural charm. These gardeners chose a fine-leaved, silver-edged winter creeper (*Euonymus fortunei*) to border the path in the left foreground, which contrasts well with the ferns and broad-leaved hostas behind it. The owners resisted the temptation to edge the entire path with one plant and instead chose plants of varied heights and forms, including azaleas, hydrangeas, iris, and peonies. The natural-looking bark path intrigues us by offering several directions in which to go.

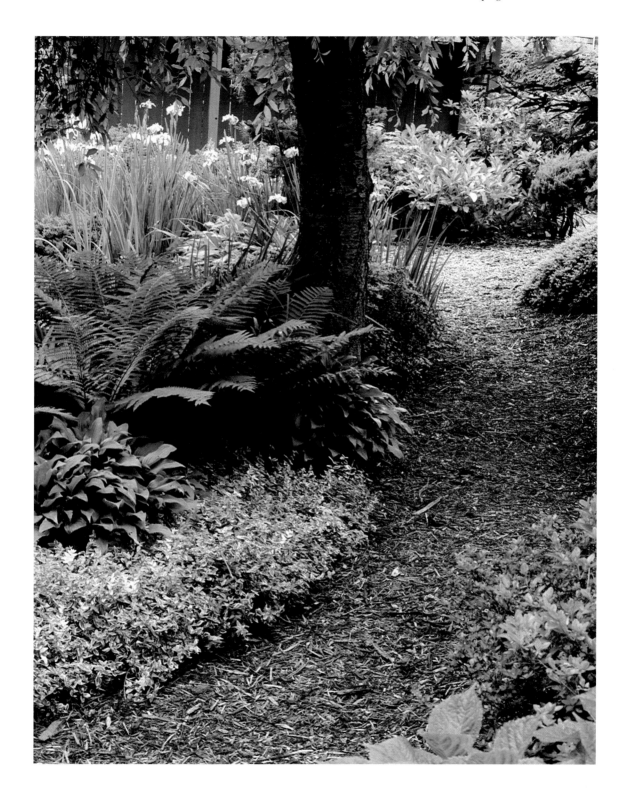

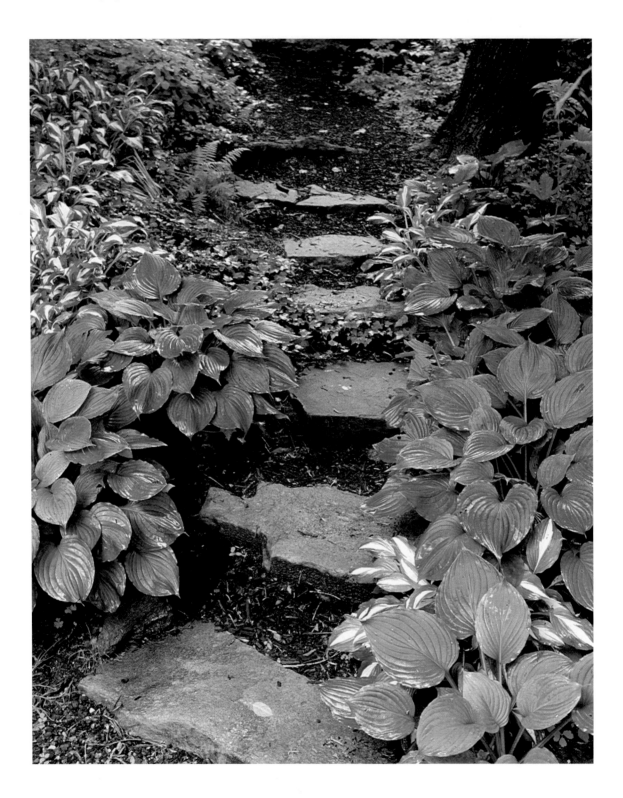

Established canopy and understory trees shade a rustic corridor between garden rooms in a landscape designed by Wayne Norton. The path of bark chips and irregularly placed flat stone steps wind through the area, slowing the walker and giving a natural appearance. Shade-loving ferns and hostas edge the path. English ivy (*Hedera helix*), native rhododendrons (*Rhododendron* spp.), eastern hemlocks (*Tsuga canadensis*), and mountain laurels (*Kalmia latifolia*) are close by in the woods. The path leads to an open "garden room" where visitors can enjoy an outdoor lunch or nap in a hammock. Norton created the densely planted path to give this "room" some privacy and to lend a sense of mystery about what lies beyond.

One benefit of creating a shady woodswalk is discovering that others come to walk it with you. A frequent fellow traveler in the East is the eastern box turtle (*Terrapene carolina*).

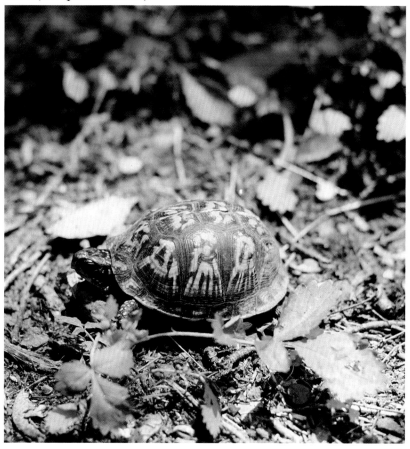

Nature's Details: Leaves

Good combinations of leaves are one of the most delightful and desirable features of designed landscapes and gardens. In the photographs on these pages, we see two inspiring examples of the way nature combines leaves and a good example of how to use this inspiration in the home garden.

The broad, maplelike leaves of elk clover (*Aralia californica*) dominate a bank of ferns in the Olympic Rain Forest in Washington. The giant holly fern or western sword fern (*Polystichum munitum*) decorates the steep bank. Below the aralia are five-fingered and deer-tongue ferns (*Adiantum pedatum* and *Phyllitis scolopendrium*) on the right, and the fine leaves and tiny white blossoms of corydalis (*Corydalis scouleri*) on the left. To recreate this scene on a shady bank at home in the East, you could substitute striped maple (*Acer pensylvanicum*) for the elk clover and use dutchman's-breeches (*Dicentra cucullaria*) to stand in for the corydalis.

The finely cut fronds of the wood fern (*Dryopteris* sp.), the cloverlike leaves of woodsorrel (*Oxalis* sp.), and the broad three-part leaves of vanilla leaf (*Achlys triphylla*) form a perfect partnership. This effect can be reproduced in most parts of North America: Where woodland conditions are found, so are native types of oxalis and ferns. You can substitute broad-leaved shade plants like mayapple (*Podophyllum peltatum*) for the vanilla leaf.

The feathery foliage of a cinnamon fern (*Osmunda cinnamomea*) and the broad, triangular leaves of the money plant (*Lunaria annua*) soften the edge of a deck. Although not as elaborate an association as the wild groupings on these pages, these plants can evoke those cool, woodsy places and remind us of their tranquillity every time we step out the back door. In the fall, silver-dollar-sized seed disks will replace the lunaria's lavender flowers.

Color in the Woods

We often think of green when we think of woodland gardening—green leaves on trees and shrubs, green vines, green moss, green groundcovers. But—as many of us have discovered with impatiens' jewel-like flowers—color and shade aren't contradictory terms. There are more shade-tolerant flowering plants than you'd guess, from native hepaticas and violets on the woodland floor to azaleas with blazing flames of flowers that lick through the forest understory each spring, and dogwood with its delicate clouds of blossoms overhead. Color accents the woods' green restfulness. The following photos show some inspiring ways to use color in your woodland garden.

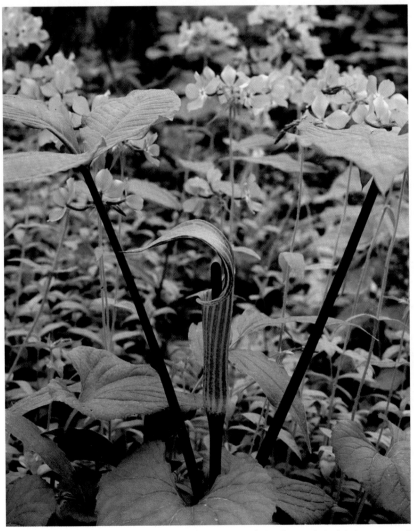

In a wild corner of an Appalachian forest, a Jack-in-the-pulpit (*Arisaema triphyllum*) displays its striking flower in front of an airy spray of wild blue phlox (*Phlox divaricata*). You can easily find inspiration in this square foot of wild woodland for more large-scale efforts at home.

Woodland gardens can be as colorful as you want. Here, the wild blue phlox (*Phlox divaricata*) is displayed to advantage with broad-leaved hostas. Behind the phlox are the rose-colored flowers of fringed bleeding-heart (*Dicentra eximia*). Farther back, the path is alight with the yellow flowers of ragwort (*Senecio* spp.). The splash of pale blue color on the wild woods floor in the photo has become a whole palette of color, thanks to the addition of shade-tolerant flowers.

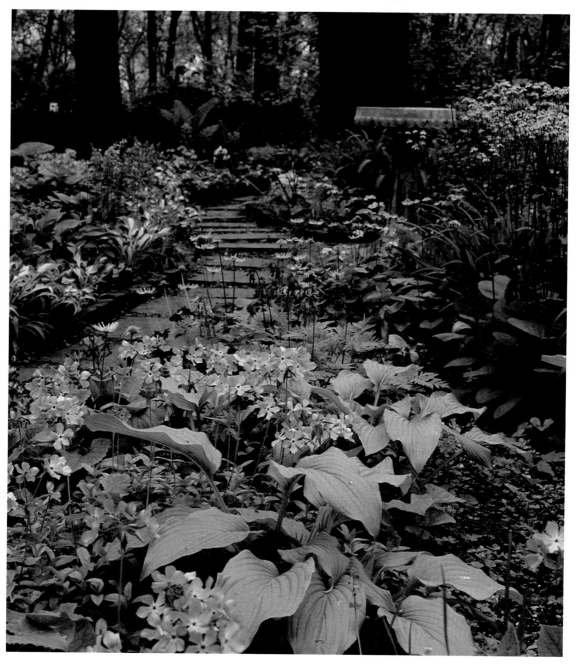

The front yard of this house in Setauket, New York, features a wide sweep of daylilies, summing up the orange and green theme Nature used in the preceding photos. Even a flower as common as the orange daylily (*Hemerocallis fulva*), in many places a roadside weed, can be very effective in the right setting. It works here because of the simplicity of the idea and the lushness of its execution.

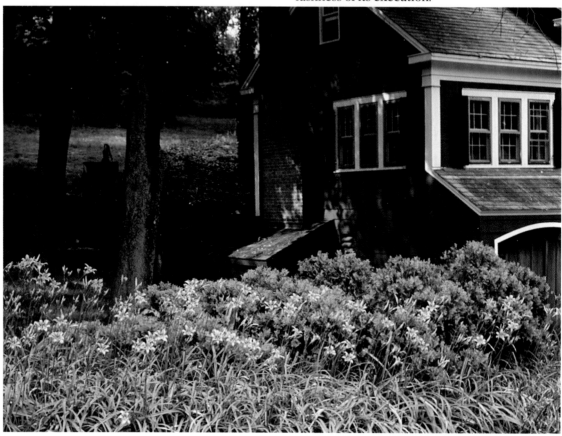

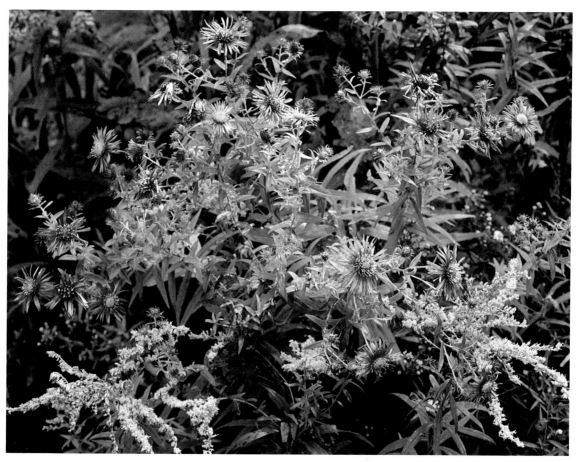

If orange is too bold for your planting scheme, substitute yellow to soften the effect. Yellow and green are another of Nature's favorite color combinations, as you can see in this roadside scene. The vibrant goldenrod seems to burst from the clump of purple asters. Cultivated goldenrods (*Solidago* spp.) such as 'Cloth of Gold' and 'Goldenmosa' make a better, more tidy show in the garden. And as everyone now knows, they're perfectly safe to plant – the villain of hayfever is ragweed, not goldenrod.

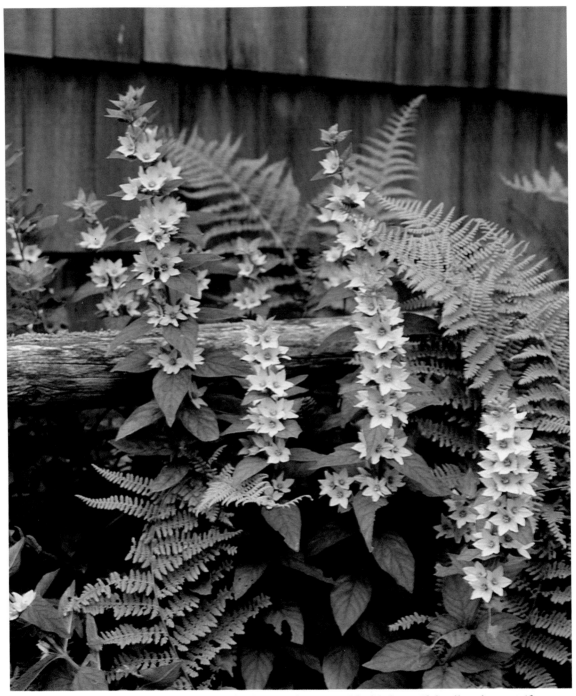

Yellow and green are also at home in the shade, as is the case with this beautiful yellow loosestrife (*Lysimachia punctata*). Note how the chains of brilliant yellow flowers echo the shape of the fern fronds behind them and how both soften the cedar-shake wall of this house.

The gardeners in this household have used nature's yellow and green theme in a powerful fall-blooming border. They've planted bright yellow rudbeckias (the cultivated form of wild black-eyed Susans) between two greens – blue-green spruce on the left and dark green rhododendrons on the right. The splash of pure white focuses the scene and gives it visual snap.

Landscapes Inspired by Nature

The remarkable series of photos on the next eight pages shows gardens designed by artist Harland Hand of El Cerrito, California. Companion photos show the exact places from which he drew his inspiration, around Silver Lake in the Sierra Nevada mountains south of Lake Tahoe, 150 miles east of El Cerrito. For each garden, we'll first see the natural site, then Hand's re-creation.

Rounded, irregular, and flowing rock forms are all part of the Silver Lake wilderness site in the Sierras. The visual strength of this landscape appeals to Hand, who is also a sculptor.

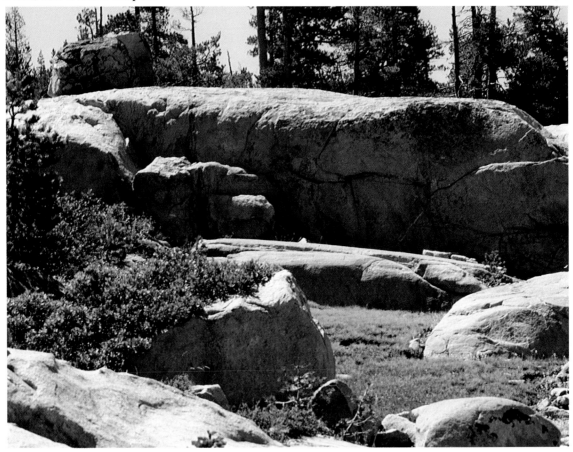

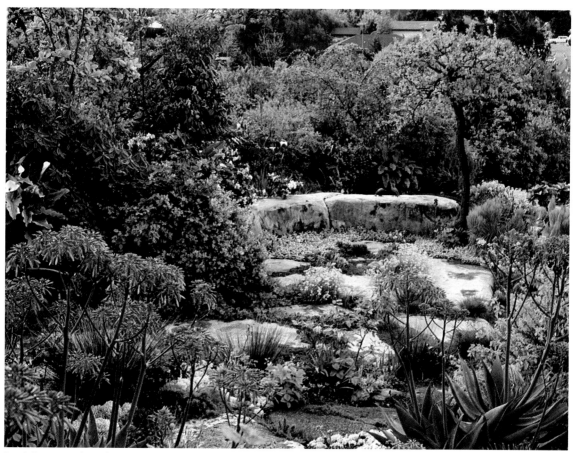

Back home at his El Cerrito garden, Hand recreated the rounded stone shapes using hand-formed concrete to suggest bedrock pushing above the soil surface. You can see how artistically he has accomplished this. The salmon-flowered plants in the foreground are aloes.

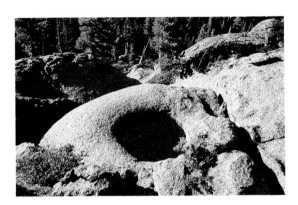

Grinding glaciers formed the pothole in these
rocks at Silver Lake.

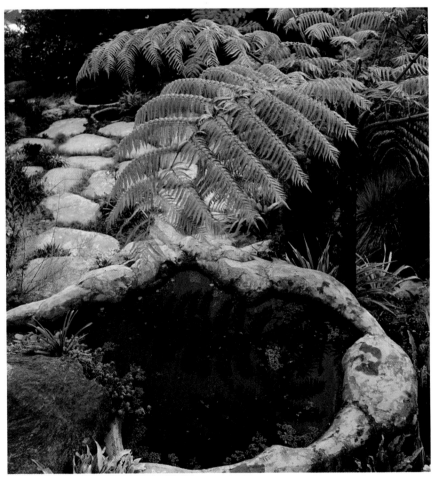

Hand's re-creation of the pothole, made entirely of hand-molded concrete,
is overarched by a Mexican tree fern (*Cimbotium schiedei*). Hand has
poured over 200 cubic yards of concrete in his quarter-acre Sierrascape.

Light-colored, glacier-scoured rock surfaces are broken by dark pools of water and tough bristle-cone pines at Silver Lake.

Hand echoes nature's use of light and dark areas in his garden. He planted sculpted bedrock fissures with "pools" of creeping thyme and the succulent blue-gray leaves of pearl echeveria, also called Mexican-gem (*Echeveria elegans*), a popular houseplant in the East.

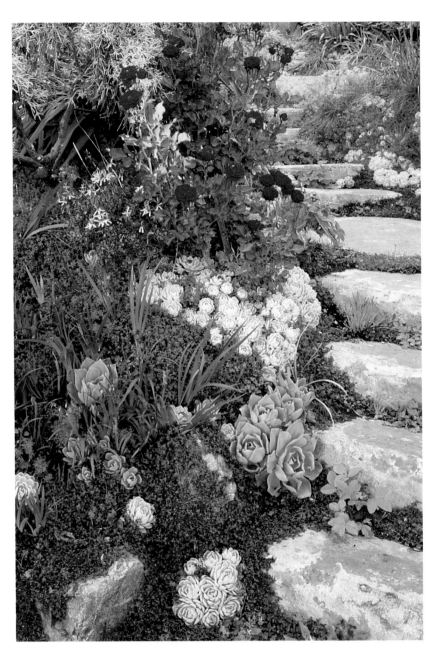

Nature plants the spaces between rocks with whatever native plants she has available. Gardeners have a much wider range of plants to choose from, so they can plant stone steps with flamboyance or restraint. This example of flamboyance is another landscape scene from Harland Hand: Red roses tumble down the left side of the path, which is bordered with hens-and-chicks (*Sempervivum* spp.) and pearl echeveria (*Echeveria elegans*). The alternation of light and dark foliage gives drama to the scene.

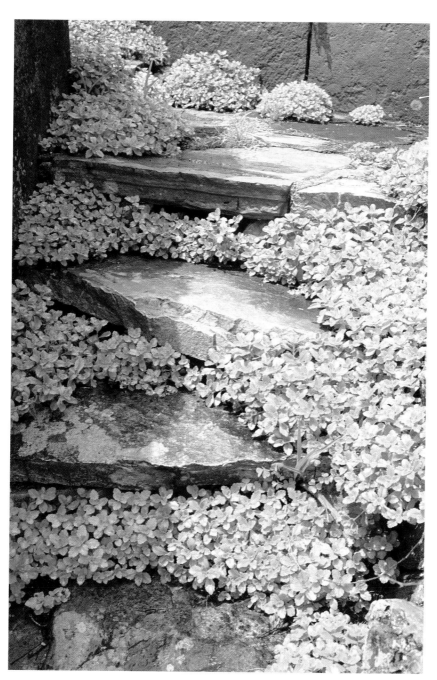

An East Coast gardener has left spaces for plants when building flagstone steps and filled them with sedum (*Sedum acre*) for a quiet and understated effect. Japanese spurge (*Pachysandra terminalis*) is another good choice.

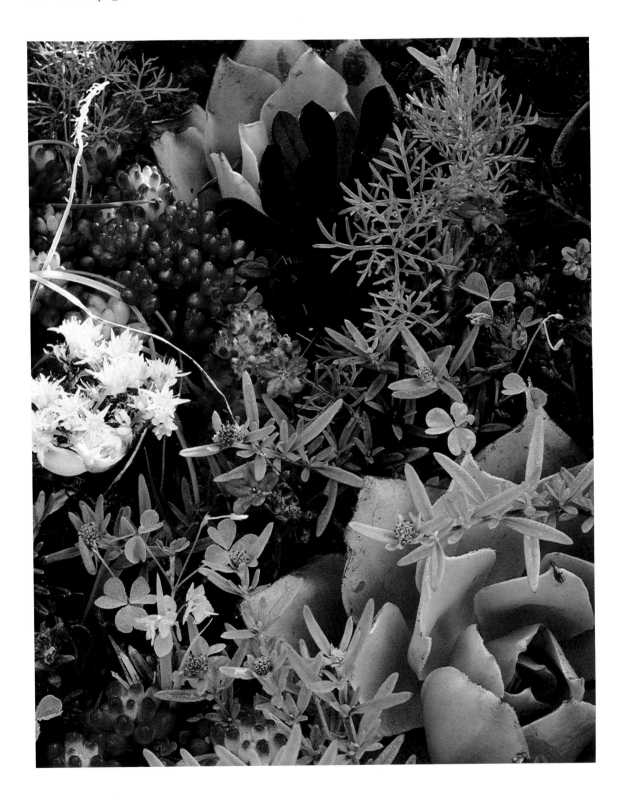

Although the big picture in Hand's garden is a re-creation of the Sierra landscape, his details reflect the natural beauty of northern California. Nature has filled the spaces between these lichen-covered rocks with colorful dudleyas (*Dudleya* spp.) – a wild relative of sedum – along the Pacific coast about 50 miles north of Hand's property. The yellow flowers, reddish flower stalks, and blue-gray leaves form a color harmony all by themselves.

If you're also inspired by the cheerful succulents, as shown in the photos on pages 163-67, but don't live in Harland Hand's mellow climate, try some of the hardier succulents in your garden. The bright yellow starry flowers of goldmoss sedum (*Sedum acre*) crowd into a group of hens-and-chicks (*Sempervivum* spp.) planted between stones in this Rhode Island rock garden. Although there aren't as many hardy succulents available to northern gardeners, they still are excellent for filling spaces between stones with color and interesting foliage.

Hand echoes the dudleyas' natural color harmony with this exquisite grouping of blue-gray pearl echeveria (*Echeveria elegans*), red jellybean sedum (*Sedum × rubrotinctum*), and the almost black leaflets of 'Zwartkop' aeonia (*Aeonia arboreum* 'Zwartkop'). Violet-flowered 'Grace Ward' lithodora (*Lithodora diffusa* 'Grace Ward') is sprinkled through the group. The patch of yellow is the bloom of a nearby succulent. "I think in terms of habitats and microclimates, not beds and borders," Hand says. He has built his steep slope into an extraordinarily beautiful garden with shelters, trails, and lookouts. It's a perfect example of landscaping with nature.

An Oriental Touch

Oriental gardeners have always tried to encapsulate the beauty of wild landscapes in the restricted space of the home garden. Like landscaping with nature, oriental gardening distills the essence of the natural experience into a landscape we can live with every day. The photos that follow show scenes from oriental-style gardens we might want to "steal" for our own yards.

This is a fine example of an oriental garden, seen through a traditional Chinese "moon gate." Garden designer Esther Burnett has landscaped and planted a small fenced yard to represent an entire natural vista, from the "lake" at lower left, to the "valley" in the foreground, back along a small path up the "mountain." As in many oriental gardens – and often in nature itself – the emphasis is on form and foliage, with few flowers.

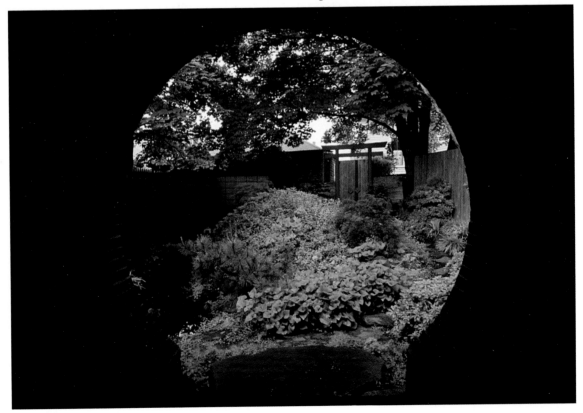

An Americanized version of an oriental landscape looks perfectly at home in the garden of David Benner, Bucks County, Pennsylvania. A large stone and a small red-leaved Japanese maple (*Acer palmatum*) are focal points. Adding interest and richness, the groundcovers include English ivy (*Hedera helix*) and climbing hydrangea (*Hydrangea anomala* subsp. *petiolaris*). A weeping hemlock (*Tsuga canadensis* 'Pendula') on the right, mountain laurel (*Kalmia latifolia*) in the center, and double bridal wreath spirea (*Spiraea prunifolia*) provide structure and flower color in season. This landscape recalls a grand vista of wilderness in a small space and transforms the driveway on the left into part of the landscape.

An ancient mossy stone seems to lecture a bank of young ferns in this glacial ravine. The cool combination of stone, moss, and ferns is entirely natural, yet looks as if it might have been created by a master garden designer.

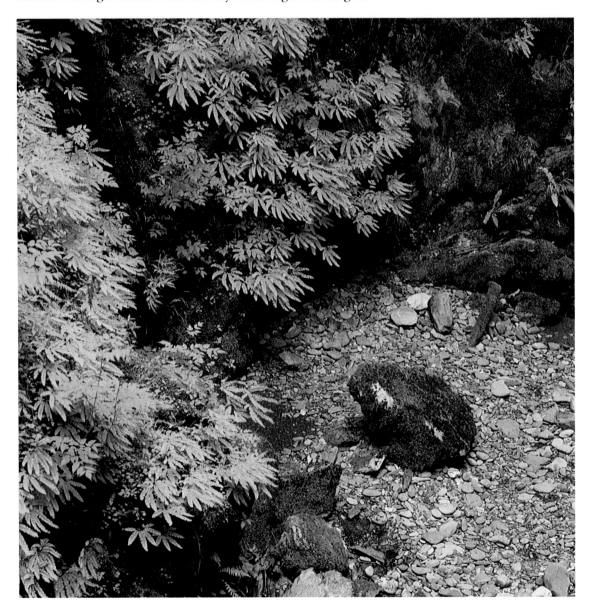

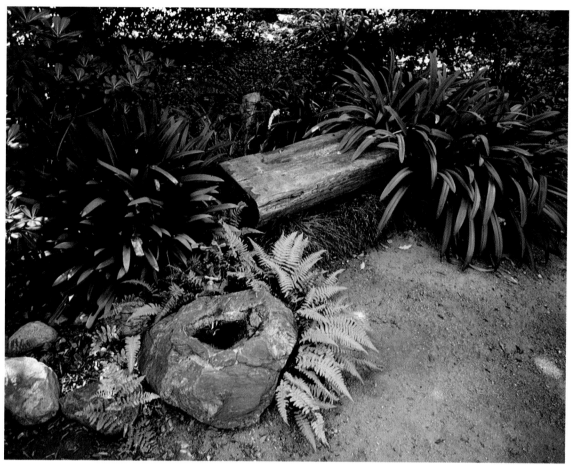

Something of the glacial ravine's wild, woodsy feeling is captured by this fern-ringed stone with the hollow on top. Here the gardener has used simple elements of rock and fern to add interest to a serene and inviting place to rest. The bench is flanked by agapanthus (*Agapanthus praecox*); north of Zone 9, substitute narrow-leaved plantain lily (*Hosta lancifolia*) for a similar effect. The natural simplicity of the elements gives the scene a Japanese feeling.

Streams, Bogs, and Waterfalls

Walter Beck of Millbrook, New York, is fortunate to have several streams and watercourses on his property. He uses them well, along with native stone, in his naturally beautiful landscape. As a result, his garden encompasses the peacefulness of nature that characterizes the local spirit of the Hudson River valley. He calls his garden "Innisfree," after the poem by the great Irish poet W. B. Yeats. These photos show several ways to bridge water naturally, in Innisfree and other gardens.

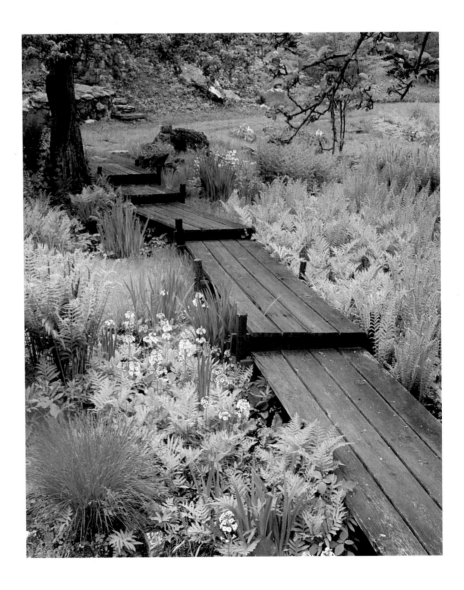

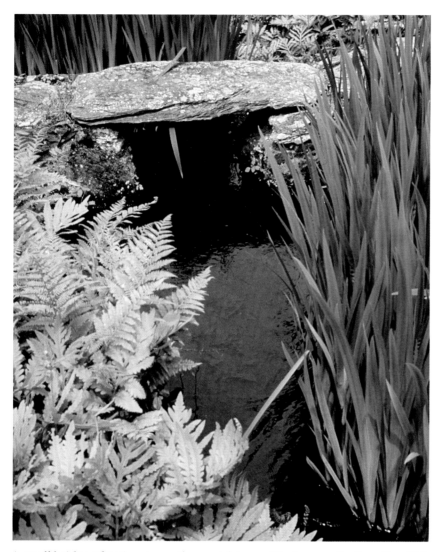

A small bridge of native stone, the upright spearlike leaves of yellow flag (*Iris pseudacorus*), and a mixture of sensitive ferns (*Onoclea sensibilis*) and lady ferns (*Athyrium filix-femina*) border a cold stream at Innisfree. The effect is at once natural and man-made, with elements of both artfully integrated.

Ferns, yellow flag iris (*Iris pseudacorus*), and the colorful flowers of primroses (*Primula japonica*) grace a marshy area at Innisfree. The simple oriental-style footbridge through the wet area doesn't detract from the natural-looking landscape. Innisfree is open to the public from May to October.

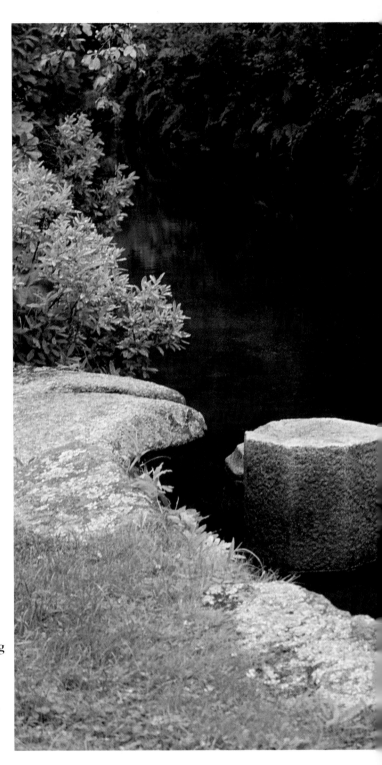

Octagonal concrete forms become stepping stones at Asticou Azalea Garden, Mount Desert Island, Maine. Their varied placement and height remind us of natural stones and cause visitors to slow down and savor the view. Although these "stepping stones" are obviously man-made, they fit naturally into the landscape.

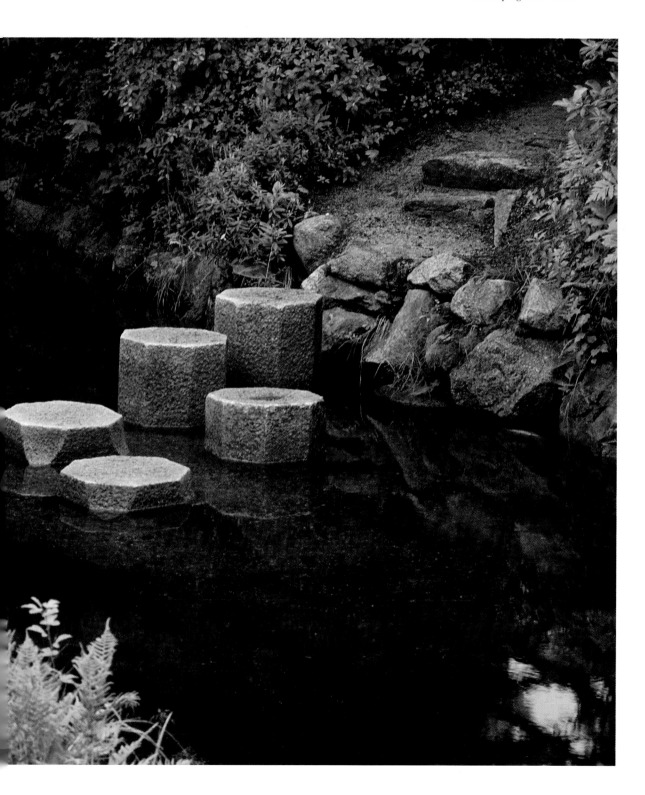

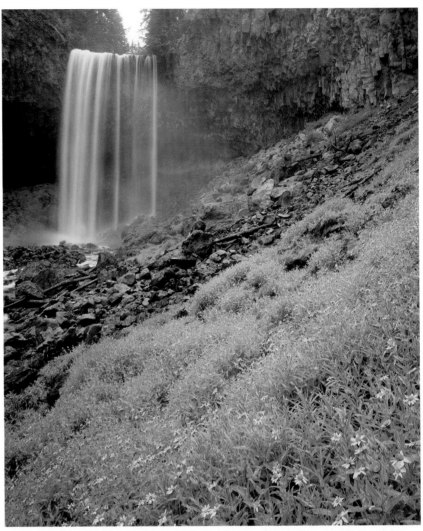

Wild arnicas (*Arnica* spp.) bloom below natural Tamanawas Falls in Oregon. It's quite a grand scene, hardly something we would try to reproduce in full size at home. Yet the slender falls are appealing enough to inspire a home gardener.

Despite appearances, this slender falls is a water-course in miniature in a garden in Saratoga, California. Ivy and Japanese maple soften the hard edges of the stones. Water going over the bottom fall drops only about 30 inches. It's easy to create your own mini-fall with a recirculating pump.

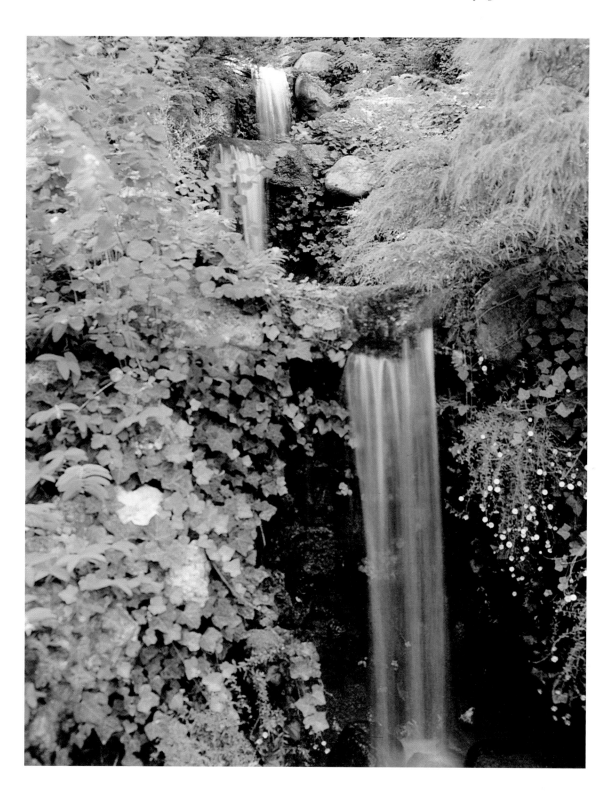

Wildlife in the Landscape

When you landscape with nature, Nature comes to landscape with you. She sends many birds, animals, and colorful insects to use the habitat you provide and adds life and movement to your yard. Plants, stones, water, and wood are home and sustenance to animals, as well as elements to beautify our home landscapes.

A landscape is more than visual. It also includes the fragrance of flowers and the sound of birdsong. One of the finest singers, the yellow warbler, is common across all of North America. Have you heard it sing "pip-pip-pip-sissewa-is-sweet" or "We-see-we-see-we-see-you"?

A butterfly comes to sip nectar from the foamy pink flower heads of showy stonecrop (*Sedum spectabile*). It carries a leisurely flash of color into the garden as it meanders among the flowers we've planted. Native perennials like butterfly weed (*Asclepias tuberosa*) and ornamentals like butterfly bush (*Buddleia davidii*) also attract these beautiful insects.

Often when walking in a natural landscape in the morning, we suddenly discover the striking yellow-and-black garden spider (*Argiope aurantia*) weaving her mathematical orbs in our shrubs, bushes, and herbaceous flowers. Besides adding an unexpected note of beauty, she and other insects are an important part of the ecological balance in the garden.

A natural landscape provides shelter, nesting sites, and food for many different animals, but none is as welcome as the tiny hummingbird. Here, a female feeds her young in a thimble-sized nest. These jewel-like birds are among the most magical creatures in the landscape and add immeasurably to the enjoyment of our backyard gardens.

With a flash of red-brown and white, a chipmunk suddenly appears in the foliage, collecting food to store in its extensive tunnel system. These ground-dwelling relatives of the squirrels are cute and fun to watch, but if you want to keep them around, bell your cats.

Mockingbirds, like this one perched among ripe 'Montmorency' sour cherries, give us impressive concerts in spring and summer. They sing their extensive repertoires of birdsong with such energy and gusto that we have to smile and even applaud. If you'd like to attract many desirable birds to your natural landscape, plant a variety of fruiting trees and shrubs. For a selection of trees and shrubs with attractive berries, see page 72.

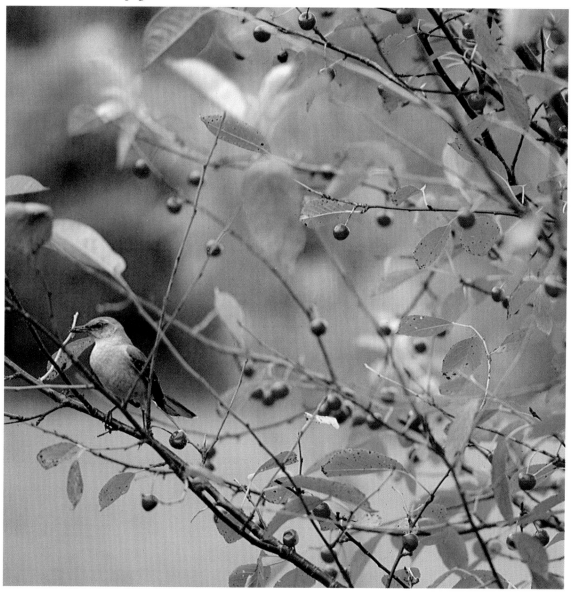

Learning from Nature

By appreciating the beauty of nature, we tend to see more than we thought we would and learn more than we expected. We'll notice for the first time how a gnarled tree trunk reveals patterns of flowing water, seemingly frozen in the wood. The lessons continue if we take our perceptions of natural beauty and try to recreate them at home. In the hands-on work of plant selection and placement in the landscape, we'll glimpse the natural principles behind the original inspiration. We'll see that there's a reason why the understory shrubs leaf out and bloom earlier than the canopy trees. We'll see how form follows adaptation and come to be able to guess a plant's best habitat from its appearance.

Landscaping with nature invites us to examine nature closely. As we look, and translate what we see—and what we like—into our landscapes, we'll find ourselves growing closer and closer to our land. In the end, our landscapes will reflect our dreams as well as our vision of natural beauty. We create gardens of meaning, places to rest or think, places to enjoy. Places to share with Nature, as Nature shares them with us.

You can plan your natural landscape as closely as you want, and still some of your favorite combinations will be serendipitous. These bright red maple leaves are the last embers left from the hot fires of summer. Scattered across the soft green of a white pine on an autumn day, they remind us of winter's coming with their Christmas colors. In the subdued autumn light, the color is incredibly intense. As these leaves fall, the garden falls asleep, to dream of summers yet to come.

PLANTS IN THE NATURAL LANDSCAPE

NATURAL LANDSCAPING STYLES

Every natural landscape is part of an ecosystem—that is, the group of interdependent plants, animals, and microscopic life forms that inhabit a climatic region. In this chapter, we'll look at natural habitats across the country, find out how to identify the natural habitats in our yards, and learn how to use native—and even exotic—plants in a natural landscape.

When we landscape with nature, we should follow nature's lead and strive for an integrated look. We should try for a woodswalk and a spring, or a wildflower meadow with a shrub and tree border, or a dry landscape with rocks and succulents—not a hodgepodge of cactus desert, pond, rock garden, woods, and moss lawn stuffed cheek by jowl into the backyard. This chapter will give you the landscaping basics

for designing a harmonious natural garden based on your personal inspirations.

As you gather ideas for your natural garden, you will find yourself working with one or more of these ecosystems, loosely interpreted:

- Swamp, bog, or freshwater marsh
- Sandy seashore
- Rocky seashore
- Coniferous forest
- Hardwood forest
- Mixed forest
- Grasslands and prairie
- Alpine meadows and tundra
- Old fields and meadows
- Lakes and ponds
- Swift stream
- Slow stream

- Tidal marsh
- Chaparral and sagebrush desert
- Cactus desert

The region where you live also fits into one or another of these categories. Ask yourself, which of these ecosystems was here when this was still a wilderness? The same influences of terrain and climate that produced the original native plant and animal habitats still exist, disrupted by human activity though they may be. A familiarity with original environments—both at home and at the natural setting you're recreating—will help you select plants that will thrive where you plant them and help you achieve the look you want. See "Best Native Plants for Your Garden" on page 205.

RECREATING NATURE

Let's say you live in southern New Hampshire, and you want to recreate the inviting look of a horse trail through a piñon forest in the Sangre de Cristo mountains of northern New Mexico. That southwestern region is high and dry. Forested slopes give way to open stands of piñon pine intermixed with grasses. The vistas are open, not closed in. To recreate the look in New Hampshire, try substituting white pines (*Pinus strobus*) for piñons, or if you want a smaller scale, use dwarf pines. Native New Hampshire grasses are long and soft and would be ideal to use between the areas of pine. Commercially available grasses for a long, soft look include tufted hair grass (*Deschampsia caespitosa*), drooping sedge (*Carex pendula*), ribbon grass (*Phalaris arundinacea*), and foun-

tain grass (*Pennisetum alopecuroides*). By planting groups of pines here and there along a pathway back into the property, with vistas to grass or gardens beyond, you can suggest the appearance of New Mexico's high country.

Some of the ecosystems in the list on page 185 are very specific for a certain group of plants: Alpine meadows are similar wherever they occur in the United States. But coniferous forests may be as different as the pine woods of Georgia, the piñon and juniper forests of the High Sierra in California, and the northern hemlock and spruce forests that extend across much of Canada.

Despite the rather loose nature of these categories, they're useful in choosing materials and plants for a natural landscape. When recreating details from nature on home properties, it's more convincing if you also suggest the original environment in the space around the recreated detail.

Let's say, for instance, that you're from Pittsburgh, Pennsylvania, visiting northern California's rocky Pacific shore, where you come across monkey flower (*Mimulus guttatus*) growing in the spring water that seeps from the bottom of a weather-worn limestone cliff. You jot down the details in your nature notebook: "20-inch yellow monkey flower. White limestone cliff weathered into interesting patterns. Found at Coleman Beach, Sonoma Coast."

In transferring the picture to your garden at home, first look for the right rocks—one large flat limestone slab, and other, thicker slabs to stack above it. Dig out the side of a steep bank in a wooded area behind the house and set the rocks in, making sure to leave a

TRANSPLANT THE EFFECT, NOT THE PLANT

How can we move the wild plants we like out of their special environments and into our home gardens when our gardens are probably situated in a totally different environment?

The answer is not to try. Don't forget the lesson of the unicorn (see page 21). Bring ideas, not physical things, back to your garden. We can recreate the natural effect at home without using the original plant. We're not attempting to transplant the plants that make up the scene we like to our home place, but rather their effect. When we substitute, we should choose plants most suited to our local climate and environment.

If, for example, you enjoyed the sight of a giant sequoia (*Sequoiadendron giganteum*) in Yosemite, but live in Asheville, North Carolina, you might want to try to recreate the shape of the big tree on a garden scale with a dawn redwood (*Metasequoia glyptostroboides*), or perhaps a weeping false cypress (*Chamaecyparis nootkatensis* 'Pendula'). In regions where the giant sequoia is at home, gardeners can plant the dwarf cultivar of giant sequoia (*Sequoiadendron giganteum* 'Pygmaeum') or the related dwarf redwood (*Sequoia sempervirens* 'Adpressa'). Many other trees and shrubs we're likely to encounter in the wild have dwarf cultivars, and those that don't can be replaced by smaller plants that resemble them in shape and appearance.

Even if you *are* tempted to "just bring home one or two plants," vandalizing wild sites is often pointless. Lady's slipper orchids (*Cypripedium* spp.) won't survive without the beneficial fungi that live in the soils where they grow, plants from acid bogs won't survive the dry conditions and neutral soils of the garden—the list is endless. Even comparatively common plants often present transplant problems: plants with deep taproots, like the orange-flowered butterfly weed (*Asclepias tuberosa*), often die after transplanting. A better solution is to buy the seed or plants of butterfly weed from a catalog or nursery—there are cultivars in a range of colors, as well as the native orange—or substitute commercially available plants that present the same color with an even more striking effect, such as tiger lilies (*Lilium lancifolium*), blackberry lilies (*Belamcanda chinensis*), or lion's tail (*Leonotis leonurus*).

space for a monkey flower where the flat rock meets the vertical face rocks. If you look for the wild yellow species in seed catalogs, you won't find it. But you *will* find many superb monkey flower cultivars, available in all shades from pale yellow to wine—including the most special of them all, 'White Croft Scarlet', a cultivar with gray-green leaves and intense fiery red flowers that prefers a shady spot.

It's a long way from a backyard in Pitts-burgh to the Pacific shores, but the original inspiration was the rocky coast of California. Is there any way that our little tableau can be given more of a coastal California look? Think about the characteristics of the coast: foggy stands of redwoods towering above the sea; Monterey cypress (*Cupressus macrocarpa*) flinging its arms up and out; conifers and piny duff that half covers rocks; woodsorrel (*Oxalis* spp.) and annual ryegrass (*Lolium* spp.).

You can't grow redwoods in Pennsylvania, but you can imitate them with a miniature eastern hemlock (*Tsuga canadensis* 'Minima') or one of the many dwarf upright junipers (*Juniperus* spp.). You can suggest the proximity of the ocean with a pool of round beach pebbles that laps at the limestone cliff you've recreated. Large ostrich ferns (*Matteuccia pensylvanica*) on the bank above the limestone look a bit like Monterey cypress in their upward, outward display of dark green fronds. Add woodsorrel, along with shade-tolerant mosses and grasses, to recreate the coastal floor. Palm branch sedge (*Carex muskingumensis*), *Carex nigra,* hakonechloa (*Hakonechloa macra*), liriope (*Liriope muscari*), and ophiopogon or mondo grass (*Ophiopogon* spp.) are all shade-tolerant grasses or grasslike plants. Common thrift or sea pink (*Armeria maritima*) thrives on the California coast, and you can find a spot for it in your Pittsburgh garden, along with red stone-crop (*Sedum* spp.) and red penstemon (*Penstemon barbatus*), if there is a sunny spot in the area. Harebells (*Campanula* spp.) love the coast of California, and the American harebell (*Campanula americana*) adds a bright blue note to the moist, shady woodland where you put your monkey flower.

The whole tableau need only be 4 by 6 feet—but you'll never be able to walk past it without returning for a moment to the late-lingering sunshine of that golden coast.

PLANTS FOR YOUR HABITAT

When taking notes in nature, jot down the natural setting—is it open and sunny, partly shady, closed? Are there hills or flat land? Make enough notes so that you can identify which of the ecosystems it fits (refer back to the list on page 185). Then find out what other plants like to grow in that habitat, and use either natives or introduced species and cultivars selected for their beauty.

Besides the "Best Native Plants for Your Garden," on page 205, there are many reference works that can help you with this task. One of the best—and one of my favorite books—is a volume entitled *Reader's Digest North American Wildlife: An Illustrated Guide to 2,000 Plants and Animals.* This excellent book breaks down North American environments into 30 different habitats and lists the common flora and fauna found there. The Audubon Society's series of field guides to North American wildflowers, trees, and fauna is a more comprehensive set of references that will provide plenty of ideas. Once you've developed a preliminary plant list, work with wildflower catalogs and comprehensive seed catalogs to find the species of flowers you're looking for, or related species or cultivars that may suit you even better than the plant you saw in the wild. (See "Sources of Wildflower Seed" on page 282 for seed catalog addresses.)

REPEATING DETAIL

In each of the environments in which Nature works, she crafts her landscapes from details repeated over and over again. They are repeated because conditions are similar over the range of the environment, creating the right habitat for a limited number of plants and animals.

One sassafras, a million sassafras. Remember the value of repetition when creating natural gardens. One clump of pampas grass cannot move in the wind the way a large drift of its feathery plumes will. Use many specimens of the same plant together in an area, then repeat that area, then repeat it again. Arrange these repetitive areas irregularly, in syncopated patterns, or you'll simply be decorating Nature instead of imitating her.

Repetition gives coherence and legibility to small landscapes. Busyness overwhelms the viewer with too much varied detail. There's no way for the eye to grasp the whole. Repetition simplifies the scene and forces the gardener to use plants creatively within tight limits. Think of the difference between a flower border, with its subtle changes tied together through repeating clumps of key plants along its entire length, and an arboretum, where plants are displayed as individual specimens, each neatly identified with a label. When you look at a well-planned flower border, you see a unified mass of form and color. When you look at an arboretum, you see a group of individual plants.

A SENSE OF STYLE

There's a recognizable sense of style in a Maine shoreline or a sweep of tallgrass prairie or an old field of upstart ash seedlings presided over by an ancient apple tree. Nature here is the stylist—always elegant, restrained, and fitting.

Style emerges because the forms in nature have evolved for successful survival. For instance, redwood trees can reach over 300 feet tall at maturity because, to survive, they must be able to reach up into the dense banks of fog that roll over them each night. Their needles are shaped like combing fingers, to collect droplets of fog and drip them onto the ground far below. The redwoods are so efficient that these drops will fill a rain gauge set on the forest floor during a month when it never rains. The thin branches are held out horizontally from the trunk and will break off in Pacific gales rather than breaking the tree's trunk the way thick branches would. The style emerges because the trees are conditioned to wind and fog, giving these vertical giants an elegant, almost cathedral-like appearance.

Each plant in our gardens has its own environmental and ecological niche. We can become better natural gardeners by investigating what niches they fill. What, for example, is the habitat of a monkey flower? References tell us that it likes seeping springs and wet areas from the sea to the mountains. Now when we see monkey flowers, we'll recognize them as natural "signposts" to places where water emerges from the ground, as at the base of a limestone cliff.

Though we should bear these habitats in mind, we shouldn't be enslaved by them. If we love monkey flowers, but don't have a spring or wet site on our property, we can still grow monkey flowers—we just have to remember to water often. If a favorite natural style includes wind-cropped trees and shrubs, as one would find on windy mountains or hilltops, on a coast, or in an unprotected spot on the eastern edge of the Great Plains, but we live in a protected area, we could still try to reproduce the effect at home with careful pruning. (See "How to Prune for Natural Beauty" on page 190.)

HOW TO PRUNE FOR NATURAL BEAUTY

Pruning is probably one of the most important—and most neglected—tasks in the garden. Many unpruned shrubs grow wild and unkempt or become shaded by nearby unpruned shrubs and get unattractively leggy. The goals of pruning are to allow more light into the plantings; to prevent legginess and give a more vigorous, leafy appearance; to promote flowering and fruiting; and to produce shapes that look good in the garden.

Getting more light to understory plantings like specimen shrubs and hedges means thinning out canopy branches in the trees above. Note shadow patterns on sunny days when the sun is high overhead. If the shade is dense, understory plants—even shade-lovers like rhododendrons and azaleas—will tend to become leggy. By removing up to a third of the branches of overhead trees, you'll let dappled sunlight in to the shrub layer below. The pruned trees will take on a lacy appearance as you look up into the canopy. Thinning out branches also enhances the natural shape of trees and shrubs. But be careful—don't take on more than you're able or endanger yourself (chain saws *are* dangerous in the yard as well as the movies!). In most cases, pruning mature trees is a job for professionals. If you want to prune your large trees, call in professional arborists and explain to them what your goal is.

Heading back shrubs' branches to a dormant bud or the nearest crotch will promote branching. So will pinching out the growing points of each stem or branch tip. This forces the buds behind the growing point to grow into new stems. Where you had one stem before, you'll

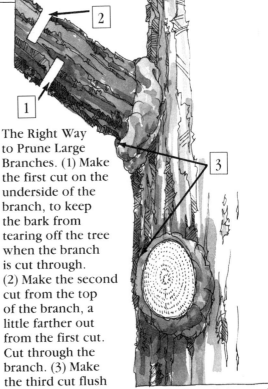

The Right Way to Prune Large Branches. (1) Make the first cut on the underside of the branch, to keep the bark from tearing off the tree when the branch is cut through. (2) Make the second cut from the top of the branch, a little farther out from the first cut. Cut through the branch. (3) Make the third cut flush with the branch collar (the thickened ring at the point where the branch attaches to the trunk). Don't cut into the collar. Cutting flush allows the stump to heal cleanly and prevents rot. Don't paint the wound—research shows that it doesn't help and may even hurt the healing process.

Removing some branches from a heavy-canopied tree allows some light to come through, creating dappled shade for plants below and a lacy branch effect on the tree.

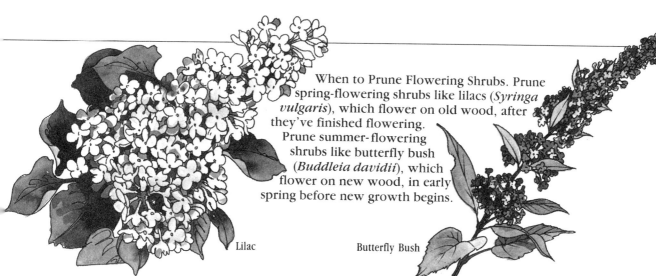

When to Prune Flowering Shrubs. Prune spring-flowering shrubs like lilacs (*Syringa vulgaris*), which flower on old wood, after they've finished flowering. Prune summer-flowering shrubs like butterfly bush (*Buddleia davidii*), which flower on new wood, in early spring before new growth begins.

Lilac

Butterfly Bush

now have two, as buds on each side of the branch send out new growth. In subsequent seasons, prune the two new branches back to a dormant bud or the nearest crotch to form four branches; then prune them back to get eight branches, and so on; or just keep pinching out the growing tips. More branches give the shrub a denser, bushier look.

Long, leggy branches are prone to damage in ice storms. Pruning regularly produces stronger, stockier stems and branches that can withstand ice damage.

Most shrubs that sucker or produce new stems from underground roots—like lilacs—will produce more and bigger flower heads if their stems are renewed by pruning. Each year, allow several new suckers to grow and remove the same number of the oldest stems. Put your shrubs on a three-year renewal pruning system. Each year, remove one-third of the stems, making sure they're the oldest ones. This means that after a few years, all the wood will be either 1, 2, or 3 years old, and there will be no chance for old, thick, or leggy wood to clutter the shrub's shape.

Three Types of Pruning

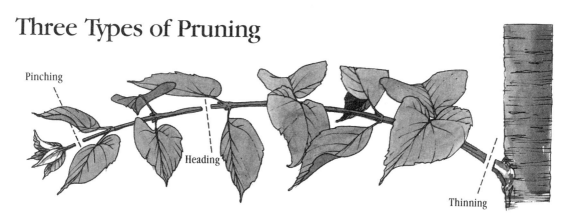

Pinching

Heading

Thinning

Pinching—removing the growing point or tip of a branch—and heading—cutting the branch farther back to a bud—both promote more branching and bushier growth. Thinning—selectively removing branches flush with their branch collars—results in a more open plant. This lets in light to promote even leaf growth and encourages good branch structure.

Rejuvenating an Old Shrub

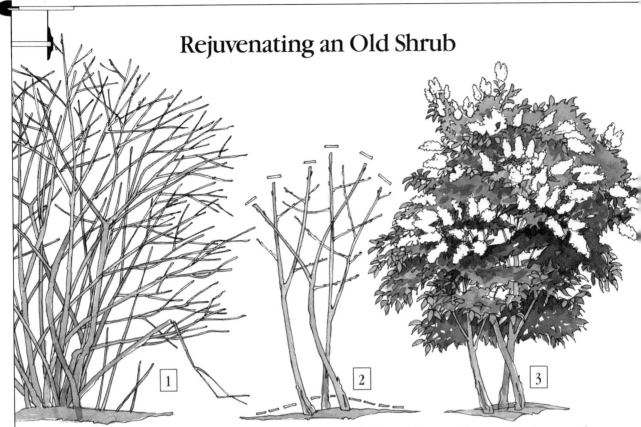

If you've inherited an overgrown shrub with densely tangled branches, no discernable shape, and poor or nonexistent flowering, here's how to get it back in shape: (1) The old shrub. If the shrub is hopelessly ugly, prune it back to the ground—it will regrow. (2) Otherwise, prune back to three healthy stems. Head these back one-third. (3) The revived shrub. Pinch back new growth to encourage bushiness.

When making pruning cuts, cut back to an outside bud—that is, to a bud that's pointing outward, away from the interior of the plant. Buds that point toward the interior will grow stems that cross and clog up the middle of the plant.

When you're cutting a branch, be sure to leave the collar—the ring of rough bark where the branch attaches to the trunk or main stem of a tree or shrub. Tree specialists have discovered that the collar is made up of specialized cells that are designed to heal wounds and prevent fungi and other diseases from entering the tree. If you cut or otherwise damage the collar, you'll defeat this natural defense mechanism.

All plants have a natural shape that they will grow into if left alone with perfect conditions of light and moisture. Perfect conditions aren't often found, however, and trees and shrubs grow unbalanced and leggy in response to imperfect conditions. You can help bring your plants back to their ideal natural shapes by thinning branches, rather than heading back or hedging the whole plant.

Although topiary—the practice of pruning and hedging plants into formal shapes, like vases and foxes—doesn't have much application in the natural landscape, you can use it to recreate the shape of a shrub that appealed to you in the wild.

Plants for Hedging and Natural Topiary

The following plants are suitable for shearing and hedging and can be easily worked into forms that recreate arresting or desirable shapes seen in the wild.

Arborvitae (*Thuja* spp.)

Box honeysuckle (*Lonicera nitida*)

Boxwood (*Buxus* spp.)

Brush cherry eugenia (*Syzygium paniculatum*)

Carolina cherry laurel (*Prunus caroliniana*)

Chinese holly (*Ilex cornuta*)

Eastern hemlock (*Tsuga canadensis*)

English cherry laurel (*Prunus laurocerasus*)

European beech (*Fagus sylvatica*)

European hornbeam (*Carpinus betulus*)

Glossy abelia (*Abelia* × *grandiflora*)

Inkberry (*Ilex glabra*)

Italian buckthorn (*Rhamnus alaternus*)

Japanese barberry (*Berberis thunbergii*)

Japanese euonymus (*Euonymus japonica*)

Japanese holly (*Ilex crenata*)

Juniper (*Juniperus* spp.)

Laurustinus (*Viburnum tinus*)

Myrtle (*Myrtus communis*)

Nanking cherry (*Prunus tomentosa*)

Pittosporum (*Pittosporum* spp.)

Privet (*Ligustrum* spp.)

Sasanqua (*Camellia sasanqua*)

Scarlet firethorn (*Pyracantha coccinea*)

Silverberry (*Elaeagnus pungens*)

Winter creeper (*Euonymus fortunei*)

Yaupon (*Ilex vomitoria*)

Yew (*Taxus* spp.)

Creating Branch Interest by Pruning

Another use for pruning in the natural landscape is to create branch interest. By cutting off cluttering side branches from a branch with a striking shape, you'll emphasize the branch structure and create a clean, oriental look.

Before

After

NATIVE PLANTS IN THE GARDEN

The phrase "a natural garden," in its traditional sense, brings to mind a garden of native plants. But such a garden of natives is a very specialized kind of garden. In effect, the gardener takes the existing natural landscape of his or her locality for inspiration and reworks it into a garden.

A native garden repositions the familiar plants from local woods and waysides, sculpting artful spaces or making subtle passages of color. The gardener's job is to bring a pleasing sense of order to what is usually a mad scramble for light and water among the wild plants. The key here is a *pleasing* sense of order—not stifling rigidity. In a traditional garden, human order is imposed to the point of suffocation in the form of parterres, paths, beds, edgings, and so forth. Wild nature, on the other hand, can sometimes be a bit more of a jumble—or even jungle—than we'd like. When we landscape with nature, we look for patterns in nature where randomness and order mix and we recreate those intermixed patterns in our gardens.

APPRECIATING NATIVE PLANTS

For instance, the woodlands of the Pocono Mountains in northeastern Pennsylvania, where I spent my youth, contain widespread stands of mountain laurel (*Kalmia latifolia*). In June, these evergreen shrubs burst into the most exquisite pink blooms. Each bud is rich pink and looks like a folded umbrella with ten spokes. These umbrellas open to form shallow, pale pink cups, daintily scalloped along their edges with mathematical regularity. Ten stamens arch out from the centers and are tipped with darker red pollen sacs, giving a very lovely and feminine appearance to the flowers. These are displayed in dense clusters amid the dark, slender evergreen leaves. The shrub is beautiful for the casual elegance of its shape and its pretty foliage in summer, fall, and winter, and it steals the show when it blooms in late spring.

As a boy, I lived surrounded by mountain laurel. I knew many haunts where wild rhododendrons and azaleas grew—the same acid-soil habitat that mountain laurel prefers. But for some reason, I never noticed it. Only later, when I had graduated from college and returned to my boyhood hometown to work on the newspaper there, did I even become aware of the region's annual Mountain Laurel Festival, during which the beauty of the plant is celebrated. If mountain laurel were not native, but were a rare exotic from some mountain cranny in the Himalayas, its beauty would be more widely prized.

Mountain laurel is often found in open woods with rocky, humus-rich, acidic soils. It prefers to associate with rhododendrons, azaleas, and blueberry and huckleberry bushes in the understory, with oaks and perhaps some hemlocks above. When designing a space for mountain laurels at home, resist the temptation to feature them out in the open. Instead, site them in an out-of-the-way, shady, woodsy spot, just where they'd grow in nature. Plant them in a mass with rhododendrons behind and perhaps an evergreen groundcover like periwinkle, or creeping myrtle (*Vinca minor*), or lilies-of-the-valley (*Convallaria majalis*) in front. Hostas (*Hosta* spp.) associate well with them, too.

However, make sure the mass of mountain laurel borders the path at some point, so that people can get a close look.

THE NATURALISTIC GARDEN

Another fine example of the artful use of native plants in a subtle landscape can be found at Winterthur Gardens in the Brandywine Valley of southeastern Pennsylvania and northeastern Delaware. Hal Bruce, who was curator of plants at Winterthur, called it a naturalistic garden. By "naturalistic," Bruce meant that the original owner, Henry Francis Du Pont, strove to exalt, but not duplicate, the natural woodlands of his Delaware valley estate.

"Du Pont never changed the character of the site," Bruce said. "If he developed an area, he preserved as much of the indigenous vegetation as he could: viburnums, azaleas, and so on. He never took down a forest tree. He planted around it. He eventually arrived at this landscape —which is fantastic. But it's as if God had planted it."

Winterthur is therefore a naturalistic garden that takes the surrounding woodlands for its inspiration. Du Pont, Bruce, and others glorified the scene by simplifying and planting more and better cultivars of the kinds of plants that grew there naturally, such as dogwoods and redbuds. This approach led to a low-maintenance garden that naturalized slowly over the years. Like Henry Du Pont, if you create a naturalistic garden, you can use exotic as well as native plants, but select the exotics carefully so they're adapted to your site and blend well with the native plants.

NATIVE ADVANTAGES

There are several advantages to gardens of native plants local to your area. Foremost, the plants are adapted to the environment. They tolerate the local insects, diseases, winter minimums, and drought patterns. If you've selected and sited them correctly, they will be reliable plants that will naturalize to take care of themselves. Secondly, they are seldom as gaudy as gardens of imported and hybridized annuals and perennials tend to be. Their color variations harmonize with the surrounding natural landscape, and their leaf forms and shapes echo those of the countryside.

The disadvantage is that the garden of natives is not usually as visually or aesthetically adventuresome as a garden that includes imported and more exotic plants. The gardener is limited to the local plants and subject to their needs. I've been in gardens of native plants that hardly look like gardens at all. It simply seems that a bit of the woods' edge has been tidied up. That's nice—but it can be boring.

EXOTIC INSPIRATIONS

What we're after is not just a smooth backdrop for our garden parties, but rather the creation of places in our yards alive with the beauty and energy that once arrested us in the wild. And when the effects we want can be achieved with natives, we should give them preference over exotic plants from other climates, because of their environmental suitability and low maintenance requirements (if selected and sited properly). But when no native provides the effect we're looking for, we shouldn't be afraid

to substitute an exotic plant that does.

Once, traveling through Arizona, I was impressed by the color of upright, shrubby stands of purple hopseed (*Dodonaea viscosa* 'Purpurea') growing near the road. The sun filled them with light, and they glowed a dark purplish red. When I came home to Pennsylvania, I wanted to use that purplish red glow and upright shape in my garden, but the hopseed isn't hardy in the colder climates.

Had I chosen a native as a replacement, I might have used the apple serviceberry (*Amelanchier grandiflora*), whose young leaves are bronzy-purple before finally turning green in summer. I'd at least have a season of purple leaves. But I wanted purple-red leaves all summer, so I chose a purple smoke tree (*Cotinus coggygria* 'Royal Purple'), which is a native of a European environment similar to the northeastern United States. I might have also chosen a purple-leaved European beech like Rivers purple beech (*Fagus sylvatica* 'Riversii'), which resembles the hopseed when young. (To keep this beautiful beech small, you'd have to coppice it.) The rule here is to choose a native when you can and a plant from a climate similar to yours when you can't.

NATIVE PLANTS IN CONTEXT

When we're discussing native plants, we're not really using "native" to refer to a political designation, like a state or county, but to a biological and climatic region or ecosystem. A plant might be "native" to North Carolina, but also be native to Tennessee, West Virginia, and other states that provide the Appalachian habitat it requires. And plants that are native to one

part of a state may be limited by their habitat requirements to that part of the state only. To give a concrete example, North Carolina contains several distinct climates and habitats within its borders, each with its own community of native plants.

The Atlantic coast of North Carolina is a coastal plain with a sweeping sandy seashore backed by huge dunes of sand. Behind the dunes is a low bog, thick with plant life. Pitcher plants, sundews, and Venus's-flytraps grow there. Stands of cattails guard pools of water lilies. As if recalling a hot swamp from the Carboniferous period of Earth's history, huge cinnamon ferns abound. In rare places, yellow-fringed orchids bloom. And in the fall, seaside goldenrod opens its plumes.

Inland from this area of primordial beauty is the open, shrubby Sandhills area. The land rises and becomes much drier. Longleaf pines grow among tall grasses, and hard, shrubby turkey oaks abound. Carolina jessamine climbs the trees seeking a proper perch. Frequent fires burn through this territory, and its plant community copes in various ways: the protection of thick bark; the ability to send up new shoots from roots after top growth burn-off; seeds that need scarification (abrasion) or heat to open.

Farther upland is the red clay Piedmont. Eastern red cedar, loblolly and Virginia pines, and mixed hardwoods such as oak and hickory are found in the woods, along with smaller forest dwellers like pipsissewa and wild ginger. Queen-Anne's-lace, broomsedge, and goldenrod clothe the fields. In the rich bottomlands between the Piedmont's hills, hackberry, black

walnut, sycamore, tulip poplar, and American ironwood dominate.

In western North Carolina, the land rises still more to form the Appalachian Mountains, with dells of rhododendron and mountain laurel and seasonal appearances by Jack-in-the-pulpit, trillium, trailing arbutus, oconee-bells, columbine, Virginia bluebells, fringed bleeding-heart, hepatica, dog-tooth violet, galax, spring beauty, and foamflower—among many others.

Each of these four regions is a unique plant community. A plant may be a native of North Carolina, but it's often found growing in only one of these four places within the state. A gardener from Franklin, in the western mountains, may be quite impressed with details of the coastal plain, but he would find it next to impossible to try to establish a coastal plain garden in Franklin, even though everything in the garden may be a "native" of North Carolina.

CONVERGENT PLANTS

Native plants, then, are plants growing in the place they come from, however large or small that "place" may be. Plants native to regions in other parts of the world that share similar climates are called convergent plants. Native garden flowers have their wild progenitors growing nearby—yarrow (*Achillea millefolium*), for example, is a native wildflower with many cultivars of varying colors available for the perennial garden. Purple loosestrife (*Lythrum salicaria*), on the other hand, is a convergent plant from a region of Europe similar to the northeastern United States and has naturalized here so vigorously that it threatens our native ecosystems.

On the West Coast, manzanita is a true California native, but Australian plants such as eucalyptus, acacia, and callistemon come from a place with a nearly identical climate, and these convergents perform just like natives in coastal California's Mediterranean climate. South Africa also has regions of this particular climate, and plants from those areas do quite well in California, too.

Convergents are climate-adapted to their new homes, but may not have any resistance to local pests and diseases. They may not be able to withstand competition from other plants in the new community that were unknown in their homelands. Conversely, they may be free from diseases and pests that kept them in check in their homelands, and, like loosestrife in the Northeast and kudzu in the South, they may start to dominate existing ecosystems at the expense of native plants.

Plants from exotic climates may do well in your area, but then again they may not. Hostas, which like the warm, moist summers of the East, will end up gasping in dry, sunny California, unless they're given a shady spot with lots of water. Shade and water in turn encourage the snails and slugs that eat them to the ground with relish. As much as we love hostas, we don't plant them in California.

Deciding whether to plant exotics, convergents, or natives that aren't adapted to your area can come down to something as straightforward as money and maintenance work. How much are you willing to spend and do? It may be great fun to reproduce a Cape Cod cranberry bog in Los Angeles, but you're going to have to pay for it over and over in dollars and sweat.

(continued on page 202)

DESIGN AN EASTERN WOODLAND
GARDEN OF NATIVE PLANTS

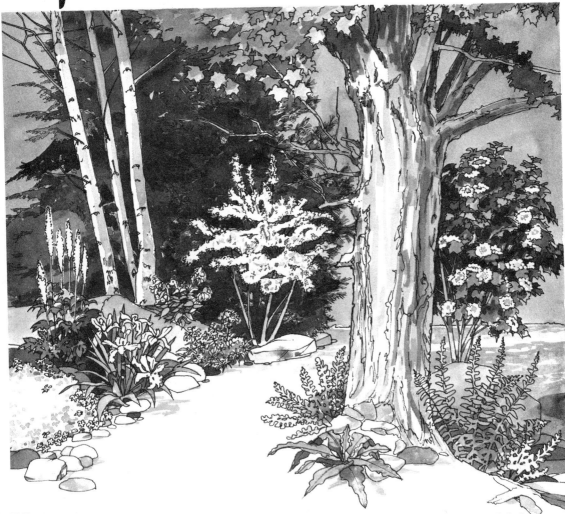

Y ou can use East Coast woodland natives to design a delightful woodland garden, as shown above. The planting has areas of deep shade, dappled shade, and partial sun to accommodate a wide range of woodland plants.

On the right side of the path, plant a scarlet oak (*Quercus coccinea*), and underplant with a bed of maidenhair ferns (*Adiantum pedatum*) or hay-scented ferns (*Dennstaedtia punctilobula*). The oak will provide partial shade for the ferns as it arches over them. You can also plant this area with spring bulbs for early color—late color will take care of itself with the oak's blazing scarlet red fall foliage. Behind the scarlet oak, add a tall highbush cranberry (*Viburnum trilobum*), which has showy red berries in fall.

On the left side of the path, plant an eastern hemlock (*Tsuga canadensis*) and white pine (*Pinus strobus*). They'll provide a dark background for the plants in the foreground—'Heritage' birch (*Betula nigra* 'Heritage') and serviceberry (*Amelanchier laevis*). The salmon-white bark of the 'Heritage' birch and white flowers of the serviceberry will seem to glow against the evergreen background.

Plant Virginia bluebells (*Mertensia virginica*) among the birches and serviceberries for delightful flowers in spring, and black cohosh (*Cimicifuga racemosa*) to send up its tall white spires in midsummer, contrasting beautifully with the dark background. In the partial sun along the path, plant a low-growing phlox (*Phlox divaricata* and *P. stolonifera*), a white-flowering fothergilla (*Fothergilla major*), which also has stunning fall color, and crested iris (*Iris cristata*).

All these plants are native to the eastern regions of the United States, where they will make a low-maintenance planting with plenty of seasonal interest.

Plants for an Eastern Woodland Garden

1. Scarlet oak (*Quercus coccinea*)
2. Maidenhair fern (*Adiantum pedatum*)
3. Eastern hemlock (*Tsuga canadensis*)
4. 'Heritage' birch (*Betula nigra* 'Heritage')
5. White pine (*Pinus strobus*)
6. Black cohosh (*Cimicifuga racemosa*)
7. Virginia bluebells (*Mertensia virginica*)
8. Serviceberry (*Amelanchier laevis*)
9. Fothergilla (*Fothergilla major*)
10. Crested iris (*Iris cristata*)
11. Blue phlox, sweet William (*Phlox divaricata*)
12. Creeping phlox (*Phlox stolonifera*)
13. Highbush cranberry (*Viburnum trilobum*)

DESIGN A CALIFORNIA NATIVE GARDEN

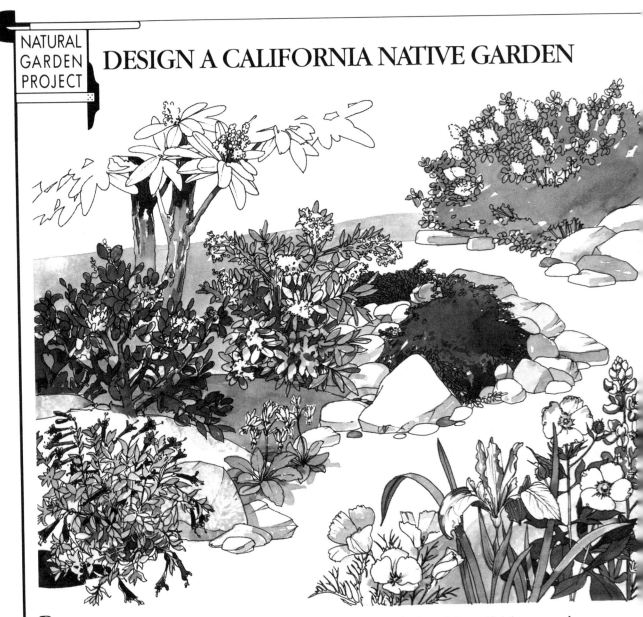

Because much of California experiences drought from late spring through early fall—the height of gardening season—when designing a garden of native plants, it's best to focus on drought-tolerant species. The plants pictured above are all beautiful as well as drought-tolerant, and they need little or no maintenance.

On the rise to the left of the path, plant madrone trees (*Arbutus menziesii*), which have reddish brown bark and beautiful leaves, and underplant with manzanita (*Arctostaphylos glauca*) with reddish burgundy bark, gray-green leaves, gorgeous white, hanging, bell-shaped flowers, and an interesting shape. The madrones will become large trees, rising high above the manzanitas. Manzanita and madrone make one of the prettiest native plant combinations, both at home and in the wild.

Beneath the manzanitas, plant California fuchsia (*Zauschneria californica*), which has bright scarlet trumpet flowers that attract hummingbirds. Tuck a toyon, or Christmas berry bush (*Heteromeles arbutifolia*), in with the California fuchsia. It is a lovely evergreen that bears bright red berries at Christmastime.

Cover the ground on both sides of the path with native California wildflowers—a mix of showy clarkias (*Clarkia biloba*), shooting stars (*Dodecatheon clevelandii*), California poppies (*Eschscholzia californica*), Douglas irises (*Iris douglasiana*), lupines (*Lupinus nana*), and matilija poppies (*Romneya coulteri*). These brilliant wildflowers will add a profusion of jewel-like color to the garden in April and May.

Where the path turns, flank the left side with California lilac (*Ceanothus cuneatus*), which has light powder-blue flowers in spring, and the right side with the fine-leaved coyote brush (*Baccharis pilularis*).

Plants for a California Native Garden

1. Madrone (*Arbutus menziesii*)
2. Manzanita (*Arctostaphylos glauca*)
3. California fuchsia (*Zauschneria californica*)
4. Toyon, Christmas berry bush (*Heteromeles arbutifolia*)
5. California lilac (*Ceanothus cuneatus*)
6. California native wildflower mix, including clarkias (*Clarkia biloba*), shooting stars (*Dodecatheon clevelandii*), California poppies (*Eschscholzia californica*), Douglas irises (*Iris douglasiana*), lupines (*Lupinus nana*), and matilija poppies (*Romneya coulteri*)
7. Coyote brush (*Baccharis pilularis*)

My advice is to keep those portions of your natural garden that use exotic plants—that is, plants from climates that are unlike yours—to a minimum, and then keep them close to the house in defined spaces, because they will often take intensive work. The hard sunlight of the high desert will have to be screened away from a garden with dog-tooth violet and bunchberry from the Maine woods. The soil will have to be changed in composition and pH, and moisture will have to be supplied constantly. All of this is not impossible, but the gardener must understand that exotic groups of plants need lots of attention to keep them thriving. By starting with natives or with convergents, a great deal of fuss can be avoided.

The New England Wild Flower Society is a marvelous group of dedicated plant enthusiasts who have made it easy for the rest of us to identify the plants native to our regions. They've put together a list of native plant societies and botanical organizations from around the country. To get this list, send $1.50 to New England Wild Flower Society, Inc., Garden in the Woods, Hemenway Road, Framingham, MA 01701.

OUR RESPONSIBILITY TO PROTECT WILD PLANTS

When seeking nursery sources for native plants, we all must give thought to the source of the stock. Someone who digs wild orchids to make a quick buck at a local nursery should not be patronized—success will just encourage further depredations. Natives should always be left where they are, unless they are in imminent danger of being bulldozed, paved over, or otherwise destroyed. If *you* stumble on one of these endangered sites, before you dig, try to find a nearby nursery that propagates native plants, and if you do, direct them to the site so they can use these plants to produce more. Stock should always come from propagation of natives at nurseries, or from seed.

To help concerned gardeners avoid wild-collected stock, the New England Wild Flower Society publishes a 72-page booklet, "Nursery Sources: Native Plants and Wild Flowers," summarizing the percentage of stock from wild, propagated, or unknown sources sold by 430 nurseries that deal in native plants. Write for the current price to New England Wild Flower Society, Inc., Garden in the Woods, Hemenway Road, Framingham, MA 01701. Between January 1 and March 15 of each year, the society also offers a list of horticulturally propagated wildflower seeds for sale, usually including about 275 wildflowers. To request the list, send $1.00 and a self-addressed, business-size envelope with a 45-cent stamp to the address given above. The American Horticultural Society, 7931 East Boulevard Drive, Alexandria, VA 22308, provides a list of nurseries that propagate their own plants. Write for "Nursery Sources for Propagated Native Plants," and enclose a stamped, self-addressed envelope.

It's our responsibility as gardeners to make sure of the sources of our plants. Ask your nursery where they come from. If they are collected from the wild, don't buy them, for even common species will eventually be eradicated in the wild if people can make money by uprooting them.

CHECK YOUR NURSERY SOURCES!

The National Resources Defense Council's (NRDC) Plant Conservation Project monitors horticultural trade in wild plants and is working for legislative and trade organization protection for endangered species. Their mailings warn that many spring bulbs offered for sale in America may have been collected from the wild in places like Turkey and may be overexploited there. As they point out, "This collecting can force these species to the brink of extinction."

The NRDC surveyed 25 nursery catalogs offering bulbs. Some of the most common, like snowdrops (*Galanthus* spp.), are likely to have been collected from the wild even when commercially propagated plants are available, due to the lower cost of wild-collected bulbs. According to one Turkish botanist, Turkey exported 28 million snowdrop bulbs in 1983. Over a dozen of the catalogs offered snowdrops without any information as to whether they are wild-collected or commercially propagated. Three catalogs specified that they were selling *Galanthus elwesii*—a species that Turkish botanists believe is so extensively collected that it is becoming endangered in its native range.

Other bulbs collected from the wild and sold to United States firms and to bulb firms in the Netherlands, where they're resold to the United States, include winter aconite (*Eranthis hyemalis*), grape hyacinth (*Muscari* spp.), crocus (*Crocus* spp.), crown imperial (*Fritillaria imperialis*), giant snowflake (*Leucojum aestivum*), winter daffodil (*Sternbergia* spp.), madonna lily (*Lilium candidum*), and species tulips (especially *Tulipa pulchella* 'Humilis'). Angel's-tears narcissus (*Narcissus triandrus* var. *triandrus*) is sold by a half-dozen nurseries, and most of these are collected in Spain, Portugal, and Turkey. Cyclamen (*Cyclamen* spp.) is another plant that may have been collected from the wild—nearly four million cyclamens were imported to the Netherlands from Turkey in 1984, and many of these were resold in the United States.

The best way to preserve our native species is to preserve wildness and open space by becoming interested in the work of groups like The Nature Conservancy, which uses funds to set aside choice natural areas to be added to state parks, wilderness areas, and so forth. Native plant societies around the country work on regional levels to protect endangered plants. Lady Bird Johnson's National Wildflower Research Center, 2600 FM 973 North, Austin, TX 78725, is doing marvelous work listing native wildflowers, shrubs, vines, and trees in every state in the union. You can get these lists, plus lists of native plant societies around the country, by writing to the organization. The center's fact sheets are free, but when requesting them, enclose a self-addressed, business-size envelope with a 75-cent stamp.

Individually, it's important for us to be careful not to disturb wild plants, even if we're just gathering seed or even photographing them. Be careful where you step so you don't crush rare wild plants. *Never* gather more than just a few seed stalks or seed heads—and then only in an area where there are many.

Those of us who love wild and native plants must protect them and must not exploit them.

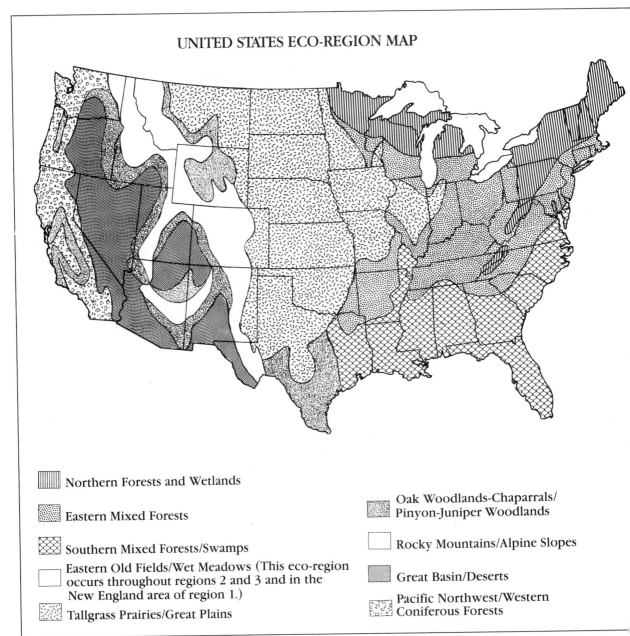

UNITED STATES ECO-REGION MAP

▥ Northern Forests and Wetlands	▨ Oak Woodlands-Chaparrals/ Pinyon-Juniper Woodlands
⣿ Eastern Mixed Forests	☐ Rocky Mountains/Alpine Slopes
⊞ Southern Mixed Forests/Swamps	▦ Great Basin/Deserts
☐ Eastern Old Fields/Wet Meadows (This eco-region occurs throughout regions 2 and 3 and in the New England area of region 1.)	▧ Pacific Northwest/Western Coniferous Forests
▨ Tallgrass Prairies/Great Plains	

BEST NATIVE PLANTS FOR YOUR GARDEN

This encyclopedia is divided into nine eco-regions, covering the entire United States, so you can match the plants in your garden to those that grow naturally in your area. Each eco-region features the most typical native plants—wildflowers, ferns and grasses, and woody plants and vines—with the conditions they need to thrive. To use the encyclopedia to create a garden of native plants, find your eco-region on the map, then find the plant list for that region. The plants are available from nurseries, some of which specialize in native plants. Read the descriptions, look the plants up in wildflower and nursery catalogs and field guides, decide which appeal to you, and you're on your way! To reproduce effects from other eco-regions, choose plants native to your eco-region that resemble the other regions' species.

When you look at a catalog of colorful wildflowers, you're probably tempted to order them all. You may wonder why some wildflowers are recommended for California, some for the Northeast, and some for the prairie. Won't they all grow in your garden? Not likely, because the area where they evolved may have very different climate and conditions from yours. North America is characterized by dramatic changes in climate, topography, rainfall, and soil types. It's bordered by two oceans and divided by four major mountain ranges. It stretches from semitropical regions north to the land of permafrost. These variations produce equally varied plant habitats that maintain distinctive species.

The nine eco-regions outlined here are simplified approximations of what are actually complex ecosystems in nature. In areas where moisture is plentiful, there are forests. This includes the vast area east of the Mississippi River north to the Arctic Circle. The center of the continent is a sea of grasses. The western mountain ranges are covered with forests, while the drier areas support oak woodlands or desert vegetation.

Within these extensive areas, regional differences occur, marked by changes in maximum and minimum summer and winter temperature, as well as seasonal rainfall. Latitude and altitude also influence plant growth. Soil varies in mineral composition and pH, as well as organic content. Water-holding capacity and groundwater influence which plants the soil can support.

From coast to coast, plants sort themselves out into plant communities based on all these factors. Each plant community is a product of its environment, but also has a hand in creating the environment. As trees grow, for example, they create shade. Other plants respond to the amount of light they receive, which diminishes as the trees grow. Each plant community has a set of characteristic plants associated with it. Each eco-region outlined also has an associated set of herbaceous wildflowers, ferns and grasses, and woody plants and vines. You can use these plants to recreate the essence of the region in which you live or as a guide to the best plants for your area.

When you visit natural areas within your region, make notes about the plants that seem to give you the essence of the place. Also note how the plants are arranged. Use these lists as a reference. The plants I've included are easy to grow if conditions of soil,

(continued)

moisture, light, temperature, and humidity are correctly or approximately matched. If you live in New England, for example, you can grow most of the plants listed under Northern Forests and Wetlands. These plants may not succeed in the Southeast, however. There are some plants that grow naturally throughout a large area, and you'll be able to grow them successfully in a variety of locations. These lists are a starting point. Books on wildflower gardening and regional field guides can provide valuable information on natural ranges, hardiness, and suitability of native plants for the garden.

Only purchase plants from reputable dealers who are known to propagate the plants they sell. Many nurseries continue to sell plants collected from the wild. Avoid them. Certain plants are intentionally omitted from the list, notably native orchids and most lilies and trilliums. These plants are not readily available as propagated material; they are still dug from the wild. Do not buy them. **Home gardeners should never dig plants from the wild. This is bad conservation and may be illegal.**

You can combine native plants in the garden as nature would combine them or as a designer would. Your personal style of gardening will influence how you use plants. Purists may create a replica of their chosen plant community, while others may combine native plants with plants from other countries. Match your garden to your personal taste and style.

These plant lists contain only native species. Non-native plants that have naturalized in this country, such as chicory and Queen-Anne's-lace, aren't included. In a favorable situation, these plants may colonize, and many naturalized species can be aggressive spreaders, out-competing the natives.

NORTHERN FORESTS AND WETLANDS

The states of the Great Lakes region and northern New England are covered with a patchwork of coniferous and deciduous forests and dotted with a variety of wetlands. The forest varies according to soil type, moisture, and age.

The young second-growth forests are dominated by birch and aspen. This forest type occurs where fire or clear-cutting has destroyed the canopy and created openings. Given time, these areas will return to coniferous forest. The drier soils will support mature forests of white, jack, and red pines, while the moist soils produce spruce, fir, larch, and white cedar.

Wetland habitats develop in areas of continuous moisture or standing water. Open, wet areas, called shrub carrs, occur in shallow water and are dominated by alder, dogwood, and sedges. Spaghnum bogs also occur throughout the region. They may be forested or open, depending on their age and the amount of water they contain. Young bogs, called quaking bogs, have mats of vegetation that actually float on top of deep ponds or lakes.

Rainfall is plentiful in the northern forest, often exceeding 40 inches. Winters are cold with a permanent snow cover. Summers are cool and moist, especially at higher elevations. Shade is dense in the conifer forest year-round, and plants of these forests are adapted to deep shade. The soil is moist and usually acidic. In the birch and aspen forest, the brighter light and high moisture produces a solid carpet of ferns and wildflowers.

Plants in this region are hardy in USDA Plant Hardiness Zones 1 to 5.

Wildflowers

BLUE-FLOWERED

Aster macrophyllus
Bigleaf aster. Large, heart-shaped foliage; forms dense groundcover. Flat-topped flower clusters 1 to 4 feet tall in late summer. Flowers violet to lavender, rarely white, with yellow centers. Prefers moist, slightly acid soil in sun or shade; drought-tolerant when established. Perennial.

Aster novi-belgii
New York aster. Tall, branching plant to 4 feet with glossy, narrow foliage clasping the stem. Showy 1¼-inch blue to violet flowers in loose clusters; blooms in August. Prefers moist soil in full sun or light shade; tolerates damp soil. Perennial.

Campanula rotundifolia
Harebell. Delicate plant, 6 inches to 2 feet tall with sky blue flowers borne all summer atop slender stalks. Grows in a variety of situations, including dry rock crevices and grassy slopes in full sun. Perennial.

Iris versicolor
Blue flag iris. Stout plant with arching, strap-shaped leaves to 3 feet. Flowers are blue with yellow veining, 4 inches wide, from May to June. Plant prefers moist soil in full sun; will grow in standing water. Perennial.

PINK-FLOWERED

Epilobium angustifolium
Fireweed. Tall, slender plant to 6 feet with dense, lance-shaped foliage and showy, elongated clusters of clear pink flowers. The plant blooms from spring to frost. Prefers poor soil or burned-over areas in full sun. Perennial.

Eupatorium maculatum
Joe-pye weed. Tall, stout plant with whorls of widely lance-shaped leaves and broad, flat clusters of densely packed pink flowers; blooms June to August. Requires moist soil and full sun for best growth. Perennial.

Linnaea borealis
Twinflower. Delicate creeping plant with small, rounded leaves. Produces paired pink bells on 4-inch stalks; blooms May to July. Prefers moist, acid soil with high organic content; sun to deep shade. Perennial.

RED-FLOWERED

Sarracenia purpurea
Purple pitcher plant. Unique, hollow, red-veined leaves trap and digest insects. Sweet-scented, red flowers borne on tall stalks in June. Demands moist to wet acid peat or sand in full sun to light shade. Perennial.

(continued)

WHITE-FLOWERED

Actaea rubra
Red baneberry. Tall plant to 3 feet with wide-spreading, compound leaves that have many small leaflets. Flower cluster rounded, fuzzy, with tiny white flowers in May and June. Summer berries are deep red, in 6- to 9-inch clusters. Requires rich, moist soil in light shade. Perennial.

Anemone canadensis
Canada anemone. Fast-spreading plant to 2 feet. Dark green, lobed leaves accent the pure white, five-petaled flowers borne in May and June. Grows in a variety of soils in full sun or light shade. Perennial.

Aralia nudicaulis
Wild sarsaparilla. Compound foliage has three leaflets, each divided into five smaller leaflets. Forms a sparse groundcover to 1 foot high. Flowers inconspicuous, in three-part, round clusters. Grows in moist to dry soil in sun or shade. Perennial.

Aster umbellatus
Flat-topped aster. Tall plant to 6 feet with attractive, lance-shaped foliage. Flowers white, forming broad, flat clusters in August and September. Grows in moist soil in full sun or light shade. Perennial.

Calla palustris
Wild calla, water-arum. Succulent plant with large, heart-shaped foliage and pure white, flowerlike bracts resembling a florist's calla; borne in summer. Prefers cool, moist to wet soil or standing water in full sun. Perennial.

Chelone glabra
White turtlehead. Stout, multistemmed plant with quilted, lance-shaped leaves and unusual inflated flowers resembling turtles' heads. Flowers from July to September. Requires moist, rich soil in full sun or light shade. Perennial.

Coptis groenlandica
Goldtread. Low-growing creeper with glossy, three-lobed leaves and delicate white flowers borne singly in summer. Grows best in acid, organic soil with even moisture; prefers shade. Perennial.

Cornus canadensis
Bunchberry. Creeping plant with a whorl of leaves atop 4- to 6-inch stems. Flowers are small and yellow, surrounded by four showy white bracts in early summer; they're followed by bright red berries. Evergreen foliage turns purple or bronze in fall. Thrives in moist, acid soil high in organic matter. Prefers shade; tolerates sun in northern areas. Perennial.

Dalibarda repens
Dewberry. Creeping plant with 1-inch, round or heart-shaped leaves and delicate white flowers in June or July. Requires a cool, shaded spot with rich, moist, acid soil. Perennial.

Gaultheria hispidula
Creeping snowberry. Prostrate plant with tiny, rounded, evergreen leaves and inconspicuous white flowers. Fruit white, showy in late summer and fall. Moist, acid soil must be high in organic matter; prefers shade. Perennial.

Gaultheria procumbens
Wintergreen. Low-growing evergreen with creeping rootstocks. Fragrant leaves glossy, turning red to purple in the fall. Small, bell-shaped flowers; edible red berries are showy throughout the winter. Adaptable to moist through extremely dry conditions in slightly to strongly acid soil; sun or shade. Perennial.

Menyanthes trifoliata
Bogbean. Creeping plant with many three-lobed, sea green leaves and clusters of lacy, five-petaled flowers atop thick stems; blooms in June and July. Grows in moist soil or standing water in full sun or light shade; prefers acid soil. Perennial.

Potentilla tridentata
Wine-leaf cinquefoil. Dense groundcover with three-part, shiny evergreen leaves and profuse white flowers on branched stems. Requires rocky to sandy soil or rock crevices in full sun to light shade. Perennial.

YELLOW-FLOWERED

Caltha palustris
Marsh marigold. Early blooming plant with lush, heart-shaped foliage and showy, five-petaled, golden yellow flowers from March to May. Grows in standing water or moist soil in partial to full shade. Goes dormant after flowering. Perennial.

Clintonia borealis
Bluebead. Rosettes of two to four satiny leaves surround the 1-foot flowering stalk. Bell-shaped, greenish yellow flowers in May and June, followed by deep blue berries. Grows in moist, rich, acid soil in partial to deep shade. Perennial.

Lysimachia terrestris
Swamp candles. Erect plant to 3 feet with pointed terminal clusters of starry yellow flowers. Blooms from June to August in wet soil with full sun or partial shade. Perennial.

Ferns and Grasses

Athyrium filix-femina
Lady fern. Lacy, thrice-divided fronds from rapidly spreading rhizome; 1 to 3 feet. Grows in moist soil in sun or shade. Perennial. Also listed as *A. asplenioides*.

Calamagrostis canadensis
Canada bluejoint grass. Tall, dense grass with jointed stems and blue-green foliage. Tawny plumes are showy in summer and fall. Prefers moist soil in sun or shade. Perennial.

(continued)

Dryopteris cristata
Crested woodfern. Erect, slender fronds to 3 feet with stair-step pinnae (leaflets); evergreen. Prefers rich, moist to wet soil in shade. Perennial.

Dryopteris filix-mas
Male fern. A striking fern with arching, twice-divided evergreen fronds in a tight rosette. Prefers cool, moist soil in shade. Perennial.

Gymnocarpium dryopteris
Oak fern. Small, delicate fern to 6 inches with three-lobed, thrice-divided, triangular fronds. Slowly spreads in rich, moist soil and shade. Perennial.

Polypodium virginianum
Rock polypody. Leathery, evergreen fronds to 8 inches from a slow-creeping rootstock. Grows in acidic soil in rock crevices or in rocky soil in sun or shade. Perennial.

Thelypteris phegopteris
Broad beech fern. Attractive fern with broadly lance-shaped, twice-divided fronds; upper pinnae (leaflets) reflexed; borne on slender stems. Creeps slowly by underground rhizomes. Prefers rich, moist soil in partial to full shade. Perennial.

Woody Plants and Vines

PINK-FLOWERED

Andromeda glaucophylla
Bog rosemary. Rounded pink bells hang delicately above the needlelike, leathery leaves in May and June. Plants 4 inches to 2 feet with open branching. Grows in cool, moist sand or peat in sun or shade.

Kalmia angustifolia
Sheep-laurel. Slender, branching shrub to 3 feet; leaves slender, leathery. Pink flowers clustered at the base of the current year's growth. Plants require moist, sandy, or peaty, acid soil in full sun or light shade.

Rhododendron canadense
Rhodora. A delicate, exquisitely beautiful shrub growing 2 to 4 feet high in openly branched mounds. Pink flowers borne before the gray-green leaves unfold. Requires moist, acid peat or sand and cool summer temperatures. Grows in sun or light shade.

Rosa spp.
Wild roses. Twiggy plants with thorny stems, compound leaves, and showy, pink, five-petaled flowers. Grow in a variety of soils, moist to dry, in full sun or light shade.

RED-BERRIED

Taxus canadensis
American yew. Low to medium-size, spreading, needleleaf evergreen shrub with deep green foliage. Red berries showy on female plants. Grows in rich, moist woods in shade. Protect from summer sun.

WHITE-FLOWERED

Acer spicatum
Mountain maple. Small tree to 30 feet with five-lobed, quilted leaves and slender spikes of greenish white flowers; fruit tinged red. Grows in cool, moist, acid soil in sun or shade.

Amelanchier canadensis
Shadbush, Juneberry. Multibranched, small tree to 20 feet. Delicate white flowers borne in early spring before the hairy leaves emerge. June fruit red to purple. Grows in moist or dry soil in sun or light shade.

Arctostaphylos uva-ursi
Bearberry. Creeping shrub with leathery, evergreen foliage and unusual urn-shaped flowers tinged pink. Large, glossy red berries follow the summer flowers and last throughout the winter. Grows in a wide variety of conditions, including acid slopes and sandy dunes. Tolerates light shade.

Aronia arbutifolia
Red chokeberry. Large shrub to 12 feet; multistemmed with wide spread. Leaves oval, deep green. Showy May flowers are white with pink stamens; fruit brilliant red, ripens in August. Excellent red fall color. Grows in wet, moist, or dry soil in full sun or partial shade.

Chamaedaphne calyculata
Leatherleaf. Low, dense, semi-evergreen shrub with small foliage turning bronzy in fall. Attractive flowers hang along one side of 6-inch spikes in June and July. Prefers moist to wet, acid peat or sand in full sun or partial shade.

Comptonia peregrina
Sweet-fern. Low, branching shrub to 2½ feet with fragrant, narrow fernlike foliage. Flowers and fruit insignificant; grown as a foliage plant. Prefers average to poor, dry sand in full sun; will tolerate clay if it is well-drained.

Ilex verticillata
Winterberry. Medium or large shrub to 12 feet. Multibranched with quilted, dark green leaves. White flowers inconspicuous; bright red fall berries very showy on female plants, often persisting until spring. Tolerates wet to dry soil in full sun or partial shade.

Ledum groenlandicum
Labrador tea. Leaves dark green, pointed, brown woolly beneath. Terminal clusters of showy white flowers accent this low-branching shrub; blooms in May and June. Requires cool, peaty soil in sun or partial shade.

Nemopanthus mucronatus
Mountain holly. Open shrub to 8 feet or more with gray-green leaves and greenish white flowers. Lovely red berries appear to be coated with white wax. Requires cool, moist, acid soil in light shade; will not tolerate summer heat.

(continued)

Rhus parviflora
Thimbleberry. Small, rambling shrub to 4 feet. Large, five-lobed leaves are sticky-haired. Flowers white, showy, borne all summer. Fruit dry, inedible. Grows in average soil in sun or partial shade.

Sambucus pubens
Red elderberry. Vase-shaped, spreading shrub to 12 feet. Leaves compound, deep green with yellow fall color. Clusters of white flowers in May. Showy, deep red fruit lasts all summer. Widely tolerant of soil, moisture, and light.

Sorbus americana
American mountain ash. Small to medium-size tree with deep green, compound foliage and mounded clusters of creamy white flowers. Red berries showy throughout the winter, eaten by many birds. Requires cool summers, moist, rich soil and full sun.

Vaccinium vitis-idaea
Mountain cranberry. Dwarf creeping shrub with tiny foliage. Summer flowers small, white to pink, followed by round, red berries. Grows in acid soil in sun or shade.

Viburnum dentatum
Arrowwood. Medium-size shrub 8 to 10 feet; opposite, rounded leaves with toothed margins. Flowers creamy white in tight, flattened clusters from May to July. Fall berries blue-black; fall color clear yellow to purple. Thrives in moist to dry soil with full sun or partial shade.

EASTERN MIXED FORESTS

This region includes the extensive forested areas from the Atlantic Coast westward to the Prairie and north to the Great Lakes region. Several distinct forest types exist within the Eastern Mixed Forest region, each characterized by a different group of tree species. The eastern deciduous forest occurs east of the Appalachian Mountain ranges; the Appalachian forest clothes the highlands; and the forests between the mountains and the Mississippi River are different from eastern deciduous and Appalachian. Characteristic eastern deciduous trees include tulip poplar, white and red oaks, American beech, and flowering dogwood. The Appalachian forest is characterized by American linden, goosefoot maple, chestnut and red oaks, shagbark hickory, and buckeye. Trees characteristic of the Mississippi River forests are burr oak and green ash, which is replacing the American elm in these woods.

In general, soils are rich and fertile, except in areas impoverished by agriculture and erosion. Rainfall is adequate, 25 to 35 inches, and occurs throughout the year.

The forest canopy allows ample sun to reach the forest floor in spring, then closes in the summer, providing cool shade. The majority of wildflowers and shrubs in these areas bloom in the spring, when light is available.

This region covers USDA Plant Hardiness Zones 4 to 8.

Wildflowers

BLUE-FLOWERED

Gentiana andrewsii
Bottle gentian. Stems to $1\frac{1}{2}$ feet with opposite, glossy leaves and rich blue, inflated flowers borne terminally and in the leaf axils. Plant blooms from August to October. Thrives in evenly moist soil in full sun or partial shade. Perennial.

Hepatica americana
Liverleaf. Three-lobed, evergreen leaves rise from a fibrous root system. Flowers borne in earliest spring on fuzzy stems are violet-blue, pink, or white. Plant prefers slightly acid soil with high organic content and partial to full shade. Perennial.

Iris cristata
Crested iris. Low-growing iris with short fans of sword-shaped leaves and sky blue to purple flowers with bright yellow spots on the falls. Blooms in May. Prefers moist, rich soil in light shade. Do not mulch heavily. Perennial.

Phlox divaricata
Wild sweet William, wild blue phlox. Plant produces deep green, basal foliage that makes a good summer groundcover. Slender stems to 1 foot bear fragrant, sky blue flowers in April and May. Grows in rich, moist soil in sun or shade. Perennial.

Polemonium reptans
Jacob's-ladder. Compound leaves persist all summer. Sky blue, open, bell-shaped flowers nod from 1-foot stems in April and May. Thrives in rich, moist soil in sun or light shade. Perennial.

PINK-FLOWERED

Anemonella thalictroides
Rue anemone. Leaves gray-green, resembling those of cultivated rue. Fragile pink or white flowers on dainty, 6-inch stalks. Grows in moist or dry sites in average soil. Prefers partial shade. Perennial.

Chelone lyonii
Pink turtlehead. Showy, summer-blooming plant with unusual, inflated pink flowers on stout stems; leaves oval. Plant thrives in rich, moist soil with full sun or light shade. Perennial.

Claytonia virginica
Spring beauty. Delicate, grassy foliage emerges in earliest spring, followed by pale pink flowers from March to May. After flowering, the plant quickly disappears. Grows in moist to dry soil in shade or sun. Perennial.

Dicentra eximia
Wild bleeding-heart. Robust, floriferous plant produces mounds of ferny foliage and a summer-long profusion of pink, heart-shaped flowers. Grows in moist, slightly acid soil in sun or light shade. Perennial.

(continued)

Geranium maculatum
Wild geranium. Erect plants with attractive lobed foliage and five-petaled pink flowers that open from April to June. Plant prefers moist, rich soil in sun or light shade. Fall foliage may be burgundy red. Perennial.

RED-FLOWERED

Aquilegia canadensis
Wild columbine. Red-and-yellow, spurred flowers nod on slender stems above compound, blue-green foliage. Plant grows from a stout taproot. It requires average, well-drained soil and sun or light shade. Perennial.

Asarum arifolium
Wild ginger. Triangular, arrow-shaped, evergreen leaves on thick, wiry stems emerge from a branching rhizome. Flowers at base of plant are maroon with three blunt lobes. Grows in moist, acid soil in shade. Perennial.

Asarum canadense
Canada wild ginger. Creeping groundcover with paired, heart-shaped leaves and three-lobed, maroon, jug-shaped flowers at base of plant. Plant thrives in moist, rich soil with full to partial shade. Perennial.

Monarda didyma
Bee balm. Scarlet red, tubular flowers cluster atop 3-foot stems with opposite, fragrant foliage. Plants require moist soil and full to partial sun. Perennial.

Trillium sessile
Toad trillium. Three mottled leaves accent an unusual maroon flower that smells like ripe fruit. Self-sows in rich, moist soil in shade. Easiest of the trilliums to grow from seed. Blooms in three to five years from seed. Buy only nursery-propagated plants. Perennial.

WHITE-FLOWERED

Actaea pachypoda
White baneberry. Spreading plant with large, highly dissected compound leaves. Flowers in May and June on tall stems. Small, tightly packed flowers give way to elongated clusters of porcelain white berries on bright red stalks. Prefers rich, slightly acid soil that remain moist all season; light to deep shade. Perennial.

Arisaema triphyllum
Jack-in-the-pulpit. Unique, green, funnelform flowerlike bract has a drooping flap that conceals the columnar spadix. Plant emerges with the flowers ready to open between two three-part leaves. Fall fruit is orange-red. Grows in damp to moist, humus-rich soil in sun or shade. Perennial.

Cimicifuga racemosa

Black cohosh. Foliage compound with many small, softly hairy leaflets. Very tall flower spike, to 6 feet, with showy, densely packed flowers with fuzzy stamens. Flowers are foul smelling. Grows best in rich, moist soil with protection from hot afternoon sun; shade-tolerant. Perennial.

Dentaria diphylla

Crinkleroot. Early spring bloomer forms a rosette of three-lobed leaves and a 6-inch stalk with clustered, four-petaled, white to pink flowers. Foliage disappears in summer and re-emerges in late winter. Grows in moist, rich soil in shade. Perennial.

Dicentra cucullaria

Dutchman's breeches. March and April bloomer with unique pronged flowers resembling inflated pantaloons hanging upside down. Gray-green, ferny foliage disappears after flowering. Grows in moist, rich or rocky soil in shade. Perennial.

Erythronium albidum

White trout lily. Spring wildflower produces a pair of mottled leaves and a single white flower with five reflexed petals that dangles on a delicate stem. Blooms from March to May and quickly disappears. Grows in rich, moist, slightly acid soil in shade. Perennial.

Podophyllum peltatum

Mayapple. Robust plant produces two bright green, lobed, umbrella-like leaves that hide the white flower; blooms in April and May. Large yellow fruit is edible, but only when fully ripe. Grows in moist soil in sun or shade. Perennial.

Polygonatum biflorum

Solomon's-seal. Tall, arching stems have oval foliage arranged like stairs. The green flowers hang in a line below the stem. Fall berries are blue-black. Plants grow in moist or dry soil in shade or sun. Perennial.

Sanguinaria canadensis

Bloodroot. A single leaf surrounds the pure white flower, which has 8 to 11 petals and a yellow center in early spring. Five-lobed, blue-green leaf. Plants grow in moist, rich to dry, rocky, neutral to slightly acid soil in shade. Perennial.

Shortia galacifolia

Oconee-bells. A lovely groundcover with rounded, evergreen leaves and white to pale pink open bells in March and April. Requires moist, acid soil high in organic matter; light to deep shade. Perennial.

Smilacina racemosa

Solomon's-plume, false Solomon's-seal. Bold plant; 2 to 5 feet with arching stems crowned by a fuzzy plume in May and June. Late-summer berries are green mottled with red. Grows in moist soil in sun or shade. Perennial.

(continued)

Tiarella cordifolia
Foamflower. A beautiful and versatile groundcover with low, evergreen leaves arising from creeping stems. White flowers clustered along 8-inch spikes in April and May resemble seafoam. Plant thrives in evenly moist soil in full to partial shade. Perennial.

Trillium grandiflorum
Large-flowered trillium. Pure white, three-petaled flower, which rises from a whorl of three oval leaves, fades to pink with age. This April and May bloomer requires moist, rich soil and light shade. Make sure you buy only nursery-propagated plants. Perennial.

Viola canadensis
Canada violet. Low groundcover with broadly heart-shaped foliage. Flowers are pure white with purple-backed petals. Blooms from March to May in shaded areas. Requires moist, rich soil. Perennial.

YELLOW-FLOWERED

Solidago flexicaulis
Zigzag goldenrod. Rounded leaves alternate up the $1\frac{1}{2}$-foot stem of this attractive woodland plant. Flowers are produced in profusion along the upper third of the stem in August and September. Plants grow in moist or dry soil in sun or shade. Perennial.

Stylophorum diphyllum
Celandine poppy. Long-blooming plant with yellow-orange, $1\frac{1}{4}$-inch, four-petaled flowers from March to June. Attractive, lobed foliage remains green all summer, especially in moist, rich soil. Prefers light shade. Perennial.

Uvularia grandiflora
Great merrybells. Slender stems pierce the oblong, green leaves and bear $1\frac{1}{2}$-inch, yellow bells at their tips. Flowers are produced from March to May on 1- to $1\frac{1}{2}$-foot plants. Grows in moist soil in shade. Perennial.

Ferns and Grasses

Adiantum pedatum
Maidenhair fern. Striking fern; unusual, horseshoe-shaped fronds with radiating pinnae (leaflets). Stipe (stem) is ebony black. Grows from a creeping rhizome in rich, moist soil in light to partial shade. Perennial.

Athyrium pycnocarpon
Narrow glade fern. Tropical-looking fern with once-divided fronds to 3 feet. Slow-creeping rhizome. Easily grown in rich, moist soil and light shade. Perennial.

Hystrix patula
Bottlebrush grass. Woodland grass to 3 feet; open habit. Bottlebrush-shaped seed head is attractive when backlighted. Grows in open shade in a wide variety of soils and moisture conditions. Perennial.

Osmunda claytoniana
Interrupted fern. Stout fronds to 4 feet radiate from a wiry rhizome. Fertile pinnae (leaflets) are borne in the center of the sterile frond, hence the common name. Grows in moist to dry, fertile soil; tolerates full sun. Perennial.

Polystichum acrostichoides
Christmas fern. Evergreen fronds to 2 feet, once-divided, radiating from a central crown. Grows in moist or dry soil; tolerates some sun. Perennial.

Thelypteris noveboracensis
New York fern. Lush, carpet-forming fern with bright green, twice-divided fronds from a fast-creeping rootstock. Prefers rich, moist soil, but tolerates dry conditions. Will grow in partial sun if soil is moist. This plant produces a toxin that inhibits the germination of woody plant seeds, so you'll often find it in open stands. Perennial.

Woody Plants and Vines

PINK-FLOWERED

Cercis canadensis
Redbud. Medium-size, vase-shaped tree; flat-topped when mature. Leaves large, heart-shaped. Pea-shaped flowers densely clustered on young twigs, borne sparsely on branches and trunk. Grows in a variety of soil conditions, moisture, and light. Tolerant of alkaline soil.

Kalmia latifolia
Mountain laurel. Twiggy shrub to 12 feet with leathery, evergreen leaves and dense clusters of rounded, pale pink flowers. Grows in acid peat or sand in full sun or deep shade. Drought-tolerant once established. To make sure you're not buying a wild-collected plant, choose one of the many named cultivars of mountain laurel.

Rhododendron catawbiense
Rosebay. Medium-size, twiggy shrub to 8 feet or more. Leaves elongated, leathery, and evergreen. Vibrant magenta flowers are extremely showy, borne in rounded clusters atop each stem, surrounded by a whorl of leaves. Grows in moist to dry, acid soil in full sun or light shade.

Rhododendron periclymenoides
Wild azalea. Tall, open shrub to 10 feet or more, spreading by stolons. Showy, fragrant flowers borne before the leaves emerge. Grows in moist or dry, acid soil. Best flowering occurs in full sun, although plants are shade-tolerant. Formerly *R. nudiflorum.*

RED-FLOWERED

Aesculus pavia
Red buckeye. Small tree to 20 feet with an equal spread. Palmate leaf has five leaflets. Flowers 1½ inches long, deep red, in elongated terminal clusters. Grows in moist soil in full sun or light shade.

(continued)

WHITE-FLOWERED

Cornus florida
Flowering dogwood. Medium-size tree to 30 feet with quilted leaves and four showy, white, petal-like bracts. Small, yellow flowers clustered in center of bracts; fruit glossy red. Leaves wine red in fall. Prefers cool, moist soil, rich in organic matter; protect from hot afternoon sun.

Halesia carolina
Carolina silverbell. Medium or large tree to 40 feet or more. Bark exfoliating on branches. Leaves oblong-ovate, turning yellow in the fall. Spring flowers pendulous, white or rarely rose, bell-shaped, and borne in clusters. Requires a moist, highly organic, acid soil and full to partial sun.

Leucothoe fontanesiana
Drooping fetterbush. Low, arching shrub with lance-shaped, evergreen leaves. White, pitcher-shaped flowers in elongated axillary clusters. Leaves turn red or purple in winter. Grows in rich, moist, acid soil high in organic matter. Will tolerate sun only if soil is moist; protect from drying winds. Also listed as *L. catesbaei.*

Oxydendrum arboreum
Sourwood. Medium-size, slender tree to 30 feet or more. Glossy leaves turn fiery red in fall. Fragrant, urn-shaped flowers in many-branched, drooping clusters at the tip of every branch. Prefers rich, moist soil, but is drought-tolerant when established. Grows in full or partial sun.

Stewartia ovata
Mountain stewartia. Small tree to 15 feet high with equal spread. Leaves large, broadly oval, turning scarlet in fall. White flowers have five to six petals and purple stamens. Grows in moist, acid soil with ample organic matter. Prefers to be shaded from hot afternoon sun.

Vaccinium staminium
Deerberry. Medium-size shrub to 8 feet. Leaves oblong, elliptical to oval, whitish beneath. White, pendulous, bell-shaped flowers open in May and June. Grows in dry, acid soil in sun or shade.

Viburnum acerifolium
Maple-leaved viburnum. Open, spreading shrub to 5 feet. Leaves three-lobed, resembling a maple, turning rose red in fall. Creamy white flowers in loose clusters at tips of branches; black fruit. Grows in moist or dry soil in sun or shade.

YELLOW-FLOWERED

Hamamelis virginiana
Common witch hazel. Large shrub or small tree to 20 feet; open, vase shape. Leaves broadly oval, fuzzy when young. Four-petaled flowers cluster along the stems in fall. Widely tolerant of soil and moisture; grows in sun or shade.

SOUTHERN MIXED FORESTS/SWAMPS

The Southern Mixed Forest region is found in the Atlantic coastal states from Maryland south to Florida and west across the Gulf states to Texas. The area also follows the Mississippi River drainage up to Missouri.

The southern forest is characterized by sandy soils that support extensive loblolly and long-leaf pine forests and wet pine savannas. These forests were originally maintained by natural fires and are now being managed with controlled burning. The forest floor is open and sunny, often with dense stands of palmetto and summer-flowering wildflowers and shrubs.

Deciduous trees occur in large stands on higher, richer soils. These forests resemble the eastern deciduous forest community, consisting mostly of sweet gum, oaks, and maples. Many spring woodland wildflowers bloom in this forest. Ferns create lush carpets in the long, moist growing season.

The region also contains extensive floodplain forests that occur in the rich, deep soils along river drainages and streams. In the deltas of these drainages, tupelo and cypress swamps occur that are constantly or intermittently flooded. These forests may be completely dry for some portion of the year.

Plants of this region are adapted to mild winters and hot, humid summers with plentiful rainfall. Plants bloom throughout the season, from late winter through fall. The region contains plants for dry, acid soils; moist, rich soils; and wet places.

This region covers USDA Plant Hardiness Zones 7 to 9.

Wildflowers ▬▬▬▬▬▬▬▬▬▬▬▬▬▬▬▬▬▬▬▬▬▬▬▬

BLUE-FLOWERED

Mertensia virginica
Virginia bluebells. Leaves thin; stem succulent from a stout rootstock. Lovely, sky blue flowers are bell-shaped and fragrant. Requires spring moisture in dappled shade or sun; goes dormant after flowering. Perennial.

Pontederia cordata
Pickerel weed. Succulent plant to 3 feet with thick, narrowly heart-shaped leaves; Purple-blue flowers are produced throughout the summer. Grows in standing water; will also succeed in moist soil. Requires full sun for best growth. Perennial.

PINK-FLOWERED

Asclepias incarnata
Swamp milkweed. Tall, slender stems rise 3 to 5 feet from a stout rootstock. Flowers in open clusters in July and August. Grows in moist to wet soil; adaptable to drier conditions. Requires full sun. Perennial.

Kosteletskya virginica
Seashore mallow. Tall, multistemmed plant to 6 feet or more. Leaves three-lobed; pink flowers like miniature hibiscus, borne throughout the summer. Grows in moist or wet soil in full sun; salt-tolerant. Perennial.

(continued)

Rhexia petiolata
Meadow beauty. Erect, slender stems topped with two to four showy, four-petaled, pink flowers. Grows in sandy, acid soil with constant moisture. Prefers full sun. Perennial.

RED-FLOWERED

Lobelia cardinalis
Cardinal flower. Showy, summer-blooming plant, 4 to 6 feet tall with dense spikes of red flowers. Leaves form a tight rosette in winter. Grows in rich, constantly moist soil. Full sun promotes bloom and prevents flopping. Short-lived perennial.

WHITE-FLOWERED

Crinum americanum
Swamp lily. Stout, bulbous plant with strap-shaped leaves to 3 feet. Spidery flowers with narrow, white petals in spring and summer. Grows in moist to wet, sandy soil in full sun or light shade. Perennial.

Hibiscus moscheutos
Marsh mallow. Coarse, multistemmed plant with large, lobed or entire foliage. Saucer-sized flowers with five white petals and red eyes; may be pink-flowered. Grows in moist, rich soil, but tolerates average soil; needs full sun for best bloom. Perennial.

Hymenocallis occidentalis
Spider lily. Bulbous plant with strap-shaped leaves to 2 feet. White flowers borne on thick stalk; a funnel-shaped cup similar to a daffodil's is surrounded by six narrow petals. Plants require moist, acid soil and full to partial sun. Perennial.

Nymphaea odorata
Fragrant water lily. Aquatic plant with floating, rounded foliage. Fragrant, multipetaled flowers held just above the water. Grows in standing water to $1\frac{1}{2}$ feet deep from a creeping rhizome. Requires full sun. Perennial.

Sagittaria latifolia
Arrowhead. Aquatic plant with broad, arrow-shaped foliage and unusual, three-petaled, white flowers. Plants may be 3 feet in height; fast-spreading from a creeping rhizome. Prefers standing water, but will grow in moist soil in full to partial sun. Perennial.

Zephyranthes atamasco
Atamasco lily. Small, bulbous plant to 1 foot with narrow, strap-shaped foliage. Showy, white, funnelform flowers in March and April. Prefers moist, acid sand or peat, but tolerates average garden soil in full sun or partial shade.

YELLOW-FLOWERED

Erythronium americanum
Trout lily. Spring wildflower with two mottled leaves and a single, yellow, bell-shaped flower with reflexed petals. Plants disappear after flowering. Grows in rich, moist soil in partial to light shade. Perennial.

Heterotheca graminifolia
Silk grass. Narrow, silvery foliage forms tufts. Yellow, daisylike flowers on stalks to 2 feet; blooms in the fall. Prefers dry, sandy soil in full sun or light shade. Perennial.

Nelumbo lutea
American lotus. Stout, aquatic plant to 3 feet with enormous leaves to 2 feet across. Showy flowers borne singly on naked stems; many light yellow petals. Grows in standing water to 2 feet deep from a thick rootstock. Requires full sun. Perennial.

Sarracenia flava
Trumpet pitcher plant. Hollow, elongated leaves with drooping hoods capture and digest insects. Yellow flowers with drooping petals, borne on 1- to 2-foot stalks before the 3-foot leaves emerge. Requires moist to wet, acid peat or sand in full sun. Perennial.

Ferns and Grasses

Chasmanthium latifolium
Northern sea oats. Attractive, airy, clump-forming grass to 3 feet. Leaves bright green. Grows in moist soil in sun or shade. Perennial. Formerly *Uniola latifolium.*

Dryopteris ludoviciana
Southern wood fern. Tall fern with narrow, upright fronds from a thick rhizome; fronds lustrous, deep green. Grows in rich, moist soil in shade. Perennial.

Osmunda cinnamomea
Cinnamon fern. Bold-textured fern, 2 to 5 feet in height; fronds twice-divided. Grows from a thick, wiry rhizome that branches frequently. Prefers moist or wet soil in sun or shade. Perennial.

Osmunda regalis var. *spectabilis*
Royal fern. Stately fern to 4 feet, growing from a thick, wiry rhizome. Fronds twice-divided, not characteristically fernlike, gray-green in color. Grows in moist or wet, acid soil in sun or shade. Perennial.

Thelypteris kunthii
Maidenfern. Large fern with long, arching fronds covered with downy white hairs. Spreads rapidly from a creeping rhizome in moist or wet soil. Prefers sun or light shade. Perennial.

Woodwardia virginica
Virginia chain fern. Rapidly spreading fern with shiny, twice-divided fronds. Stipe (stem) is jet black. Grows in acid sand or peat in sun or shade. Perennial.

Woody Plants and Vines

BLUE-FLOWERED

Passiflora incarnata
Passion vine. Herbaceous vine to 10 feet with three-lobed, toothed foliage. Exotic, blue-purple flowers borne all summer, and ovoid, edible fruit. Plants grow in average to poor soil in full sun.

(continued)

Wisteria frutescens
American wisteria. A rambling vine to 30 feet or more. Leaves compound, leaflets rounded and delicate. Purple to lavender, pea-shaped flowers in elongated clusters from June to August. Grows in moist soil in sun or light shade.

PINK-FLOWERED

Callicarpa americana
Beautyberry. Coarse, open shrub to 6 feet, often dies back to the ground in winter. Leaves large, paired, softly hairy. Lavender-pink flowers in summer. Showy, magenta fruit clusters in leaf axils in fall. Grows in average, well-drained soil in sun or shade.

Lyonia lucida
Fetterbush. Mounding shrub to 6 feet. Evergreen leaves oval or rounded. Arching branches bear clusters of pale pink, juglike flowers from April to June. Grows in moist, peaty or sandy, acid soil in sun or shade.

RED-FLOWERED

Anisostichus capreolata
Cross vine. A gorgeous vine to 30 feet or more with large, tubular, orange-red flowers and shiny leaves. Grows in moist, slightly acid soil in full sun or light shade. Formerly *Bignonia capreolata.*

Calycanthus floridus
Carolina sweetshrub. Attractive shrub to 8 feet with bright green, glossy leaves and spidery, fragrant flowers in May and June. Grows in average soil, but prefers rich, moist soil in sun or light shade.

Erythrina herbacea
Coral bean. Shrub or vine to 20 feet with triangular foliage and scarlet flowers from May to July. Grows in moist or dry, acid, sandy soil in full to partial sun.

Lonicera sempervirens
Coral honeysuckle. Twining vine to 10 feet or more. Leaves gray-green, oval or round. Long, tubular flowers are scarlet with orange throats. Grows in moist soil in full sun or partial shade.

WHITE-FLOWERED

Aesculus parviflora
Bottlebrush buckeye. Wide, spreading shrub to 8 feet with bold, compound leaves and striking elongated spikes of tasslelike, white flowers in May. Grows in moist, organic soil in full sun or partial shade.

Befaria racemosa
Tarflower. Medium shrub to 6 feet or more. Leaves oblong and leathery; evergreen. Large, spidery flowers densely clothe the plant in June and July. Grows in moist or dry sand or peat soil in full to partial sun.

Chionanthus virginicus
Fringe tree. A beautiful shrub or small tree to 25 feet. Leaves coarse on stout twigs;

yellow fall color. Delicate flowers resemble long tassles. Grows in moist to dry, rich soil in full to partial sun.

Clethra alnifolia
Sweet pepperbush, summersweet. Dense shrub to 8 feet with shiny leaves and upright terminal clusters of strongly fragrant summer flowers. Grows in moist, acid soil in full sun or light shade. Tolerant of seaside conditions.

Cyrilla racemiflora
Leatherwood. Large shrub to 10 feet or more; densely branching. Tiny flowers in tight, drooping spikes that cover the entire plant in June. Red fall color. Prefers moist to wet, rich, sandy soil in full to partial sun.

Gordonia lasianthus
Loblolly bay. Stunning, columnar tree to 40 feet or more. Leaves thick, evergreen. Pure white, 1½-inch flowers with bright yellow centers in May and June. Grows in moist to wet, acid sand or peat in full to partial sun.

Hydrangea quercifolia
Oakleaf hydrangea. Medium-size, bold-textured shrub to 8 feet. Large, lobed leaves resemble oak leaves. Showy flowers in long, tapering clusters that fade to pink with age. Needs rich, moist soil in sun or light shade.

Ilex glabra
Inkberry. Evergreen shrub from 4 to 8 feet with equal spread. Leaves broadly oval to broadly lance-shaped; slightly toothed at the tips. Flowers insignificant; summer berries black. Grows in moist or wet, sandy, acid soil in full sun or light shade.

Itea virginica
Virginia sweetspire. Mounding shrub to 5 feet with arching stems and long terminal clusters of small, fragrant flowers from April to June. Brilliant red fall color in sun. Grows in moist or wet, acid peat or sand. Prefers full sun or partial shade.

Magnolia grandiflora
Southern magnolia, bullbay. Large, upright tree to 60 feet or more with leathery, evergreen leaves, shiny above, brown and hairy below. Exquisite, pure white, strongly lemon-scented flowers from May to July. Grows in rich, moist soil in full sun or light shade.

Magnolia virginiana
Sweetbay magnolia. Narrow, upright or multistemmed tree to 30 feet or more. Leaves semi-evergreen, gray-green above, white below. Creamy white flowers to 3 inches, lemon-scented, borne in May and June. Grows in rich, moist or wet soil in full to partial sun.

Myrica cerifera
Wax myrtle. A wide shrub, reaching 10 feet or more with an equal spread. Fragrant, evergreen foliage and gray-blue berries. Flowers insignificant. Widely tolerant of soil moisture and fertility. Good for seaside conditions.

(continued)

Osmanthus americanus
Devilwood. Tall, open shrub to 20 feet or more with dark, evergreen leaves and sweet flowers in March and April. Grows in moist to wet, acid soil in sun or light shade.

Persea borbonia
Red bay. A medium-size, aromatic tree grown for its lustrous evergreen foliage and decorative black fruit. Grows in moist or wet, acid soil in full to partial sun.

Rhododendron viscosum
Swamp azalea. Tall, twiggy shrub to 8 feet with strongly fragrant summer flowers. Grows in moist to wet, acid peat or sand in sun or shade.

Rhus copallina
Winged sumac. Tall, spreading shrub to 15 feet with shiny, compound leaves; rich red fall color. White or greenish flowers in dense, plume-shaped clusters. Fruit purple-red, short-lived. Grows in dry, sand or clay soil in full to partial sun. Tolerates seaside conditions.

Sabal minor
Dwarf palmetto. Small palm with pinwheel foliage on short stalks. Grows from a short, stout trunk to 20 feet. Prefers moist to dry, acid, sandy soil in sun or shade. Most cold-tolerant palmetto.

YELLOW-FLOWERED

Gelsemium sempervirens
Carolina jessamine. Woody vine to 20 feet with deep green, shiny leaves and $1\frac{1}{2}$-inch, funnelform, yellow flowers in March and April; fragrant. Grows in average, acid soil in sun or shade. Widely tolerant of soil and moisture conditions.

EASTERN OLD FIELDS/WET MEADOWS

Throughout the Eastern Mixed Forest region, openings in the forest canopy have been created by natural and human disturbances. These disturbances have allowed sun-loving plants to thrive in otherwise shady environments.

At one time, fire was a major factor in providing openings in the forest, allowing colonization by grasses, wildflowers, and shrubs. These plants stabilize the area and initiate the process called succession, which eventually returns the area to forest. While sun is plentiful, these open fields bloom with showy summer wildflowers. Similar openings occur following the sedimentation of ponds, creation of river sandbars, and other natural processes. Open areas also occur on mountain slopes and bald mountaintops.

In certain areas, especially the Northeast and the areas bordering the Prairie, where the soil is too wet or too poor and dry to support trees, meadows and glades may exist. These areas are naturally open and maintain plant species that require sun.

Once European settlement occurred, forests were cleared at an accelerated rate and native wildflowers, along with many brought from Europe, colonized these areas. We now see sun-loving plants growing abundantly in old fields, pastures, and along roadsides, in addition to the places where they occur naturally.

This region covers USDA Plant Hardiness Zones 4 to 8.

Wildflowers

BLUE-FLOWERED

Aster novae-angliae
New England aster. Mounds of lavender-blue or pink flowers clothe this 3- to 4-foot plant in August and September. Leaves that clasp the stem and are gray-green, broadly lance-shaped, and hairy. Grows in moist to wet, rich soil in full to partial sun. Perennial.

Baptisia australis
Wild false indigo. Tall, shrublike plant with three-part, gray-green leaves and spikes of deep blue, pealike flowers. Blooms from April to June. Grows in moist, rich soil in full to partial shade. Adaptable to dry conditions. Perennial.

Lupinus perennis
Wild lupine. Low-growing plant with neat, palmate leaves and blue, pealike flowers in 1- to 2-foot spikes. Blooms in May and June. Requires well-drained, acid sand or clay soil and full to partial sun. Perennial.

PINK-FLOWERED

Echinacea purpurea
Purple coneflower. Stout, multistemmed plant, densely flowered with large flower heads bearing drooping magenta petals. Blooms from July to August. Grows in moist or dry, average soil in full sun. Perennial.

Monarda fistulosa
Wild bergamot. Fragrant, twiggy herb with rounded clusters of tubular, lavender-pink flowers in June and July. Grows in moist or dry soil of average fertility. Prefers full sun. Perennial.

Penstemon hirsutus
Hairy penstemon. Erect, hairy plant to 2½ feet with fuzzy, pale pink, tubular flowers in May and June. Grows in dry sand or clay soil in full or partial sun. Perennial.

Physostegia virginiana
False dragonhead. Bushy plant with erect, many-branched stems terminated by four-sided clusters of inflated, tubular flowers. Grows in moist or wet soil in full or partial sun. Perennial. Also listed as *Dracocephalum virginianum.*

RED-FLOWERED

Asclepias tuberosa
Butterfly weed. Low, mounding plant covered with red-orange flowers in June and July. Demands a well-drained sand or clay soil in full sun. Perennial.

Liatris spicata
Spiked gayfeather. Tall, slender spikes of reddish purple flowers intermingle with grassy foliage in July and August. Grows in moist or dry soil in full sun. Perennial.

(continued)

Vernonia noveboracensis
New York ironweed. Tall, sparsely branching, multistemmed plant to 6 feet with rich green leaves and vibrant purple-red flowers in August and September. Grows in moist to wet, rich, organic soil in full sun. Perennial.

WHITE-FLOWERED

Eupatorium perfoliatum
Boneset. Tall plant to 4 feet with deep green, opposite leaves pierced through the center by a stout stem. Mounds of white flowers open from July to October. Prefers moist to wet soil in full sun, but is widely tolerant. Perennial.

Sanguisorba canadensis
Canadian burnet. Tall, white, bottlebrush spikes are borne in August above bright green, compound leaves. Requires cool, rich organic soil in full sun or partial shade. Perennial.

Silene stellata
Starry campion. Airy plant with deep green, whorled foliage and open spikes of inflated, feathery, white flowers in May and June. Grows in average soil in sun or partial shade. Perennial.

YELLOW-FLOWERED

Helenium autumnale
Sneezeweed. Erect, multistemmed plant with yellow to orange, daisylike flowers in August and September. Plants reach 1 to 4 feet in moist to wet, rich soil in full sun. Perennial.

Rudbeckia hirta
Black-eyed Susan. Open, mounded plant bears large, yellow, daisylike flowers with dark brown centers. Blooms throughout the summer. Tolerant of a wide range of soil and moisture conditions. Prefers full sun. Self-sows. Biennial or short-lived perennial.

Solidago nemoralis
Gray goldenrod. Low, erect plant to 1 foot with gray-green foliage and one-sided spikes of lemon yellow flowers in July and August. Grows in dry sand or on exposed clay in full sun. Perennial.

Ferns and Grasses

Andropogon virginicus
Broomsedge. Tall, clumping grass to 4 feet with tawny spikes and cottony white flowers in August and September. Good in dried arrangements. Grows in dry, poor soil in full to partial sun. Perennial.

Eragrostis spectabilis
Purple lovegrass. Wispy grass with tiny purple flowers and seeds borne in profusion in August. Grows in dry sand or clay soil in full sun. Perennial.

Panicum clandestinum
Deertongue. Short, broad-leaved grass with shiny blades. Flowers airy, clustered at the end of the stems. Grows in moist, sandy soil in full sun. Perennial.

Tridens flavus
Purpletop. Tall, sparsely flowering grass with airy, purple flowers in July. Seed heads moderately decorative. Grows in moist or dry soil in full sun. Perennial.

Woody Plants and Vines

PINK-FLOWERED

Rosa carolina
Pasture rose. Low, slender rose to 3 feet with pale to bright pink summer flowers and showy red hips. Grows in sandy or rocky soil in full sun. Not the invasive *R. multiflora* that torments farmers.

Spiraea tomentosa
Meadowsweet. Twiggy, mounding shrub to 5 feet with woolly, overlapping leaves and puffy spires of bright pink summer flowers. Grows in wet or dry soil in sun or partial shade.

WHITE-FLOWERED

Aralia spinosa
Devil's-walking stick. Tall shrub or small tree to 15 feet with enormous compound leaves and wide plumes of small, greenish white flowers. Showy, purple berries form in the fall. Trunk and stems fiercely spined. Grows in dry, sandy or rocky soil in full sun.

Clematis virginiana
Virgin's bower. Rambling vine to 20 feet or more with three-lobed leaves and airy sprays of fragrant white flowers in August. Grows in moist soil in full to partial sun.

Rhus glabra
Smooth sumac. Tall, branching shrub to 15 feet with exotic-looking compound leaves and triangular clusters of greenish white summer flowers. Brick red fruit forms in early fall and persists all winter. Grows in sandy or rocky soil in full sun.

TALLGRASS PRAIRIES/GREAT PLAINS

This vast region stretches between the forests along the Mississippi River, the conifer forests of northern Saskatchewan and Alberta, and the long Rocky Mountain chain, down to Texas. Before European settlement, these grasslands stretched unbroken, but are now divided into agricultural and pasture land.

Grasslands are characterized by the height of the dominant grass species. The dominant grasses are determined by the annual rainfall with the shorter grasses being found in the drier areas. The dry Prairies, found in the rain shadow of the Rocky Mountains, are called Shortgrass Prairies. The dominant grasses, less then 2 feet tall,

(continued)

include buffalograss and blue grama. Rainfall may be less than 10 inches annually, or up to 15 inches. Plants growing here are extremely drought-tolerant.

Along the eastern edge of the grassland, the grasses grow to 5 feet or more. This is the Tallgrass Prairie, characterized by big bluestem in moist areas and prairie cordgrass in wet areas. The soil here is rich and deep, and rainfall is plentiful most years, from 25 to 39 inches.

An intermediate area is referred to as the Mixed Grass Prairie, which has elements of each. The average grass height is 2 to 4 feet, and the dominant grasses are little bluestem and sideoats grama. The area has a variety of soils, and receives 14 to 23 inches of annual rainfall.

Plants that grow on Prairies are adapted to rigorous conditions. Winters may be bitterly cold and summers hot and dry. The plants have extensive root systems that allow them to adapt when water is scarce. They often have hairy foliage to help retard evaporation. If water is not available, the plants go dormant or do not grow until water is adequate.

Prairies are fire-maintained communities, and plants often depend on fire for best growth. When an area burns, competition is reduced and nutrients are returned to the soil.

Plants growing on Prairies are adapted to USDA Plant Hardiness Zones 3 to 8.

Wildflowers

BLUE-FLOWERED

Aster laevis
Smooth aster. Slender, branching aster to 3 feet with smooth, blue-green foliage and mounds of blue to lavender flowers in September. Prefers rich, moist soil in full sun; tolerates dry conditions. Perennial.

Eustoma grandiflorum
Prairie gentian. Upright, smooth plant with blue-green foliage and 3-inch, blue-violet flowers resembling tulips. Blooms from June to September on 1½- to 2-foot stalks. Grows in moist, rich soil in full sun. Short-lived perennial.

Lupinus texensis
Texas bluebonnet. Foliage palmate, deep green. Brilliant blue, pealike flowers with white eyes borne in tight spikes to 1 foot. Grows in average to rich soil in full sun. Annual.

Mechaeranthera tanacetifolia
Tansy aster. Low, upright plant to 1 foot with ragged, ferny foliage and 1- to 2-inch, yellow-centered violet flowers. Blooms from May to October. Grows in dry, sandy soil in full sun. Annual.

Penstemon grandiflorus
Large-flowered penstemon. Erect, stately plant with blue-green, oval foliage up the stem and 2-inch, lavender-blue, tubular flowers in June. Grows in well-drained, sandy soil in full sun; drought-tolerant. Perennial.

Phacelia congesta
Blue curls. Showy, upright perennial to 3 feet with compound leaves and curled,

multiflowered clusters. Flowers blue-violet, five-lobed, and bell-shaped. Grows in moist or dry, sandy or gravelly soil in sun or partial shade. Annual or biennial.

Viola pedata
Bird-foot violet. Showy violet with 1-inch, pale blue or blue-and-purple bicolor flowers above deeply palmate foliage. Blooms in March and April. Grows in poor, dry sand or clay in full sun. Perennial.

PINK-FLOWERED

Asclepias speciosa
Milkweed. Stout, upright plant to 3 feet with wide, leathery leaves and round clusters of lobed, pink flowers from May to September. Grows in rich or poor, moist or dry soil in full sun. Perennial.

Callirhoe involucrata
Wine-cups. Low, creeping plant with deeply lobed foliage and attractive magenta or wine red flowers; blooms March to July. Grows in moist or dry soil in full to partial sun. Perennial.

Dodecatheon meadia
Shooting star. Spring wildflower with crisp, green leaves surrounding a single, 1-foot stalk crowned with an explosion of pointed flowers with reflexed petals. Grows in moist, rich soil in sun or shade. Disappears after flowering. Perennial.

Echinacea pallida
Pale purple coneflower. Tall, slender stems topped with large-headed flowers with slender, drooping, purple-pink petals; blooms in July and August. Grows in average, dry soil in full sun; tolerates alkaline soil and drought. Perennial.

Eupatorium purpureum
Joe-pye weed. Tall, multistemmed plant to 5 feet with large, whorled foliage and broad clusters of fragrant, rose pink flowers from June to August. Grows in evenly moist or wet soil in full sun. Perennial.

Geum triflorum
Prairie smoke. Low groundcover with lovely, fernlike foliage and unusual rose red, juglike flowers. Beauty lies in the airy June seed heads resembling smoke. Grows in dry soil in full sun to partial shade. Perennial.

Monarda punctata
Horsemint. Unusual, mounding plant with insignificant, spotted flowers above showy, clear pink bracts; blooms from June to August. Grows to 3 feet in moist or dry soil with full to partial sun. Tolerates seaside conditions. Perennial.

Petalostemum purpureum
Purple prairie clover. Bushy, multibranched plant with tiny, three-lobed foliage and lovely magenta flowers in a tight cluster resembling clover. Plant grows to 2 feet or more. Prefers moist, rich soil in full sun; tolerates drought. Perennial.

(continued)

Phlox pilosa
Prairie phlox. Slender, delicate plant to 2 feet with hairy, lance-shaped foliage and fragrant, pink flowers in April and May. Grows in average to poor, dry soil in full sun. Perennial.

RED-FLOWERED

Gaillardia pulcherrima
Blanket flower. Brightly bicolored orange-and-red flowers clothe the 1- to 3-foot plants all summer. Grows in average, moist or dry soil in full or partial sun. Biennial or short-lived perennial.

Liatris pycnostachya
Prairie blazing star. Tall, densely flowered perennial with narrow, grasslike foliage. Reddish purple flowers in a tight cluster on the upper half of the stem. Grows in moist, rich soil in full sun. Perennial.

WHITE-FLOWERED

Anemone patens
Pasque flower. Eight-inch plant; foliage deeply dissected, fuzzy; disappears by mid-summer. Early spring bloomer with large, crocuslike flowers; outsides of petals tinted pink or blue. Grows in dry, sandy soil with good drainage; requires full sun. Perennial. Formerly *Pulsatilla patens.*

Eryngium yuccifolium
Rattlesnake master. Tall, striking plant in bloom; branched stalk crowned with small, golf ball–shaped flowers that open white and fade to green. Grows in moist, rich soil with full sun; tolerates drought. Perennial.

Heuchera richardsonii
Coralbells. Low, leafy plant with oval foliage in dense tufts. Flower stems naked, to 1½ feet; ¼-inch flowers inflated, greenish white. Grows in sandy or rocky soil, also rich soil in full sun or light shade. Perennial.

Melampodium leucanthum
Blackfoot daisy. Low, mounding plant covered with white, daisylike flowers. Foliage narrow, softly hairy. Grows in dry, sandy or rocky soil in full sun. Perennial.

Penstemon cobaea
Foxglove. Compact, large-flowered plant with inflated, open-lipped, white flowers in May. Grows in sandy or rocky soil in full sun. Short-lived perennial.

Smilacina stellata
Starry Solomon's-plume. Attractive, blue-green foliage accents terminal cluster of ¼-inch, white flowers from April to June; berries black, striped with green. Grows in moist to dry soil in sun or shade. Perennial.

Veronicastrum virginicum

Culver's root. Tall perennial to 5 feet with attractive, whorled foliage and 8- to 10-inch candelabra-like spikes of fuzzy, white flowers. Grows in rich, moist soil in full to partial sun. Perennial.

Yucca glauca

Soapweed. Spiky plant with slender, blue-gray, needlelike foliage and tall stalks of nodding, greenish white flowers. Blooms from June to August. Grows in poor, sandy or rocky soil in full sun. Perennial.

YELLOW-FLOWERED

Baptisia leucophaea

Plains wild indigo. Mounding plant to 2 feet with three-lobed leaves and drooping clusters of creamy yellow, pealike flowers. Grows in rich or sandy soil in full sun. Perennial.

Coreopsis tinctoria

Annual coreopsis. Delicate, densely branched plant with golden, brown-eyed flower heads, borne in profusion all season. Grows in average to poor soil in full sun or light shade. Annual.

Engelmannia pinnatifida

Engelmann daisy. Densely flowered, yellow daisy to 2 feet with attractive, dissected foliage forming a tight rosette. Plants bloom from April to July. Grows in average, sandy or rocky soil in full sun. Perennial.

Helenium amarum

Bitterweed. Densely branching plant covered by flowers with round, brown heads and a ring of drooping yellow petals. Grows in a variety of soils in full sun. Annual.

Helianthus maximiliani

Maximilian sunflower. Very tall perennial to 8 feet or more. Large, golden sunflower with many flowers up the tall stem. Grows in moist or dry soil in full sun; dry soil will decrease plant height. Perennial.

Heliopsis helianthoides

Oxeye. Bushy plant to 3 feet or more with an equal spread. Paired, deep green leaves and golden yellow, daisylike flowers with orange centers. Grows in moist to dry soil in sun. Perennial.

Lithospermum canescens

Puccoon. Compact plant with woolly foliage and five-petaled, yellow-orange flowers in June and July. Prefers average, sandy soil in full to partial sun. Perennial.

Oenothera missouriensis

Sundrops, Missouri evening primrose. Large-flowered, creeping primrose with narrow, shiny leaves; lemon yellow flowers, to $2^1/_2$ inches, from April to July. Grows in moist or dry soil in full to partial sun. Perennial.

(continued)

Ratibida columnifera
Prairie coneflower, Mexican hats. Rounded, multistemmed plant to 4 feet with compound leaves. Flowers have elongated heads with orange-yellow petals. Grows in poor, dry soil in full sun. Perennial.

Silphium laciniatum
Compass plant. Tall, stately plant to 10 feet or more with decorative, deeply dissected leaves and large, 2- to 3-inch, lemon yellow flowers. Grows in rich, moist soil or drier sandy soil in full sun. Perennial.

Solidago rigida
Stiff goldenrod. Stiff, upright plant to 3 feet with showy, bright yellow, flat-topped flower clusters in August and September. Grows in average to dry soil in full sun. Perennial.

Ferns and Grasses

Agropyron smithii
Western wheat grass. Erect grass to 2 feet with spikes of tightly packed flowers. Roughly hairy, stiff, slender leaf blades. Grows in dry soil in full sun. Perennial.

Andropogon gerardii
Big bluestem. Tall, late summer grass with branching flower heads resembling turkey's feet. Leaves and flowers may be reddish; dries to a tawny color in fall. Grows in rich, moist or dry soil in full or partial sun. Perennial.

Bouteloua curtipendula
Sideoats grama. Attractive, airy grass with low rosette of foliage and tall, slender spikes with one-sided flowers. Grows in average to dry, sandy or rocky soil in full sun. Perennial.

Koeleria cristata
June grass. Small, compact grass to 1 foot with pale green plumes that dry to tan by July. Grows in dry, sandy soil in full sun. Perennial.

Panicum virgatum
Switch grass. Airy, summer-blooming grass to 5 feet with an equal spread. Leaves densely packed along the stem. Seed heads white or pinkish; seeds tawny. Grows in moist soil in full sun. Perennial.

Schizachyrium scoparium
Little bluestem. Medium-size, clumping grass with blue-green foliage turning reddish in fall. Flowering stems 1 to 3 feet tall, flowers white or silvery in late summer. Grows in moist or dry soil in full to partial sun. Perennial.

Sorghastrum nutans
Indian grass. Tall grass, to 5 feet in flower, from a low cluster of bright green foliage. Seed heads golden or tawny. Grows in average, moist or dry soil in full sun. Perennial.

Woody Plants and Vines

BLUE-FLOWERED

Amorpha canescens
Lead plant. Succulent shrub from 2 to 3 feet with an equal or greater spread. Leaves compound, gray-green with downy, white hairs. Purple-blue flowers in slender, branched spikes. Grows in moist to dry soil in full to partial sun.

PINK-FLOWERED

Rosa arkansana
Arkansas rose. Low, thorny plant with pale pink or white flowers and shiny red hips. Grows in moist or dry soil in full to partial sun.

WHITE-FLOWERED

Cornus racemosa
Gray dogwood. Twiggy shrub to 10 feet or more with opposite, lance-shaped leaves. White flowers in loose clusters, followed by decorative white berries. Red fall color. Grows in moist to dry soil and full to partial sun.

Corylus americana
American hazel. Variable shrub from 1 to 10 feet in height. Attractive, oval foliage turns yellow in fall. Edible nuts surrounded by long bracts. Grows in moist or dry soil in sun or shade.

Prunus americana
Wild plum. Small tree to 20 feet with fragrant, white or pale pink spring flowers and edible fruit in late summer. Grows in a variety of soils in sun or light shade.

YELLOW-FLOWERED

Hamamelis vernalis
Vernal witch hazel. Large shrub or small tree to 15 feet or more. Late-winter bloomer with small, four-petaled yellow to reddish flowers. Leaves oval, softly hairy. Grows in rich, moist soil in full to partial sun. Drought-tolerant.

OAK WOODLANDS-CHAPARRALS/PINYON-JUNIPER WOODLANDS

These plant communities are found in semi-arid regions of the West and Southwest. Woodlands form transition zones between the coniferous forests of the higher, more moist areas and the drier grasslands or deserts.

These woodlands differ from other forests. They are composed of drought-tolerant species such as oaks, pines, and junipers. Oaks cover the foothills of southern California and the lower mountains of Arizona and New Mexico. Pines and junipers dominate in the areas around the Great Basin, lower Rockies, and parts of southwestern Texas. The southern areas have hot, dry summers and cool, moist winters. Rainfall is 15 to 25 inches

(continued)

yearly. The northern areas are colder and have less rain. Plants that grow here are able to withstand extended periods of drought.

The California Chaparral is often interspersed with the Oak Woodland. The Chaparral vegetation consists mostly of evergreen shrubs, sagebrush, and drought-tolerant wildflowers. Fire is important for maintaining both Oak Woodlands and Chaparral communities.

Plants growing in these regions are hardy in USDA Plant Hardiness Zones 6 to 9.

Wildflowers

PINK-FLOWERED

Clarkia amoena
Farewell-to-spring. Erect plant to 3 feet with large, four-petaled, pink flowers, each petal with a red blotch. Grows in moist or dry soil in full sun. Annual.

Dodecatheon hendersonii
Shooting star. Leaves broadly oval with tapering petioles in a rosette around the flowering stem. Stem 1 to 2 feet, crowned with a cluster of 3 to 15 pink flowers resembling small darts. Grows in rich, moist soil in sun or shade. Perennial.

Mirabilis multiflora
Desert four-o'clock. Huge, triangular leaves to 6 inches on thick stems to 3 feet. Purplish red, tubular flowers grouped in clusters surrounded by leafy bracts. Grows in dry soil in full sun. Annual.

RED-FLOWERED

Echinocereus triglochidiatus
Claret-cup cactus. Low-growing cactus with spiny, oblong stems to 5 inches. Scarlet flowers borne from April to June. Grows in dry, rocky soil in full sun. Perennial.

Penstemon barbatus
Scarlet bugler. Open, sprawling plant to 3 feet. Leaves bright green, 2 to 4 inches long. Red flowers in loose axial clusters in June and July. Grows in moist to dry soil in full sun. Perennial.

Zauschneria californica
California fuchsia. Upright, multibranched shrub to 2 feet with gray-green foliage and pendulous red flowers borne summer to fall. Evergreen in mild climates. Grows in moist or dry soil in sun or partial shade. Perennial.

WHITE-FLOWERED

Romneya coulteri
Matilija poppy. Tall, stiff plant with stout stems and blue-green, lobed or divided leaves. Flowers extremely showy; six white petals resembling crepe paper surround orange-yellow centers. Grows in moist or dry soil in sun or light shade. Perennial.

Yucca baccata
Banana yucca. Clumps of 2-foot, daggerlike leaves rise directly from a short trunk. Flowers borne in dense clusters on 2¹/₂-foot stems in May and June. Grows in dry soil with full sun. Perennial.

YELLOW-FLOWERED

Balsamorhiza sagittata
Arrowleaf balsamroot. Large, velvety, silver-gray leaves borne in clumps alongside the large, sunflower-like flowers on 2¹/₂-foot stalks. Blooms May to July. Plants die back after flowering. Grows in moist to dry soil in full sun. Perennial.

Corydalis aurea
Golden smoke. Low, spreading plant with ferny, blue-green foliage and golden yellow, spurred flowers. Grows in moist or dry soil in sun or shade. Annual or biennial.

Eschscholzia californica
California poppy. Sprawling, succulent plant with ferny, blue foliage and showy, orange flowers borne all summer. Grows in well-drained, sandy or rocky soil in full sun. Annual.

Fritillaria lanceolata
Mission bells. Tall stem to 3 feet with whorled leaves. Flowers nodding in leaf axils, greenish yellow with purple spots. Grows in moist, rich soil in sun or shade. Perennial.

Iris douglasiana
Douglas iris. Clump-forming, evergreen iris with 1-foot leaves. Flowering stem to 2 feet with two to five yellow, cream, or blue flowers from January to May. Widely tolerant of soil and moisture conditions. Prefers full sun or light shade. Perennial.

Layia platyglossa
Tidy tips. Low, branching plant to 1 foot. Leaves linear to narrowly oblong; lower leaves toothed. Showy, flat, daisylike flowers with broad petals; petals yellow in the center with white edges. Grows in moist or dry soil in full sun. Annual.

Zinnia grandiflora
Wild zinnia. Open, branching plant to 1 foot with brilliant, yellow-orange flower heads borne on thin stems. Grows in dry, rocky soil in full sun. Perennial.

Woody Plants and Vines

BLUE-FLOWERED

Salvia clevelandii
Cleveland's sage. Rounded, shrubby plant to 3 feet. Leaves aromatic and grayish green with silky hairs. Blue-violet flowers in compact clusters from April to July. Grows in dry soil in full sun.

(continued)

WHITE-FLOWERED

Arctostaphylos glauca

Manzanita. Large, treelike shrub to 18 feet; leathery, evergreen leaves oblong to oval; blue-gray. White or pale pink, urn-shaped flowers borne in early spring; fruit brownish. Grows in dry soil in full or partial sun.

Ceanothus velutinus

Buckbrush. Dense shrub to 8 feet. Evergreen leaves oval, resinous, with the aroma of turpentine. White flowers in loose clusters that cover the plant in summer. Requires full sun and well-drained soil.

Fallugia paradoxa

Apache plume. Small to medium-size shrub with semi-evergreen, lobed leaves and 1½-inch, white flowers resembling single roses. Flowers open in April and May. Grows in extremely dry soil in full sun.

YELLOW-FLOWERED

Lupinus arboreus

Tree lupine. Large, rounded shrub to 8 feet or more. Leaves palmately compound, covered with silky hairs. Yellow flowers in dense spikes to 10 inches long. Grows in sandy soil in full sun. Tolerates seaside conditions.

Purshia tridentata

Bitterbrush. Twiggy, upright or floppy shrub to 10 feet with small, three-lobed leaves and dainty, star-shaped, yellow flowers in spring. Grows in dry, average soil in full sun.

ROCKY MOUNTAINS/ALPINE SLOPES

The Rocky Mountain forests are mostly composed of conifers, including ponderosa pine, lodgepole pine, and Douglas fir. In areas where the forest is cleared by nature or by man, quaking aspen quickly colonize until the slow-growing conifers can get re-established. A variety of summer-blooming wildflowers occurs in this region, most adapted to the deep shade of the coniferous forest. Moisture is adequate, and the summer temperatures are moderate. Winters are cold with deep snow.

Above the timberline, the dry rocky scree slopes and lush, wet alpine meadows and streamsides are carpeted with flowers from June through August. Due to the short growing season and ample rainfall, many plants bloom simultaneously, creating a floral spectacle unparalleled by any other plant community in the country.

The plants of this region are highly variable, depending on their habitat. Forest plants grow in deep shade, generally in moist to wet, rich, acid soils. Plants from the lower slopes prefer drier, rocky or sandy soils and tolerate less shade. Alpine plants need full sun, rich gravelly soil, ample moisture, and excellent drainage.

This area includes plants hardy in USDA Plant Hardiness Zones 3 to 7, depending on altitude.

Wildflowers ▬▬▬▬▬▬▬▬▬▬▬▬▬▬▬▬▬▬▬▬▬▬▬

BLUE-FLOWERED

Aquilegia caerulea
Rocky Mountain columbine. Showy columbine with large, blue-spurred flowers and neat, gray-green foliage. Grows in rocky soil in full to partial sun. Perennial.

Camassia quamash
Camas. Slender, grassy foliage from 1 to 2 feet. Showy flowers borne on erect spikes are deep blue with bright yellow stamens. Blooms in April and May along streams and in wet meadows in full sun. Perennial.

Erigeron speciosus
Showy daisy. Multistemmed plant to 2½ feet with small foliage and lavender, daisylike flowers with bright yellow centers. Blooms in June and July. Grows in moist or dry soil in full sun. Perennial.

Gentiana calycosa
Mountain gentian. Small, bushy plant with erect, open, deep-blue, bell-shaped flowers. One flower is borne per stem in July and August. Grows at high elevations on moist slopes and in rocky outcroppings in full sun. Perennial.

Iris missouriensis
Rocky Mountain iris. Tall iris to 2 feet with violet-blue flowers from May to July, depending on elevation. Grows in open, wet meadows in full sun at low to medium elevations. Perennial.

Linum perenne var. *lewisii*
Lewis flax. Slender, erect stems to 2 feet with fine, lance-shaped foliage. Sky blue, saucer-shaped flowers from June to August. Grows in dry soil and full sun. Perennial.

Lupinus sericeus
Bluebonnet. Striking, clump-forming plant with silvery, palmate leaves and dense spikes of deep blue, pealike flowers. Grows in moist or dry soil in full sun. Perennial.

Mertensia ciliata
Mountain bluebells. Large, leafy plant with 1- to 4-foot flowering stalks and drooping clusters of sky blue, tubular flowers. Blooms from June to August, depending on elevation. Prefers rich, moist soil in full to partial sun. Perennial.

Penstemon montanus
Mountain penstemon. Low, creeping plant with woody stem. Leaves stiff and serrated; tubular, lavender flowers with open lips. Blooms from May to July. Grows on dry slopes in full sun. Perennial.

Phacelia sericea
Silky phacelia. Dense spikes of purple-blue flowers crown the thick stalks of this alpine plant. Plants grow to 1½ feet; bloom from June to August. Grows in dry or moist soil or rock crevices in full sun. Biennial.

(continued)

Polemonium pulcherrimum
Jacob's-ladder. Funnelform, blue-violet flowers are held above ferny, compound leaves in June and July. Grows in rich, moist soil and rock crevices in sun or light shade. Perennial.

PINK-FLOWERED

Dodecatheon pauciflorum
Shooting star. Delicate plant with basal foliage and a naked flowering stalk to 16 inches bearing a crown of dart-shaped, deep pink flowers. Blooms from April to July, depending on elevation. Prefers rich, moist to wet soil in full to partial sun. Perennial.

Epilobium latifolium
Alpine fireweed. Low, mounded plant with large pink flowers from June to August. Prefers higher elevations. Grows in moist, rocky soil in sun. Perennial.

Geranium viscosissimum
Sticky cranesbill. Stout plant with attractive, lobed foliage and $1/2$-inch, pink or white flowers in early to midsummer. Grows in moist, humusy or rocky soil in sun or shade. Perennial.

Iliamna rivularis
Mountain hollyhock. Tall, clump-forming plant to 6 feet with densely packed spikes of 2-inch flowers resembling hollyhocks. Grows in rich, moist soil in sun or partial shade. Perennial.

Lewisia rediviva
Bitterroot. Apparently leafless plant bears 2-inch, pale pink flowers as the early spring leaves are fading. Grows on dry, rocky slopes in full sun. Perennial.

Silene acaulis
Moss campion. Leaves tiny and linear. Bright pink flowers cover this mat-forming plant from June to August. Grows at high elevations in gravelly soil in full sun. Perennial.

Townsendia parryi
Townsendia. Leaves narrow, dark green, persistent; lovely pink or lavender, daisylike flowers with large, yellow centers. Grows on scree slopes and in mountain meadows; requires full sun. Perennial.

RED-FLOWERED

Primula parryi
Parry primrose. Coarse, rank-smelling plant with large, 1-foot leaves and a 6- to 18-inch flowering stalk crowned with a cluster of tubular, blood red flowers. Blooms in July and August. Grows in rich, moist or wet soil at high elevations in partial shade. Perennial.

WHITE-FLOWERED

Anemone occidentalis
Western pasque flower. Large, crocuslike flowers borne close to the feathery foliage from May to August, depending on elevation. Grows in moist, peaty or rocky soil in full to partial sun. Perennial. Formerly *Pulsatilla occidentalis.*

Caltha leptosepala
Western marsh marigold. Early spring bloomer with large, rounded leaves and creamy white, starry flowers on succulent stems. Grows at high or low elevations in standing water or moist soil; alpine plants smaller. Prefers full sun or light shade. Perennial.

Claytonia lanceolata
Spring beauty. Early blooming plant with paired succulent leaves and starry white or pale pink flowers. Grows at low and high elevations and blooms from April to August. Prefers moist soil in full sun or partial shade. Perennial.

Clintonia uniflora
Queen's cup. Paired, shiny green, basal leaves accent a single, open, cup-shaped flower. Blooms in June and July in moist, acid soil high in organic matter. Prefers full shade. Perennial.

Dryas octopetala
Alpine avens. Mat-forming plant of the Alpine zone to 1 foot across with small, crinkled leaves and a woody stem. Creamy white flowers; borne in July and August. Grows in rocky soil, on slopes in full sun. Perennial. Formerly *D. hookerana,* which is now classed as *D. octopetala* subsp. *hookerana.*

Heracleum sphondylium subsp. *lanatum*
Cow parsnip. Tall, coarse plant to 6 feet with enormous, shallow-lobed leaves and 1-foot, flat-topped clusters of tiny, white flowers from May to July. Grows in rich, moist to wet soil and in full sun to deep shade. Perennial.

Phlox multiflorus
Cushion phlox. Low, creeping phlox with 1/2-inch, white flowers borne from June to August. Grows in rock crevices and on scree slopes in full to partial sun. Perennial.

Trollius laxus
Globeflower. Low plant with palmately lobed leaves and a single, creamy white, 1-inch flower resembling a buttercup. Blooms from May to July in wet meadows and bogs at higher elevations. Grows in moist, humus-rich soil in full sun to partial shade. Perennial.

Xerophyllum tenax
Beargrass. Tall, showy plumes of densely packed white flowers tower 2 to 5 feet above the wiry, grasslike foliage. Blooms June to August. Grows on rocky slopes and in moist meadows in full to partial sun. Perennial.

(continued)

YELLOW-FLOWERED

Aquilegia chrysantha
Columbine. Robust plant with densely branching stems and yellow May flowers with elongated spurs. Grows in cool, moist soil in sun or shade. Perennial.

Arnica cordifolia
Arnica. Attractive, summer-blooming plant with fuzzy, heart-shaped leaves and yellow, daisylike flowers. Grows in rich, moist soil in shade or in open areas with partial sun. Perennial.

Eriogonium flavum
Umbrella plant. Low-creeping plant with disproportionately large, ball-shaped clusters of bright yellow flowers. Flowers from May to July. Grows at higher elevations in dry soil, also in foothills. Full sun. Perennial.

Erythronium grandiflorum
Glacier lily. Delicate plant growing in huge colonies. Leaves paired; single, bright yellow flowers with reflexed petals. Grows at various elevations in moist, organic soil and scree slopes in full sun. Perennial.

Mimulus guttatus
Common monkey flower. Bushy plants grow to 1½ feet. Bright yellow flowers resemble small snapdragons and bloom from May to August. Grows in moist to wet, organic soil in full sun. Perennial.

Opuntia polyacantha
Plains cactus. Flat, jointed stems form prickly pads that act as leaves. Waxy, luminous flowers with overlapping petals. Blooms in May and June. Found in very dry, sunny spots at low to medium altitudes. Perennial.

Thermopsis montana
False lupine. Tall plant to 4 feet with bright green, three-lobed leaves and spikes of yellow flowers resembling lupines. Blooms from April to June. Prefers moist or wet soil in full sun. Perennial.

Wyethia amplexicaulis
Mule's-ears. Large, glossy, lance-shaped leaves form a dense clump. Leafy flower stalk bears one to five showy, orange-yellow flowers resembling sunflowers. Blooms from May to July. Grows in moist to dry soil in full sun. Perennial.

Ferns and Grasses

Buchloe dactyloides
Buffalograss. Sod-forming grass to 8 inches with gray-green foliage and slender flowering stems with one to three one-sided flowers. Grows in dry soil in full sun. Perennial.

Chryptogramma crispa
Rock brake. Leafy fern to 1 foot with deeply dissected fronds resembling parsley. Grows in acid soil or rock outcroppings in sun or light shade. Perennial.

Hordeum jubatum
Foxtail barley. Low grass to 8 inches with curved, plumelike flower heads in summer. Grows in moist or dry sites in full sun. Annual.

Polystichum lonchitis
Holly fern. Clumping fern to 2 feet with once-divided, deep green fronds. Grows in rich, moist, neutral or alkaline soil in shade. Perennial.

Woody Plants and Vines

BLUE-FLOWERED

Clematis columbiana
Blue clematis. Climbing vine to 10 feet or more. Clear blue, 2- to 3-inch flowers with four elongated petals. Blooms from April to July. Grows in dry or moist soil in partial shade.

PINK-FLOWERED

Phyllodoce empertiformis
Mountain heath. Low, evergreen shrub with needlelike leaves and pink, urn-shaped flowers in summer. Grows in moist or wet soil at high elevations in partial shade.

Spiraea splendens
Pink spirea. Showy, much-branched shrub from 2 to 7 feet with terminal clusters of fuzzy, pink summer flowers. Grows in moist soil in sun or partial shade.

WHITE-FLOWERED

Amelanchier alnifolia
Saskatoon. Low, stoloniferous shrub to 4 feet or more. May grow as a small tree to 20 feet. Early spring flowers are borne on naked branches. Summer fruit edible, dark blue. Grows in moist or dry soil in sun or light shade.

Holodiscus discolor
Mountain-spray. Multistemmed shrub to 15 feet with large sprays of creamy white flowers that clothe the plant in summer. Grows in moist woods in sun or light shade.

Sorbus scopulina
Mountain ash. Stout shrub to 15 feet with glossy, compound leaves and flat-topped clusters of small, white flowers. Blooms from May to July; fall fruit bright red. Grows in moist, rich soil in full sun.

Vaccinium ovalifolium
Blueberry. Low, erect shrub to 2 feet with inconspicuous white or pink flowers and edible blue berries in summer. Grows in moist or dry, acid soil in sun or partial shade.

(continued)

YELLOW-FLOWERED

Acer glabrum

Rocky Mountain maple. Large shrub or small tree to 24 feet with lustrous, lobed leaves and yellow to orange fall color. Insignificant flowers give rise to rose red, winged seeds. Grows in moist soil in sun or partial shade.

Mahonia repens

Creeping mahonia. Low, creeping shrub to 1 foot with compound, spiny foliage and clusters of bright yellow flowers from April to July. Fall berries are bluish purple. Grows in moist or dry soil in sun or shade.

Potentilla fruticosa

Shrubby cinquefoil. Dense, rounded shrub 1 to 4 feet tall with small, lobed leaves and bright yellow flowers. Blooms from June to August. Prefers moist soil in full sun to light shade, but is widely adaptable. Tolerates saline soil.

GREAT BASIN/DESERTS

This is a complex region made up of windswept plateaus, low valleys, mountain ranges, and intermittent lakes. The region stretches from central Washington east to Idaho and Colorado, west to the Sierra Nevada ranges, and south to Arizona and west Texas.

In general, the areas are characterized by intermittent rainfall and drastic daily and seasonal temperature fluctuations. The rainfall and temperature patterns vary greatly depending on the region. The average rainfall for these areas is 10 inches. The area includes four distinct deserts.

The Great Basin lies between two great mountain ranges, the Rockies and the Sierra Nevadas, and is characterized by small mountain ranges and low, dry valleys. Lakes occur after spring melt but may disappear during the summer. The area covers the upper half of the Desert region, from southern Nevada north to Washington. This is a cold desert and receives most of its precipitation as winter snow.

The Sonoran desert of southwestern Arizona and southeastern California has the most diverse plant life. This is a hot desert, and because of its southern location and moderate elevation, it is the warmest of the deserts. Rain falls in long winter rainy spells and late-summer thunderstorms. Most of the plants bloom in early spring.

The Mojave desert is located in western California and southern Nevada and includes the Grand Canyon area of northern Arizona. This is also a hot desert. Despite its more northern location, elevations are relatively low, so the area stays warm. Rain falls in winter. Plants bloom in the spring and early summer.

The Chihuahuan desert is characterized by high valleys as well as low deserts along the Rio Grande. It is a hot desert as well, with summer rains.

Plants in desert regions are able to grow with intermittent and uncertain rainfall because their long evolution has adapted them to harsh desert conditions. Some adaptations to the environment include succulent, water-holding leaves and stems, hairy foliage, early leaf drop, and extensive spreading roots or deep taproots. Spines help

conserve water in the swollen cactus stems and keep animals from eating them. Many plants are annuals. They grow, bloom, and seed after a rain, then die. The cycle resumes when the rain comes again.

The Great Basin/Desert region covers USDA Plant Hardiness Zones 5 to 8.

Wildflowers ▰▰▰▰▰▰▰▰▰▰▰▰

BLUE-FLOWERED

Delphinium parishii
Desert delphinium. Slender plant to 2 feet, leaves deeply lobed with three to five lobes. Sky blue flowers with reflexed petals and a single spur; borne from March to June. Grows in moist to dry, rocky soil in sun. Perennial.

Mertensia oblongifolia
Bugle lungwort. Low, succulent plant from 5 to 14 inches with nodding, sky blue bells in April and May. Grows in moist soil in full sun. Perennial.

PINK-FLOWERED

Abronia villosa
Desert sand verbena. Stems creeping, with paired oval leaves. Showy plant with rounded clusters of tubular, rose pink flowers from February to August. Grows in sandy soil in full sun. Annual.

Echinocereus engelmannii
Engelmann's hedgehog cactus. Mounding plant to 1 foot with elongated, cylindrical stems covered with tufts of long spines. Pink, red, or (rarely) yellow flowers borne in April and May. Grows on dry, rocky slopes in sun. Perennial.

Mammillaria tetrancistra
Yaqui cactus. Small cactus to 1 foot with green, cylindrical stems and clustered spines. Rose pink flowers. Grows on rocky slopes in full sun. Perennial.

Penstemon palmeri
Palmer's penstemon. Erect plant to 4 feet with gray-green, serrate leaves and inflated pink flowers. Upper leaves surround the stem. Grows on rocky slopes in full sun. Perennial.

RED-FLOWERED

Astragalus coccineus
Crimson locoweed. Low, spreading plant with woolly compound leaves. Flower stalk to 2 feet with a terminal cluster of crimson, pealike flowers. Grows in rich, moist to dry soil in full sun. Perennial.

Fouquieria splendens
Ocotillo. Tall, woody, cactuslike plant to 20 feet with spiny stems and ephemeral leaves. Showy flowers bright red, in terminal clusters. Grows in rocky soil in full sun. Perennial.

(continued)

Ipomopsis aggregata
Desert trumpet. Sparse, upright plant to 3 feet with thin, pinnate leaves and bright red, tubular flowers with pointed petals. Grows in dry soil in full sun. Perennial.

Opuntia basilaris
Beavertail cactus. Small, spiny plant to 1 foot with oval, gray-green pads. Red or crimson flowers, purple fruit. Grows in dry soil in full sun. Perennial.

Orthocarpus purpurascens
Red owl's clover. Low, clump-forming plant to 16 inches with dissected linear leaves and dense clusters of rose or blue-violet spring flowers. Grows in moist or dry soil in full sun. Annual.

Penstemon eatonii
Eaton's firecracker. Tall plant to 3 feet with triangular leaves and scarlet red, tubular flowers from March to July. Grows in dry, rocky soil on mountain slopes in full sun. Perennial.

WHITE-FLOWERED

Calochortus nuttallii
Sego lily. Delicate, slender-stemmed plant to 16 inches with several showy, tuliplike flowers. Blooms from May to August, depending on altitude. Grows in dry woodlands and on open slopes in sun or partial shade. Perennial.

Carnegiea gigantea
Saguaro. Massive, sparsely branching cactus to 50 feet with enormous, cylindrical trunks covered with rows of spines. Snowy white, tubular flowers open at night throughout May on older plants. Grows in dry, rocky soil. Perennial.

Dasylirion wheeleri
Desert sotol. Mounds of sword-shaped, serrated leaves arise from a stout, woody stem. Flower stalks to 10 feet with a huge plume of creamy white flowers. Grows on dry, rocky slopes in full sun. Perennial.

Hesperocallis undulata
Desert lily. Tall plant to 6 feet with alternate, linear foliage and a showy crown of trumpetlike flowers. Blooms from March to May. Grows in intermittently moist, sandy soil in sun. Perennial.

Nolina parryi
Grasstree. Mounds of grasslike leaves to 3 feet. Insignificant flowers on an open-branched stalk. Grows in average to dry soil in sun. Perennial.

Oenothera caespitosa
Tufted evening primrose. Low, spreading plant; leaves lance-shaped with lobed margins. Large, four-petaled, white flowers age to pink. Grows on dry slopes in full sun. Perennial.

Oenothera deltoides
Birdcage evening primrose. Erect or open plant to 1 foot with spatulate leaves and large, four-petaled, white flowers. Grows in dry, sandy soil in full sun. Perennial.

Opuntia bigelovii
Teddybear cactus. Tall plant to 8 feet with cylindrical stems clothed in vicious spines. creamy white or greenish flowers borne in April. Grows in extremely dry sites in full sun. Perennial.

Phlox hoodii
Hood's phlox. A low, cushion-forming plant with needlelike foliage and five-petaled, white flowers from May to July. Grows in rocky soil at higher elevations in full sun. Perennial.

Yucca brevifolia
Joshua tree. Tall, coarsely branching, treelike yucca to 30 feet with 14-inch, daggerlike foliage and dense clusters of greenish white, bell-shaped flowers. Grows in dry, sandy or rocky soil in full sun. Perennial.

Yucca whipplei
Whipple yucca. Stiff, swordlike foliage in tight clumps. Creamy white flowers in large, branched clusters on tall stalks to 14 feet. Grows in rocky soil. Full sun. Plants mature slowly, then die after flowering. Perennial.

YELLOW-FLOWERED

Agave parryi
Mescal. Tight, round rosette to 3 feet with attractive gray leaves that have sharp spines at the tip. Flower stalk tall with drooping, tubular flowers. Grows in dry soil in full sun. Plants may take 50 to 100 years to bloom, then die after flowering. Perennial.

Baileya pleniradiata
Woolly marigold. Low, densely branched plants to 2 feet, covered with bright yellow, daisylike flowers borne nearly all season long. Grows in dry, sandy soil in full sun. Annual.

Cleome lutea
Yellow bee plant. Slender plant to 3 feet with palmate leaves and a terminal cluster of bright yellow flowers; seedpods flat, conspicuous. Grows in sandy or rocky soil in full sun. Annual.

Coreopsis bigelovii
Bigelow's coreopsis. Low, open plant with a basal rosette of foliage and 2-foot stalks bearing a single, blunt-lobed, yellow daisy. Grows in average to dry soil in sun. Annual.

Eucnide bartonioides
Yellow rock nettle. Branching, shrubby plant to 2 feet with rounded, hairy leaves and showy, five-petaled, yellow flowers from April to June. Grows in dry, rocky places in full sun. Biennial.

(continued)

Ferocactus viridescens
Coast barrel cactus. Squat, rounded plant with thick spines. Yellow-green flowers. Grows on rocky hillsides in full sun. Perennial.

Fritillaria pudica
Yellow bells. One to three nodding yellow flowers per 1-foot stem from April to June. Linear, bright green leaves, to 8 inches. Grows in moist, humus-rich soil in sun or shade. Perennial.

Opuntia mojavensis
Mojave prickly pear. Low, spiny cactus with broadly oval pads. Showy, saucer-shaped, clear yellow flowers. Grows on rocky mountain slopes in sun or light shade. Perennial.

Stanleya pinnata
Golden prince's plume. Tall, erect plant with multiple stalks bearing brushlike terminal clusters of yellow flowers. Grows on dry, rocky soil in full sun. Perennial.

Woody Plants and Vines

PINK-FLOWERED

Calliandra eriophylla
Fairy duster. Broad, spreading shrub to 3 feet tall and 5 feet wide. Compound, evergreen leaves divided into tiny leaflets. Flowers fuzzy, resembling a bottlebrush, borne in February and March. Grows on very dry sites in full sun.

Chilopsis linearis
Desert willow. Showy, open shrub to 25 feet with willowlike foliage and large, open, trumpet-shaped flowers borne all season. Grows in moist to dry soil in sun or light shade.

Rosa woodsii
Woods' rose. Spiny shrub to 6 feet. Compound leaves with five to seven leaflets. Pink or white flowers borne in spring. Grows in moist or dry soil in full sun.

WHITE-FLOWERED

Artemisia tridentata
Big sagebrush. Evergreen shrub from 1½ to 15 feet. Dense, twiggy crown is rounded when young. Narrow, aromatic foliage is gray-green; flowers are insignificant. Grows in dry soil in full sun.

YELLOW-FLOWERED

Berberis trifoliata
Agarito. Open, stiff shrub with three-lobed, spiny, evergreen leaves and yellow spring flowers borne in the leaf axils; fruit black. Grows in moist or dry soil in sun or light shade. Also listed as *Mahonia trifoliata.*

Cercidium floridum
Palo verde. Fast-growing tree to 30 feet with an equal spread. Lovely green branches

bear leaves for a short time. In March and April, clustered yellow flowers completely clothe the plant. Grows in moist to dry soil in full sun.

Chrysothamnus nauseosus
Rabbitbrush. Dense, twiggy shrub to 7 feet with narrow, hairy leaves. Yellow flowers borne in dense heads. Grows in extremely dry soil in full sun.

Larrea tridentata
Creosote bush. Broad, upright branching shrub to 8 feet with leathery, evergreen leaves and abundant, small, yellow flowers throughout the season. Grows in moist or dry, sandy soil in full sun.

Prosopis glandulosa
Mesquite. Wide, spreading deciduous tree to 30 feet. Compound leaves with many small leaflets. Tiny, greenish flowers borne in catkinlike clusters. Grows in extremely dry soil in full sun.

PACIFIC NORTHWEST/WESTERN CONIFER FORESTS

This region encompasses a variety of forest types, including wet coastal mountain ranges with rainforests, inland plateaus with dry forests, and the moist to dry forests of the Sierra Nevada range. The mountains are some of the highest in North America; many are volcanic peaks.

The rainforests of the Olympic Peninsula and the Coastal and Cascade ranges of the Pacific Northwest are clothed in dense forests of tall spruces and firs. The understory is sparse and the forest floor is a dense, lush garden of ferns, shrubs, and wildflowers, all able to grow in the moist, rich soil and dim, year-round shade. In northern California, the redwood forests are equally lush.

The moist slopes and valleys of the Sierra Nevadas contain large stands of ponderosa pine, white fir, and Douglas fir. The canopy is dense, and the wildflowers and ferns are adapted to shade. The drier slopes boast stands of lodgepole pines with enormous trunks. The canopy is open and the light is bright, supporting a dense understory of large shrubs.

The high mountain peaks have sub-alpine forests, alpine scree slopes, and meadows. Winters are cold and the summer sun is bright. Plants growing here bloom during the short summer season between snowfalls.

The western states have many beautiful native species to offer gardeners, and many different habitats in which to grow them.

Plants in these areas are hardy in USDA Plant Hardiness Zones 7 to 9.

Wildflowers

BLUE-FLOWERED

Lupinus polyphyllus
Blue-pod lupine. Tall, leafy plant to 5 feet with palmate leaves and dense spikes of deep blue, pealike flowers. A parent of the Russell Hybrid lupines. Grows in rich, moist soil in sun or shade. Perennial.

(continued)

Mertensia paniculata
Tall lungwort. Erect plant with fleshy leaves and stems to 5 feet. Small, sky blue, nodding, bell-shaped flowers from May to August. Grows from low to high elevations in wet soil with full to partial sun. Perennial.

Penstemon speciosus
Showy penstemon. Low, spreading plant with flowering stems to 3 feet. Purple-blue flowers with open lips borne from May to July. Grows in moist to dry soil in full sun. Perennial.

PINK-FLOWERED

Dicentra formosa
Bleeding-heart. Flattened, heart-shaped flowers nod in clusters above the ferny, gray-green foliage. Blooms from March to July in moist soil and sun or shade. Perennial.

Douglasia laevigata
Cliff Douglasia. Basal rosette of small, strap-shaped leaves; forms dense mats several feet across. Flowering stem to 6 inches, flowers rose pink, like pinwheels, borne from March to August. Grows at high elevations on rocky soil in full sun. Perennial.

Erigeron peregrinus
Wandering daisy. Upright plant to 2½ feet with clasping, lance-shaped foliage and showy, rose pink heads. Grows in moist soil on mountain slopes in full sun. Perennial.

Geranium richardsonii
Richardson's geranium. Leaves five-lobed, deeply dissected. Showy, pink flowers with five rounded petals; blooms from June to August on 2-foot stems. Grows in moist soil in sun or light shade. Perennial.

Phlox diffusa
Spreading phlox. Low, creeping phlox of high mountain slopes with needlelike leaves and showy, five-petaled flowers in summer. Grows on rocky soil and scree slopes in full sun. Perennial.

Sisyrinchium douglasii
Grass widows. Linear, grasslike leaves to 2 feet. Six-petaled, showy flowers, pink with yellow eyes. Grows in moist, rich soil in sun or shade. Perennial.

Trillium ovatum
Western trillium. Three-petaled, pink or white flower on a slender stem above three broadly oval leaves; plants to 2 feet. Blooms from March to June in rich, moist soil and shade. Perennial.

RED-FLOWERED

Asarum caudatum
Long-tailed ginger. Large, heart-shaped leaves shelter the unusual jug-shaped maroon flower with three long, spidery lobes. Grows in moist soil in shade. Perennial.

Mimulus lewisii
Lewis's monkey flower. Bushy plants to 3 feet, with coarse, opposite foliage and large, wine red, open-faced flowers in summer. Grows in rich, moist or wet soil at higher elevations; sun or light shade. Perennial.

WHITE-FLOWERED

Achlys triphylla
Vanilla leaf. Attractive, three-lobed leaf borne singly alongside a slender flowering stem to 2 feet, with a dense spike of small white flowers. Grows in rich, moist woods in shade. Perennial.

Boykinia major
Mountain boykinia. Broadly oval leaves with five shallow lobes from dense clumps. Flowering stalk 1 to 3 feet, topped with densely packed, white flowers in summer. Grows in moist to wet soil in shade. Perennial.

Disporum hookeri
Hooker's fairybell. Leaves oval; lower leaves clasp stem. Small, funnelform, greenish white flowers dangle at the ends of erect, branching, leafy stalks. Grows in rich, moist soil in shade. Perennial.

Elmera racemosa
Elmera. Mat-forming groundcover to 5 feet across with round, scalloped leaves. Six-inch flower stalks with $1/4$-inch, inflated, cream-colored flowers. Grows at high elevations on gravelly or rocky soil in full sun. Perennial.

Erythronium montanum
Glacier fawn lily. Broad, bright green leaves paired; flower stalk slender with a single, large, white flower banded in yellow. Blooms in early spring after snowmelt. Grows in moist or wet meadows at higher elevations in partial shade. Perennial.

Heuchera micrantha
Crevice heuchera. Leafy perennial from woody rhizomes. Rounded leaves in dense clusters. Small, white or greenish flowers in clusters on a thin, hairy stalk in summer. Grows in moist, rocky soil and crevices in sun or shade. Perennial.

Maianthemum dilatatum
False lily-of-the-valley. Stout groundcover with 6-inch, heart-shaped leaves. Flower stalk to 15 inches, with one to three leaves and tiny white flowers in a spike. Blooms in May and June. Grows in rich, moist, acid soil in shade. Perennial.

Peltiphyllum peltatum
Umbrella plant. Immense, umbrella-shaped leaves grow in large mounds from a stout rhizome. Flower stalk to 4 feet, crowned with an open cluster of small, white or pink flowers. Grows in wet, rocky soil in sun or shade. Perennial.

Petasites palmatus
Western coltsfoot. Terminal clusters of white flowers borne on a naked stalk above large, triangular, lobed leaves. Grows in moist soil and shade. Perennial.

(continued)

Pyrola secunda
One-sided wintergreen. Low, creeping plant with shiny, oval leaves and a one-sided flower cluster composed of small, urn-shaped flowers. Grows in dry, acid soil in deep shade. Perennial.

Tellima grandiflora
Fringe cups. Leaves clustered at base of the plant resemble those of coralbells; stems and leaves hairy. Small, cuplike flowers with fringed tips scattered along a 1- to 3-foot spike. Grows in rich, moist soil in shade. Perennial.

Vancouveria hexandra
Inside-out flower. Low groundcover with compound leaves bearing many squarish leaflets. Flowers in loose clusters, with swept-back petals. Grows in rich, moist soil in deep shade. Perennial.

Veratrum viride
False hellebore. Tall, coarse plant with oval, pleated leaves and drooping, branched clusters of green flowers. Blooms from June to September, depending on altitude. Grows in moist or wet, acid soil in sun or shade. Perennial.

YELLOW-FLOWERED

Aquilegia flavescens
Golden columbine. Leaves blue-green, thrice-divided, with three leaflets per division. Nodding yellow flowers have short, flat spurs; flower stalks to 2 feet or more. Grows in moist soil in sun or shade. Perennial.

Lilium columbianum
Columbia lily. Slender, erect plant to 4 feet with whorled leaves and nodding yellow to orange flowers with reflexed petals. Grows in moist soil in partial shade. Purchase only nursery-propagated plants. Perennial.

Lysichiton americanum
Yellow skunk cabbage. Large, yellow bract encloses upright, fleshy spike of flowers before the leaves emerge. Leaves to 5 feet, strong-scented, radiating outward in a circle. Grows in wet, acid soil in sun or shade. Perennial.

Ferns and Grasses

Blechnum spicant
Deer fern. Tall, slender fronds to 3 feet, evergreen, once-divided, arising from a basal tuft. Grows in moist or dry soil in shade. Perennial.

Cheilanthes gracillima
Lace fern. Lacy, thrice-divided fronds are densely clustered from a wiry rhizome. Grows in dry rock crevices in sun or shade. Perennial.

Dryopteris dilatata
Shield fern. Large, deciduous fronds to 3 feet are broadly triangular and thrice-divided.

Grows in moist, partially shaded sites; tolerates sun. Perennial. Formerly *D. austriaca.*

Polypodium hesperium
Licorice fern. Leathery, evergreen fronds are once-divided, with rounded pinnae (leaflets). Grows from a creeping rhizome in rock crevices or on tree trunks in sun or shade. Perennial.

Polystichum munitum
Sword fern. Large, bushy fern with narrow, once-divided fronds to 5 feet. Fronds deep green, evergreen, radiating in dense clusters from a stout rhizome. Grows in moist to dry soil in shade. Perennial.

Woodwardia fimbriata
Chain fern. Large fern with 4- to 6-foot, arching, evergreen fronds, twice-divided with coarse pinnae (leaflets). Grows in rich, moist or wet soil in sun or shade. Perennial.

Woody Plants and Vines

BLUE-FLOWERED

Ceanothus integrifolius
Deer bush. Tall, open shrub to 12 feet or more with sparse gray-green foliage and airy clusters of small, blue-violet to lilac flowers in April and May. Grows in a variety of soils in sun or shade.

Rhododendron macrophyllum
Pacific rhododendron. Large, evergreen shrub to 25 feet with bold, leathery foliage in a whorl below large rounded clusters of 1-inch, pale lavender-purple flowers. Grows in moist, humus-rich soil in sun or shade.

PINK-FLOWERED

Arctostaphylos columbiana
Hairy manzanita. Large, single-trunked evergreen shrub to 15 feet with a broad, oval crown. Leaves gray-green, hairy, clustered at the tips of the twigs. Clustered, urn-shaped, pale pink or white flowers in spring or early summer. Prefers sandy, well-drained soil in full or partial sun.

Gaultheria shallon
Salal. Low to medium-size evergreen shrub to 6 feet or more with leathery, oval leaves. Pale pink, urn-shaped flowers, nodding in loose clusters; blooms in May and June. Grows in a variety of soils in sun or shade.

RED-FLOWERED

Pachistima myrsinites
Oregon box. Low, prostrate shrub to 3 feet with small, oval evergreen leaves. Red, insignificant flowers in the leaf axils. Grows at low and high altitudes in a variety of soils with full sun or shade.

(continued)

Ribes sanguinea

Red-flowering currant. Tall, multistemmed shrub to 10 feet with clusters of deep red or rose flowers in spring before the leaves emerge. Black fruit with a waxy coating. Leaves oval, three-lobed, attractive all summer. Grows in moist soil in sun or partial shade.

Taxus brevifolia

Western yew. Large shrub or small tree with evergreen needles and fleshy scarlet fruit. Highly variable in nature. Grows in well-drained soil in sun or shade.

WHITE-FLOWERED

Arbutus menziesii

Madrone. Massive, bold-textured, evergreen tree to 50 feet or more. Decorative, cinnamon red bark; leaves broadly oval, shiny. Small flowers in an upright clusters borne in spring; fruit dull red. Grows in moist or dry soil in full sun to partial shade.

Cornus nuttallii

Pacific dogwood. Large shrub or small tree, single-trunked or multistemmed. Specimens may reach 20 to 50 feet. Leaves oval, paired on stems. Small flowers in center of showy white bracts. Grows in moist, rich soil in sun or partial shade.

Ledum glandulosum

Labrador tea. Low, spreading evergreen shrub to 3 feet or more. Leaves leathery, oval, woolly beneath. White flowers densely clustered at the tips of the branches. Grows in moist to wet, acid soil in sun or shade.

Leucothoe davisiae

Western leucothoe. Neat, mounding evergreen shrub to 3 feet with rounded, leathery leaves and upright clusters of white, urn-shaped flowers; blooms in June. Grows in moist to wet, acid soil high in organic matter. Prefers a semishaded site.

Myrica californica

California wax myrtle. Dense, fine-textured evergreen shrub to 15 feet. Leaves narrow, dark green with serrated margins. Flowers insignificant; fruit pale purple in fall and winter. Grows in sand or peat soil in full sun. Good for seaside conditions.

Philadelphus lewisii

Mock orange. Medium to large, multistemmed, deciduous shrub with broadly oval leaves and large, snow white, fragrant flowers in June. Grows in moist or dry soil in sun or shade.

Vaccinium ovatum

Evergreen huckleberry. Erect, multistemmed shrub to 10 feet or more. Leaves small, broadly oval with serrated margins, deep, lustrous green. Small, bell-shaped flowers in spring, followed by dark purple, edible berries. Grows in moist, acid soil in sun or shade.

YELLOW-FLOWERED

Mahonia aquifolium
Oregon grape holly. Coarse, evergreen shrub to 8 feet with leathery, compound leaves and terminal clusters of bright yellow flowers in early spring. Decorative, purple-black fruit persists and complements the shiny foliage. Grows in a variety of soils in sun or shade.

Phyllodoce glanduliflora
Yellow alpine heather. Low, mat-forming plant of high mountains, with tiny, needlelike leaves and round, urn-shaped, yellow flowers in June and July. Grows in moist soil in sun or light shade.

ELEMENTS OF THE NATURAL GARDEN

THE ELEMENTS

Home landscaping has conventionally meant arranging trees, shrubs, lawns, and other elements to produce the look of a city park—an open area about as far from the concept of wilderness as an agriculture-based population could make it. But a walk in a natural area will show you that in nature, these elements are arranged according to geological and ecological principles, rather than the principles of landscape design.

In the wild, thickets of shrubs and trees tend to mass in sheltered areas protected from prevailing winds. Paths created by deer tend to connect watercourses, browsing areas, and the thickets where the deer sleep. Mixtures of plants differ according to their exposure to light and wind—hemlock and beech on the north side of hills, oaks and poplars on the southern exposures. Beauty in nature follows usefulness and necessity, an important key to successfully reproducing it in your yard.

In this chapter, we're going to examine landscape elements, the building blocks of a natural garden, to see how they might reflect these natural influences. We'll also look at ways to remove the human tendency toward regularity and decoration, replacing it with ideas taken from Nature herself. This is another place where the fun of making a natural landscape comes in: to see what Nature has done to create beauty and reproduce it at home.

We'll be learning ways to use landscaping elements—paths, rocks, lawns, groundcovers,

wildflower meadows—with natural principles in mind. Another element, water, is so closely connected with wildlife in the landscape that it's discussed in chapter 7, Wildlife and Water in the Natural Garden.

PATHS AND STEPS

If you've ever traveled through a pathless wilderness, you'll know what a struggle it is. You have to keep constantly on the alert, sizing up the possibilities, trying to see if it would be easier to duck under the branch or plow through the thicket. You zigzag this way and that as you look for clear, firm footing. Mistakes can result in bruises, sprains, or broken bones. The pathfinder experiences a landscape quite differently than people do who walk the reassuring paths made by others.

You must play the role of pathfinder through the natural landscape you create at home. It's up to you to blaze a trail for others to follow. Almost all your subsequent experiences of a garden are affected by the way you walk through it for the first time—and this is true for your garden visitors, too.

Notice how a path looks in the wild. It's discernible, but certainly not obtrusive, the way a path edged prominently with stones and filled with contrasting material is. Trees and shrubs are cleared back to form a green tunnel through which the path passes. A path is least obtrusive when it is simply made of whatever materials make up the ground around it.

To make a natural-looking path, just remember to make sure it blends with its surroundings.

If your path runs under tall pines, then make it with pine needles. If it runs through a wet and boggy area, place flat rocks naturally to allow people to cross the bog without getting their feet muddy. A well-designed path through a natural landscape will whisper a suggestion of the way to go, rather than shout it. For great ideas on designing beautiful woodswalks, see the photos on pages 144-46.

You can make an even more natural-looking path with low, tough plants. Grass, of course, is the standard paving plant. Groundcovers like chamomile (*Chamaemelum nobile*) and mother-of-thyme (*Thymus serpyllum*) also take some foot traffic. Mazus (*Mazus reptans*), Irish or Scotch moss (*Sagina subulata*), and, in California, Korean or mascarene grass (*Zoysia tenuifolia*) look good growing around paving stones, which take the brunt of foot traffic. In the warmer USDA Plant Hardiness Zones 9 and 10, New Zealand brass buttons (*Cotula squalida*) will tolerate medium shade to full sun and foot traffic, too.

ADDING STEPS TO THE PATH

When constructing steps of stone or natural-looking concrete or even fallen logs, make them appear to be terraced elevations formed naturally in the landscape. The way to do this is to avoid edging the path with rigid rows of plants or stones or logs and vary the materials that form the path.

Use small plants and groundcovers to tie the steps into the path and the rest of the landscape. A series of stones placed as steps on a slope will look natural and appropriate if the

(continued on page 258)

MAKING A NATURAL STAIRWAY

A Stairway of Stone

The most natural stairways are paths with stones, logs, exposed roots, or other natural materials as the steps. If well placed, these elements will look like the soil has just washed away over time to reveal them—just as it does in nature.

Site Before Steps Are Installed

Choose the stairway's position by thinking about where a path may have formed naturally. Don't forget to take attractiveness and ease of use into account, too.

Excavating the Stairway

Dig the stairway path deep enough to bury stepping stones to one-third their height.

Set in Stones with Flat Tops

Remember walking comfort when choosing stones for your stairway; they should be flat, but with a good gripping surface. Don't use smooth stones —rain, snow, and ice make smooth surfaces slick and hazardous.

Fill In around Stone Steps

Refill the stairway path with excavated soil, pulling the soil back up against the stones so it looks as though they've worn through to the surface. Landscape your path with groundcovers like mazus (*Mazus reptans*), chamomile (*Chamaemelum nobile*), and mother-of-thyme (*Thymus serpyllum*). Plant them so they'll grow around and between the stones.

1. First, site your stairway.
2. Excavate the stairway. Put excavated soil on a tarp for later use.
3. Set in stones with flat tops.
4. Bury stones so the flat tops are at the surface.
5. Refill around the stones with the excavated soil, then plant groundcovers.

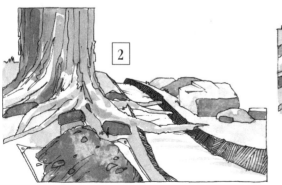

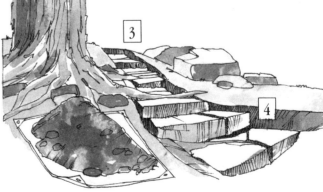

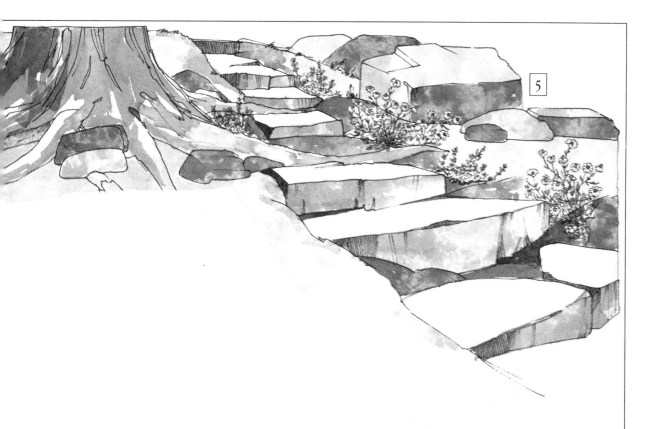

Other Materials for Natural Stairways

Use exposed tree roots for step edging.

Use a section of a fallen log for each step.

When making steps in dirt paths, "crown" the paths by making the center slightly higher. Then water won't wash gullies down the middle.

stones are interwoven with groundcovers that emerge from and disappear back into the surrounding plantings. Plant other patches of these groundcovers nearby so that their appearance on the path looks natural and doesn't seem forced.

MAKING A MOSSY PATH

One of the best ways to soften paving stones and make them look as though they've been in place for centuries is with patches of moss. Companies that sell bonsai supplies sell moss spores, or if you have moss growing somewhere on your property, you can transplant it.

Moss will only grow where the soil is shaded and moist with a high humus content and low pH. This makes it ideal along a woodland path. If you're transplanting moss from elsewhere in your yard, take some soil with the moss and keep it moist until you're ready to put it in.

Plant moss by first working up the soil between the stones and freeing it of roots and weeds. Next, water it until it is soaking wet and allow the surface water to sink in and run off. Then, press the patch of moss into the muddy soil so it makes good contact. When you're finished, wet it down with very dilute fish emulsion—and for good measure, pour a cup of milk into each gallon of water you're wetting the moss with. The milk helps acidify the soil and feeds the moss. Once established in a spot with the right conditions, your moss will need no further care.

You can also grow your own moss from a fist-sized clump collected from your yard. Place a couple of inches of good potting soil in a flat, then cover it with a single layer of cheesecloth. Allow the moss to dry and crumble it over the cheesecloth. Place another single layer of cheesecloth over the moss crumbles and press it lightly, then water it well. Place it in a shady, protected spot and keep it moist until the moss grows through the cheesecloth. Take slices as needed to fill areas between the paving stones.

If you'd like a mossy cover between the stones of your woodland path, but have no moss on your property, don't despair. Once you set up the right moist, shaded conditions, you'll eventually have moss, because moss spores travel for miles on the wind. Some will certainly find your path.

MAKING PATHS USER-FRIENDLY

Techniques like this soften the visual impact of the path, but they don't obliterate it. It's important for visitors to know how to proceed. On entering the garden, a visitor looks for the path in. Once on the path, the visitor's focus changes and he looks for the way through. At some point, the visitor starts looking for the way out.

Try to construct your path so that you anticipate these subtle changes in focus and provide clues signaling them at appropriate points along the way. Gardens that provide branching pathways of equal appeal can be exciting, but mostly are confusing. Make one single pathway be the obvious one through the garden, rather than have the visitor stand perplexed, wondering which way to go. Side paths can be smaller or made of different materials.

Making the path obvious doesn't mean making it boring, though. You want the visitors to enjoy the experience of walking through your garden almost as much as the garden itself. To make sure they will, give your path a critical evaluation. Squint at the scene, and if the path seems to disappear, it's fine as is. If it is a dark or light streak running through the landscape, interrupt its line. Bend it around a corner so it disappears, introduce materials of contrasting colors, and most of all, place plants and stones to break into the sightline of the edges of the path ahead. Being unable to see what's around the next bend puts some of the pathfinder's adventure and excitement in your own backyard.

Plants can add color and interest to your path. But don't get carried away with your planting. We enjoy an easy walk through a wild place most. Bring plants up to—and occasionally even into—the walkway, but leave room for the visitor to move easily along the path.

Once you've established the way through the garden in these subtle ways, a well-used path will almost maintain itself. Foot traffic will beat down the grasses. Passersby will brush the tips of the understory shrubs. However, if a branch grows or a weed springs up in an annoying place, take it out. The primary purpose of the path, after all, is to enhance your ease and enjoyment of the garden.

RIVERS OF STONE

How can you have a river of stone? First, think about the rocks in a creekbed or on a beach. Then, think about how they were shaped. Put yourself in this scene: You are on a trail that winds east, then south along a cliff in Moon Rocks State Park on the California coast in northern Sonoma County. The cliff faces the open Pacific, and the shrubs there are heavily sculpted by the wind. At the foot of the cliff, thundering waves have gouged out a cove that arcs from one headland to another about 500 feet south.

The beach consists entirely of smooth, rounded boulders, each one weighing several tons. You sit on a boulder just beyond the reach of the water and watch the waves die in the ebbs and swells among the rocks. These last wavelets lick the boulders with every tide, sometimes gently and sometimes with stormy violence.

After countless years of this, the once-broken shards of bedrock have lost their sharp edges and taken on the smooth shapes of lozenges. When you look at such rocks, you are really seeing the enormous incremental power of water, frozen in shapes that proclaim its dominance over stone.

Smooth, round rocks and cobbles suggest flowing water because they are formed in flowing water. So if we create a gently meandering river of cobbles and smooth stones in the garden, we are creating the same emotional effect as if water flowed there. Rivers and pools of cobbles and round stones make dramatic edging for shrubs and perennials that hang over their banks and trail into the "water." Another dramatic effect that you might want to recreate is water's ability to absorb light, especially when shaded, and make a dark contrast with bright, sunstruck foliage. Dark cobbles can substitute for water in this case.

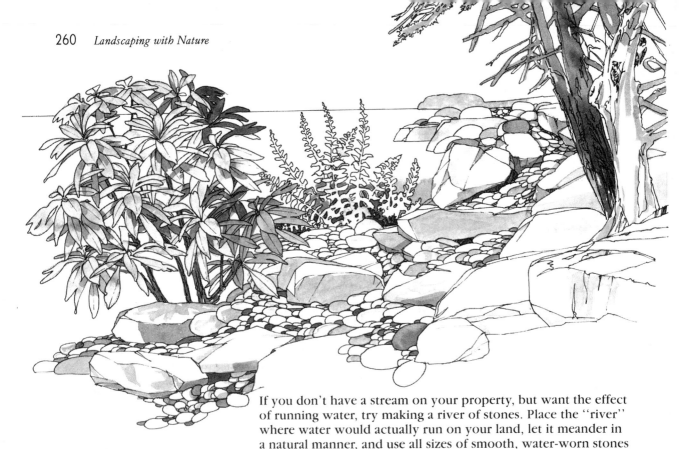

If you don't have a stream on your property, but want the effect of running water, try making a river of stones. Place the "river" where water would actually run on your land, let it meander in a natural manner, and use all sizes of smooth, water-worn stones in the streambed.

SITING YOUR "STREAM"

When deciding where to site a river of stone in your garden, consider water runoff and drainage patterns. Are there low places where water tends to run and pool during rainstorms? Are there gullies that wash out during downpours? How about alongside the house where roof water drains? These are obvious spots and should receive first consideration. It makes landscape sense to suggest flowing water in places where water actually flows, even if it doesn't usually flow heavily enough to make a true watercourse.

If your stream of cobbles is going to have to carry lots of runoff water or surface drainage, consider burying drainage pipes in the channel to carry the bulk of the water away, then covering them with loose rock, like a French drain.

An alternative is to mix cement and soil or sand half-and-half, line the bottom of the bed about 4 inches thick, then spread and tamp cobbles into the surface of the wet mixture. It will dry hard and be weed free.

In areas with deep winter freezes, you should spread the cement mixture over a sub-base of sand and gravel at least 8 inches deep to prevent frost from heaving the cement and breaking it. To make a sub-base, you must first tamp the earth of the bed, then lay in about 6 inches of gravel, tamp the gravel, lay in about 2 inches of sand, and finally tamp, smooth, and level the sand before spreading the cement.

Another way to site your rivers and pools is to put them wherever you would put pools of water and flowing streams, if you had unlim-

ited resources to work with water in the landscape. Pools look nice under trees and shrubs, and meandering streams of cobbles can separate beds, planting areas, and "rooms" in the garden. Site your garden path to meet the stream of cobbles, and either build a small bridge or set large rocks of a contrasting color to be stepping stones across the "stream."

Suggest a pool of water more strongly by growing water-loving plants at the edge of the pool of stones: cattails (*Typha* spp.), for instance, or some of the ornamental sedges (*Carex* spp.). If you try this effect with water-loving plants, remember to keep them wet! Papyrus (*Cyperus papyrus*) makes a wonderful suggestion of water, but won't take freezing in the winter, so use it in pots that can be taken indoors. A large, waterproof container holding a water lily (*Nymphaea* spp.) can be set into the soil by the edge of the pool or stream of stones.

Sometimes water flows rapidly downstream in a series of waterfalls. You can create all-rock waterfalls in steep portions of the landscape, and plant cranberry cotoneaster (*Cotoneaster apiculatus*), trailing vines and Kenilworth ivy (*Cymbalaria muralis*), stonecrops (*Sedum* spp.), or carpeting groundcovers to make green waterfalls.

If the stones in the meandering stream are set in firmly, the stream can double as a path, and the waterfalls of stones and greenery will be steps leading from one part of the garden to another. Generally, however, I'd advise against making a stream of stones into a pathway; the footing isn't as solid or as nice as a regular earth or woodchip path, especially when it's wet. It's always more pleasant to walk on the soft dirt path beside the stream than to wade up it—even if the stream is made of stones.

Similarly, it's not a good idea to have paths double as watercourses. Paths set between berms will channel water where you want it, but they will be soft and gooey for quite a while after every rain, and the soil or woodchip surfaces may wash out. It's best for both walking and drainage to keep paths and water-drainage depressions separate.

MAKING A REALISTIC STREAMBED

Notice how Nature handles the details when she makes a streambed or watercourse: Round rocks are wedged on the bottom, while sharper-edged rocks are found up on the sides of the bank. Observe how she builds with rocks and follow her patterns at home. You'll see that rocks almost always rest on their most stable side. Nature seldom reveals a whole rock—it's either half buried in the soil or wedged among other rocks. She places the largest rocks at the bottom of slopes and arranges bands of rocks in rough horizontal layers.

A close look at a dry creekbed shows that the stones occur in all sizes: Boulders are few and massive, smaller stones and cobbles more frequent, and these in turn are edged by myriads of tiny stones that form sandy gravels. Make sure your river of stone includes sandy gravels in bands where they would naturally occur—in hollows and eddies and on the edges of the stream.

Streams throw deposits in these bands depending on the size and weight of the particles. The farther out from the center of the stream

you go, the finer the particles carried by the water. So, you'll find bands of cobbles, then gravel, then sand, then silt. Arrange the cobbles in your "creek" so that their shapes seem to be a believable streambed—that is, one can visualize the flowing water that has formed the shape of the stones.

Streams, whether of stones or water, need banks. So berm the sides of your streams, or excavate the riverbeds from 1 to 1½ feet deep. Keep weeds from growing in the "rivers" by excavating them down 4 to 6 inches (in addition to the 1 to 1½ feet, if you've dug your creek down rather than bermed its sides) and by covering the bottom with extra-thick, black, plastic sheeting, then filling it with river cobbles.

You can grow plants in your "river" by poking a hole in the plastic, putting in the plant, then drawing cobbles back up around the stems. Ornamental grasses and arching plants like wandflower (*Dierama pulcherrimum*), with its violet purple tubular flowers, are particularly beautiful setting off the level courses of stones.

You'll find that rivers of stone and stone walls that suggest stream banks, when planted with groundcovers, mosses, and flowers, will look as though they have always been a part of the landscape. And that's exactly the look you want when landscaping with nature.

MELODIC STONE ARRANGEMENTS

Music has a powerful effect on us—we all enjoy melody and harmony, even if we don't all love the same kinds of music. Surprisingly, music also gives us a strong tool for arranging rocks and siting trees and shrubs in our gardens.

Look at the rhythm in the way nature places rocks. Her arrangements are syncopated: empty space, then a stone, then an empty space, then two stones. Think of a rhythm you like and tap it out with your knuckles on the tabletop.

To illustrate, let's use the recognizable jingle of "shave and a haircut, two bits." The rhythm starts with an emphasized note, then a pause, then three notes quickly together with a fourth that's separated from the three by the slightest pause, then another pause, and two emphasized notes together: seven notes in all. *DA-dadaDA-da—DA-DA.*

Now if our notes are stones extending in a line, they would look like this:

SHAVE - and a HAIR - cut — TWO - BITS

But stones aren't usually set into a garden in a line. Certainly they aren't usually found that way in nature. She works on the double dimension of width as well as length. If we set our seven stones in a plane according to our rhythmic pattern, we might end up with a placement like this:

There's yet a third dimension in the physical world—height. Height can be represented in by the pitch of the notes. In our shave-and-a-haircut example, the notes go *FA-dodoRE-do—MI-FA.*

If we give *do* a value of one measure of height, then *re* would be two, *mi* three, and *fa* four, and so on. Let's assign the stones relative heights based on the notes of the jingle.

There is a final musical measurement we can apply to our arrangement: volume. In our jingle, the opening *fa* and final *mi fa* are given more volume than the *do* and *re* notes in the middle. The final note is given special emphasis. Let volume represent the size of the rocks. We'll redraw our sketch one more time, this time with the rocks given the size consistent with their emphasis in the jingle.

To try this technique, first make a map of the place where you want to create a natural landscape. Begin applying the melodic method of stone and shrub arrangement by thinking of the natural place you are using for inspiration. Pretend you are there, seeing, hearing, and smelling it. Feel again how you felt when you were actually there. What would you call that feeling? Solemn, awesome, contented, exhilarated? Try to nail it down. Now choose a catchy bit of a classic melody that fits the mood—perhaps one that already suggests nature. Just use the first five or ten notes of the theme for your inspiration.

Folk songs, hymns, and popular melodies can also give you ideas for siting rocks. I used "Tara's Theme" from the movie *Gone with the Wind* to design a series of rocks coming down an embankment near the house. I used the first eight notes (*do*-high *do-la-so; do*-high *do-so-fa*); the results were excellent. If you don't read music, you can still analyze a favorite melody using the *do-re-mi* system, and use that analysis to site rocks, shrubs, or any other elements that have weight in the landscape.

This method is particularly suited for placing rocks, because the music has already proven the quality of the arrangement before its translation into stone. Solidifying music into a scatter of stones gives the natural garden a good deep structure. It imparts a hidden, central theme to the movement in the landscape, from which the gardener can spin off harmonies that tie the whole garden design together.

Musical phrases build to a crescendo and resolution that can be directly applied to the siting and size of rocks. Have stones of various

sizes build up to and away from a dominant crescendo stone. If the crescendo note in the melody resolves what's gone before, then the stone can reflect this by its shape, which resolves the tension of the shapes leading to it. Three stones that lean to the right, for instance, may be balanced at the crescendo point by a large rock that leans to the left, resolving the tension and balancing the whole arrangement.

Melody is comprised of motion and rhythm, and so is the arrangement of stones in a landscape. Stones and water state the basic themes of the Earth. The plants around the stones and water state the harmonies and embellishments. Great gardens, like great vistas in the wilderness, are symphonic in their impact.

BUILDING A NATURAL STONE WALL

When I lived on 6 rustic acres in Pennsylvania, every shovelful of soil had a big rock in it. The farmers used to say that the soil there grew rocks. Every fall they'd plow down their cover crops and the fields would look like nothing but dark, rich earth. But by spring, the winter rains would reveal enormous numbers of stones washed bare of soil and bleached light by the sun. Two hundred years of picking rocks out of the fields and piling them on the fencerows created miles and miles of unceremonious jumbles of stones and boulders bordering the fields.

I swiped those stones to make a dry wall—a stone wall without mortar—to hold and terrace a long steep bank planted with perennials. To make the wall as beautiful as I could, I built it the old way, like the Vermont farmers chronicled by Robert Frost and the Pennsylvania Dutch

who built huge barns and houses from native stone. Their rule was: one over two and two over one. That meant that the place where two stones came together was topped with a stone that covered the joint and some of each of the rocks. Similarly, the center of each rock became a place where two stones could touch. Here and there I used a long rock set front to back, rather than side to side, as a "tie stone" to add stability, and topped off the wall with flat "cap stones."

The wall was sturdy; it never heaved from the frost, it held the bank securely, and it had the pretty regularity of something man-made. My wall actually got compliments from friends. I felt then that I knew plenty about stone walls.

That was before I started to landscape with nature on my absolutely stone-free acre in Sebastopol. The soil here is deep Goldridge loam—soft and sandy with nary a pebble, let alone something you could use for wall building. The property has a bank between the driveway and the front lawn that curves in a semicircle—the perfect place for a new rock and ornamental garden. For years before I moved in, the bank was held by rotting railroad ties.

Marilyn and I spent a couple of years trying different arrangements of plants in that space, but nothing worked. We were too new to the region. The garden always looked flat. Meanwhile, the railroad ties grew uglier by the year.

Finally it dawned on us that the garden needed "bones"—big rocks to anchor it to the bedrock of the earth and define discrete planting spaces. Also, the railroad ties had to go, so we needed a wall to keep the bank's soft earth from washing onto the lawn during winter's heavy rains.

ADDING LANDSCAPE "BONES"

We first ordered a truckload of big boulders from a local landscaping firm, to be used in the garden itself for structure. We wanted them to look as natural as possible, to give the impression that they were emerging from the soil from some unseen ledge of buried rock, rather than simply perching on the soil like amorphous sculpture. So we grabbed shovels and made randomly spaced holes into which the landscape crew obligingly pushed the boulders.

After the boulders were placed, we were very pleased: The garden space was defined, separated into different planting places by the intervening groups of boulders. Now there were bones for the garden's green flesh. It had unity and looked as if the stones had always been there.

But we still needed a wall at the bottom of the bank to replace the railroad ties. I envisioned what the traditional stone wall of the East (one over two...) would look like bordering this very naturalistic California garden. It wouldn't look right at all. It was too human, too regular, too stiff. At that point, I didn't know what to do. But at least I knew what not to do.

It was just about that time that I made my Valentine's Day hike at Sugarloaf Park and found the creekbed where the gurgling brook tumbled down the hill and washed away the soil, revealing rocks that held back the steep, forested banks. (For more inspirations from this hike, see "Glade, Glen, and Grotto" on page 7.) I thought, This is how nature makes a stone wall! The stone wall at home must look like the sides of the stream, as though its rocks and boulders were revealed by water washing away the soil in its downward course.

Nature was very clever building her wall. For starters, the stream banks had rocks of many sizes, rather than stones of roughly the same size, as in a traditional wall. I counted a few really huge boulders, a dozen or so large boulders, several dozen medium-size boulders, and lots of smaller boulders, rocks, and stones, all fit together in ascending tiers, rather than in a perpendicular wall.

Furthermore, almost all the stones in the bank were emerging from the ground in these tiers, rather than being set atop one another. The tiered ascent of the stones created small level places that held miniature terraces of soil, where native ferns and mosses grew. We could get the same effect in the garden at home and use the little terraces for dry-soil rock garden plants like hens-and-chicks (*Sempervivum* spp.), thyme, and sedum.

To look natural like the stream's sides, the stones have to be the same kind and color of rock. Mixing round, whitish rocks with sharp, dark slabs would look contrived.

BUILDING OUR OWN WALL

I went back to the landscaping company, but couldn't find rocks with water-softened edges that were also all the same type of stone. So Marilyn and I went looking for rocks in the mountains each day, miles from home. On a lonely stretch of road high in the hills, we found an abandoned gravel pit where the highway department had long ago dumped many loads of river cobbles and chunks of water-washed rocks of various sizes. They were just

what we were looking for. Over the next month, we brought home a dozen trunkloads of rock and put in our naturalistic rock wall.

Just as in the stream bank, we first sited a few boulders so big we could barely move them. These we buried partway into the ground at lawn level just in front of the bank. We found that they look most natural when only the top third of the rock is above the soil level. The bottom two-thirds is suggested and more powerfully felt because of it. Here and there we created ascent by burying only the bottom third of a boulder.

Though the work was hard, dirty, and sweaty, we relished it. We could see something magical taking place in front of our eyes. Between the biggest rocks, we partially buried several smaller boulders in a staggered line from in front of the bank back into the bank. Even though the back rocks would disappear under other rocks, they would add stability to the wall. In areas of the country where winter freezes hit hard, these underpinnings should be set into sand footings to drain away water and prevent frost-heaving.

Next, we partially buried smaller rocks in front of the places where the boulders touched. Behind the boulders, above the underpinnings, we partially buried more small rocks, so that the wall had a dimension of depth as well as height.

Using stones of widely different sizes gave the retaining wall a natural appearance, but it still looked unified because the stones were the same material and color. To make sure the wall didn't begin abruptly at the edge of the lawn and stop abruptly at its top, we took flat-topped rocks and buried them here and there in front of the wall, and did the same at the top of the wall. These stones made the retaining wall look like it arose from the lawn and merged with the structural rocks in the garden itself.

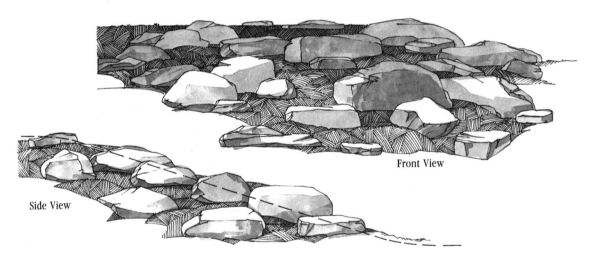

Front View

Side View

To make a natural-looking stone retaining wall, use the kind of rock that's found naturally in your area. Place the stones so they seem to have been strewn on the slope by glaciers or a stream. Put the largest rocks at the base of the bank, using smaller stones as you ascend. Partially bury the rocks, and leave pockets of soil between stones so you can plant groundcovers.

FINISHING TOUCHES

When we were finished, we planted up the many little nooks and crannies in the wall with echeverias, hens-and-chicks (*Sempervivum* spp.), sedums, and other succulents, and with mats of Irish moss (*Sagina subulata*) and creeping thyme (*Thymus serphyllum*). In a few places, we planted light blue annual lobelias and clumps of small, gray-green ornamental grasses such as blue fescue (*Festuca caesia*). On top of a prominent corner we planted a California fuchsia (*Zauschneria californica*) that showered its bright red, teardrop-shaped flowers over the wall and onto the lawn. The plants softened the rocky appearance of the wall and further tied it into the greenery above and lawn grass below. The little terraces make perfect planting beds for alpines and miniature plants, too.

A wall like ours has several advantages over the traditional stone wall. First, it's sturdier. Because it is built in stages into the bank, it isn't a precarious stack of stones as are most traditional walls. A little frost-heaving won't destroy it.

Second, it is more fun and artistic to build and may actually take less rock than a stacked wall. With the traditional wall, choice of stones is critical because of the neatness and regularity the builder wants to achieve. But with the natural wall, the builder has much more leeway to use a variety of stones in any one place.

And third, while it's impossible to plant most traditional walls, this one lends itself to landscaping with choice little plants. Rock garden plants are special favorites and are totally at home in, as well as beautifully set off by, a natural wall like ours.

RULES FOR BUILDING STONE WALLS

To sum up, here are our rules for building this naturalistic wall.

1. Use stones of widely varying sizes, but all of the same type and color(s).
2. Place the largest rocks first, then the next largest, on down to the smallest.
3. Bury most rocks two-thirds into the soil; for contrast, bury some one-third into the soil.
4. Make the wall 1½ feet deep for each foot of rise. Thus a wall that's 3 feet high would be approximately 4½ feet deep.
5. Bury some rocks at the top of the rise and at the bottom of the wall to tie the wall into the landscape.

LAWNS AND GRASSES

Americans spend between $25 and $30 million a year on their lawns. We loll on 30 million acres of lawn, half of which surrounds our more than 50 million homes. We love grass. But we don't often plant it or treat it with a clear idea about its use and functions in nature.

Wilderness is not always dense forest. Much of it is grassland, like our own prairies. Natural grasslands cover a full third of the earth's land surface, occupying land too cold, too dry, or too wet for trees. Only lichens can live in harsher climates than grass.

Grasslands in the temperate zones occur where dry or wet conditions prevent much tree growth. The extensive grassy prairies of the Great Plains grow in the rain shadow of the Rockies, where rain is sparse and grasses take

advantage of seasonal wetness to rush through their cycle of growth, flowering, and setting seed. The savannas of Georgia and Florida are wetlands comprised of water grasses, sedges, and reeds that grow where trees die out. In the rolling hills of California, oaks grow in the more moist folds and gulleys, but the high, open parts of the hills are covered with annual grasses. They sprout green in the fall when the rains begin, stay small over winter, then grow lush in the warm, wet spring before turning tan when the rains end in June. All this means that grasses are available for every gardening situation, from sun to shade, from dry to wet, from cold to hot.

PRACTICAL REASONS FOR HAVING LAWNS

Practically, grasses and other groundcovers that can stand foot traffic give us needed open space for walking and playing. Landscaping with nature doesn't mean planting a jungle of native plants, but rather arranging garden passages according to nature's rules. These gardens look best flanked by open areas planted with grass, which allow us easy access to their parts.

Since lawns serve very practical purposes and set off natural gardens so well, they are a necessary part of the landscape. It's important to care for them properly, without going overboard. The worst possible approach to lawn care is to hire a chemical lawn service, with its regular applications of broad-leaf herbicides, injections of pesticides, fungicidal rinses, and doses of soluble chemical fertilizers. Who knows what these products do to our groundwater? And who wants to loll and play on a chemical-soaked lawn?

I'm wary of any lawn-care products that promise to do the work for me. I'd rather weed than apply herbicides, and I don't believe grass needs much fertilizer unless it's growing poorly or has yellowed blades. Lawn pests, such as the white grubs of the Japanese beetle, can be controlled safely using the pests' natural enemies and other biological controls. Milky spore disease provides good control of these pests.

RECIPE FOR GOOD LAWN GROWTH

Turf lawns wake up when the average daily temperature gets to about 50°F—late March in the mid-Atlantic states. Here's a regimen for good lawn growth that should be followed every year before the first cutting—mid- to late April over most of the East.

First, forget about thatch. It was about 25 years ago, I believe, when some smart marketing person invented the idea that thatch is something to worry about. According to the ads, thatch is the residue of past plant growth and matted clippings that causes lawns to look sparse and brown and should be removed using the featured product. But thatch isn't really a problem except with zoysiagrass.

Thatch, in fact, can be beneficial. Here's why: Each summer, a householder attaches a grasscatcher to the mower and collects the clippings, which he puts in plastic lawn bags for the garbageman to cart away. Over the season, he may remove a dozen mowings' clippings from the lawn, instead of allowing these nitrogen-rich materials to act as a natural fertilizer. Carting off the clippings depletes the soil of its nutrients. Then he has to bring in expensive

fertilizers or bulky manures to feed the starving turf. The high nitrogen content of the fertilizer forces artificially fast growth, and this *can* actually create a thatch problem.

As you can see, our homeowner is using a bad recipe for lawn care. Don't follow his example. Take the grasscatcher off your mower and let the clippings fall where they may. They will dry out and fall between the blades of living grass, become buried under more clippings, and eventually be eaten up by soil microorganisms. These organisms in turn die, adding nutrients to the soil. There the roots of the turfgrasses take them up to build new green tissue. The process is cyclical and runs itself, and you don't have to add much . . . except maybe ground limestone and an application of organic fertilizer every third year.

Grass just loves ground limestone. Unless you live in an area with a limestone or alkaline soil, an application of ground limestone at the rate of 100 pounds per 1,000 square feet every three years will be most appreciated by the lawn. Put it on before the first cutting of spring. Unlike hydrated lime, it won't burn the lawn.

Don't let the grass get more than 4 or 5 inches tall before making that first mowing of the season, and set the blade at about 3 inches high. In late May, when you have to mow more often, set the blade down to 2 inches. I never set it lower than that for ordinary lawn turf and usually just leave it at 3 inches. A little extra length makes the grass softer and more luxurious. It also shades the decomposing clippings, which hastens their decay and spins the cycle of growth, cutting, and death a little faster.

Remember lawn rollers? They were large cylinders with lawn mower-type handles filled with water and used to flatten lawns after a winter of frost heaving. In the 1940s, they rolled grass seed into millions of acres of new lawns around post-war housing. They seem to have fallen out of favor, I suppose because rolling the lawn may be just too fastidious for these hectic times.

However, consider that winter frost heaving leaves little air pockets under the soil that may slow root growth in the spring. Rolling snugs the grass roots evenly against the earth so a thicker stand of grass is produced. And it reduces high spots in an uneven lawn that would be scalped bare by the lawn mower if not flattened. Giving your lawn a spring roll will improve your summer loll later on. And lawn rollers are still commonly available at garden centers and other lawn-care suppliers.

ESTABLISHING NEW LAWN

To establish areas of new lawn, start in spring or early fall east of the Rockies and in fall or early winter in the mild coastal climates of the West. Turn up the area with a tiller, take out rocks and roots, and rake it level. Now put down as thick a layer as you can—2 or 3 inches would be ideal—of moist, humusy, weed-free topsoil or crumbly compost. This layer will suppress weeds and give your grass seed a fine bed to grow in.

Divide the grass seed into two bags. Sow one bag over the entire surface by walking back and forth in one direction, then sow the second bag at right angles to the first sowing. Very lightly rake over the entire surface. The seed

should be at or just under the soil surface, and the surface should be fresh and slightly moist.

After the seed germinates, water thoroughly with a gentle mist from the hose nozzle or fine sprinkler so as not to disturb the little plants with a forceful jet of water. And when the grass is about 3 inches tall, roll it lightly with an empty or partially filled lawn roller. When the grass recovers and grows past 3 inches, mow it back to the 3-inch height. Try not to use this lawn area the first season. Sod, of course, provides instant, weed-free lawn.

GRASS SEED MIXES

Most grass seed for new lawns is a mixture of several species, such as creeping red fescue (*Festuca rubra*), Kentucky bluegrass (*Poa pratensis*), and perennial ryegrass (*Lolium perenne*).

They're mixed to prevent disease and to accommodate a variety of conditions of sun, moisture, and soils. Grass is sown thickly, and the individual grass plants are crowded—even overcrowded. This stresses the plants, making them more susceptible to rots, fungal diseases, and other soilborne diseases. If all the grass in the lawn were of one species, and a disease that attacks that species were to get a foothold, a whole lawn could be wiped out. By mixing plants with varying resistance and susceptibility to different diseases, you ensure your lawn's health.

Similarly, lawns are not usually entirely in full sun or shade. They tend to have areas that are out in full sun, and other places in partial or full shade. The mixture of grass species and cultivars usually includes grasses that are shade-tolerant as well as those that enjoy full sun, insuring a healthy stand across the spectrum of conditions.

Kentucky and other bluegrasses grow best in sunny, open areas on well-limed, fertile soils. Fescue adapts well to shady and infertile areas, while perennial ryegrasses are fast growing and help nurse the others along.

The range of lawn grass cultivars is large and it grows year by year as new grasses are introduced. Many of these are specially adapted to particular conditions. Among bluegrasses, for instance, 'Nugget', 'Glade', 'Touchdown', and 'A-34' are recommended for shady conditions; 'Glade' and 'Nugget' are also low-growing cultivars especially suited to lawns that are mowed short.

Check your local lawn and garden center to see what's available for conditions in your area. And read the labels carefully. Germination rates are listed, and these should be in the 80- to 90-percent range. The label will also tell you the weed seed content of the grass. Obviously, the fewer weed seeds, the better. You can store grass seed for three or four years if you keep it cool and dry, so save what you don't use.

GRASS FOR A PEST-FREE LAWN

In all my years of gardening and establishing lawns, I've never encountered really serious pest problems. I've learned to live with the insects, as long as they don't overwhelm the lawn grasses. In those areas of the country where lawn pests pose a real problem, choose some of the new resistant cultivars.

Grass breeders have identified certain strains of grass that host endophytic fungi. They've

GRASS MIXES FOR YOUR LAWN CONDITIONS

The following chart is taken from USDA Agricultural Extension Service data for parts of the country east of the Rockies and north of a line drawn between Missouri and South Carolina. It should cover conditions in the Northeast and Midwest.

Percentage of Grass Species in Mixtures for Various Lawn Conditions

Condition	Fescue (%)	Bluegrass (%)	Ryegrass (%)
Varied lawn conditions	40	20	40
Full sun, fertile soil	20	50	30
Fast-growing lawn	20	20	60
Full sun, heavy clay soil	—	100	—
Short-mowed, sunny lawn	—	100	—
Steep bank, not mowed	60	20	20
Dry, shady soil (under trees)	80	20	—
Shady, moist soil	40	30	30

discovered that these fungi, living in beneficial association with their grass hosts, repel armyworms, sod webworms, and bluegrass billbugs; these three, with Japanese beetle larvae, are the chief pests of lawn turf.

'Repel', a cultivar of perennial ryegrass with extremely high levels of endophytic fungi in its tissues, and therefore a high resistance to pests, is available wholesale from Lofts Seed, Inc., P.O. Box 146, Bound Brook, NJ 08805. If you're interested in this cultivar, have your garden center contact them. The cultivars 'Prelude' and 'Premier' are also very pest-resistant. 'Citation II' is a perennial ryegrass that won high marks for pest-, drought-, and heat-resistance in tests in both Oregon and New Jersey. Look for them at your garden center.

Perennial ryegrass has no creeping rhizomes or underground stolons, so it needs to be reseeded when bare spots occur. A reseeding mixture is marketed under the tradename Patchwork. It's widely available. Ryegrasses are tougher, more drought-tolerant, and more adaptable than standard Kentucky bluegrass, yet they're just as good looking: Perennial ryegrass has fine, dark green leaves.

Be on the lookout for a cultivar of lawn grass called 'Pinnacle'. It's a perennial ryegrass with a low growth habit, and it's leading the way for several strains of short grasses. As you

might guess, short grasses mean less mowing. Breeders are now working on even shorter grasses—grasses that may be short enough to need no mowing at all—but they aren't yet available.

GOOD GRASSES FOR WARM CLIMATES

In the Southeast and West, where hot nights prevail, several types of grass that are especially well adapted to these conditions can be useful. These include:

- Bahiagrass (*Paspalum notatum*). Coarse-textured bahiagrass forms a tough, thick, uneven turf. Not particularly easy to mow, it's good for rough places because it's low-growing, durable, and a light feeder. Buy named cultivars. It's the most shade-tolerant, warm-season grass.

- Bermudagrass (*Cynodon dactylon*). Improved cultivars of this coarse, tough grass have finer leaves that are stiff and medium to dark green. Bermudagrass grows rapidly in the hot months and prefers full sun. It has excellent drought and wear tolerance, but is a heavy feeder. It is not hardy north of the line between Missouri and South Carolina, but in its range, it can be an invasive and hard-to-eradicate weed if it escapes into flower beds or vegetable gardens. Where the temperatures drop below freezing, bermudagrass will turn brown as soon as the thermometer drops below 32°F.

- Centipedegrass (*Eremochloa ophiuroides*). Centipedegrass is a medium-texture, medium green grass that's fairly attractive.

It likes poor, acid soils, prefers full sun, and needs little maintenance. It has excellent drought tolerance, but can't take a lot of wear.

- St. Augustinegrass (*Stenotaphrum secundatum*). A nice-looking, tough, dark green grass that's shade-tolerant. Unlike most grasses, it has broad-bladed leaves. St. Augustinegrass likes sandy soil, but it's a heavy feeder and won't hold up under really heavy wear.

- Zoysiagrass (*Zoysia japonica*). In the summer, it's tough, thick, and attractive. Zoysia has fine, stiff, medium green leaves. In the winter it tends to turn brown. It prefers full sun, is a light feeder, and has excellent wear tolerance. Thatch buildup is a problem; you'll have to remove thatch every few years.

Along the California coast, new cultivars of tall fescues, torgrass, and buffalograss are also outperforming the old types of Kentucky bluegrass and other lawn grasses. Tall fescue (*Festuca elatior*), once used only as a forage grass for pastures, has been bred down to turfgrass size —short and able to take mowing down to 2 inches. Look for 'Jaguar', 'Olympic', 'Adventure', 'Apache', and 'Falcon'—all new, tested cultivars of fescue. Like perennial ryegrass, tall fescue produces no underground runners and needs reseeding in bare spots. It's a medium green grass with good drought tolerance and is adapted to a wide range of soils and pH.

Plant breeders in Florida and California are also working on new cultivars that will require 30 to 40 percent less water. A water-conserving tall fescue named 'Chesapeake' is

being marketed by O. M. Scott and Sons. All of Scott's grasses are sold through garden centers.

Torgrass (*Brachypodium pinnatum*) is a Mediterranean species that stays green in the winter, as opposed to zoysiagrass, which turns brown when killing frosts hit. It has shown great promise in experiments in California.

Buffalograss (*Buchloe dactyloides*) is a drought-resistant, short, low-maintenance grass for the mildest climates. In cool and cold climates, it turns unacceptably brown over winter.

ORNAMENTAL GRASSES

The latest trend in landscaping keeps the grass but avoids the turf. Landscaping with ornamental grasses—some as tall as 15 feet—is becoming more popular due to the exciting landscapes created by Oehme, Van Sweden and Associates of Washington, D.C. But these are gardens, not lawns, and anyone caught lolling in the waving plumes of purple miscanthus (*Miscanthus sinensis* 'Purpurascens') would be nabbed for vandalism.

Because grasses are so widespread, almost any trip to wild and natural areas will give you plenty of ideas for using ornamental grass in the natural landscape. Notice how effective beautiful grass is when its seed heads are backlit by the setting sun. I've seen thick stands of foxtail set afire at sunset, and it's as gorgeous a sight as any contrived by gardeners.

The subtle colors and simple shapes and textures of ornamental grasses augment the clean lines of natural wood, rivers of stone, and even concrete patios and flagstoned areas. This group of plants needs little care—maybe just a

cleaning up of spent foliage in spring before new growth starts. They are seldom bothered by pests and are long-lived, and—best of all for the natural landscaper—many of them naturalize easily.

OUTSTANDING ORNAMENTAL GRASSES

Although ornamental grasses tend to grow in huge stands in the wild, in the home garden, they are most effective used as accents for broadleaved plants, either as single specimens or a small group of three. Small conifers like the mugho pine (*Pinus mugo* var. *mugo*) mixed with succulents and spiky blue oat grass (*Helictotrichon sempervirens*) is one of my personal favorite combinations, evocative of a western seashore. Gardeners who live at the seashore should use beach grass (*Ammophila breviligulata* or *Uniola paniculata*), rushes (*Juncus inflexus, J. effusus*, and *Scirpus validus*), or blue Lyme grass (*Elymus glaucus*).

Shade-loving ornamental grasses lend themselves to settings we don't usually think of as places for grass, such as an open woodland where azaleas, mountain laurels, and rhododendrons grow. Northern sea oats (*Chasmanthium latifolium*) grows wild in the riparian woods, its small clumps tossing out pendant, heart-shaped seed heads. Tufted hair grass (*Deschampsia caespitosa*) forms a 3-foot, feathery, light-colored panicle amid the semishade formed by trees with a broken canopy. For even shadier spots, the variegated cultivar of greater wood rush (*Luzula sylvatica* 'Marginata') has silver edges that stand out in the shade. There are two sedges of surpassing beauty for shady spots under trees: variegated Japanese sedge (*Carex*

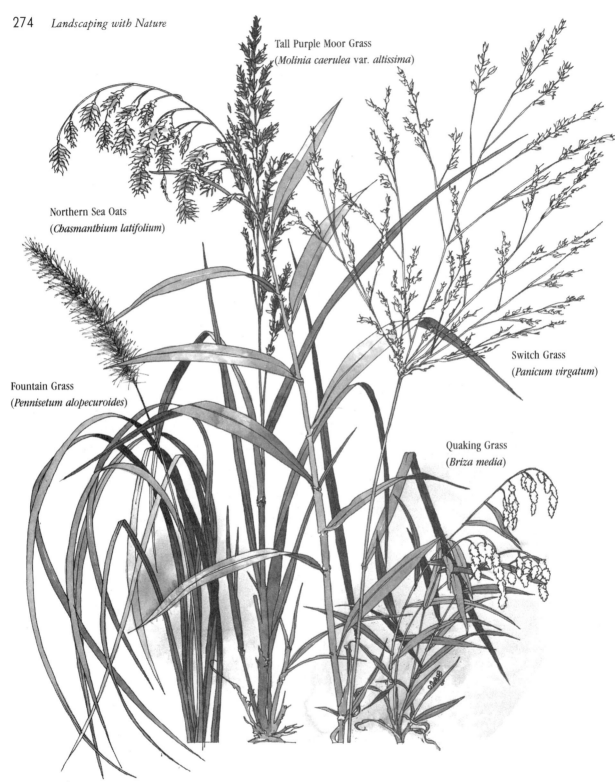

Tall Purple Moor Grass
(*Molinia caerulea* var. *altissima*)

Northern Sea Oats
(*Chasmanthium latifolium*)

Fountain Grass
(*Pennisetum alopecuroides*)

Switch Grass
(*Panicum virgatum*)

Quaking Grass
(*Briza media*)

Ornamental grasses can add height, structure, and four-season interest to your natural garden.

morrowii 'Aureo-Variegata'), a small bushy plant, and drooping sedge (*C. pendula*), which makes a tall plant with arching flowering stems.

Although bamboo—which is a grass—is not normally found in the wild in North America, it can be used to provide strong vertical elements as you reproduce scenes from nature in your garden. I'd caution growers in Zone 7 and warmer to choose either black bamboo (*Phyllostachys nigra*) or golden bamboo (*P. aurea*) for their gardens, as these bamboos have short rhizomes and form well-behaved clumps. Black bamboo is also gorgeous, with older canes turning a rich ebony. Most of the other kinds of bamboo are rampantly invasive with rhizomes that can shoot out dozens of feet from the parent plant and soon overwhelm the garden.

ORNAMENTAL GRASSES FOR NATURAL GARDENS

For ornamental use, the following grasses are superior.

- Blue fescue (*Festuca caesia,* often sold as *F. ovina* var. *glauca*) makes spiky mounds of blue-green foliage up to a foot tall. It makes a bold statement in rock gardens. Perennial. Zone 3.

- Blue oat grass (*Helictotrichon sempervirens*) looks very much like blue fescue, but grows to 2 feet tall. We grow ours with several colors of stonecrops (*Sedum* spp.) and hens-and-chicks (*Sempervivum* spp.). Perennial. Zone 5.

- Feather reed grass (*Calamagrostis acutiflora* var. *stricta*) grows to 4 feet and produces feathery flowers in June and July. Perennial. Zone 5.

- Fountain grass (*Pennisetum alopecuroides*) looks like a rosy brown version of common foxtail and grows to 3 feet. Very pretty habit. Perennial. Zone 5.

- Japanese silver grass (*Miscanthus sinensis*) makes a gorgeous 6- to 8-foot display of long, straplike foliage and bears puffy plumes of flowers late in the season. Giant miscanthus (*M. floridulus*) grows to 15 feet. Both are perennial. Zone 4.

- Northern sea oats (*Chasmanthium latifolium*) tolerates partial shade. It grows 3 feet tall, blooming late in the season with heart-shaped, dangling flowers. Perennial. Zone 5.

- Quaking grass (*Briza media*) is a 2-foot plant with heart-shaped flowers that dangle from tough grass stems. Perennial. Zone 4.

- Silver spike grass (*Spodiopogon sibericus*) is a choice grass with reddish leaves that grows 4 to 5 feet tall and blooms in August. Perennial. Zone 5.

- Switch grass (*Panicum virgatum*) grows in tidy, upright clumps and turns reddish in summer. It opens clouds of purplish red flowers in July that fade to beige in the fall. A native of the Tallgrass Prairie. Perennial. Zone 5.

- Tall purple moor grass (*Molinia caerulea* var. *altissima*) carries impressive blooms on 4- to 6-foot plants and blooms late in the season. Perennial. Zone 5.

- Tufted hair grass (*Deschampsia caespi-*

tosa) is a drought-tolerant grass that forms beautiful low mounds (to 2 feet) of fine foliage and thrives in most conditions, from full sun to full shade. Perennial. Zone 5.

● Variegated Japanese sedge (*Carex morrowii* 'Aureo-Variegata') is a swirl of yellow and green that grows a foot tall and is very ornamental. Perennial. Zone 5.

GROUNDCOVERS AS ALTERNATIVES TO GRASS

As substitutes for heavily used grass lawns, most groundcovers have serious drawbacks—few will take much foot traffic. But groundcovers are perfect low-maintenance lawn substitutes if you just want to have the visual effect of a lawn rather than a playing field, and they're ideal for hard-to-mow sites like steep slopes and for shady areas where you just can't get a good stand of grass.

Groundcovers can add interest to the yard with their varied colors and textures without needing the intensive work of a flower garden. Once established, many groundcovers resist weeds—pachysandra, English ivy, hostas, and ajuga are examples. And they don't need to be staked, cut, watered, fertilized, sprayed, and generally fooled with like flowers.

In most landscapes, groundcovers work best when they supplement the lawn rather than replace it entirely. But if your heart is set on a no-mow, all-groundcover lawn, plan paths and stepping stones to keep traffic off the plants.

Groundcovers that *will* take some stepping on include dense plantings of woolly yarrow (*Achillea tomentosa*), chamomile (*Chamae-*

melum nobile), and mother-of-thyme (*Thymus serpyllum*)—all tough, drought-resistant plants. Mother-of-thyme is also especially good to plant in spaces between the risers in steps made of wood or stone in Zone 4 and warmer. Where it's walked on, it shrinks back, but otherwise it fills in bare spots and grows over the edges of the steps, softening them and giving them a natural look.

GREAT GROUNDCOVERS FOR NATURAL GARDENS

Hardy groundcovers for cold-winter climates include:

● 'Burgundy Glow' ajuga (*Ajuga reptans* 'Burgundy Glow') has dark green leaves with a purple-red tinge and pretty blue flower spikes in spring. It forms dense mats and is very well-behaved, staying just a couple of inches tall. Ajuga, also called bugleweed, looks good around stone steps in partial shade. There are many other cultivars to choose from. 'Metallica Crispa', 'Bronze Ripple', and 'Rubra' all have red-bronze leaves. 'Giant Bronze' and 'Jungle Bronze' are larger plants, to 10 inches tall. 'Purpurea' and 'Atropurpurea' have bronze-purple leaves that are somewhat larger than the species. 'Variegata' has leaves edged with light cream. Zone 3.

● Common thrift or sea pink (*Armeria maritima*) makes low mounds of grasslike foliage in full sun and is covered with delightful small, pink, chivelike flower heads in spring. 'Alba' has white flowers. Hardy to Zone 4.

Chamomile
(*Chamaemelum nobile*)

'Burgundy Glow' Ajuga
(*Ajuga reptans* 'Burgundy Glow')

Kenilworth Ivy
(*Cymbalaria muralis*)

Shortleaf Stonecrop
(*Sedum brevifolium*)

Spring Cinquefoil
(*Potentilla tabernaemontani*)

Mother-of-Thyme
(*Thymus serpyllum*)

Groundcovers can create a tapestry of color and texture on the floor of your natural garden. Shade-loving groundcovers like Kenilworth ivy and ajuga work especially well under trees, sun-tolerant groundcovers like stonecrop and cinquefoil are ideal for exposed banks, and abuse-resistant groundcovers like chamomile and mother-of-thyme make fragrant herbal lawns.

● Creeping baby's-breath (*Gypsophila repens*) makes low mats of fine gray-green foliage with lots of white to pale lilac flowers in early to midsummer. Hardy to Zone 3.

● Creeping speedwell (*Veronica repens*) is a dense, mat-forming groundcover that takes full sun and covers itself with pale blue flowers in late spring. Zone 5.

● Dead nettle (*Lamium maculatum*) is a trailing groundcover with many fine variegated cultivars, especially the well-known 'Beacon Silver', which has green-edged silver leaves and pink flowers, and 'White Nancy', with silver-variegated foliage and white flowers. Hardy to Zone 3.

● English ivy (*Hedera helix*) forms trailing and climbing stems of rich green leaves with whitish veins and is hardy to Zone 6. 'Wilson' is a super-hardy cultivar that can be grown as far north as Zone 4. Many beautifully variegated cultivars exist, but these are usually less hardy than the species; try a couple of plants outdoors before committing yourself to a larger planting.

● Hostas or plantain lilies (*Hosta* spp.) are excellent groundcovers for partial shade. These are not low growing, ranging from 10 to 30 inches tall, but their lance-shaped to rounded foliage is lovely and their flower spikes are effective and often fragrant. Many cultivars exist; leaves range in color from chartreuse to a powder blue, and many have white or yellow variegations, as well as puckering or deeply incised, decorative lines; flower color may be lilac or white. They bloom in mid- to late summer. Hostas do best in moist, well-drained soil. All are hardy to Zone 4.

● Kenilworth ivy (*Cymbalaria muralis*) and its smaller relative, *C. aequitriloba,* like shade and moisture and produce pretty little lilac blue or mauve flowers. Kenilworth ivy can be invasive where it's happy, so don't plant it where it can force its way into the cracks in a wooden wall or grow up through a deck. Zone 3.

● Liriope or creeping lilyturf (*Liriope muscari* or *L. spicata*) is another taller groundcover that forms graceful arching clumps of strap-shaped, dark green leaves. *L. muscari* can reach 1½ feet tall and has decorative spikes of blue-purple flowers, followed by ornamental black berries; it is hardy to Zone 6. *L. spicata* is 10 inches tall with pale lilac flowers, and is hardy to Zone 5. Both are evergreen, and both have variegated cultivars.

● Maiden pink (*Dianthus deltoides*) makes low mats of trailing foliage with lavender-pink flowers on 6- to 8-inch stems in spring. Cultivars have white and red flowers, some with contrasting central "eyes." It must have well-drained, alkaline soil and good air circulation. Zone 4.

● Mazus (*Mazus reptans*) makes low trailing mats of foliage with pretty, purplish blue-and-white, tiny flowers in late spring. Full sun. Hardy to Zone 3.

● Moss pink (*Phlox subulata*) is a delightful groundcover that makes 6-inch-tall, mosslike mats that are covered with purple, reddish, pink, or white flowers in spring.

Takes full sun and well-drained soil. Shear after bloom for more compact growth. Hardy to Zone 3.

● Moss sandwort (*Arenaria verna*) looks like small tufts of grass and produces lovely little white flowers in spring. It likes a sunny spot. Hardy to Zone 5.

● Perennial candytuft (*Iberis semper-virens*) makes lovely mounds of dark green, evergreen foliage and is covered with delightful, honey-scented, white flower heads in spring. May reach 1 foot tall. Hardy to Zone 5.

● *Pratia angulata* is a New Zealand introduction that forms a 6- to 8-inch mat of creeping stems. Mow it back to 3 or 4 inches each spring. It likes partial shade, grows in damp spots, and is hardy to Zone 7. Ideal for the Pacific Northwest.

● Purple rock cress (*Aubrieta deltoidea*) makes low mounds of evergreen foliage with intensely purple flowers in late spring. Some pink-flowered cultivars. Hardy to Zone 5.

● Rock candytuft (*Iberis saxatilis*) has evergreen foliage that takes full sun, and white flowers in mid- to late spring. Hardy to Zone 3.

● Rupturewort (*Herniaria glabra*) makes a pretty, creeping, mosslike groundcover with densely packed, small, plump leaves to just an inch or so tall. The flowers aren't conspicuous, but the leaves can turn red-bronze in fall. Zone 5.

● Serbian bellflower (*Campanula pos-charskyana*) has dainty, 4- to 6-inch trail-ing stems and produces a profusion of inch-wide, lavender-blue flowers in early summer. Prefers full sun. Drought-resistant. Hardy to Zone 3.

● Shortleaf stonecrop (*Sedum brevifo-lium*) and two-row stonecrop (*S. spurium*) are both interesting-looking, succulent groundcovers with evergreen leaves. The plants stay low to the ground. *S. spurium* 'Dragon's Blood' has red-tinged leaves and red flowers. *S. brevifolium* is hardy to Zone 4; *S. spurium,* to Zone 3.

● Snow-in-summer (*Cerastium tomento-sum*) forms low mats of woolly evergreen foliage and has pretty white flowers in summer. It takes full sun, covers wide areas, and is hardy to Zone 3.

● Spring cinquefoil (*Potentilla tabernae-montani*), which grows 2 to 6 inches tall, has strawberry-like leaves and tiny golden-yellow flowers in spring. It turns brown in winter, but recovers early in spring. You can mow it to 3 or 4 inches tall. Zone 4.

● Spring heath (*Erica carnea*) is a short, dense sub-shrub with fleshy pink flowers in early spring and is hardy to Zone 5.

● White cupflower (*Nierembergia repens*) has trailing stems that form mats with large, white-and-rose, morning-glory-like flowers in summer. Full sun. Zone 7.

● Woolly thyme (*Thymus pseudolanugi-nosus*) forms a pretty gray-green, soft, woolly mat that stays about 3 inches tall. It can take some foot traffic, too, just like the very fine-leaved mother-of-thyme (*T. serpyllum*). Both Zone 4.

Australian Violet
(*Viola hederacea*)

Baby's-Tears
(*Soleirolia soleirolii*)

Dichondra
(*Dichondra micrantha*)

GREAT GROUNDCOVERS FOR WARM-ZONE GARDENS

Gardeners in the warm Zones (8 to 10) have additional groundcovers to choose from:

● Australian violet (*Viola hederacea*) can only be grown in frost-free zones. There it has pretty little leaves that stay about 3 inches tall all year and produces tiny blue to white violets over its surface in summer. Like most violets, it likes shade and lots of water.

● Baby's-tears (*Soleirolia soleirolii*) is superb surrounding shady pools of water and growing between stone steps in shady, moist places.

● Blue star creeper (*Laurentia fluviatilis*) produces little, blue-white, starlike flowers from February to summer, stays just 3 inches tall without mowing, and makes a tightly knit groundcover.

Irish Moss
(*Sagina subulata*)

Tiny evergreen groundcovers are perfect for softening the harsh outlines of bricks and stones.

- Dichondra (*Dichondra micrantha*) is another fine-leaved, tightly knit groundcover for steps and rock gardens. Hardy to Zone 9.

- Irish moss or Scotch moss (*Sagina subulata*) is dark green and looks like the finest, softest, mossy grass. There is also a yellow-green cultivar (*S. subulata* 'Aurea'). Both are just an inch high. It likes full sun and plenty of water.

- Korean or mascarene grass (*Zoysia tenuifolia*) resembles Irish moss, and is, if anything, even finer. It's a very dark green, mat-forming plant, but where frosts occur, it turns an unpleasant tan-brown like all zoysiagrass. Hardy to Zone 9.

- Rupturewort (*Herniaria glabra*) is very low and tiny, perfect for softening the effect of paving stones. Its leaves turn red-bronze in winter.

There are, of course, hundreds of other groundcovers, but these are relatively trouble-free, easy to grow, and look spectacular.

THE WILDFLOWER MEADOW

One of the most appealing ideas for a natural landscape is to turn a sunny piece of land into a wildflower meadow. But can you really make an instant meadow by tossing wildflower seeds on the lawn?

The answer is: of course not. To create an established, naturalized meadow of self-sustaining wildflowers takes some special knowledge and techniques—*and* a willingness to do some work.

The results can be so spectacularly beautiful that the work is worth it. And in the past few years, seed companies have moved away from marketing meadow mixes that are supposed to work in all parts of the country (but don't) and are putting together high-quality mixtures of regionally adapted seeds.

Now is a good time to take advantage of these regional mixes to turn a weedy and scrubby part of the property into a sunny field of flowers. Most of the mixes include annuals and perennials—the annuals giving color the first year, then reseeding themselves in subsequent years when the perennials mature and begin to flower.

Some meadow mixtures also contain native bunch grasses like big and little bluestem (*Andropogon gerardii* and *Schizachyrium scoparium*), switch grass (*Panicum virgatum*), and prairie brome (*Bromus unioloides*). These clump-forming grasses are noninvasive, and they act as nurse crops, competing with weeds and enriching the meadow's diversity as the wildflowers establish themselves. These grasses are a major component of natural meadows, and they'll look good in yours. Don't, however, plant lawn grasses with your wildflowers. These grasses, like bluegrass and perennial ryegrass, grow by sending out underground runners called stolons. They're the bane of the flowering meadow, as the vigorous runners choke out more delicate wildflowers. Only clump-forming grasses that don't invade neighboring turf are well-behaved enough for a wildflower meadow, though you can also add beautiful ornamental grasses as accent plants. Put in ornamental grasses as started plants after the meadow is under way.

Most meadow mixes contain some North American natives plus some wildflowers from

SOURCES OF WILDFLOWER SEED

The following sources carry regionalized seed mixes as indicated. Not all the wildflowers in these mixes will naturalize in your meadow, but regionalization guarantees that many of them will. The individual plants in a mix designed for your region will do well in your yard if they find conditions that suit them.

Applewood Seed Co., Inc.
Arvada, CO 80002

Clear, detailed descriptions and cultural notes are presented for dozens of wildflowers, with color and black-and-white photos. Regional mixtures for ten regions, plus mixes for shade, dry and moist conditions, and groundcovers.

W. Atlee Burpee & Co.
300 Park Ave.
Warminster, PA 18974

Burpee is offering exclusive mixtures for the various regions of the country, guaranteed to contain no invasive species, and you can order many of the finest species individually.

Clyde Robin Seed Co., Inc.
3670 Enterprise Ave.
Hayward, CA 94545

From the people who brought you the Meadow-in-a-Can now come regional mixtures and a large selection of individual seeds. Send $2 for catalog.

Moon Mountain
P.O. Box 34
Morro Bay, CA 93443

A thoughtful and delightful catalog with lovely illustrations and a large selection of annual and perennial wildflowers. Cultural information, bloom season, native range, and suitable climate area are given for each wildflower, as well as description and notes, and you can buy seed in three different quantities. There are also many wildflower mixes, including a Water Saver Seed Sampler, Seed Sampler for a Shady Spot, and Seed Sampler for Year-Round Color, plus mixes for each region. Send $2 for catalog.

Plants of the Southwest
930 Baca St.
Santa Fe, NM 87501

For those who live in the Southwest, this catalog is indispensable. It carries meadow mixtures for specific sub-regions and conditions within the area, and you can also buy dozens of wildflowers individually. Send $1.50 for catalog.

Smith & Hawken
25 Corte Madera
Mill Valley, CA 94941

This upscale garden catalog now carries seven regionalized mixtures. Nice mixes of the best wildflowers.

The Vermont Wildflower Farm
P.O. Box 5, Rt. 7
Charlotte, VT 05445

A fabulous catalog that breaks the nation into nine regions, offers natives as well as introduced wildflowers, and carries mixtures for specific needs like dry areas, partial shade, and seeds for large-scale plantings.

other places. The most successful mixes are those that are matched most closely to your area. For help evaluating wildflower meadow mixes or choosing individual wildflowers for your meadow, see "Best Regional Wildflowers" on page 284.

Now, let's take a closer look at what you need to do to establish a wildflower meadow that will naturalize and take minimal yearly care. Unless you're converting a weed-free garden bed into a minimeadow, bear in mind that you need to begin the season before you plant, so you can solarize your soil and kill as many weeds as possible.

Showy wildflowers add splashes of color to your meadow garden, or you can feature them in a wildflower border. Shown here are: (1) purple coneflower (*Echinacea purpurea*), (2) butterfly weed (*Asclepias tuberosa*), (3) Texas bluebonnet (*Lupinus subcarnosa*), (4) California poppy (*Eschscholzia californica*), (5) Sundrops (*Oenothera missouriensis*), and (6) Black-eyed Susan (*Rudbeckia hirta*).

BEST REGIONAL WILDFLOWERS

The following meadow wildflowers are all relatively easy to grow from seed, and they're very reliable in the regions indicated. Some are native and some are naturalized. Although they don't make a finished meadow all by themselves, they are the backbone of any wildflower meadow.

NORTHEAST

Including Connecticut, Delaware, Maine, Maryland, Massachusetts, New Hampshire, New Jersey, New York, Pennsylvania, Rhode Island, Vermont, and West Virginia.

Annual coreopsis (*Coreopsis tinctoria*)
Annual Indian blanket (*Gaillardia pulchella*)
Butterfly weed (*Asclepias tuberosa*)
Dame's-rocket (*Hesperis matronalis*)
Evening primrose (*Oenothera biennis*)
Lance-leaved coreopsis (*Coreopsis lanceolata*)
New England aster (*Aster novae-angliae*)
Oxeye daisy (*Leucanthemum vulgare*, formerly *Chrysanthemum leucanthemum*)
Purple coneflower (*Echinacea purpurea*)
Wild bergamot (*Monarda fistulosa*)

SOUTHEAST

Including Alabama, Arkansas, Florida, Georgia, Louisiana, Mississippi, North Carolina, eastern Oklahoma, South Carolina, Tennessee, eastern Texas, Virginia, and Washington, D.C.

Annual coreopsis (*Coreopsis tinctoria*)
Annual Indian blanket (*Gaillardia pulchella*)
Bachelor's-button (*Centaurea cyanus*)
Black-eyed Susan (*Rudbeckia hirta*)
Butterfly weed (*Asclepias tuberosa*)
Coneflower (*Dracopis amplexicaulis*)
Lance-leaved coreopsis (*Coreopsis lanceolata*)
Oxeye daisy (*Leucanthemum vulgare*, formerly *Chrysanthemum leucanthemum*)
Purple coneflower (*Echinacea purpurea*)
Texas plume (*Ipomopsis rubra*)

MIDWEST

Including Illinois, Indiana, Iowa, eastern Kansas, Kentucky, Michigan, Minnesota, Missouri, eastern Nebraska, Ohio, and Wisconsin.

Black-eyed Susan (*Rudbeckia hirta*)
Butterfly weed (*Asclepias tuberosa*)
Lance-leaved coreopsis (*Coreopsis lanceolata*)
Prairie coneflower (*Ratibida columnifera*)
Purple coneflower (*Echinacea purpurea*)
Sneezeweed (*Helenium autumnale*)
Sundrops (*Oenothera missouriensis*)
Sunflower (*Helianthus grosseserratus*)
Swamp sunflower (*Helianthus angustifolius*)

TEXAS AND OKLAHOMA

Including the western portions of these two states.

Annual coreopsis (*Coreopsis tinctoria*)
Annual Indian blanket (*Gaillardia pulchella*)
Annual phlox (*Phlox drummondii*)
Corn poppy (*Papaver rhoeas*)
Evening primrose (*Oenothera speciosa*)
Lemon mint (*Monarda citriodora*)
Maximilian sunflower (*Helianthus maximiliani*)
Prairie coneflower (*Ratibida columnifera*)
Texas bluebonnet (*Lupinus subcarnosus*)
Texas plume (*Ipomopsis rubra*)

WEST

Including Colorado, Idaho, western Kansas, Montana, western Nebraska, northern Nevada, North Dakota, eastern Oregon, South Dakota, Utah, eastern Washington, and Wyoming.

Annual coreopsis (*Coreopsis tinctoria*)
Annual Indian blanket (*Gaillardia pulchella*)
Indian blanket (*Gaillardia aristata*)
Lemon mint (*Monarda citriodora*)
Mountain phlox (*Linanthus grandiflorus*)
Oxeye daisy (*Leucanthemum vulgare*, formerly *Chrysanthemum leucanthemum*)
Prairie coneflower (*Ratibida columnifera*)
Rocky Mountain columbine (*Aquilegia caerulea*)
Sunflower (*Helianthus annuus*)
Tidy tips (*Layia platyglossa*)

(continued)

BEST REGIONAL WILDFLOWERS – *Continued*

PACIFIC NORTHWEST

Including northern California, western Oregon, and western Washington.

Annual coreopsis (*Coreopsis tinctoria*)
California poppy (*Eschscholzia californica*)
Chinese-houses (*Collinsia heterophylla*)
Five-spot (*Nemophila maculata*)
Gumbo lily (*Oenothera caespitosa*)
Lance-leaved coreopsis (*Coreopsis lanceolata*)
Mountain phlox (*Linanthus grandiflorus*)
Prairie coneflower (*Ratibida columnifera*)
Sneezeweed (*Helenium autumnale*)
Wind poppy (*Stylomecon heterophylla*)

SOUTHWEST

Including Arizona, southern California, southern Nevada, and New Mexico.

Annual coreopsis (*Coreopsis tinctoria*)
Anual Indian blanket (*Gaillardia pulchella*)
California poppy (*Eschscholzia californica*)
Chinese-houses (*Collinsia heterophylla*)
Gumbo lily (*Oenothera caespitosa*)
Indian blanket (*Gaillardia aristata*)
Lance-leaved coreopsis (*Coreopsis lanceolata*)
Prairie aster (*Machaeranthera tanacetifolia*)
Prairie coneflower (*Ratibida columnifera*)

SOURCE: Adapted with permission from *The Wildflower Meadow Book: A Gardener's Guide* by Laura C. Martin. Copyright ©1986. Published by The East Woods Press (2d edition, August 1990, published by The Globe Pequot Press).

PREPARING THE SOIL

Look over the area where you want to establish a meadow. Is it a place with dry, poor soil? A steep bank? A low, boggy spot? Is it an area of rich, well-drained soil? Meadow mixes are formulated for all these conditions and for others. But unless they are specially prepared for shady woodlands, all wildflower mixtures are meant to be planted in full sun.

Resist the temptation to create a huge expanse of meadow all at once. Several acres of meadow will be beyond your ability to police, and the weeds will win before the first season is out. Make the area small at first—no larger than you'd care to hand weed during the hot days of midsummer. That might be a rough

square anywhere from 20 to 50 feet on a side, depending on your enthusiasm.

Once you've chosen the site of your meadow, work it up in spring. Clear it of brush and turn it with a plow or a rotary tiller set on its deepest setting, then rake it smooth.

At this point, I use soil solarization, the nontoxic method of sterilizing the top few inches of soil. This will really give your meadow plant seeds the advantage when they are sown.

Wet the freshly turned soil thoroughly. This will encourage weed seeds to sprout, so the tender seedlings can be killed. Next, cover it completely with overlapping sheets of clear plastic mulch weighted down with stones at the overlaps so they won't blow away. Bury the outer edges of the plastic under soil. If you do this when the ground has warmed in spring and leave the plastic in place through the summer, the heat under the plastic from the intense summer sunshine will be great enough to kill grasses and weed seeds in the top few inches of earth, where they are able to germinate.

As long as you do not turn up this soil, or disturb it below the sterilized layer, your weed problem will be minimized and your germinating wildflower seedlings will face much less competition.

After removing the plastic, mulch the meadow site with salt hay, compost, peat, or decomposed rice hulls—any organic matter that doesn't contain weed and grass seeds. Don't fertilize the soil and don't add nitrogen-rich manure. Wildflowers are usually light feeders, and fertilizing them heavily will only flush them into overly lush, weak, green growth at the expense of flower bud production.

SOWING THE MEADOW GARDEN

If you live in USDA Plant Hardiness Zone 6 or warmer—that is, where winter minimums don't get much below $-10°F$—sow your meadow mixture in September. If you live in Zone 5 or colder, sow the seed in late fall when the ground is icing up, so that it undergoes winter's deep freeze, which some species need for proper germination. If you live in a cold-winter zone and are planting a mix that doesn't need a period of stratification, as the freezing treatment is called, let the ground sit mulched over the winter, then plant the seed in the spring as soon as the soil surface thaws. (Check with the seed company to find out if your mix needs a cold treatment.)

As little as 5 to as much as 20 pounds of seed sows an acre, depending on the mix, so about $1/4$ to $1/2$ pound will sow 1,000 square feet. Mix the seed thoroughly with a couple of buckets of peat moss or sawdust. This makes it easier to spread seed evenly over the surface. Remove the mulch, then sow half your mixture while walking up and down the plot in one direction, then sow the other half walking up and down perpendicular to the first direction. Toss the peat moss and seed mixture with sweeping motions of your hand, getting it as even as you can.

Scratch the seed into the soil with a bamboo or flexible-tined rake, but don't dig deeply. Just rough up the surface. Then roll it with a water-filled lawn roller to press the seed into the soil. If the area is small, stamp it down with your feet or lay a flat board on the surface and stand on it, then move the board until the whole plot is pressed flat. Wet the area thor-

oughly and cover it with a light mulch of weed-free material, such as dry, weed-free straw. This light mulch should just cover the soil, with some bare spots. You don't want to bury the seed, just protect it from direct sun and hungry birds.

CONTINUING CARE

If you've chosen a mix that's adapted to your conditions, your meadow shouldn't need a lot of coddling. However, when the seedlings germinate, it's important to give them a hand. If rains keep the soil slightly moist, you're in good shape. But if it's clear and the soil's drying out, water the area every day—even twice a day during hot, dry spells—but don't allow water to stand in puddles. If you let the sprouted seedlings dry out between waterings, they'll die; if you drown them, they'll also die. You're looking for the happy medium—keeping them constantly moist but not soaking wet.

Once you see the first leaves of the seedlings, water when the surface is dry. When the plants reach 4 to 6 inches tall, water only when the surface soil is dry down to 1 inch. When the plants are a foot or more in height, water only when the soil dries down 2 inches. Water thoroughly and deeply to encourage roots to stay deep. Watering no deeper than the soil surface encourages roots to stay shallow. Then, when you're away and that layer dries out, your shallow-rooted plants can't reach the moisture deep in the soil. They'll bite the dust—literally.

Fall-sown annuals and perennials will germinate and winter over as small plants in the milder zones, then make new growth in the spring. Spring-sown mixtures will bloom a bit later, but the earliest annuals should still be blooming by June.

In this first year, annuals will provide all the color. In subsequent years, the perennials will begin to bloom, augmented by annuals that reseed themselves. Each fall or winter, starting in the first year, mow the meadow with the blade set at about 6 inches. This mowing will keep woody invaders like young trees in check, but won't harm the crowns of perennials. Mow only after a killing frost has browned the summer's stalks and foliage. By then, the seeds of self-sowing annuals and perennials will be ripe. Mowing scatters the seed and covers it with chopped-up vegetation. Many people like to wait until late winter to mow, so they can enjoy the ornamental seed stalks and golden grasses through the dreary months. The birds enjoy them, too.

It will take three years for the perennials to size up and compete successfully with the weeds. Over this time, the plant population in your meadow will change. Certain annuals will not reseed themselves. Some of the perennials in the mix will die out. But those that naturalize will live happily ever after if you keep the weeds away, and divide and renew them every three years or so for best bloom.

Get in the habit of pulling weeds from your meadow whenever you visit it. Even if you solarize, you'll be pulling them out regularly in the first two or three seasons. It takes that long for the perennial plants in your mix to grow root systems big and strong enough to gain control of a piece of ground and crowd out any weeds that might sprout there. Even when your

meadow is mature, you should patrol it regularly with a weather eye out for such vigorous menaces as thistles. Wear sturdy gloves and pull and/or trowel out these invidious "space invaders" as soon as you see them. It's an ongoing process that becomes easier with time. Possession is nine-tenths of the law in the garden, and weeds can't grow in a spot already occupied by a mature perennial.

PLUGGING IN PLANTS

The initial sowing is just the beginning of your meadow. You can adjust the plant mix over the years to create just the look and have the colors you want. One way is to buy started wildflower plants from reputable nurseries, or grow your own. Plug these started plants into places that look bare. Scratch up patches here and there in the spring, and plant more annuals from time to time. Renew the mulch so weeds never get a chance to take over the meadow. You'll find that grass is your worst enemy, especially orchard grass and quackgrass. Even soil prepared by

solarization will eventually be recolonized by grasses unless you persistently weed them out.

Experiment with new plants to see how they do. Ruthlessly pull out plants you don't like. Keep the meadow small and manageable, and you'll be pleased with the results. If things go well and your meadow mixture seems well adapted to the site, add new areas of meadow year by year, so that it finally expands to cover that formerly rank acre.

Add some ornamental shrubs or fruit trees to parts of your meadow in scattered clumps and groupings for a natural look. A group of blueberry bushes makes a pretty—and delicious—place to visit on your meadow tours. Also try black and red currants and gooseberries. Grow a patch of blackberries or raspberries to look like the wild berry patches that colonize old fields. Tuck strawberry plants down among the perennials. The meadow mix is a diverse ecosystem, harboring a rich mix of birds and many beneficial insects.

The end result of your meadow gardening will probably astound you. Some of the most beautiful places I've ever seen have been meadows filled with the sparkling colors of wildflowers.

WILDLIFE AND WATER IN THE NATURAL GARDEN

ATTRACTING WILDLIFE TO YOUR GARDEN

Wild creatures are symbols of the great web of nature at work, just as our natural landscaping is symbolic of the wild place that inspired it. The natural landscape is meant for visits from the animals, and if we've done our job well, perhaps they'll feel at home there.

Any kind of landscaping affects the mix of animals that are drawn there. Even a routine landscape of grass lawn edged with evergreen plantings attracts wild species that prosper in such a habitat—robins, Japanese beetles, and mice, for instance. An extensively developed natural landscape might favor a different group —such as bluebirds, tree frogs, tiger swallowtails, and chipmunks.

We'd be thrilled to see some of these animals if they came to visit. Who doesn't love the whistling call of the bobwhite or the sight of an indigo bunting? Others, like woodchucks, are decidedly unwelcome in the garden.

But no matter how we feel about the animals that visit us, we must realize that all animals have an important place in the natural community. Any landscape we design will be attractive to an assortment of animals, some more beautiful or lovable than others. While we have our preferences, Nature welcomes all. We need to learn to attract the ones we like and live with the ones Nature sends along as their companions.

In this chapter, we'll list animals that homeowners might want to attract because of the

beauty of their graceful movements, their song, coloring, form, or contribution to the garden's ecology. Obviously, there are thousands of insects, amphibians, reptiles, birds, and mammals that you might encounter at home, so the list is very selective. The animals listed here will be fairly common in a variety of settings—suburban, urban, or rural. They'll be the ones most people enjoy seeing.

CREATE A BACKYARD WILDLIFE HABITAT

The National Wildlife Federation has been encouraging property owners to create backyard wildlife habitats by providing information on how we can care for wildlife's needs at home. The Federation sells a "Gardening with Wildlife Kit" that includes a book on planting an oasis for wildlife—including plants for every region of the country, plus sample plans and tools you can use to plot out your own natural wildlife oasis, a guide to attracting and feeding birds, and a journal for you to take notes and records of wildlife observations.

The federation also will certify backyard wildlife habitats. About 6,000 American backyards already qualify for certification under this program. The purpose of the program is to counteract the destruction of wildlife habitat by land development by making sure properties in developments include habitat. About 1,000 new properties are being added each year, and the number is rising. New York, Pennsylvania, and California are the three leading states in terms of interest, but backyard wildlife habitats are certified in all 50 states.

Backyard wildlife habitats provide adequate food, water, and shelter for a variety of animals.

Most certified backyards are ¼- or ½-acre plots, but one in Kansas is 235 acres. "Backyard habitats aren't meant to replace the National Wildlife Refuge System," says federation Program Coordinator Antoinette Pepin, "but they are meant to recognize homeowners with an awareness, a sense of stewardship in providing habitat. It also carries a sense of congratulation and acknowledgement for their efforts."

YOUR OWN WILDLIFE HABITAT

Landscaping with nature reproduces the look and appeal of various natural wildlife habitats in the backyard, and thus fulfills part of the federation's goal of creating little pockets ("oases") of refuge for animals at home. Wildlife has four requirements in order to make an ecological living on our properties: food, cover, water, and a place to raise young. When making excursions into nature to gather ideas for home gardens, jot down these four factors and keep an eye open for them in the landscape.

When you find a place of great natural beauty you'd like to reproduce at home, see which of these factors are present for the range of animals. Are there food sources? Is there water? Is there cover and shelter where animals can raise young without disturbance? When actually designing the space at home, keep the needs of wildlife in mind. Although bushes with berries for birds may not have grown in the place of wild inspiration, perhaps you can mix a few, like autumn olive (*Elaeagnus umbellata*) and barberry (*Berberis* spp.), into the landscape. If there was no water in the wild place, you might decide to install a natural pool just so animals are attracted.

AN INSPIRED BACKYARD HABITAT

Elinor and Roger Eddy have been gardening on a quarter-acre near Milwaukee since 1960. They have planted over 300 trees and shrubs there, including both ornamentals and plants that produce an abundance of fruit and nuts for wildlife. A few years ago, they created a miniature meadow on a small portion of their property, and today, 35 species of native prairie plants and other species thrive there.

Now they've noticed that wildlife is moving into their garden, including many types of birds such as cardinals, goldfinches, mallards, and pheasants. Because they have created natural habitat, nature is populating their quarter-acre with as rich a variety of wildlife as many more remote acres. Their yard is becoming a more and more natural place, where their input is lessened and nature's is increased.

Your natural landscape need not—probably should not—be designed primarily for wildlife. It should be designed to delight you and for your enjoyment. But it can be detailed and finished in ways that make it attractive to wildlife. A diverse landscape that includes food, cover, and water will attract the most species of animal. The ideal habitat would probably be a diverse mixture of woods, open meadow, fencerows, and wetlands.

Write to the National Wildlife Federation, 1412 Sixteenth Street NW, Washington, DC 20036-2266, for its kit, and when you finish landscaping with nature, apply for certification. It's the kind of intelligent, ecologically sensitive approach that needs support from organic gardeners and nature-lovers across the country.

ORGANIC GARDENING FAVORS WILDLIFE

Speaking of organic gardening, it is the technique of choice when planning a natural garden that doubles as wildlife habitat. It's cruel to lure birds and insects and mammals to your property and then use herbicides, fungicides, pesticides, and other chemicals that can poison and destroy them. The organic garden's cycle of growth, decay, and regeneration is the cycle of nature recreated in the backyard.

The heart of the organic cycle is the compost pile. This mass of decaying plant material provides food for many animals and shelter for some. Its end product—compost—is just what you need to fertilize ornamental plants and condition the soil. Try to include a shady, moist place for a compost pile or two or three. (Once you start making and using compost, you'll probably find that there's never enough.)

If you're composting and want to attract wildlife, you'll want the pile to compost slowly. The decay processes will proceed faster or slower depending on the amount of nitrogen you put in the pile. Manures, for instance, are rich in nitrogen and speed the process up so that it's possible to make compost in a month or less. Lots of carbon-rich materials like leaves and weeds, without the addition of manure, will

take about a year to decay. The slow-decay piles offer the most food for animals. Earthworms breed in the piles, so when you add compost to your garden, you'll add earthworms and enrich the soil. Beneficial beetles breed and take cover in these piles. Compost piles are sources of edible fungi for many creatures.

FOOD, COVER, AND WATER

Plants—alive and dead—provide food and cover in the natural landscape. Fortunately, many of the plants that attract animals to the garden are those we'd choose to plant. And, as we'll see, water for wildlife needn't be anything grand.

FOOD SOURCES

Wildflowers are a source of food that suits a range of animals. They are usually nectar-rich and attract insects and birds. Seeds and fruit that follow also bring birds and small mammals to feed.

Bright flower colors attract two garden favorites—hummingbirds and butterflies. Hummingbirds like bright red and orange flowers, like beebalm (*Monarda didyma*) and trumpet vine (*Campsis radicans*), while butterflies seem to like purple, pink, and yellow, in medium to pastel shades rather than dark colors. Favored butterfly flowers in these colors include cosmos (*Cosmos bipinnata* and *C. sulphureus*), perennial asters (*Aster* spp.), phlox (*Phlox* spp.), stonecrop (*Sedum* spp.), verbenas (*Verbena* × *hybrida*), and zinnias (*Zinnia elegans*). Butterflies prefer flat, single rather than double flowers.

And they like to sip from flowers in full sun rather than shade.

Trees and shrubs that produce nuts and berries are food sources for birds and small mammals. (For a selection of choice berry-producing trees and shrubs, see page 72.) Grasses and thick vines usually have abundant amounts of seed, and they provide nesting materials. Pollen plants like alfalfa and buckwheat will bring lots of bees and other insects to enrich a backyard planting.

PROVIDING COVER

Cover can mean lots of things for wildlife, but among the chief sources are brush piles, dead trees, hollow logs, thick stands of brambles, masses of small, dense shrubs (including evergreens like hollies), medium-size shrubs and small trees, and tall canopy trees. Vines grown up trees or on walls also shelter many animals and give birds places to nest.

WATER FOR WILDLIFE

Water can be something as simple as a birdbath, or as complex as a garden pool with a waterfall. If you opt for a small birdbath or other small container of still water, dump the water and rinse the birdbath out with the garden hose, refilling with fresh water every other day or so. Scrub the birdbath out with a wire brush periodically. This will keep the drinking water clean for small animals and birds. The cleaning procedure has to be done regularly or mosquito larvae and pond scum will proliferate, and bird droppings will contaminate the water with whatever diseases the birds carry. For more on "natural" birdbaths, see page 294.

There are other easy ways to add water for wildlife. Half-barrels filled with water and sunk into the ground also are a simple way to get water into the backyard garden, but make sure to keep a pair of goldfish in all such miniature "ponds" to eat mosquito larvae. Even making a puddle with the hose can provide a summertime drink for thirsty creatures.

WILDLIFE FOR THE NATURAL LANDSCAPE

The following categories of wildlife include only beneficial or nondisruptive species. Most are old favorites—and rightfully so, for they are beautiful and useful inhabitants of any natural landscape.

BIRDS IN THE BACKYARD

Our purpose is to create a garden based on a beautiful place in wild nature. Such wild places don't have squirrel-proof bird feeders, birdbaths, and gingerbread birdhouses. And yet, they have birds.

Our task is to do what's necessary to attract birds, but to make it look natural.

Providing Water

First, forget the traditional clay birdbath or even the fancy ones shaped like large scallop shells. Keep your eyes open for a rock with a shallow depression on top that will function as a birdbath. Several garden catalogs now carry birdbaths that look like a giant granite pebble with a depression in one side; if you can't find a real rock, these are handsome, natural-looking alternatives.

I've noticed that many birds flock to rainwater puddles in wheel ruts in dirt driveways. This morning, several ruts in my driveway were filled by an overnight rain and more than a dozen fat sparrows took turns fluttering joyfully in the water. In creating the natural garden, consider making a small, shallow pond formed from a mixture of cement and clay that you can fill with the garden hose from time to time and that functions as a birdbath in the ground. Give it a low lip where birds can perch as they drink. Keep the water in any birdbath fresh.

Place it in an open area where the birds can see who's sneaking up on them. If you'll notice, birds are always on the lookout. The birds in my driveway rut are taking turns bathing and standing guard duty. They fly up to the tree limbs above the rut and keep watch for a spell, then fly down and trade places with bathing birds.

Feeding the Birds

The best way to feed birds in the natural landscape is by planting trees, shrubs, and herba-

Many familiar trees, shrubs, vines, and flowers will draw birds into your yard for food, nesting, and shelter. Popular backyard birds you might attract, with typical food plants, include: (1) black-capped chickadee, (2) blue jay, (3) red-breasted nuthatch, (4) ruby-throated hummingbird, (5) tufted titmouse, (6) white pine (*Pinus strobus*), (7) flowering dogwood (*Cornus florida*), (8) red oak (*Quercus rubra*), (9) sunflowers (*Helianthus annuus*), (10) rugosa rose (*Rosa rugosa*), (11) smooth sumac (*Rhus glabra*), (12) elderberry (*Sambucus canadensis*), and (13) bee balm (*Monarda didyma*).

ceous plants that provide food (see the opposite page). But in the winter, it's fun and humane to give birds some extra help finding food.

Make "bird cake" using ½ pound of suet or lard to each pound of birdseed, add bits of dried fruit, some chunky peanut butter, bread crumbs, and so forth. Melt the suet or lard and mix it with the dry ingredients in a bowl. When it hardens, take a sturdy spatula or knife and slather it into the cracks in pine tree bark or other bark; pack it into holes in tree trunks where limbs have rotted away, and find other places accessible to birds that don't involve formal feeding stations.

Giving Birds a Home

Similarly, the best birdhouses in the natural landscape are those that are natural—holes in dead trees, weathered fence posts, coconut shells, pieces of sturdy bark tacked to tree trunks with spaces underneath for nesting. If you must use nesting boxes, camouflage them with mosses, lichens, twigs, and bark.

Landscaping for Birds

When selecting plants for the natural landscape, choose those favored by birds whenever possible. As a category, native plants provide the best living for native birds—they've evolved together. Don't remove well-established trees unless you must, for these are the backbone of your landscape and contain nesting sites and hordes of bugs for the birds to nibble. An exception might be the relatively useless (to birds) maples or sterile ornamentals like rhododendrons that don't set seed or harbor insects.

Oaks are probably the best native trees because of the hundreds of species of insect that make their living on them, and make food for the birds. Their acorns are also food for wood ducks, jays, and pigeons. Willows, whether weeping or of other species, also harbor hundreds of different kinds of insect and are valuable for birds because of it. To this list add poplars and birch—both harboring over 100 species of insect. Birches additionally have catkins, curious-looking cylindrical flower spikes named for their resemblance to little cat's tails, that attract redpolls and other small birds.

Another consideration for birds is their need for patches of bare soil to scratch for insects and tiny pebbles for their crops. In designing gardens based on nature, look for naturally occurring bare patches, perhaps in the duff under dense shrubs and trees, and make sure you include them in your design in the proper proportions.

Probably the greatest boon to birds is a fence row or wild thicket overgrown with a rich and heady mixture of wild roses, hawthorn, brambles like blackberries, sassafras, poison ivy, sumac, wild grapes, wild filberts, chokecherries, greenbriar, pokeweed, and other seed-bearing weeds. In my years in the country in Pennsylvania, I became intimately familiar with these because of my love of wild grapes. I spent many hours tucked away deep inside these bowers, savoring the wild grapes and watching hundreds of birds that also came to forage there.

A reminder: If you're going to attract birds to your property, it's only fair to bell your cats. Explain what you're doing to your cat-owning neighbors and ask them to bell their cats, too.

BEST TREES AND SHRUBS FOR BIRDS

By planting trees and shrubs that provide food, cover, and nest sites for birds, you can draw more species to your yard. If you add some of these desirable plants to your landscape, birds will quickly find them. Some of the best food trees and shrubs for birds include:

TREES

- Alders (*Alnus* spp.) attract chickadees, warblers, redpolls, and other small birds. These trees like the edges of lakes and streams.
- Ashes (*Fraxinus* spp.) have aerodynamic, single-winged seeds that are produced in abundance and feed many seed-eaters. Ashes are deciduous, hardwood trees that can reach 60 feet with a large, open, spreading habit.
- Beeches (*Fagus* spp.) drop their nutritious little nuts, attracting woods-dwellers like grouse, wood ducks, and wild turkeys, as well as seed-eaters like evening grosbeaks. These deciduous trees eventually grow into large (up to 100 feet) specimens.
- Cherries (*Prunus* spp.), including wild, pie, and sweet cherries, have interesting bark, grow 20 to 50 feet tall, and are deciduous. Cherry orcharding really comes down to who gets the fruit, the orchardist or the birds? In the natural landscape, we can plant cherries specifically for birds.
- Chokecherries (*Prunus virginiana*) attract lots of insects and produce fruit that birds devour. They are usually found wild in the fencerows and old fields of the mid-Atlantic states and transplant easily when small. These deciduous wild cherries are 25 to 30 feet tall.
- Crabapples (*Malus* spp.) also have fruit that's much more attractive to birds than people—unless you're fond of crabapple jelly. Crabapples can be 12 to 40 feet tall with highly ornamental white, pink, or rose flowers, showy red, orange-red, purplish, or yellow fruit, and green or bronze-purple leaves. Many fine cultivars are available.
- Hawthorn trees (*Crataegus* spp.) produce red winter berries for a wide range of birds. They also have showy flowers and prominent thorns. These deciduous trees can reach 30 feet tall.
- Hollies (*Ilex* spp.) offer berries in winter, nesting sites in spring, and the evergreen species give good, dense cover all year. There are deciduous as well as evergreen hollies, and many hollies are shrubby, though the evergreen American holly (*I. opaca*) can reach 50 feet tall.
- Larches (*Larix* spp.) harbor insects and make good nesting trees for birds. These beautiful trees have needles and cones, but are deciduous, turning a handsome reddish brown before dropping their needles in fall. They need coddling, requiring an acid soil and constant moisture to thrive. Where they are happy, they will eventually reach 90 feet.
- Mountain ashes or rowans (*Sorbus* spp.) produce clusters of bright berries that don't last long when birds are around. They grow 20 to 30 feet tall and are deciduous.

(continued)

BEST TREES AND SHRUBS FOR BIRDS – *Continued*

TREES – *continued*

- Mulberries (*Morus* spp.) make prolific amounts of fruit that not many humans are fond of, but that birds just love. These deciduous trees can reach 60 feet. Don't plant them near the house, driveway, or heavily trafficked areas: Their fruit is extremely messy.
- Pines (*Pinus* spp.) produce lots of edible seed, and their bark harbors insects for birds to pry out. Pines can also be very useful structural elements when designing natural landscapes, because of their density and because they are so frequently a part of wild scenes. These handsome evergreens range in height from the dwarf mugho pine (*P. mugo* var. *mugo*), which eventually reaches 8 feet, to the giant sugar pine (*P. lambertiana*), which may reach 200 feet. Match your choices to the size of your property.
- Russian olive (*Elaeagnus angustifolia*) is one of the best bird plants. It grows to 15 or 20 feet tall and produces reliable crops of berries that look like small olives. These berries are used as a food source by many birds as the days lengthen into winter. It takes any kind of punishment from winds, droughts, and deep freezes. It's superb in the landscape as a neutral background plant or thicket, and as such, makes good cover and provides plenty of nesting sites for birds.
- Serviceberries (*Amelanchier* spp.) are pretty, with tasty fruit, but you'll have to battle the birds for it. These graceful, small trees (25 to 35 feet tall) are covered with clouds of white to pinkish flowers in spring and red to purple fruit in summer. They have good fall color, too.

SHRUBS

- Barberry bushes (*Berberis* spp.) are prolific producers of hanging reddish fruit that sustains birds through the winter. There are many species and cultivars, some evergreen and some deciduous, ranging from 2 to 8 feet tall. Japanese barberry (*B. thunbergii*) has cultivars with purple and yellow leaves and gorgeous scarlet fall color. They make good dense cover and shelter for small birds. Be careful to root them out if they self-seed all over your property.
- Cotoneasters (*Cotoneaster* spp.) produce red berries and make dense cover. Some of the best for these purposes are *C. simonsii, C.* × *watereri,* and rockspray cotoneaster (*C. horizontalis*). The cotoneasters, like the barberries, can be deciduous, evergreen, or semi-evergreen, depending on the species, and range from 1 to 12 feet tall.
- Elderberries (*Sambucus* spp.) have leaves and flowers that attract insects and juicy fruit that attracts a whole range of small birds. They are clump-forming, short-lived plants with soft, woody stems that reach 15 feet.
- Hazelnuts or filberts (*Corylus* spp.) give good cover and nuts in the fall, if the squirrels and gardeners don't get them first. These deciduous, clump-forming shrubs reach 20 to 25 feet. They'll produce the best nut crop if you let them sucker freely.

- Pyracantha or scarlet firethorn (*Pyracantha coccinea*) is a showy evergreen shrub to 15 feet tall. Pyracantha produces masses of orange to scarlet winter berries that birds love. It is also especially striking espaliered against a wall.
- Quince bushes (*Chaenomeles* spp.) are favored by many small birds for their dense cover. These deciduous shrubs reach 3 to 10 feet and produce a profusion of beautiful, 1- to 2-inch, red, scarlet, rose, pink, or white flowers in spring, followed by golden fruit that makes fine jelly.
- Viburnums (*Viburnum* spp.) of many types produce lots of berries for the birds. They are showy in flower, and the fragrant species can perfume a path. Some are evergreen and some deciduous, depending on the species, with a height range of 4 to 30 feet. Flowers are white to pinkish, followed by handsome red, blue, or bluish black berries.
- Woody vines like climbing roses (*Rosa* spp.), honeysuckle (*Lonicera* spp.), and especially English ivy (*Hedera helix*) are also good choices for birds. Roses provide edible red fruit, called hips, and honeysuckle has masses of red or purple fruit. Both also produce gorgeous, fragrant flowers for the yard and house. Sparrows, house finches, and cardinals all like to nest in ivy, which also harbors insects.

FLOWERS FOR THE BIRDS

Herbaceous wildflowers, perennials, and weeds that provide food for birds include:

Asters (*Aster* spp., *Callistephus* spp.)
Aubretias (*Aubretia* spp.)
Balsam (*Impatiens balsamina*)
California poppy
 (*Eschscholzia californica*)
Candytufts (*Iberis* spp.)
Clarkias (*Clarkia* spp.)
Cornflower, bachelor's-button
 (*Centaurea cyanus*)
Dame's-rocket (*Hesperis matronalis*)
Delphiniums (*Dephinium* spp.)
Docks (*Rumex* spp.)
Evening primrose (*Oenothera biennis*)
Foxgloves (*Digitalis* spp.)
Hebes (*Hebe* spp.)
Lavenders (*Lavandula* spp.)
Lobelias (*Lobelia* spp.)

Lunarias (*Lunaria* spp.)
Mignonettes (*Reseda* spp.)
Oreganos (*Origanum* spp.)
Ornamental grasses
 (numerous genera
 in the Gramineae family)
Phlox (*Phlox* spp.)
Poppies (*Papaver* spp.)
Primroses (*Primula* spp.)
Scabious (*Scabiosa* spp.)
Snapdragon (*Antirrhinum majus*)
Stocks (*Matthiola* spp.)
Sunflowers (*Helianthus* spp.)
Thymes (*Thymus* spp.)
Valerians (*Valeriana* spp.)
Wallflower (*Cheiranthus cheiri*)
Woodsorrels (*Oxalis* spp.)

MAMMALS

Natural areas usually provide habitat for some mammals, and our backyard landscapes are no exception. Some mammals are more welcome than others—the sight of cuddly bunnies chasing each other around the yard suits most of us better than an unexpected encounter with a skunk in the driveway or an opossum in the trash can. But even pest species like the graceful deer, the clever raccoon, and the bearlike groundhog are fun to watch, even as we try to keep them out of our gardens. Here are some mammals almost all of us would be pleased to share our yards with.

Squirrels and Chipmunks

Gray, red, and flying squirrels, and chipmunks, their ground-dwelling relatives, all make their living from pine cones, acorns, hickory nuts, walnuts, hazelnuts, beech mast, and other seed-bearing and nut trees. To the sorrow of homeowners, squirrels also eat bulbs, buds, and sometimes bark—and of course, if there's any way to get to the feeder, they love to gorge on birdseed. Red squirrels additionally eat a wide variety of food, from birds' eggs to mushrooms. Squirrels' rowdy behavior and occasional bad eating habits make them unwelcome in some yards, but their cheerful antics and cleverness make up for their few drawbacks. We think their liveliness adds a lot to our landscape.

Gray squirrels (*Sciurius carolinensis*) are much more common than red squirrels in suburbs and parks and will come to inhabit any woodsy, shrubby areas where they can collect nuts. They are amazing aerialists, and watching one frolic at the end of a bobbing, pendulous branch is always great fun. Grays raise their litters in holes in trees and in late-summer nests made of leaves and twigs out toward the end of branches. Breeding season occurs twice a year, bringing on a burst of fights, chases, and noise. Males play no part in raising the young, which average three per litter.

Red squirrels (*Tamiasciurus hudsonicus*) are noisier than grays. Their rapid, loud, chittering calls fill the northern woods from Maine to Minnesota down through the Appalachians, and again in the Rockies. These squirrels are active at dawn and dusk. They spend their summers cutting down pine cones and storing them for winter use. Red squirrels are an important source of food for birds of prey.

Flying squirrels (*Glaucomys volans*) are fairly common in the entire eastern United States, but they are nocturnal, so most people never get to see one "fly." (They don't actually fly, but glide—ordinarily 20 to 30 feet—downward from tree to tree, using wide flaps of skin along their sides as "wings.") If you are lucky enough to see one of these pretty squirrels in flight, you'll note that they immediately scurry to the far side of any tree they land on, just in case an owl is watching.

Chipmunks are ground-dwelling squirrels that make extensive tunnels, laid out along the lines of the hobbit-holes in J. R. R. Tolkien's *The Hobbit.* They have a storage chamber that can hold up to a half-bushel of nuts and other food, plus sleeping rooms, a latrine, and a dump. The tunnels, which can extend up to 12 feet, have several concealed entrances. The eastern chipmunk (*Tamias striatus*) is striped red and brown. The least chipmunk (*Eutamias minimus*),

the most common of about a dozen western species, is grayer than the eastern chipmunk. All chipmunks hibernate in winter, although the eastern chipmunk wakes frequently to feed.

Cottontail Rabbits

Although cottontails (*Sylvilagus floridanus*) can be a nuisance in the garden, their presence in a natural landscape is usually welcome and insures food for predators like foxes. Cottontail rabbits like brushy areas, briar patches (of course), the boundaries between forests and meadows, and low, swampy areas. They also like to nest in rough lawn areas. If your property has any of these habitats, you'll undoubtedly have rabbits.

Deer

Like rabbits, deer can be real pests when they browse on your carefully selected plants. But they are also beautiful in any landscape, appearing like apparitions in the morning mists and the dimming dusk. Open, rural areas with a mixture of woods, swamps, brushy areas, farmland, and yards favor these graceful creatures. In the East, the common deer is the whitetail deer (*Odocoileus virginianus*), and in the West, the mule deer (*O. hemionus*), slightly smaller and more compact than its eastern cousin. The mule deer is named for its large, mulelike ears.

Deer like to browse on the buds and tender tips of woody plants like shrubs and fruit trees, and they can wreak havoc with expensive woody ornamentals, as well as with preferred perennials like hostas and asters. Commercial deer repellents are now readily available. The most effective,

Big Game Repellent (also sold as Deer Away), is made from a minute quantity of rotten egg in water—you can't smell it, but deer can. You can make your own egg-based repellent by mixing 12 to 18 eggs (note: fresh eggs are fine) in 5 gallons of water and spraying on vulnerable plants. Reapply after heavy rains.

Other Animal Visitors

Opportunistic mammals like mice, raccoons, skunks, mink, opossums, porcupines, groundhogs (also called woodchucks) and such are not ordinarily the kind of fauna people want to attract to their gardens—they just show up unbidden to rattle the garbage cans, burrow under the porch foundation, or spray the dog. Often, a dog or two can help cut down on these visits. Dogs keep large mammals like deer out of the garden, warning them away with their bark or their scent. Some will even kill groundhogs and rabbits. Cats occasionally help, too, keeping down the population of mice and moles, though they're not reliable predators since they tend to kill for sport rather than food. Cats aren't selective, either—they're as likely to kill birds and butterflies as undesirable rodents. Make sure your pets' rabies inoculations are up-to-date if you let them patrol the yard!

Obviously, most of the mammals that inhabit your region would do best on your property if it were not improved at all, but allowed to return to nature. They are usually in competition with humans for space and food, which is why so many mammals are considered pests. Mammals are quite capable of finding your property on their own and usually need no encouragement.

INSECTS

Most of the time, we're only vaguely aware of the insects around us. But if you spend a quiet hour in the wild or the garden looking for insects— noticing what's flying, what's crawling, what's under rocks and between grass blades— you'll see a marvelous world populated with dozens and dozens of these distinctive creatures. And you'll discover, perhaps for the first time, how truly beautiful many insects are.

Insects' place in any natural landscape is large and important. They pollinate flowers, break down decaying vegetation, attack weak plants, and otherwise manage the land and its resources. We can learn much about our own role in nature by observing the ways in which insects and plants interact. You should scrupulously avoid using pesticides and other poisons, for they tear apart the intricate web of garden life and substitute the simplistic "Terminator" approach to landscape management: Kill everything that moves, just in case. When you landscape with nature, you use appropriate species-specific controls, and only use them when a pest's damage level is unacceptable. Often, handpicking is enough.

Let's look at some attractive garden insects in more detail.

Butterflies

The key to attracting this beautiful group of insects is to provide them with the specific plants on which they lay their eggs. More than most insects, butterflies have an extremely close association with certain plants—so much so that many species are only found in areas where these host plants grow. If you put butterfly eggs on a nonhost plant, the hatchlings won't eat and will starve to death. For example, the caterpillars of monarch butterflies (*Danaus plexippus*) must have milkweed plants (*Asclepias* spp.), their sole food source, to feed on.

Butterfly larvae are caterpillars, and therefore, if you want butterflies, you're going to have to tolerate the presence of caterpillars. Most do minimal damage. And, if you look at them closely, they're often as beautiful as butterflies in their own way.

No environmentally conscious person would use pesticides to kill a few caterpillars. The only time caterpillars are cause for concern is if they are of a species that you know is a pest, such as the tent caterpillars (*Malacosoma americana*), which can defoliate a cherry tree almost overnight, or the gypsy moth caterpillars (*Lymantria dispar*), which have wrought such devastation in the eastern forests. If you're a vegetable gardener, you'll want to keep an eye out for pest caterpillars like the tomato hornworm (*Manduca quinquemaculata*) and the imported cabbageworm (*Pieris rapae*).

If you find these pests, you can always control them with nonpoisonous techniques. Hornworms can be handpicked; Bt (*Bacillus thuringiensis*), now readily available at garden centers and in catalogs, will take care of cabbageworms. But be aware that Bt will kill *all* caterpillars on plants where it is applied and must be used with care, even if it is an organic control. I've kept tent caterpillars completely out of the trees on 5 acres simply by taking a long stick along on my frequent walks around the property. I swirl the stick in the nest and bring it down to the ground, then finish the job with

my boot heel. Caterpillars left on the tree don't seem to do much harm. If you find great numbers of gypsy moth caterpillars on your trees, call your local extension agent—many states have Bt spray programs.

After pupating in an often beautiful, always fascinating chrysalis, caterpillars turn into adult butterflies. Interestingly, adults don't always favor the same plants they liked as caterpillars. In their adult form, they eat nectar rather than foliage, so they prefer nectar-rich plants like spearmint (*Mentha spicata*), lantana (*Lantana camara*), and even good old marigolds (*Tagetes* spp.).

This means that in our efforts to attract butterflies to the backyard, we need to plant both caterpillar favorites and nectar plants for the adults. In addition, we should provide a source of moisture, from a simple mud puddle to the bank of a pond or stream. Butterflies don't drink water like birds and mammals, but they do take up minerals and nutrients from the

It's easy to attract beautiful butterflies to your yard if you plant or encourage the wildflowers they prefer. Don't forget to include plants for the caterpillars to feed on. Shown here: (1) mourning cloak, (2) monarch, (3) monarch caterpillar, (4) black swallowtail, (5) black swallowtail caterpillar, (6) tiger swallowtail, (7) common milkweed (*Asclepias syriaca*), (8) red clover (*Trifolium pratense*), and (9) Queen-Anne's-lace (*Daucus carota*).

moist soil near a water source. You can add to your landscape's attractiveness to butterflies even more by using licorice root mulch (a great but expensive attractant sometimes available at garden centers), putting out rotting fruit (but not too close to the door—it can also draw yellow jackets), and providing light-colored stones for sunning.

Scientists have found that a 1-acre backyard wildlife sanctuary is not large enough to maintain a resident population of many different butterflies. Dennis Owen, a British entomologist, found that only three species of small butterfly bred in his intensely managed ¼-acre suburban backyard. But another 13 species used it as a temporary home, and in five years, he captured, marked, and released 9,000 butterflies.

The table on the opposite page shows butterflies common to many areas east of the Rockies, as well as some parts of the West Coast. It lists the plants their caterpillars feed on and plants that the adults like. Orange-eye butterfly bush (*Buddleia davidii*), the related fountain buddleia (*B. alternifolia*), and the milkweeds (*Asclepias* spp.) will most strongly attract desirable species of butterfly. The buddleias have the added advantage of being absolutely stunning landscape plants with gorgeous flowers.

There are many more butterflies than are listed in this table, of course—the checkered skippers (*Pyrgus* spp.), hairstreaks (*Strymon* spp.), coppers (*Lycaena* spp.), blues (*Plebeius* spp.), and sulfurs (*Colias* spp.) among them. If, however, you make your natural landscape hospitable to the species listed in the table, you'll induce other species to venture in.

Moths

There are some beautiful moths that we can appreciate on the wing but not in their larval stage in the garden. The large hawk moth (*Manduca sexta*), a symphony of grays and browns, is the tobacco hornworm—close kin to our old friend, the tomato hornworm—in adult form. The spectacular luna moth (*Actias luna*), with its sea green wings, and the richly colored cecropia moth (*Platysamia cecropia*) both are common denizens of the eastern woodlands and mature landscapes.

Moths are inconspicuous by day, and unless there's a bright light left on outside at night, hard to spot even when they're active. Adult moths ordinarily do without food their entire lives. Their caterpillars act pretty much like those of butterflies, and are attracted by diverse plantings of trees, shrubs, and wildflowers.

Beetles

Two types of beetle are beloved by children (and by the adults the children eventually become). The first is the firefly, or lightning bug (*Photuris pennsylvanica*), which especially favors meadows and lawns that border brushy or woodsy areas. The other is the ladybug or ladybird beetle (*Hippodamia convergens*), which we gardeners have come to know as a prolific aphid eater.

You can help ladybugs feel at home by allowing aphid infestations to take their course, unless they are destroying some favored plants. The 'Gravenstein' apple tree that stands just outside my front door had a wicked aphid infestation on its branch tips last spring. I let it go, and within a few weeks, the aphids had

BACKYARD BUTTERFLIES AND THEIR PREFERRED FOODS

Species	Caterpillar Food Plants	Adult Food Plants	On the Wing
Baltimore (*Euphydryas phaeton*)	Turtlehead (*Chelone glabra*) Plantain (*Plantago lanceolata*)	Milkweeds (*Asclepias* spp.)	May–July
Eastern black swallowtail (*Papilio polyxenes*)	Wild carrot (*Daucus carota* var. *carota*) Rue (*Ruta graveolens*)	Red clover (*Trifolium pratense*)	Late spring–early fall
Great spangled fritillary (*Speyeria cybele*)	Violets (*Viola* spp.)	Thistles (*Cirsium* spp.) Black-eyed Susan (*Rudbeckia hirta*)	June–mid-September
Monarch (*Danaus plexippus*)	Dogbanes (*Apocynum* spp.) Milkweeds (*Asclepias* spp.)	Goldenrods (*Solidago* spp.) Milkweeds (*Asclepias* spp.)	June–September
Mourning cloak (*Nymphalis antiopa*)	Willows (*Salix* spp.) Roses (*Rosa* spp.)	Lilac (*Syringa vulgaris*)	Spring–fall
Pipevine swallowtail (*Battus philenor*)	Pipevine (*Aristolochia durior*)	Phlox (*Phlox* spp.) Milkweeds (*Asclepias* spp.)	April–fall
Red admiral (*Vanessa atalanta*)	Nettles (*Urtica* spp.)	Purple loosestrife (*Lythrum salicaria*) Thistles (*Cirsium* spp.)	April–October
Spicebush swallowtail (*Pterourus troilus*)	Spicebush (*Lindera benzoin*) Sassafras (*Sassafras albidum*)	Japanese honeysuckle (*Lonicera japonica*) Milkweeds (*Asclepias* spp.)	Spring–early fall

(continued)

BACKYARD BUTTERFLIES AND THEIR PREFERRED FOODS – *Continued*

Species	Caterpillar Food Plants	Adult Food Plants	On the Wing
Tiger swallowtail (*Pterourus glaucus*)	Willows (*Salix* spp.) Birches (*Betula* spp.) Cherries (*Prunus* spp.)	Phlox (*Phlox* spp.) Red clover (*Trifolium pratense*) Boneset (*Eupatorium* spp.)	Spring-fall
Viceroy (*Limenitis archippus*)	Willows (*Salix* spp.) Cherries (*Prunus* spp.) Apples/crabapples (*Malus* spp.)	Milkweeds (*Asclepias* spp.) Goldenrods (*Solidago* spp.) Thistles (*Cirsium* spp.)	April-September
Zebra swallowtail (*Eurytides marcellus*)	Pawpaw (*Asimina triloba*)	Milkweeds (*Asclepias* spp.)	April-October

SOURCE: Adapted from "Gardening for Butterflies," by Bryon Shissler and Mark Holman, *Pennsylvania Wildlife and Outdoor Digest,* vol. IX, No. 3, 1988.

disappeared, the crinkled foliage shriveled away and was replaced, and I noticed ladybugs on patrol all across my garden.

Other Insects

Who doesn't enjoy the surprise of being out in nature and seeing a twig suddenly walk away? The walkingstick (*Diapheromera femorata*) resembles a twig so closely that it seems to be a vision from an old sci-fi movie in which the plants come to conscious life.

Praying mantids (*Mantis religiosa*) are also fun to watch—the ultimate horror-movie creature. I still remember my shock at first spying a mantis's fierce visage peering back at me from a garden bush when I was a child. They often inhabit gardens as well as fields and woods. The best way to encourage both mantids and walkingsticks is to not use pesticides to disrupt the ecology that supports them.

Water in the landscape increases your chances of attracting the black-winged damselfly (*Agrion maculatum*)—a dark, jewel-like "darning needle" with two sets of wings—or other forms of dragonfly. Their nymphs, which are the immature form, live in water and are a prized food for fish, as I learned when young. We called them hellgrammites, and they were the ultimate bait for catching trout.

A pesticide-free garden is hospitable to the banded argiope, also called more prosaically the black-and-yellow garden spider (*Argiope aurantia*). This is the big, handsome orb-weaver that spins the large, precisely radial webs that catch the morning dewdrops like strings of diamonds. The sensitive gardener will avoid using the path this beautiful web is strung across. If you have to move it, use two sticks and move the web and spider (she's usually found near the center of the web) gently to the nearest bush or safe place. She can always re-build. Besides her beauty, this garden spider provides free organic pest control.

Earthworms aren't really insects, but, like the garden spider, are close enough to include here. All earthworms, and especially night crawl-ers (*Lumbricus terrestris*), are not only good bait, they are superb at soil improvement. Soil containing plenty of actively decaying organic matter favors earthworms. Compost piles and piles of rotting leaves or other organic matter help increase their numbers. Scientists have found that earthworm castings (digested soil particles) are seven times as rich in some of the major soil nutrients as surrounding soil that hasn't passed through an earthworm.

REPTILES

Turtles

A wet environment such as a pond can be home to several pretty turtles. The spotted turtle (*Clemmys guttata*) has an ebony shell with lovely, yellow, decorative spots and likes to bask in the sun. It is native to the entire eastern seaboard and the Great Lakes region. Both the slider (*Chrysemys scripta*) and painted turtle (*C. picta*) like the weedy edges of ponds. The slider is native to the East Coast from the mid-Atlantic south, across the Midwest and down into Mexico, while the painted turtle's range covers the entire East Coast (excluding Florida), the Midwest, and the Northwest, including southern Canada. I remember as a child that "red-eared turtles"—in reality, sliders—were commonly given as gifts to small children who usually had no idea how to care for them.

For those without ponds, but who plan a natural landscape in a moist woodland, field, or floodplain, the eastern box turtle (*Terrapene carolina*) may make an appearance. The shell of this beautiful turtle looks like tortoiseshell—yellow or orange patterns on the brown or black shell. The western box turtle (*T. ornata*) is found on dry scrubland and plains from Texas to Minnesota. Its shell has Indian-basket pat-terns in yellow on black or brown. The hinged lower shells of these turtles enable the box turtles to close up tight when threatened. Unless you live in a rural area where these turtles can safely wander away, it's not a good idea to bring home a box turtle to your property. If you provide the right habitat, a turtle will find you. Box turtles will eat fruit, snails, earthworms, insects, and some plants, including toadstools.

Snakes

Although people share the inbred fear of snakes common to primates, only one-sixth of North America's 115 species of snake are venomous. Most of these are not deadly (although many will bite if threatened). And that's just the down side. Many snakes are beautiful, most are

harmless to people, and all are very useful in keeping the ecological balance of nature. Among the most useful snakes, because they eat rats, mice, and other vermin, are the corn snake (*Elaphe guttata*) with gorgeous gold and salmon markings; the rat snake (*E. obsoleta*), which is solid black; the beautifully marked milk snake (*Lampropeltis triangulum*), which has red markings edged in black on white or yellow; and the common king snake (*L. getulus*), which is mottled brown or black.

Although very beneficial, the milk snake and the king snake are often killed on sight because the milk snake resembles a copperhead and the southeastern scarlet king snake (*L. getulus,* southeastern race) resembles the deadly coral snake (*Micrurus fulvius*). As a sensitive, environmentally minded gardener, be aware that the milk snake has a bi-colored head with a Y- or V-shaped mark on top, while the copperhead has an unmarked, coppery-colored head. The scarlet king snake's red bands border black bands, while the deadly coral snake has its red bands bordering yellow ones (remember: red next to yellow kills a fellow).

Other familiar and harmless snakes that may come to inhabit your landscape include the garter snake (*Thamnophis sirtalis*), the eastern ribbon snake (*T. sauritus*), and the western cousin of the race, the western terrestrial garter snake (*T. elegans*). All three of these slender snakes have three stripes on their bodies, one down the back and one on each side. These snakes like damp meadows, marshes, and waterside habitats. They feed primarily on frogs, toads, and worms.

Despite my early fear of these creatures,

I've learned to appreciate them and what they do to reduce rodent and insect populations on my property. Now I count myself lucky to see them sliding through the grass.

Lizards

In the Southeast, Southwest, and West, you may find lizards on your property. With the exception of the poisonous Gila monster (*Heloderma suspectum*) of the desert, lizards are harmless to humans and beneficial to the garden, eating spiders, insects, and worms. In the East, the most common lizard is the eastern fence lizard (*Sceloporus undulatus*) with a range that extends to the Chesapeake Bay and across the Midwest. It favors dry woodlands, open prairies, and brushlands. A common and beautiful eastern lizard is the five-lined skink (*Eumeces fasciatus*) with a range extending into Canada. Young skinks are black and silver with a gorgeous blue tail. Skinks hibernate in the winter.

In the Southwest, there are many lizards, including the horned lizards (*Phrynosoma* spp.), desert iguana (*Dipsosaurus dorsalis*), collared lizard (*Crotaphytus collaris*), and banded gecko (*Coleonyx variegatus*). Horned lizards, often called horned toads because of their squat, plump outline, are among the most appealing lizards; their spined heads account for the first part of their name. Collared lizards are large (8 to 14 inches) and handsome, with a brilliant green body accented with yellow stripes and spots on the back and a characteristic black-and-white "collar." The desert iguana is even larger (10 to 16 inches), but its subdued gray-brown color and lack of head spines makes it easily distinguishable from the much larger true iguana of

Mexico and Central America. Unlike most lizards, the desert iguana is a vegetarian. Banded geckos are nocturnal lizards with large heads and fat tails; they hibernate from October to May.

Green anoles (*Anolis carolinensis*)—the "chameleons" of pet stores—are native along the Gulf of Mexico and the southeast coast. These 5- to 8-inch lizards earned the name chameleon because their color varies from brown to green, the males especially turning green when excited. Males also have an inflatable red throat pouch. It's fun to visit the Deep South and find these popular little lizards sitting on hedges, walls, and fences; their padded toes help them cling to vertical surfaces.

AMPHIBIANS

Salamanders and Newts

These harmless amphibians are often beautifully colored. They like moist conditions, such as under the dense, closed canopy of an Eastern woodland, especially where there's a nearby pond, stream, or wet place. They're often found in decaying organic matter on the shady forest floor. They also burrow under rocks. All eat insects.

A few of the more spectacularly colored species include the spotted salamander (*Ambystoma maculatum*), which is black with orange or yellow spots on its back; the marbled salamander (*A. opacum*), which is beautifully marked with silver or white on its black or charcoal body; and the tiger salamander (*A. tigrinum*), with beautiful orange-and-black markings. Tiger salamanders are particularly eye-catching because they're big—sometimes more than a foot

long. All these are common in the Midwest and East.

The long-tailed salamander (*Eurycea longicauda*), which is slender and bright orange with black markings and a long tail, inhabits grottoes, wet cave entrances, springs, and freshwater brooks. The red salamander (*Pseudotriton ruber*) is a rich vermillion with black spots on its back. It's stubbier-looking than the long-tailed salamander and is most often found in Appalachian Mountain ranges near springs, bogs, or streams, and adjacent woodlands. The eastern newt (*Notophthalmus viridescens*) has an aquatic phase and a land-dwelling phase. During its stint on land, it looks like a red salamander and is called a red eft. It varies from bright orange to reddish brown and has dark red dots on its back. You can lure salamanders to your property by establishing a pond or pool under tree canopies in an out-of-the-way place.

Toads and Frogs

Toads are quite common around the country. The toads you're most likely to see are the American toad (*Bufo americanus*) and the Fowler's toad (*B. woodhousei,* eastern race). American toads are 2 to 4½ inches long and can be any shade of brown, tan, or even rust-colored. The Fowler's toad is more clearly mottled with dark blotches and a lighter line down its back; size ranges from 2½ to 5 inches long. The American toad is an opportunist who inhabits everything from gardens to high mountains, while the Fowler's toad prefers sandy areas near fresh water.

Spadefoot toads—the kind I usually encounter around my property—occur across the

country. There's a western and plains species, but the most familiar in the eastern United States is the eastern spadefoot (*Scaphiopus holbrooki*), which is 1³/₄ to 3¹/₄ inches long, with some warting and irregular light and dark lines extending from the eyes to the rear end.

Toads eat insects at night and are very beneficial in the garden. You can aid them by allowing a diversity of insect life on your property and by making toad houses from rocks or chunks of wood placed over depressions in the soil in out-of-the-way parts of the garden. Toads tend to live in dry environments, from forests to gardens, breeding in pools of rainwater—although they appreciate a reliable source of water nearby.

In contrast to the warty, easygoing toads, frogs are smooth-skinned and move quickly. They also require more water than the terrestrial toads, and so any permanent body of water —even a small water garden—will greatly multiply the chances of a variety of frogs appearing to take advantage of it.

Tree frogs live in trees and shrubs, low plants near bogs and swamps, and wet woodlands. This group of frogs, with members from Maine to California, includes the spring peeper (*Hyla crucifer*), which is only ³/₄ to 1¹/₄ inches long. This little frog's early spring choruses of melodious peeps sound like the world itself waking up.

When I moved to my wooded 5 acres in Pennsylvania, I was surprised the first year that no peepers greeted the return of spring in my woods. My wife, Marilyn, caught a few on her excursions and released them in our woods, which included an acre of wet and boggy land overgrown with trees—perfect peeper habitat. We lived there 12 years, and by the time we moved away, the spring peepers were so thick in early April that their chorus was deafening.

Some of the most common true frogs, which inhabit wetlands, streams, and just about any permanent body of water, include the pond-dwelling bullfrog (*Rana catesbeiana*), the common green frog (*R. clamitans*), and the handsome leopard frogs, named for their leopardlike spots. The northern leopard frog (*R. pipiens*) is brownish with dark spots, while its Dixie cousin, the southern leopard frog (*R. sphenocephala*), has dark spots on green.

WATER IN THE GARDEN

It should be clear by now that if you want the widest variety of wildlife on your property, you have to have water. Water is our most precious element, the building block (as we all remember from grade school) of life. And it's also the most precious element in our landscapes. It seems almost alive in the garden setting as it sparkles in the sun, but its mood can change with the passing of a cloud and the riffle of a stiff breeze.

WATER FOR WILDLIFE

When you add water to the garden, nature comes to you. We installed two small pools on this property, and they brought immediate changes. One pool is a 4-foot-wide lily pond at the base of a natural wall. It contains a solar-powered recirculating pump that pumps water to the top of the natural wall, where it emerges from beneath a stone, crosses a flat rock, pours

off the edge onto another rock below, then splashes into the pond to be recirculated.

The lily pond is in good ecological balance—it isn't a green slime pit, but a clear, dark pool of water in which fish and other creatures make their homes. We planted a yellow-flowered water lily (*Nymphaea* 'Charlene Strawn'), an umbrella palm (*Cyperus alternifolius*), and a spike rush (*Eleocharis montevidensis*) in the pond, so that leaves cover about half its surface. We stocked it with four goldfish to eat mosquito larvae and to look pretty. That was all we put in the pool.

It wasn't long afterwards that I started to notice various creatures volunteering to join this small aquatic society. One of the first to arrive was a water strider. We're a mile from the nearest body of water, so I was amazed to find the water strider there. Within a few weeks, there were half a dozen skittering around on the surface.

But that was only the beginning. Hummingbirds came there to drink, and many other small birds came to frolic in the waterfall. Dragonflies and damselflies arrived soon after that, then the bees and yellow jackets stopped by to collect droplets of water for their hives or nests. Lizards scampered about on the stones. I heard a frog croak by the pool, but I've yet to spot it. Butterflies flutter by. And in the evening, our cat, Frankie, saunters over to stare at the fish, take a drink, and clean a paw.

A "POND" IN A BARREL

Nothing brings the garden to life as much as a body of water, be it ever so small. You can make a water garden the size of a dishpan. Just bury a container to within a few inches of the rim. We've done this with a half wine barrel just outside our front door. The barrel has been in place about three years now, and has a single white water lily ('Marliac Albida') growing in it. The lily is in a #10 can that sits on two bricks in the bottom of the barrel. Each year it sends up a single bloom.

I clean this tiny pond out from time to time by lifting out the plant and bricks, bailing out the water, putting bricks and plant back in, and filling it up with the hose. A couple of goldfish keep down the mosquito larvae. In this area, I can leave the barrel filled all year, but where temperatures drop below freezing, "rescue" the fish and plants for the winter by bringing them indoors or putting them in an in-ground pond. Left out over winter in cold areas, the barrel would freeze solid and kill them.

(continued on page 314)

BUILDING A ZIGZAG BRIDGE

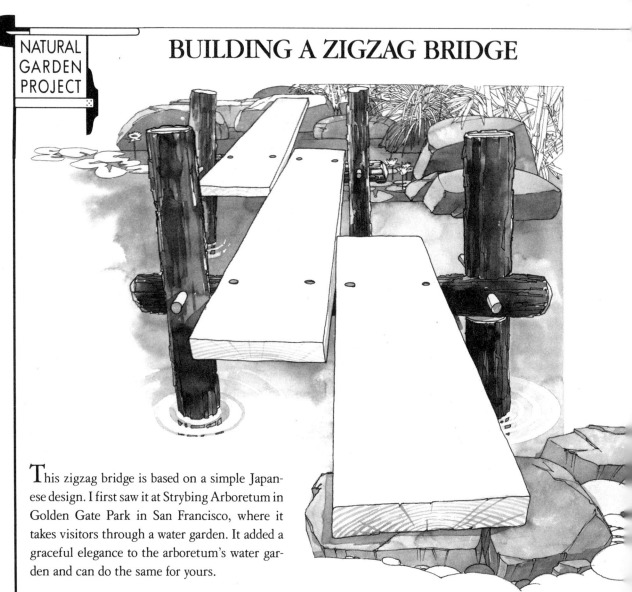

This zigzag bridge is based on a simple Japanese design. I first saw it at Strybing Arboretum in Golden Gate Park in San Francisco, where it takes visitors through a water garden. It added a graceful elegance to the arboretum's water garden and can do the same for yours.

Plants to Landscape Your Bridge

All of these plants thrive in wet or boggy conditions. Use them to landscape the area around your bridge.

Cardinal flower (*Lobelia cardinalis*)
Common monkey flower (*Mimulus guttatus*)
Lotuses (*Nelumbo* spp.)
Primroses (*Primula* spp.)

Rodgersias (*Rodgersia aesculifolia, R. podophylla*)
Rushes (*Juncus* spp.)
Sedges (*Carex* spp.)
Water lilies (*Nymphaea* spp.)
Yellow flag iris (*Iris pseudacorus*)

Bridge Dimensions

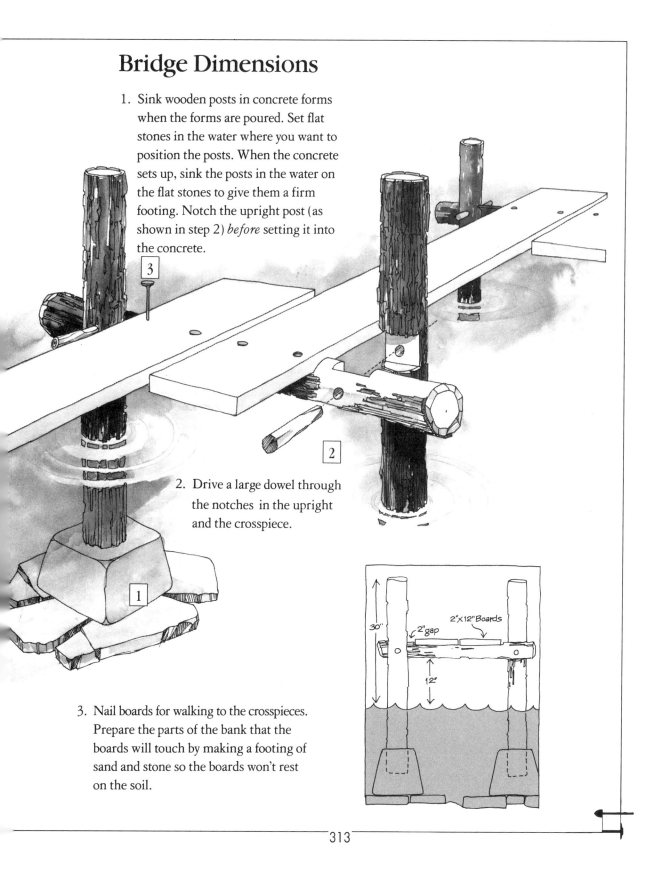

1. Sink wooden posts in concrete forms when the forms are poured. Set flat stones in the water where you want to position the posts. When the concrete sets up, sink the posts in the water on the flat stones to give them a firm footing. Notch the upright post (as shown in step 2) *before* setting it into the concrete.

2. Drive a large dowel through the notches in the upright and the crosspiece.

3. Nail boards for walking to the crosspieces. Prepare the parts of the bank that the boards will touch by making a footing of sand and stone so the boards won't rest on the soil.

30"

2" gap

2"X12" Boards

12"

We call this barrel our pond. It's now rimmed with baby's-tears (*Soleirolia soleirolii*), a little, fine-leaved, moisture-loving groundcover, and shaded by the broad overarching leaves of a Japanese fatsia (*Fatsia japonica*). In cold-winter areas, you can substitute a hardy, small-leaved groundcover, such as perennial candytuft (*Iberis sempervirens*), for the baby's-tears, and a rodgersia (*Rodgersia* spp.) for the fatsia. The fatsia, by the way, is so thrilled with its spot between the tub and a big old 'Gravenstein' apple tree that it is blooming with spiky, ivory-colored balls on ivory stems.

The barrel pond is a favorite place for birds to come in the evening for a drink. I've even seen brazen little birds sitting on the lily pads, fluttering and bathing in the water.

SIMPLE WATER FEATURES

It's especially nice for a garden path to lead over water, either over a bridge or on stepping stones. The water separates garden areas, forming a neutral area between passages. Stepping stones are the most natural of all the ways a path can cross water. They can be placed as small steps through the water or placed in a syncopated fashion using melodic spacings that encourage the traveler to skip, step, and even jump. But a bridge doesn't have to clash in a natural landscape. A natural-looking, easy-to-build bridge is the zigzag bridge, a style found commonly in Japan.

DIG YOUR OWN LILY POND

Our second lily pond, with the solar recirculating pump, was installed at the base of a bank.

When we started, the bank was simply loamy fill with no stones.

Like most water gardens, our pond has two levels—one shallow, one deep—to accommodate the different depths needed by aquatic plants. The higher level is usually from 6 to 9 inches below the surface, while the bottom of the pond is no more than 1½ to 2 feet deep. This is the right depth for water lilies and lotuses. But even a shallow pond like this can become a danger to small children and may need fencing to satisfy local laws regulating backyard ponds.

To site a lily pond in a natural setting, think first about how pools of water occur in the wild landscape. The pond will look most natural in the lowest place in the yard. Before you start digging, however, make sure you're not considering an area where runoff collects. Runoff can cloud the water or fill the pond with leaves, mulch, and other debris after heavy rains. But worst of all, if your neighbors use pesticides or herbicides, residue can run into your pond and kill fish and plants.

If your yard is flat, you can site the pond just about anywhere, but it should get at least 5 hours of sunlight a day for good water lily and lotus bloom. That means you shouldn't place it under or near the dripline of a tall tree unless it's due south of the tree and just beyond the dripline.

Ponds look natural nestled in the bottoms of banks, as though formed from a flowing spring. Think about the water flowing beneath the surface and get a feel for where it might appear above ground. Think about proportion. The size of the pond should fit in with the

groups of plants and the size of the yard around it. A 3-foot pond will appear puny in a great expanse of lawn edged with mature trees and evergreens, and a 10-by-12-foot pond would be out of place in a small backyard.

STEP-BY-STEP WATER GARDEN

Get a feel for your water garden's proportions by outlining your intended pool with a length of garden hose. Adjust it back and forth until its shape fits the contours of the land and surroundings. A 5-by-8-foot pond is a generous size even in a large backyard, and it can accommodate many plants. A 3-by-5-foot pond is appropriate for a small space in the backyard.

Since the pond is going to have a natural look, as though nature placed it there, place it as nature would. Vary the edges to fit the shape of the land. Natural means no corners, no symmetry, nothing perfectly round. You should create the shape that suits your site best, so avoid rigid pond liners, which come in precast shapes. A flexible sheet of polyvinyl chloride (PVC) or rubber, especially made for pond lining, will conform to whatever shape you dig. Buy or order the liner before you start digging, so you can put it in place before rains fill or erode the excavation. (*Don't* order fish or plants until you've dug the water garden and installed the liner; the water needs to age before plants and fish are added.)

Once you have the shape, dig off the turf and excavate the soil from the pond. Leave a tier 6 inches below the water level and 12 inches wide in one or more places along the edges. You'll be able to place pots of beautiful

bog plants and ornamental water grasses on this ledge. Excavate the rest of the pool 1 1/2 to 2 feet deep. Slope the bottom very slightly toward the end where you'll empty the pond. It makes draining easier.

Dig the sides nearly vertical, not gently sloping. This makes the pond look deeper when it's finished. Use a long, straight board and a spirit level to make sure the edge of the pond is level all around. When the pond is full, the surface will be dead level, so you want to make sure that the liner is evenly submerged and doesn't stick out of the water on a high side.

Remove any sharp rocks or roots protruding from the edges and bottom of the excavation, or they could rupture the pool liner. Put an inch of damp sand in the bottom of the hole and tamp it to make a soft, smooth bottom for the liner to rest on.

As I mentioned earlier, use a flexible PVC liner rather than a preformed piece of plastic or fiberglass. Another durable and flexible liner option is butyl rubber, but it's more expensive than PVC. I recommend a sheet of black, 32-mil PVC. Thinner liners are offered for sale, but 32-mil PVC has a longer life—up to 20 years—and is more resistant to punctures than thinner liners. However, even 20-mil PVC will last 7 to 10 years before needing replacement. The sheet of PVC also gives you leeway in designing a natural-looking pond that fits your landscape, rather than being limited to the shape molded into a preformed liner. And, though the PVC liners are a little more complicated to install, they cost considerably less than preformed liners. To determine what size pool liner you need, see page 317.

(continued on page 318)

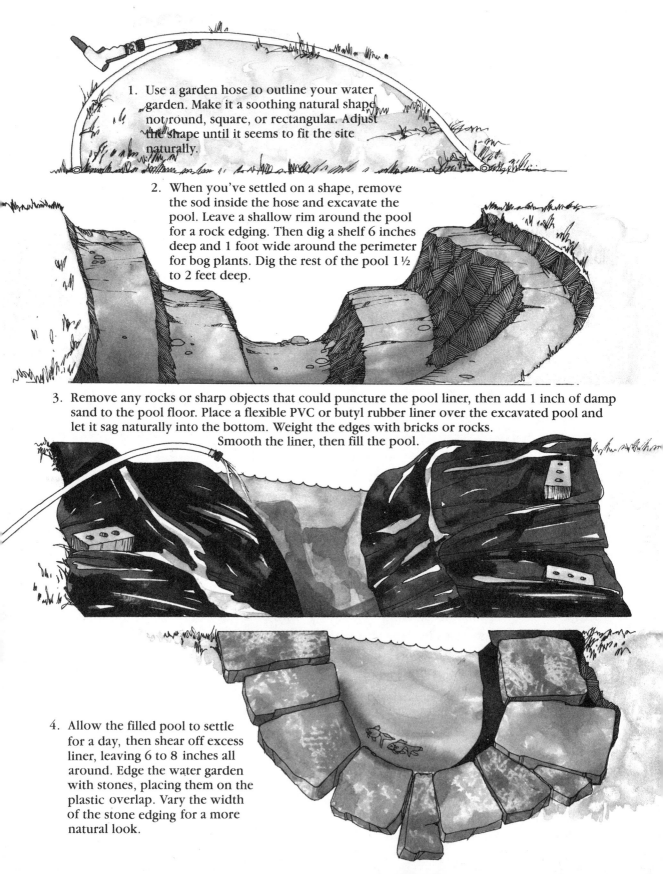

1. Use a garden hose to outline your water garden. Make it a soothing natural shape, not round, square, or rectangular. Adjust the shape until it seems to fit the site naturally.

2. When you've settled on a shape, remove the sod inside the hose and excavate the pool. Leave a shallow rim around the pool for a rock edging. Then dig a shelf 6 inches deep and 1 foot wide around the perimeter for bog plants. Dig the rest of the pool 1 ½ to 2 feet deep.

3. Remove any rocks or sharp objects that could puncture the pool liner, then add 1 inch of damp sand to the pool floor. Place a flexible PVC or butyl rubber liner over the excavated pool and let it sag naturally into the bottom. Weight the edges with bricks or rocks. Smooth the liner, then fill the pool.

4. Allow the filled pool to settle for a day, then shear off excess liner, leaving 6 to 8 inches all around. Edge the water garden with stones, placing them on the plastic overlap. Vary the width of the stone edging for a more natural look.

HOW TO FIND THE RIGHT POOL LINER SIZE

To find the correct liner size for your pond, multiply the depth by 3 and add it to the maximum width to get the width of the liner, then add it to the maximum length to get the length of the liner.

For example, suppose your pond's maximum dimensions are 5 feet wide, 8 feet long, and 2 feet deep.

Pond dimensions:
5 feet wide (W)
8 feet long (L)
2 feet deep (D)

Multiplying the depth by 3 gives you 6. Add 6 to the width (5 feet) to get 11. Add 6 to the length (8 feet) to get 14.

$$2\,(D) \times 3 = 6$$
$$5\,(W) + 6 = 11$$
$$8\,(L) + 6 = 14$$

Thus, the liner size you need is 11×14 feet.

Wait about a week before planting your water garden or adding fish, since it takes at least three days for the chlorine in the water to evaporate. Then add pots of water-loving bog plants on the shallow shelf, and set containers of water lilies, lotuses, and oxygenating plants on the bottom of the pool. Even a small water garden has room for a dwarf lotus or water lily. Don't forget to plant around the water garden, too.

If you'd like a mini-waterfall for your water garden, add a submersible pump and hose. Bury the hose in a bank leading down to the pool before you put in the retaining stones, leaving both ends of the hose free. Attach the pool end of the hose to the pump, and let the other end emerge from stones set in the bank. Use a clear or natural-colored hose and place the stones so the hose is as unobtrusive as possible.

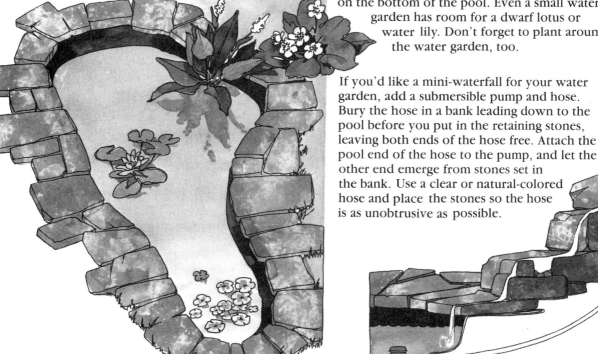

Buy the PVC liner for your pond from a reputable water garden supply company. That way, you'll be sure that there are no toxic substances that will leach into the water to kill or injure fish or the other creatures who will be attracted to drink from and use the pond. Use only black or dark brown PVC—nothing light, or the pond will look like a swimming pool. The plastic eventually gets a patina of mud and is indistinguishable under the water from natural rocks.

When you're about ready to put in the liner, spread it out in the sun for a while so it's supple and easy to manipulate. It really helps to have two people spread the liner. Place it over the hole so that it overlaps the edges evenly on all four sides and let it sag naturally into the hole until it rests on the bottom. The liner is heavy and may tend to keep sliding into the hole, so weight it with stones around the edges. Make sure you don't poke any holes in the liner.

Take off your shoes and get into the hole. Your partner should stand outside the hole. Between the two of you, fold and tuck the liner to make it as smooth as possible and reduce the number of wrinkles. You won't be able to remove all the wrinkles, but you can remove a lot of them by folding and tucking.

Start filling the pond with the garden hose. As it fills, it will pull some of the plastic into the hole, so remove rock weights as needed to allow the plastic to settle without stretching too much or tearing. When the pond is full, allow it to settle for a day, then shear off the excess plastic, leaving 6 to 8 inches of overlap all the way around. Spread the overlap out on the ground.

FINISHING TOUCHES

Now comes the interesting task of edging the pond with stones or other natural materials so that it looks natural and not just decorated with a flouncing of stones. The stones and rocks go on top of the plastic overlap, protruding an inch or so over the water.

Use at least one very large rock. If you're going to use more than one large rock, use three in a group with two close together and one somewhat away. If the pond is close to a terrace, you might extend the terrace to reach a portion of a pond edge. Put the terracing stones down right on top of the liner overlap, then mortar them together.

Whether you terrace or just use a rock edging, it's important to cover the liner overlap with stones. They'll hold the plastic in place, and they'll cover it to reduce ultraviolet deterioration of the PVC. You can vary the width of the stone edging for a more natural look.

When it rains, the pond will overflow. Set one stone along the edge slightly lower than all the others so the runoff occurs where you want it to. Channel it down a hill or out onto the lawn. Runoff will not be very great from a small pond.

If the pond is in a natural setting, you can use an old stump in an upright position or a fallen log to interrupt the regularity of the stones. You could also do a portion of the edge in sandy gravel. Mix this with mortar so it holds together when it sets up, so that while it looks loose, it doesn't keep falling into the pond.

Plant shrubs and creeping plants just outside the liner overlap and train them to trail over the rocks and plastic. This effect is especially good when the shrubs and plants merge

with the bog plants and water grasses emerging from pots resting on the tier you made at the edge of the pond.

Take your clues from ponds and pools of water in Nature. She often has stones emerging from the water and joining other stones on the surface. That tiered shelf 6 to 9 inches under the surface could also hold stones that could protrude partially above the water. Set these stones on a terra-cotta dish or plate if they have sharp edges. Any puncture in the plastic will let the water out. You can repair the PVC yourself, however, if you need to patch a hole. The water garden catalogs and stores that sell PVC liners also sell patch kits.

If you're planning a larger water garden, you might also place a large rock or stones directly on the bottom of the pond so that it emerges from the water. Again, set it on something flat that won't puncture the vinyl sheet. Putting all of these techniques together, you should be able to create a setting for your pond that doesn't look edged, even though it *is* edged.

As I mentioned, we have a solar-operated submersible pump in our pond. It pumps water up a hose we set into the bank before we put in the retaining stones. Then the water runs down the bank in a mini-waterfall and splashes back into the pool. Use clear hose or an earth-colored length of old garden hose. Again, no bright colors that would spoil the natural look of the pond. A clear or earth-colored hose becomes almost invisible. The pump is a 1.5-amp, 12-volt, direct-current, submersible pump with a plastic housing and large screen to prevent it from clogging up.

The solar panel is an 8-watt panel that we attached to the south side of the house on adjustable mounting brackets. These allow me to increase or decrease the angle at which the panel is set to catch more solar energy at different times of the year. Pumps that attach directly to house current are also available at plumbing supply houses. For information about the solar panel and pump for this project, write to Solar Electric, 175 Cascade Court, Rohnert Park, CA 94928.

When the sun shines, the water falls and plays its ancient tune for me. Sometimes I am completely refreshed just by sitting near the pond and hearing the water splash into the pond.

PLANTING YOUR WATER GARDEN

Don't plant or stock your pond with fish right away, especially if you have chlorinated city water. It takes a good three days or so for the chlorine to evaporate. The process is helped if you stir the pond water vigorously with a stick every day for three days. The water will also reach the ambient ground temperature during this time. If your community uses chloramine rather than chlorine to treat its water, you have to neutralize it before you can add plants and fish. Unlike chlorine, chloramine—a chlorine/ammonia compound—doesn't evaporate, and it will kill fish. To neutralize chloramine, treat your pond water with DeChlor, Aqua Safe, or a similar product from your water garden supplier.

Water plants are planted in containers, and you set the potted plants on the pond bottom rather than planting them directly. Containers can just be lifted out for pond-cleaning or to bring tender plants inside for the winter, as well as for dividing plants and keeping them

from taking over the pond. For the natural pond, make sure the container is a natural color. Terra-cotta is fine, but don't leave terra-cotta pots in the pond over the winter because they may crack. Alternatives include plastic dishpans and the large, black, plastic pots trees and shrubs come in—you can cut these down if they're too deep—as well as a range of containers available from water garden suppliers. If you use plastic, make sure the pots are black or dark gray so they won't show too much in the water.

Pot up the water plants with regular, heavy topsoil, not commercial potting mixes that may contain chemicals and kill fish. Clay soil is best. Avoid humus-rich soils with lots of leaf mold and other organic matter; organic matter will decay in the water and foul the pond. To keep the potting soil from floating out of the pots when they are submerged, we cover the surface of the soil with an inch or two of fine gray or brown gravel; this also keeps fish from digging the plants up. The pebbles help make the plant look more natural in the water. One water lily for every 12 to 24 square feet of pond surface is plenty. Don't plant too thickly or the lilies will cover the entire surface of the water. Many aquatic plants tend to grow straight up out of the water—think of irises (*Iris* spp.), cattails (*Typha* spp.), and rushes (*Pontederia* spp. and *Eleocharis* spp.). Balance their uprightness with water lilies (*Nymphaea* spp.), lotuses (*Nelumbo* spp.), and spreading plants like four-leaf water clover (*Marsilea mutica*).

You'll find many plants available for water gardening, including some of the most beautiful plants there are. Hardy water lilies are available in subtle and gorgeous whites, yellows, reds, pinks, and salmon. Some have beautiful burgundy-mottled foliage, and some are fragrant. Hardy water lilies will act as perennials and survive the winter if their containers don't freeze. If you live in a zone where your water garden would freeze solid (USDA Plant Hardiness Zone 5 and colder), even hardy water lilies will have to be put to bed in the cold cellar for the winter. This involves taking them out of the pond after a few hard freezes, trimming off their tops and wrapping the containers in wet newspapers, then putting them in plastic bags in a spot in the cellar where it doesn't freeze but temperatures don't rise above 40°F. They can be put back in the pond when it thaws out in March.

Tropical water lilies are available in a more spectacular range of colors, including periwinkle blue, purple, lavender, and magenta. Their brilliant yellow centers often give them a multicolored appearance, and some also have mottled foliage. The tropicals only survive outdoors over winter in Zone 10, but are routinely planted as annuals in water gardens in areas as cold as Zone 3. Besides their colors, they are also deliciously fragrant, and there are both day and night bloomers. Night-blooming water lilies are especially great if you work, because they'll be open when you get home, after the day bloomers have closed for the night.

Most lotuses require more elbow room than water lilies, but are even more spectacular in color, fragrance, and form. Some small cultivars for little ponds are available, such as 'Momo Botan' lotus (*Nelumbo nucifera* 'Momo Botan'), with rose flowers and small leaves. Other "barrel lotuses" include the tulip lotus (*N. nucifera* 'Shirokunshi'), with creamy white, tulip-shaped

flowers, and 'Charles Thomas' lotus (*N. nucifera* 'Charles Thomas'), which has deep pink flowers shading to lavender. There's even a native American lotus, *N. lutea,* with light yellow flowers; it's beautiful in a larger pond. Lotuses are hardier than you think—most survive outdoors through Zone 5, and *N. lutea* is hardy through Zone 4.

Hardy bog plants, tropical bog plants, oxygenating plants, and water irises are also available to complete your water garden picture. Some of the loveliest are shown below.

KEEPING YOUR POND IN BALANCE

Any lily pond will soon turn to a horrible slimy mess unless you create the conditions for ecological balance in the pool. Sunlight not only causes plants to grow in the soil, it causes algae and pond scum to proliferate (or "bloom") in the water. Water plants shade the water below, curbing algae growth, and use up nutrients in the water that otherwise might feed scum and algae.

Plant submerged water plants—the kind that grow completely under water and that are

Some of our most beautiful flowers, including water lilies, lotuses, and Japanese irises, grow in or near water. It's easy to create a beautiful flowering water landscape, whatever your pool's size. And where there's water, there will soon be frogs, enlivening the garden with their cheerful antics. A few favorite water garden plants include: (1) lotus (*Nelumbo nucifera*), (2) pickerel weed (*Pontederia cordata*), (3) water clover (*Marsilea mutica*), (4) Japanese iris (*Iris ensata*), and (5) marsh marigold (*Caltha palustris*).

often sold for aquariums—to oxygenate the water and provide habitat below the water line. You'll need two or three bunches of submerged water plants for each square yard of water surface. Anacharis (*Elodea canadensis*) and myriophyllum (*Myriophyllum* spp.) are easy to get from garden suppliers who deal in water plants.

Keep hungry fish away from your submerged water plants until they become established—they will root in a few weeks. Plant these and all water plants in heavy topsoil in a pot, cover the soil with a layer of gravel or pebbles, and submerge the pots. Potting soils contain too much organic matter (like peat), which is undesirable for water plantings. Potting soils containing perlite or vermiculite aren't suitable, either; these substances float to the surface. If you can obtain a few tadpoles, put them into the pond along with fish to eat mosquito larvae. The fish will stay on mosquito patrol after the tadpoles turn into frogs.

Keep the pond bottom clean or your water garden will smell abysmal every time the water is disturbed. Scoop around pots of plants on the bottom. Again, siting water gardens where trees and shrubs can't drop leaves, flowers, and fruit in them simplifies cleanup. Make sure you scoop debris and fallen leaves from the surface daily,

and drain the pool and clean the bottom every other year. Anaerobic bacteria thrive in submerged organic matter, giving off methane that can kill fish, especially in the winter when the pond has a skin of ice on it and these gases are trapped in the water.

If you live in an area where the pond would freeze to the bottom, you can put a stock tank de-icer, available from well-stocked hardware stores and water garden suppliers, in the water. Other options are to try to overwinter the fish in a tank that won't freeze—which is tricky if they've become environmentally stabilized in your pond—or restock the pond each spring with new fish. If you have fish and your pond is covered with ice for more than three weeks in winter, you'll have to use a pond de-icer to thaw the surface. Don't try cracking up and removing the sharp ice or you'll very likely poke holes in the liner.

The perennial flowering plants listed on the opposite page tolerate boggy or pond- and poolside conditions. By making a careful selection of these plants, you will be able to add spots of color and interesting leaf textures and shapes to your water garden throughout the growing season. All are hardy at least to Zone 6, and most to Zone 4 or 5.

SELECTED PERENNIALS FOR WET OR BOGGY CONDITIONS

Plant Name	USDA Plant Hardiness Zone	Height	Bloom Time	Bloom Color
Full Sun				
Blue flag iris (*Iris versicolor*)	4	2-3 ft.	June	Blue
Blue vervain (*Verbena hastata*)	3	5 ft.	Aug.-Oct.	Blue
Boneset (*Eupatorium perfoliatum*)	3	3-4 ft.	Aug.-Oct.	White
Cardinal flower (*Lobelia cardinalis*)	3	3 ft.	Aug.-Sept.	Red
Common monkey flower (*Mimulus guttatus*)	6	2 ft.	July-Aug.	Yellow
Creeping Jenny (*Lysimachia nummularia*)	3	1 in.	June-July	Yellow
Culver's root (*Veronicastrum virginicum*)	3	6 ft.	July-Aug.	White
'Desdemona' bigleaf ligularia (*Ligularia dentata* 'Desdemona')	4	4 ft.	July-Aug.	Orange
'Dropmore Purple' purple loosestrife (*Lythrum virgatum* 'Dropmore Purple')	4	6 ft.	June-Aug.	Purple
'Dunkelburg' bigleaf ligularia (*Ligularia dentata* 'Dunkelburg')	4	4 ft.	July-Aug.	Orange
Fingerleaf rodgersia (*Rodgersia aesculifolia*)	6	4 ft.	June-Aug.	White
Garden loosestrife (*Lysimachia punctata*)	5	4 ft.	June-July	Yellow
Giant hogweed (*Heracleum mantegazzianum*)	4	6 ft.	July	White
Golden meadowsweet (*Filipendula ulmaria* 'Aurea')	3	3 ft.	July	White
Goldenrods (*Solidago* spp.)	4	5 ft.	Aug.-Oct.	Yellow

(continued)

SELECTED PERENNIALS FOR WET OR BOGGY CONDITIONS – *Continued*

Plant Name	USDA Plant Hardiness Zone	Height	Bloom Time	Bloom Color
Full Sun – *continued*				
Gooseneck loosestrife (*Lysimachia clethroides*)	4	3-4 ft.	July-Sept.	White
Great blue lobelia (*Lobelia siphilitica*)	5	3 ft.	Aug.-Sept.	Blue
'Gregynog Gold' bigleaf ligularia (*Ligularia dentata* 'Gregynog Gold')	4	4 ft.	July-Aug.	Yellow
Heath aster (*Aster ericoides*)	3	2-3 ft.	Aug.-Sept.	White
Hemp agrimony (*Eupatorium cannabinum*)	4	3-5 ft.	Aug.-Oct.	Mauve
Hesse's ligularia (*Ligularia × hessei*)	4	6 ft.	July-Aug.	Orange
Hodgson's ligularia (*L. hodgsonii*)	4	3 ft.	July-Aug.	Orange
Japanese iris (*Iris ensata*, formerly *I. kaempferi*)	5	3 ft.	July	Purple
Joe-pye weed (*Eupatorium maculatum*)	3	6 ft.	Aug.-Oct.	Mauve
Joe-pye weed (*E. purpureum*)	4	10 ft.	Aug.-Oct.	Mauve
Knotweed, smartweed (*Polygonum affine*)	4	1½ ft.	Aug.-Oct.	Rose
Ledebour globeflower (*Trollius ledebourii*)	4	3½ ft.	June-Aug.	Orange
Loosestrife (*Lysimachia ciliata*)	4	3-4 ft.	June	Yellow
Loosestrife (*L. ephemerum*)	6	3 ft.	July-Aug.	White
Marsh marigold (*Caltha palustris*)	3	6-12 in.	May	Yellow
'Morden Gleam' purple loosestrife (*Lysimachia virgatum* 'Morden Gleam')	3	5 ft.	June-Aug.	Rose

Plant Name	USDA Plant Hardiness Zone	Height	Bloom Time	Bloom Color
'Morden Pink' purple loosestrife (*L. virgatum* 'Morden Pink')	3	6 ft.	June–Aug.	Pink
'Morden Rose' purple loosestrife (*L. virgatum* 'Morden Rose')	3	4 ft.	June–Aug.	Rose
New England aster (*Aster novae-angliae*)	3	4–6 ft.	Sept.–Oct.	Various
New York ironweed (*Vernonia noveboracensis*)	5	6 ft.	Aug.–Oct.	Purple
Ornamental rhubarb (*Rheum palmatum*)	4	6 ft.	May–June	White
'Othello' bigleaf ligularia (*Ligularia dentata* 'Othello')	4	4 ft.	July–Aug.	Orange
Oxeye daisy (*Telekia speciosa*)	5	3 ft.	July–Sept.	Yellow
Pickerel weed (*Pontederia cordata*)	4	4 ft.	July–Oct.	Blue
Queen-of-the-meadow (*Filipendula ulmaria*)	3	6 ft.	July	White
Shavalski's ligularia (*Ligularia przewalskii*)	4	6 ft.	July–Aug.	Yellow
Siberian iris (*Iris sibirica*)	4	3 ft.	June	Various
Smooth aster (*Aster laevis*)	4	2–4 ft.	Aug.–Sept.	Blue
Snakeweed (*Polygonum bistorta*)	4	2 ft.	Aug.–Oct.	Rose
Spiderwort (*Tradescantia ohiensis*)	5	3 ft.	June–Aug.	Blue
'Superba' featherleaf rodgersia (*Rodgersia pinnata* 'Superba')	5	4 ft.	June–Aug.	Pink
'Superbum' snakeweed (*Polygonum bistorta* 'Superbum')	4	2½ ft.	Aug.–Sept.	Rose

(continued)

SELECTED PERENNIALS FOR WET OR BOGGY CONDITIONS – *Continued*

Plant Name	USDA Plant Hardiness Zone	Height	Bloom Time	Bloom Color
Full Sun – *continued*				
Swamp milkweed (*Asclepias incarnata*)	3	4-5 ft.	June-July	Pink
Umbrella plant (*Peltiphyllum peltatum*)	5	5 ft.	June-July	Pink
Variegated meadowsweet (*Filipendula ulmaria* 'Aureo-variegata')	3	3 ft.	July	White
Variegated water iris (*Iris laevigata* 'Variegata')	5	2-3 ft.	June	Lavender
'Venusta' Queen-of-the-prairie (*Filipendula rubra* 'Venusta')	3	6 ft.	July	Rose
Water mint (*Mentha aquatica*)	5	2 ft.	June-July	Lavender
Widow's-tears (*Tradescantia virginiana*)	4	3 ft.	June-Sept.	Blue
Wild calla, water-arum (*Calla palustris*)	2	6 in.	April-May	White
Yellow flag iris (*Iris pseudacorus*)	4	5 ft.	June	Yellow
Yellow skunk cabbage (*Lysichiton americanum*)	6	4 ft.	April-May	Yellow
Partial Shade				
Arrowhead (*Sagittaria latifolia*)	5	4 ft.	Aug.-Sept.	White
Astilbes (*Astilbe* spp.)	4	1-3 ft.	June-Aug.	Various
Bee balm (*Monarda didyma*)	4	4 ft.	June-July	Various
Butterbur (*Petasites japonicus*)	5	6 ft.	April-May	Yellow
Butterworts (*Pinguicula* spp.)	3	6 ft.	June-July	Purple
Candelabra primrose (*Primula pulverulenta*)	6	8 in.	May-June	Wine

Plant Name	USDA Plant Hardiness Zone	Height	Bloom Time	Bloom Color
False hellebore (*Veratrum viride*)	3	4 ft.	April-May	Yellow
Foxglove (*Digitalis purpurea*)	5	4 ft.	May-June	Various
Globeflower (*Trollius europaeus*)	5	3 ft.	June-Aug.	Yellow
Goatsbeard (*Aruncus dioicus*)	4	6 ft.	July	White
Golden creeping Jenny (*Lysimachia nummularia* 'Aurea')	3	1 in.	June-July	Yellow
Hardy forget-me-not (*Brunnera macrophylla*)	3	2 ft.	May-June	Blue
Japanese primrose (*Primula japonica*)	5	2 ft.	May-June	Mauve
King-of-the-meadow (*Thalictrum polygamum*)	4	8 ft.	May-July	White
Meadow rue (*T. aquilegifolium*)	5	3 ft.	May-July	Various
Meadow rue (*T. dasycarpum*)	3	6 ft.	May-July	White
Mist flower (*Eupatorium coelestinum*)	5	2-3 ft.	Aug.-Oct.	Blue
Monkshoods (*Aconitum* spp.)	3	6 ft.	Aug.-Oct.	Blue
Mugwort (*Artemisia lactiflora*)	4	3-4 ft.	Aug.-Sept.	White
Pink turtlehead (*Chelone lyonii*)	4	3 ft.	Aug.-Sept.	Rose
Pitcher plants (*Sarracenia* spp.)	3	2½ ft.	April-July	Various
Purple turtlehead (*Chelone obliqua*)	6	2 ft.	Aug.-Sept.	Purple
Skunk cabbage (*Symplocarpus foetidus*)	3	2 ft.	March-April	Purple-brown
Sundews (*Drosera* spp.)	4	4-6 in.	June-Aug.	Various

(continued)

SELECTED PERENNIALS FOR WET OR BOGGY CONDITIONS – *Continued*

Plant Name	USDA Plant Hardiness Zone	Height	Bloom Time	Bloom Color
Partial Shade – *continued*				
'Sun Gold' narrow-spiked ligularia (*Ligularia stenocephala* 'Sun Gold')	4	4 ft.	July-Aug.	Yellow
'The Rocket' narrow-spiked ligularia (*L. stenocephala* 'The Rocket')	4	3 ft.	July-Aug.	Yellow
Water avens (*Geum rivale*)	3	2 ft.	June	Orange
White turtlehead (*Chelone glabra*)	4	4-6 ft.	Aug.-Sept.	White
Wild bergamot (*Monarda fistulosa*)	4	4 ft.	June-July	Lavender

SOURCE: Adapted from "Suggested Hardy Bog Perennials," by Yvonne Giunta, *The Green Scene* (Pennsylvania Horticultural Society), July 1988.

SOURCES OF SUPPLIES FOR BACKYARD LILY PONDS

Water garden catalogs are not usually free, but their lavish color photos and how-to information make them well worth the price. Write to these companies for their current prices.

Lilypons Water Gardens
6800 Lilypons Rd.
P.O. Box 10
Lilypons, MD 21717
or
Lilypons Water Gardens
839 FM 1489
P.O. Box 188
Brookshire, TX 77423

Paradise Water Gardens
14 May St.
Whitman, MA 02382

S. Scherer and Sons
104 Waterside Rd.
Northport, NY 11768

Slocum Water Gardens
1101 Cypress Gardens Blvd.
Winter Haven, FL 33880

William Tricker, Inc.
7125 Tanglewood Dr.
Independence, OH 44131

Van Ness Water Gardens
2460 North Euclid Ave.
Upland, CA 91786

EPILOGUE: A LAST WORD

By now, I hope you're full of energy, enthusiasm, and ideas for your own natural landscape. But before you begin the exciting work of transforming your yard, take a minute to focus your ideas and remember what landscaping with nature is all about. The idea of this book is a simple one: that the wild landscape can inspire home gardeners to create personal interpretations of its beautiful details. These very personal gardens reflect both the natural landscapes that inspire them and the taste of the gardeners who select and build them.

Landscaping with nature is more than decoration of the home place; it's a very individual expression, in water, stone, wood, and plants, of what nature means to each of us. Your natural garden will capture the essence of what *you* mean by "nature."

We benefit from the process of creating a landscape with nature in more ways than the obvious one of designing a beautiful backyard. On the physical level, landscaping with nature —like all gardening—provides us with healthy, stimulating exercise. On the intellectual level, it provides us with the excitement of choosing lovely natural features and interpreting them in our gardens. On the spiritual level, landscaping with nature provides us with the opportunity to discover a personal relationship to the whole of Nature through this work.

Discovering our relationship to Nature— our connection with her—is vitally important now. Our efforts to make the world safe and comfortable for our own species have threatened, and sometimes ended, the existence of countless plant and animal species. As the global impact of our actions becomes more and more apparent—acid rain, the greenhouse effect, pesticide misuse, groundwater contamination, garbage overload, nuclear dumping—we realize that our actions have endangered our own species as well. We must learn how to live on this Earth without destroying the fabric of life. And we must learn soon.

This book suggests that we look both ways before proceeding: first outside at Nature, wherever we find her, then inside at our own relationship to the natural world. In that relationship, so full of potential for the betterment of life on Earth, is the answer.

USDA PLANT HARDINESS ZONE MAP

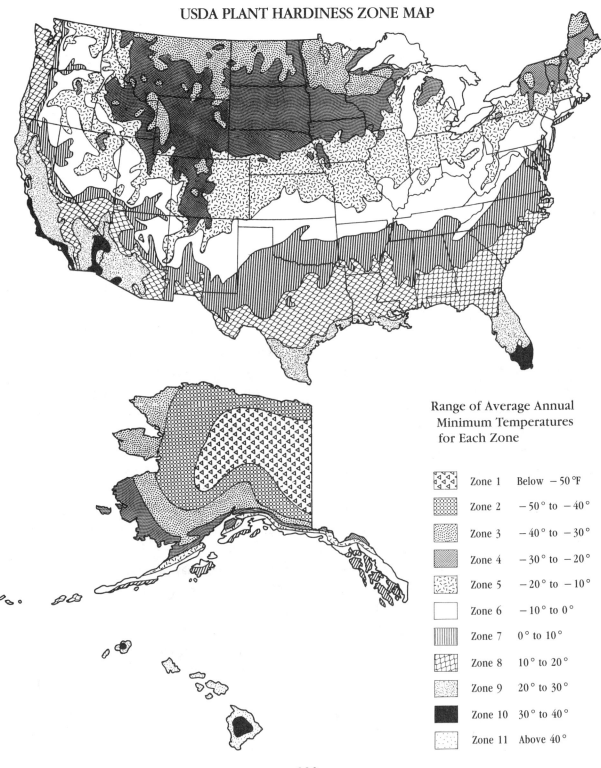

Range of Average Annual
Minimum Temperatures
for Each Zone

	Zone	Temperature
	Zone 1	Below −50 °F
	Zone 2	−50° to −40°
	Zone 3	−40° to −30°
	Zone 4	−30° to −20°
	Zone 5	−20° to −10°
	Zone 6	−10° to 0°
	Zone 7	0° to 10°
	Zone 8	10° to 20°
	Zone 9	20° to 30°
	Zone 10	30° to 40°
	Zone 11	Above 40°

FOR FURTHER REFERENCE

GENERAL LANDSCAPING AND GARDENING

Bush-Brown, James, and Louise Bush-Brown. *America's Garden Book.* Rev. ed. New York: Charles Scribner's Sons, 1980.

Clausen, Ruth Rogers, and Nicolas H. Ekstrom. *Perennials for American Gardens.* New York: Random House, 1989.

Cox, Jeff, and Marilyn Cox. *The Perennial Garden: Color Harmonies through the Seasons.* Emmaus, Pa.: Rodale Press, 1985.

MacKenzie, David S. *Complete Manual of Perennial Ground Covers.* Englewood Cliffs, N.J.: Prentice Hall, 1989.

Still, Steven M. *Herbaceous Ornamental Plants.* Champaign, Ill.: Stipes Publishing Co., 1982.

Sunset Magazine and Book Editors. *Sunset Western Garden Book.* Menlo Park, Calif.: Lane Publishing Co., 1988.

NATURAL LANDSCAPING

Collins, John F., and Marvin I. Adleman. *Livable Landscape Design.* Ithaca, N.Y.: Cornell University, 1988.

Diekelmann, John, and Robert Schuster. *Natural Landscaping.* New York: McGraw-Hill Book Co., 1982.

Druse, Ken. *The Natural Garden.* New York: Clarkson N. Potter, 1989.

Flemer, William, III. *Nature's Guide to Successful Gardening and Landscaping.* Columbia, S.C.: University of South Carolina Press, 1972.

McHarg, Ian L. *Design with Nature.* Natural History Press, 1971.

Smyser, Carol A., and the Editors of Rodale Press Books. *Nature's Design: A Practical Guide to Natural Landscaping.* Emmaus, Pa.: Rodale Press, 1982.

TREES AND SHRUBS

Cox, Jeff, and Marilyn Cox. *Flowers for All Seasons: A Guide to Colorful Trees, Shrubs, and Vines.* Emmaus, Pa.: Rodale Press, 1987.

Dirr, Michael A. *Manual of Woody Landscape Plants.* 3rd ed. Champaign, Ill.: Stipes Publishing Co., 1983.

Hudak, Joseph. *Shrubs in the Landscape.* New York: McGraw-Hill Book Co., 1984.

————. *Trees for Every Purpose.* New York: McGraw-Hill Book Co., 1980.

Whitcomb, Carl E. *Know It and Grow It II.* Stillwater, Okla.: Lacebark Publications, 1983.

Wyman, Donald. *Shrubs and Vines for American Gardens.* Enl. rev. ed. New York: Macmillan Publishing Co., 1969.

————. *Trees for American Gardens.* New York: Macmillan Publishing Co., 1969.

WILDFLOWERS

Art, Henry W. *The Wildflower Gardener's Guide: Northeast, Mid-Atlantic, Great Lakes, and Eastern Canada Edition.* Pownal, Vt.: Storey Communications, 1987.

————. *A Garden of Wildflowers: 101 Native Species and How to Grow Them.* Pownal, Vt.: Storey Communications, 1986.

Audubon Society Staff. *The Audubon Society Field Guide to North American Wildflowers.* New York: Alfred A. Knopf, 1979.

Martin, Laura C. *The Wildflower Meadow Book.* Chester, Conn.: The Globe Pequot Press, 1990.

————. *Wildflower Folklore.* Charlotte, N.C.: The East Woods Press, 1984.

Niehaus, Theodore F. *The Peterson Field Guide to Pacific States Wildflowers.* Boston: Houghton Mifflin Co., 1976.

Peterson, Roger Tory, and Margaret McKenny. *A Field Guide to Wildflowers of Northeastern and North-Central North America.* Boston: Houghton Mifflin Co., 1968.

WATER GARDENING

Brooklyn Botanic Garden Record, Plants and Gardens. *Water Gardening.* Handbook no. 106. Vol. 41, no. 1. Brooklyn: Brooklyn Botanic Garden, 1985.

Paul, Anthony, and Yvonne Rees. *The Water Garden.* New York: Viking Penguin, 1986.

Swindells, Philip. *The Overlook Water Gardener's Handbook.* New York: The Overlook Press, 1984.

Uber, William C. *Water Gardening Basics.* Upland, Calif.: Dragonflyer Press, 1988.

BIRDS AND BUTTERFLIES

Dennis, John V. *A Complete Guide to Bird Feeding.* New York: Alfred A. Knopf, 1975.

———. *Beyond the Bird Feeder.* New York: Alfred A. Knopf, 1981.

Harrison, G. H. *The Backyard Birdwatcher.* New York: Simon & Schuster, 1979.

Klots, Alexander B. *A Field Guide to the Butterflies of North America, East of the Great Plains.* Boston: Houghton Mifflin Co., 1951.

Kress, Stephen W. *The Audubon Society Guide to Attracting Birds.* New York: Charles Scribner's Sons, 1985.

Mahnken, Jan. *Feeding the Birds.* Pownal, Vt.: Garden Way Publishing, 1983.

Milne, Lorus, and Margery Milne. *The Audubon Society Field Guide to North American Insects and Spiders.* New York: Alfred A. Knopf, 1980.

Peterson, Roger Tory. *A Field Guide to Western Birds.* Boston: Houghton Mifflin Co., 1972.

———. *A Field Guide to the Birds East of the Rockies.* Boston: Houghton Mifflin Co., 1980.

Proctor, Noble. *Garden Birds.* Emmaus, Pa.: Rodale Press, 1986.

———. *Songbirds: How to Attract Them and Identify Their Songs.* Emmaus, Pa.: Rodale Press, 1988.

Schneck, Marcus. *Butterflies: How to Identify and Attract Them to Your Garden.* Emmaus, Pa.: Rodale Press, 1990.

WILDLIFE AND WILDLIFE GARDENING

Dennis, John V. *The Wildlife Gardener.* New York: Alfred A. Knopf, 1985.

National Wildlife Federation. *Gardening with Wildlife.* Washington, D.C.: National Wildlife Federation, 1974.

Wernert, Susan J. *Reader's Digest North American Wildlife.* Pleasantville, N.Y.: Reader's Digest Association, 1982.

PHOTO CREDITS

Page 121: T. L. Gettings, top; Alison Miksch, bottom
Page 122: David Cavagnaro, top; Marilyn Cox, center; John P. Hamel/Secret Garden Tour, Newport, R.I., bottom
Page 123: Marilyn Cox, top; Susan A. Roth, bottom (garden of Jim and Conni Cross, Cutchogue, N.Y., designed by Conni Cross)
Page 124: T. L. Gettings, top; Susan A. Roth, bottom (garden of Mr. and Mrs. Robert Alexander, East Hampton, N.Y., designed by Thomas A. Reinhart, Creative Landscaping)
Page 125: T. L. Gettings (landscape design by Stoney Bank Nurseries)
Page 126: Harold Davis, top; Susan A. Roth, bottom (garden of William and Dolores Kreitsek, Southold, N.Y., designed by Conni Cross)
Page 127: Susan A. Roth (bottom: garden of Andrew and Mitsuko Collver, Stony Brook, N.Y., designed and installed by the Collvers)
Page 128: David Cavagnaro, top; Susan A. Roth, bottom (designed by Madeline Bastis, Reflections Water Garden Designs, East Hampton, N.Y.)
Page 129: Susan A. Roth (top: Alexander garden)
Page 130: Susan A. Roth
Page 131: Susan A. Roth, left (Alexander garden); T. L. Gettings, right
Page 132: David Cavagnaro, top; Susan A. Roth, bottom
Page 133: Susan A. Roth (top: Cross garden)
Page 134: Steve Terrill
Page 135: Susan A. Roth
Page 136: Steve Terrill
Page 137: Jeff Gnass, left; Steve Terrill, right
Page 138: T. L. Gettings (garden of Grace Rose, Berwyn, Pa.)
Page 139: Susan A. Roth (Kreitsek garden)
Page 140: Steve Terrill, top; Joanne Pavia, bottom
Page 141: John P. Hamel/Secret Garden Tour, Newport, R.I.
Page 142-43: Susan A. Roth (Collver garden)
Page 144: T. L. Gettings (garden of David Benner, Bucks County, Pa.)
Page 145: Susan A. Roth (Collver garden)
Page 146: Carl Doney (garden designed by Wayne Norton)
Page 147: Barbara W. Ellis
Page 148: David Cavagnaro
Page 149-50: Susan A. Roth
Page 151: Susan A. Roth (Lloyd Neck Wildflower Garden)
Page 152: Susan A. Roth (garden of Mr. and Mrs. Charles K. Woltz, Charlottesville, Va., designed by the Woltzes)
Page 153: Susan A. Roth
Page 154: Donna H. Chiarelli
Page 155: T. L. Gettings, left; Steve Terrill, right
Page 156-58: Susan A. Roth
Page 159: Susan A. Roth (designed by Conni Cross)
Page 160-63: Pamela J. Harper
Page 164: Marilyn Cox
Page 165: T. L. Gettings (Innisfree, garden of Walter Beck, Millbrook, N.Y.)
Page 166: Marilyn Cox
Page 167: David Cavagnaro, left; John P. Hamel/Secret Garden Tour, Newport, R.I., right
Page 168: John P. Hamel/Secret Garden Tour, Newport, R.I.
Page 169: T. L. Gettings (Benner garden)
Page 170: David Cavagnaro
Page 171: Carl Doney
Page 172-73: T. L. Gettings (Beck garden)
Page 174-75: T. L. Gettings
Page 176: Jeff Gnass
Page 177: Marilyn Cox
Page 178: Barbara W. Ellis
Page 179: Janet H. Ellis
Page 180: Barbara W. Ellis
Page 181-82: Janet H. Ellis
Page 183: T. L. Gettings
Page 184: Susan A. Roth

INDEX

Page references in *italic* indicate charts and tables.

A